Excess
Fashion and the Underground in the '80

CW00734418

EXCESS
Fashion and the Underground in the '80s

Edited by Maria Luisa Frisa and Stefano Tonchi

FONDAZIONE PITTI IMMAGINE DISCOVERY

CHARTA

<p style="text-align:center">* * *</p>

design coordination
Gabriele Nason

editorial coordination
Emanuela Belloni, Elena Carotti

editing
Harlow Tighe-Taverna

copy and press office
Silvia Palombi Arte&Mostre, Milan

web design and on-line promotion
Barbara Bonacina

© 2004
Edizioni Charta, Milan

© Fondazione Pitti Immagine Discovery,
Florence

©Pat Bates, Javier Vallhonrat,
Jean-Charles de Castelbajac, Jenny Holzer,
Carlo Maria Mariani, by SIAE 2004

© the artists for their images

© the authors for their texts

All rights reserved

ISBN 88-8158-465-4

Printed in Italy

catalogue edited by
Maria Luisa Frisa
Stefano Tonchi

editing and editorial coordination
Federica Cimatti
with Francesca Del Puglia

graphic design, scan-lifes
Alessandro Gori

translations
Gráphein s.r.l.

production secretary
Valeria Santoni

authors
Carlo Antonelli, Andrew Bolton,
Francesco Bonami, Alix Browne,
Mariuccia Casadio, Michele Ciavarella,
Roberto D'Agostino, Peter De Potter,
Giacinto Di Pietrantonio, Giusi Ferré,
Maria Luisa Frisa, Minnie Gastel,
Sofia Gnoli, Benjamin Liu,
Gianluca Lo Vetro, Antonio Mancinelli,
Alessandro Mendini, Ruben Modigliani,
Renata Molho, Federica Muzzarelli, Louise
Neri and Malcolm McLaren, Lorenza
Pignatti, Stefano Pistolini, Maddalena Renzi,
Olivier Saillard, Ingrid Sischy, Deyan Sudjic,
Mauro Tinti, Stefano Tonchi, Guy Trebay,
Luca Trevisani, Alessandra Vaccari

cover: collage with photocopy from L'Uomo Vogue,
no. 158, December 1985, photo Aldo Fallai and
image from the Moschino advertising campaign,
fall/winter 1987, photo Robert Diadul

Fondazione Pitti Immagine Discovery
via Faenza 111
50123 Florence
Tel. +39 0553693211/407
Fax +39 0553693200
discovery@pittimmagine.com
www.pittimmagine.com

Edizioni Charta
via della Moscova 27
20121 Milan
Tel. +39 026598098/026598200
Fax +39 026598577
edcharta@tin.it
www.chartaartbooks.it

Excess
Fashion and the Underground in the '80s

Stazione Leopolda, Florence
8 January - 8 February 2004

project produced by
Fondazione Pitti Immagine Discovery

in collaboration with
Centro di Firenze per la Moda Italiana
Pitti Immagine

with the scientific collaboration of
Galleria del Costume di Palazzo Pitti

curated by
Maria Luisa Frisa
Stefano Tonchi

associate curators
Peter De Potter [ИЕО80]
Mario Lupano [design and architecture]

women's fashion consultant
Mariuccia Casadio

guest consultants
Francesco Bonami
Giusi Ferré

research
Massimo Bertolaccini (Mtv Italia)
Livia Corbò
Francesca Del Puglia
Alba De Marinis
Angelo Teardo
Luca Trevisani

installation design
qart progetti: Donatella Caruso,
Luca Emanueli, Franco Pisani

fashion installation
Kyle Bradfield

music consultant
Nicola Guiducci

graphic design
Alessandro Gori

executive coordination
Marina Mele
Anna Pazzagli with
Cristiana Busi
Simonetta Mocenni

production secretary
Valeria Santoni

project director
Lapo Cianchi

public relations
Sibilla della Gherardesca
with Sybille Bollmann

press office/coordination
Cristina Brigidini
Francesca Tacconi

press office/media relations
Alessandra Buompadre
with Elisabetta Basilici Menini
Roberto Ruta

press office/web
Andrea Mugnaini

press office/reception and logistics
Caterina Giolli

with the contribution of

 |

with the patronage of

Region of Tuscany

Municipality of Florence

in collaboration with
the Cultural Council of the Municipality of
Florence

 |

FONDAZIONE PITTI IMMAGINE DISCOVERY WOULD LIKE TO THANK

Harry N. Abrams; Azzedine Alaïa; Alessi; Allegri; Angelo Vintage Palace; Shigeo Anzai; Arena; Arena Hommes Plus; Catherine Arigoni; Giorgio Armani; Artforum; Asap; Peter Ashworth; Richard Avedon; Luca Babini; David Bailey; Aldo Ballo; Giampaolo Barbieri; Andro Bansone; Carole Bario; Nancy Barr; Basile; Gabriele Basilico; Pat Bates; Howard Baum; Benetton; Gilles Bensimon; Maurizio Berlincioni; François Berthoud; Edo Bertoglio; Lina Bertucci; Andrew Bettles; Emmanuelle Beuvin; Alberto Bianchi Albrici; Biblioteca Tremelloni; Black Star; Didier Blanchat; Blitz; Eo Bocci; Koto Bolofo; Bompiani; Bona Bonarelli; Chiara Boni; Elena Bordignon; Zina Borgini; Martin Brading; Carrie Branovan; Brad Bransen; Andrea Branzi; Brioni; Daniele Brolli; Paola Brustia and Gianni Manassa; Vanni Burkhart; Remo Buti; Sergio Caminata; Canali; Stefano Canulli; Rita Capezzuto; Casa Vogue; Cerruti 1881; Cerruti Finpart; Chikuma Shobo Co.; CITY Magazine International; Closed; Dave Cockrum; Comme des Garçons; Complice; Attilio Concari; Contact Press; Enzo Contini; Contrasto; Converse; Corbis Sygma; Corneliani; Nicola Corona; Enrico Coveri; Richard Croft; Roberto Daolio; Jean-Charles de Castelbajac; De Diseño; Giuseppe Del Freo; Ann Demeulemeester; Robert Diadul; Aldo Di Domenico; Antonella Di Marco; Dolce & Gabbana; Dolce Vita; Domus; Donna; Doppia Firma; Driade; Barry Dunn; Andy Earl; Editions Assouline; Edizioni Condé Nast; Edizioni Gabriele Mazzotta; Paul Edmond; Egoïste; Arthur Elgort; Elle; Ellesse; Perry Ellis; Esquire; Cesare Fabbri; Façade; Aldo Fallai; Fashion Library; Fashion Today; Marina Fausti; Elio Ferrario; Gianfranco Ferré; Fabrizio Ferri; Hans Feurer; Elio Fiorucci; Franck Fournier; Gianni Franceschi; Frigidaire; Jill Furmanovsky; Katsuaki Furudate; Gabo; Galleria Clio Calvi Rudy Volpi; John Galliano; Giovanni Tommaso Garattoni; Giovanni Gastel; Jean-Paul Gaultier; Genny; Gibò; Romeo Gigli; Stefano Giovannoni; Marithé François Girbaud/Closed; Donatella Girombelli; Leonardo Girombelli; Paul Gobel; Greg Gorman; Jean-Paul Goude; Janet Gough; GQ; Grafiche AZ; Gran Bazaar; Timothy Greenfield-Sanders; Mats Gustavson; Ken Haak; Katharine Hamnett; Harumi; Henri Lloyd; Jane Hilton; David Hiscock; Jenny Howarth; George Hurrell; Sandro Hyams; i-D; Idea Book Edizioni; Igort; Interni; Interview; Massimo Iosa-Ghini; Franco Jacassi; Jet Set; Daniel Jouanneau; Lisa Kahane; Donna Karan; Bill King; Laurence King; Stephanie Klosed; Calvin Klein; Nick Knight; Silvia Kolbowski; Jeff Koons; Icare Kosak; Bob Krieger; Krizia; Barbara Kruger; François Lamy; Giorgio Lari; Valerio Lari; Barry Lategan; Ralph Lauren; Mike Laye; Le Case d'Arte; Lei; Leonardo Arte; Leonelli; Jean François Lepage; Levi's; Mark Lewis; Tanino Liberatore; Peter Lindbergh; Benjamin Liu; Marisa Lombardi; London Features International; Robert Longo; Lotto; Roxanne Lowit; L'Uomo Vogue; Laura Lusuardi; Lybra Immagine; Andrew Macpherson; Magnum; Gaël Mamine; Edland Man; Gianni Manassa; Max Mara; Tiziana Marchi; Martin Margiela; Massimo Mariani; Maripol; Stefano Massimo; Massimo Mattioli; Lorenzo Mattotti; David Maupin; Marcella Mazzetti; Barry Mc Kinley; Eammonn McCabe; Ian McKinnell; Steven Meisel; Memphis srl; Tony Meneguzzo; Men's Bazaar Italia; Avi Meroz; Michel Aveline Éditeur; Missoni; Issey Miyake; Modo; Modular srl; Moncler; Jean-Baptiste Mondino; Mondo Uomo; Claude Montana; Danilo Montanari Editore; Popy Moreni; Jamie Morgan; Moroso; Moschino; Davide Mosconi; Thierry Mugler; Nadir; Virginia Napoleone; Neon; Grazia Neri; Helmut Newton; Nike; Nikos; Nuovi Equilibri; Occhiomagico; Willem Odendaal; Robert Ogilvie; Margherita Palli; Persol by Luxottica; Omnibus Press; Miguel Oriola; Karla Otto; Pal Zileri; Cindy Palmano; David Palterer; Andrea Panconesi; Pantheon Books; Parkett; Paper; Jean Pierre Peersman; Per Lui; Phaidon; Photo 12; Photo Masi; Photo Masi (Welch and Collins); Photomovie; Pierre et Gilles; Polimoda, Florence; Pony Express Firenze; Power House Books; Prada; Praxis; Franceline Pratt; Primo Carnera; Eric Pujalet Plaà; Purple; Random House; Ray Ban by Luxottica; Martin Reavley; Guglielmo Renzi; Marcia Resnick; Retna Ltd; Derek Ridgers; Herb Ritts; Michele Robecchi; Robert Mapplethorpe Foundation; Patrick Robijn; Sheila Rock; Riccardo Romano; Alex Ross; Italo Rota; Paolo Roversi; Cinzia Ruggeri; Satoshi Saikusa; Eiichiro Sakata; Lou Salvatori; Denis Santachiara; Francesco Scavullo; Wendy Schecter; Schirmer/Mosel; Ferdinando Scianna; David Seidner; Jamel Shabazz; Cindy Sherman; Shogakukan Publishing; Kate Simon; Skrebneski; Sigfrido Martin Begué; Snap Photo; Lord Snowdon; Tom Sobolik; Socrep; Franca Soncini; Sonnabend Gallery; Soprani; Carla Sozzani; Franca Sozzani; Stephen Sprouse; Steidl; John Stoddart; Lorenzo Stralanchi; Studio Guenzani; Swatch; Stefano Tamburini; Gilles Tapie; Steve Taylor; TDR; Mario Testino; Thames & Hudson; The Estate and Foundation of Andy Warhol; The Face; Wist Thorpe; Eric Tibush; Timberland; Tod's; Isabella Tonchi; Leo Torri; Oliviero Toscani; Trussardi; Deborah Turbeville; Shoji Ueda; Keni Valenti; Mario Valentino; Valentino; Javier Vallhonrat; Fabio Valtancoli; Walter Van Beirendonck; Dries Van Noten; Willy Vanderperre; Vanity; Gian Marco Venturi; Guido Venturini; Gianni Versace; Violette Editions; Vitra Design Museum; Vogue; Vogue Hommes International; Vogue Italia; Albert Watson; Bruce Weber; Westuff; Vivienne Westwood; Westzone; Wet; James White; Larry Williams; Scalo; Yohji Yamamoto; Mike Yavel; Ermenegildo Zegna; ZG; Zigen; Fabio Zonta.

Contents

— / Around the mid-eighties, when Italy's fundamental role in the world of fashion had already become abundantly clear, people began talking about the culture of fashion. It was not just a reaction to the tendency to mythologize the new figure of the designer – an attitude that seemed in tune with other widespread mythologies of the time: hedonism, narcissism, yuppiedom, in their turn reactions to other isms that had made the previous decade so dreary and had looked at fashion with such a critical eye. Above all, fashion culture signified the recognition of something much more profound at work under the surface of fashion that could help us understand our contemporary world.

The concept of fashion culture has evolved a great deal since then, acquiring a breadth and intensity of inquiry and a full awareness of the fact that fashion is a central phenomenon of our time and one of its most pervasive creative languages. The Centro di Firenze per la Moda Italiana and Pitti Immagine have certainly played a part in this evolution. They were among the leading figures of the initial phase of the process, and still are today, through the quality and great variety of initiatives they undertake.

Among these initiatives, the Fondazione Pitti Image Discovery has taken a particular interest in fashion's capacity to establish links with other disciplines and other contemporary creative languages. The Fondazione's program promotes exhibition and publishing projects in which fashion draws themes and materials of reflection and production from its interaction with the visual arts, cinema, photography, advertising, architecture, design and music.

The exhibition and book *Excess: Fashion and the Underground in the '80s* focus their attention on a period in which, as Italian fashion established its place in the world, a cultural interest in fashion emerged. The Fondazione Discovery can certainly be regarded today as being on the cutting edge of the examination of this phenomenon at an international level.

ALFREDO CANESSA
Chairman, Fondazione Pitti Immagine Discovery
Chairman, Centro di Firenze per la Moda Italiana

— / Fashion, and Italian fashion in particular, owes a great deal to the eighties. And the eighties owed a lot to fashion. Some of the key themes of that decade, the sensational ones that contrasted most strongly with the gloominess and hyperinflation of the seventies, but also those that seemed less banal and glittering in a period often accused of extreme superficiality and hedonistic glamour, have left a deep mark.

On the cultural plane, the value placed on image, on communication and on an unbearable lightness of doing and thinking at once proved important discoveries: discoveries that in those years quickly revealed their potential for enrichment and liberation, but also produced misery and modern forms of slavery, something we are only beginning to recognize now.

That decade saw the emergence of the figure of the *stilista* – the most successful of whom were Italian, even if they were called fashion designers. The full development of an industrial fashion system in Italy blended with the traditions of its rich and varied territory, renewing them and bringing them into contact with the broadest cross section of contemporary life and then projecting them out into the world.

All this happened with the greatest spontaneity, with a spirited enthusiasm that had an excellent grasp of aesthetics but was unfortunately fairly weak on the level of organization, business and finance, research and basic and advanced training. Only now are we becoming aware of this, and with some justified concern, given that growth has stalled and it is no longer possible to cover up the shortcomings, but also with the knowledge that the qualities needed to react are all there.

Italian fashion has been at once an instrument and a catalyst of these processes. And a decisive part has been played in its economic role, as well as its social and cultural ones, by an abundant creativity on the part of individuals and groups, by a mental flexibility and by an eclectic range of references that are part of the genetic makeup of our country. Qualities that swam like fish in the rough and bracing waters of that period. The book and exhibition *Excess: Fashion and the Underground in the '80s* look back at a creative ferment that had something extraordinary about it and that gave form and substance to much of the situation in which we find ourselves today.

GAETANO MARZOTTO
Chairman, Pitti Immagine

EXCESS
THE LANDSCAPES OF THE FUTURE ARE ALREADY HERE

/

/

The sky above the port was the color of television, tuned
to a dead channel. . . . The Sprawl was a long strange
way home over the Pacific now, and he was no console
man, no cyberspace cowboy.
William Gibson, *Neuromancer*, 1984

I would like to express my gratitude to Giacinto Di Pietrantonio, my friend from those years and director of the Galleria d'Arte
Moderna e Contemporanea in Bergamo, for having invited me to join the group working on the exhibition
Italia infinita: Gli anni di piombo e d'oro del made in Italy.

/— Almost twenty years have gone by since the publication of William Gibson's *Neuromancer*. The future that Gibson imagined is already coming into being in the megalopolises that are continuing to grow, becoming more and more like organisms that regenerate themselves by duplication, in lands and nations not such a long strange way from us. They are cities that tell the stories of themselves and their awesome and unhappy expansion through the exponential growth of their populations. Ten million, twelve million, twenty million. Lights, channels of communication, streets and flows trace their plans and functions, while knowledge and the access to data banks and services increasingly determine the power of certain groups or individuals.

In this apparently unrelated *incipit* can be found one of the first reflections out of which the project *Excess: Fashion and the Underground in the '80s* sprang and took shape. Not only did we realize, looking around us, that the eighties were coming back in fashion, in music, in graphics, in politics, but also that the future envisaged in that decade, in such seminal novels as *Neuromancer* or in epoch-making films like *Blade Runner*, *Alien* or *Brazil*, had become more of a reality than we thought. And of course all of it, seen through the magnifying lens of globalization, on a gigantic scale.

The media now incorporate all the systems that produce ideas and culture and use them in a process of continual renewal, developing new forms and languages to be employed in the most diverse strategies of marketing. This glossy and alluring marketing imposes models of behavior and living that tend to homogenize individuals. At the same time, it is very quick to take notice of the birth of new types of consumers, of new pockets of resistance, in order to cater to them and meet their needs and moods in real time. The power of the models imposed is so pervasive that the celebrity system generates global icons that prescribe the same desires and fashions all over the world.

The transgression and excess of the eighties, which were born out of a real and almost ingenuous need to be different, unique and unmistakable, have now been watered down in a society of the spectacle which requires you to be transgressive and excessive on command, in order to stay in and not to be pushed to the margins of the out. So the decade of the image, with all its limits, its defects and even its missed opportunities, is revealed to have been a lively and swashbuckling time, a period of shattering of canons, of interaction with other techniques and forms of expression, always in search of a new point of view. Marion D'Amburgo of Magazzini Criminali, muse and icon of a generation on the move, wrote in the pages of the theatrical company's wonderful magazine: "Lacerated in this way, my body is a rubber ball. My imagination is wild. My land is now at the center of the universe. I've lost my supports; the Pillars of Hercules have collapsed out of delight in dreaming."

The renowned economist Francis Fukuyama, in a famous article written in the eighties, claimed that the modern and Western idea of history had come to an end because, after the collapse of the monarchies, the totalitarian regimes and the bipolar system of capitalism and socialism, what was being imposed on a global scale was the model of democracy and advanced capitalism, presenting the integration of markets as the only means of human progress towards modernity. After the attack on the towers of the WTC on September 11, this concept has become highly topical again, reviving the debate. Samuel Huntington, writing in the *New York Times* and referring to that theory, has argued that history is anything but over and that it in fact started again on that fateful date. None of us wants to stay still, or still less to turn back. The events of our lives have changed us and made us citizens of our time, sentimentally tied to what we have and eager to go forward to meet the future that awaits us. MLF

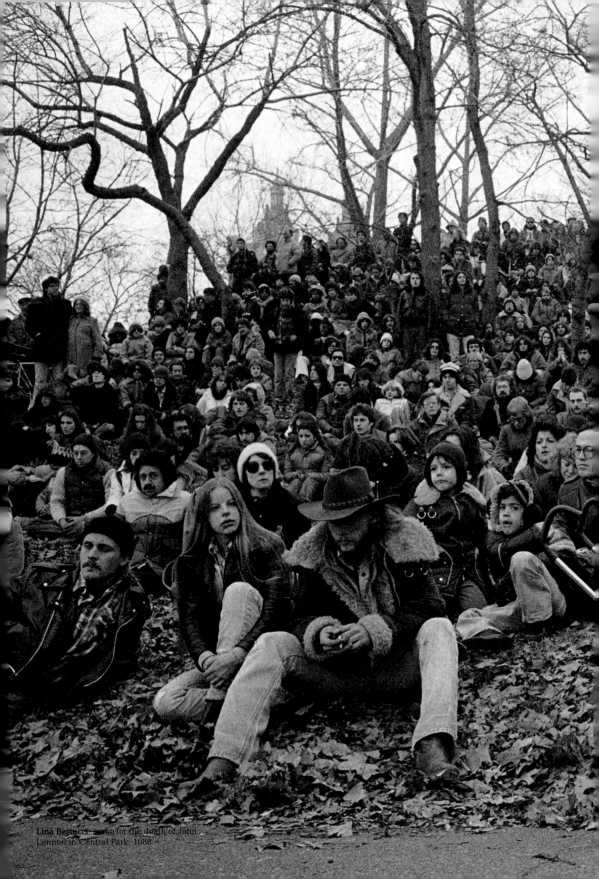

Lina Bertucci, *wake for the death of John Lennon in Central Park*, 1980 →

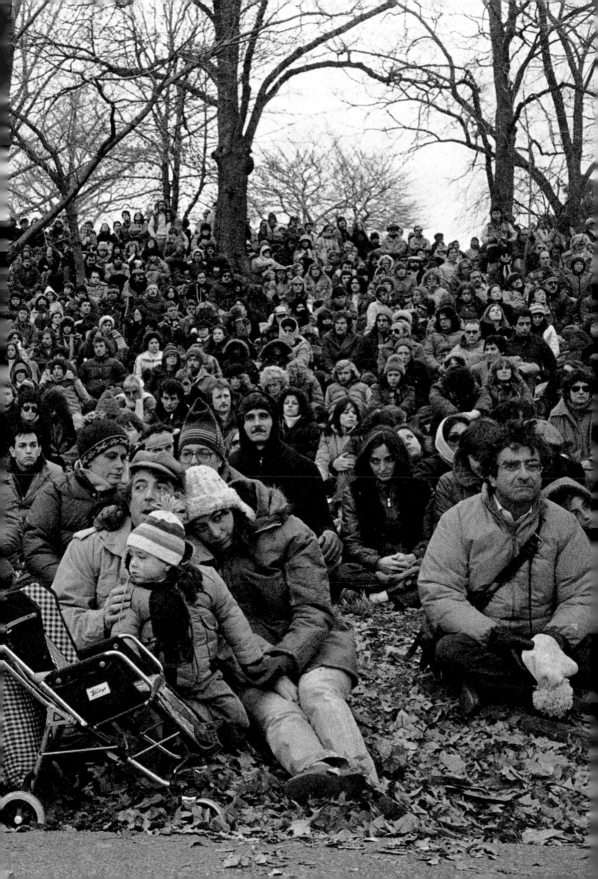

Clothes that construct and model the body. But also a body that begins to define its own structure with aerobics and the gym. The garment is designed to give personality and power to individuals. Padding builds up the shoulders and lends an imposing and authoritative touch to the female figure. Fashion makes figures stand out from the background and constructs defined, confident lines. The female superbody is at its ease in the uniform of the career woman as well as in the costume of the sexy heroine. The fashionable man becomes soft and sensual, colorful and unconventional. The male superbody is sculpture and has no fear of turning into a neoclassical gay icon.

SUPEЯBODY

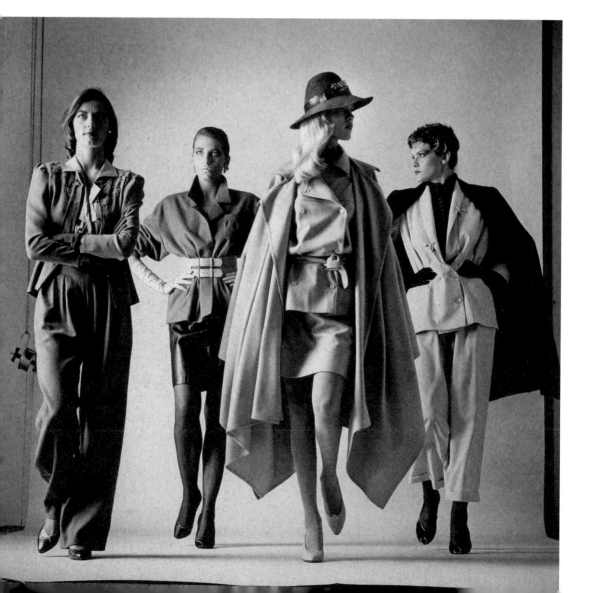

Helmut Newton for *Vogue France*, *"Sie kommen" Dressed*, 1981 and *"Sie kommen" Naked*, 1981. © Helmut Newton/TDR ¬

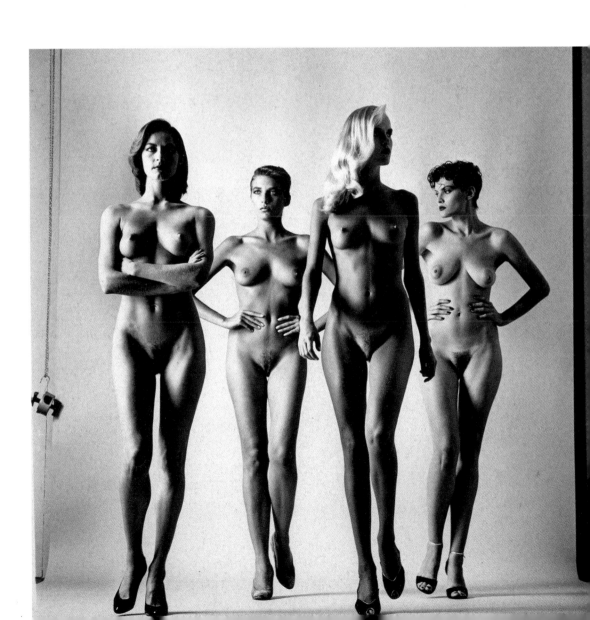

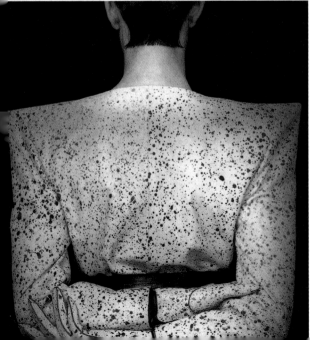

Silhouettes

Broad shoulders. Λ thin waist. Long, svelte legs. Perceiving the body in architectural terms is allegorical of an architecture of being that exists according to the new rules assailing an ever-optimistic Western society, despite the grim interlude of the seventies. Sartorial virtuosity responding to the changes of the era. Workshop training on styles and shapes enabled women to follow a brand-new destiny: that of interpreting new roles that "happen" contemporaneously, and no longer successively.

Whereas previously the time you spent as a student, a worker, a wife and a mother followed a chronological order, in the eighties it was possible to be a student, a worker, a wife and a mother at the same time. The examnation of the textile structure was therefore a symbolic, functional transposition of a totally new mode for women to exist in the world. It would appear that society, still in ferment with deliberately destabilizing social-political and emotional phenomena, now gave in to the allurement of a previously unheard-of call to order, or at least a formal order. Some spoke of a return to the classical, meaning by "classic" a re-elaboration of already known stylistic features, with purely European roots, revisited with a postmodern touch. However, the stamp of fashionable elegance with which the team of Italo-French fashion designers began to lay down the law in the kingdom of appearances was far removed from the "institutional" concept of elegance. This lean, strong, decisive silhouette that paraded the catwalks of Milan and Paris was the logical consequence of a cultural clash between couture's memory and a fascination with uniforms. Shoulder pads, stemming from the military uniform and a clear indication of masculinity, revealed (and demonstrated) a woman who was happy to personally assume the responsibility of new commitments. Λnd who was not afraid of how onerous they might be. On the contrary, she welcomed them. With regards to serving a purpose, the blazer's geometric severity meant you could always feel you had "got it right" at any time of the day or evening, simply by changing a few details, such as a blouse, a piece of jewelry or an accessory. What's more, the fashion industry, which only recently had begun to define itself as a "system," sketched a figure dislocating the signs of masculinity and femininity that predominated in our cultural codes. While on the one side it appeared to exalt a renewed cult in male-female seduction, on the other side it seemed to flatten and confuse sexual differences. It did not propose the utopia of unisex, but "other" feminine modes of "masculine" dressing, and "other" virile modes of "feminine" dressing (softer fabrics for formal attire, dart-stitched trousers, a *total look* verging into cosmetics and the care of the self). Λn ethical, esthetic revolution thus began, with the legitimate divisions between him and her surpassed and resolved with a silhouette which was in itself a guaranteed signature of the creative process endorsed by the initials or logo of the designer, in what was maybe the only possible certainty in a world seeking stability, confirmation, gratification and equivalencies between container and content. With style rapidly transforming itself into a form of religion, a sense of belonging and a set of values.

Λⁿтоⁿιо ΜλⁿсιⁿεLLι

Krizia, fall/winter 1988-1989 and spring/summer 1984 collections, photo Giovanni Gastel. From Isa Tutino Vercelloni (ed.), *Krizia*, Milan, Leonardo Λrte, 1995 ¬

DONNA

INTERNATIONAL FASHION MAGAZINE

MENSILE DI MODA E CULTURA - ANNO 1° N. 1 - MARZO 1980 - SPED. IN ABB. POST. GR. III/70 - LIRE 4000

evolve
la moda
la cultura
l'estetica

la donna cambia immagine

Prêt-à-porter
da Milano
Parigi
New York

edizione italiana

Claude Montana, photo Oliviero
Toscani. Cover of the first issue of
Donna, no. 1, March 1980 ¬

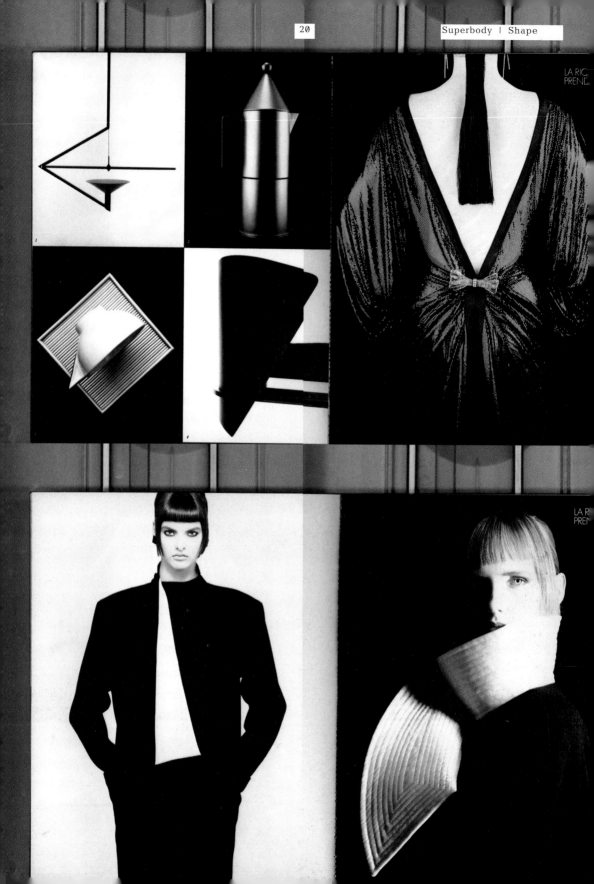

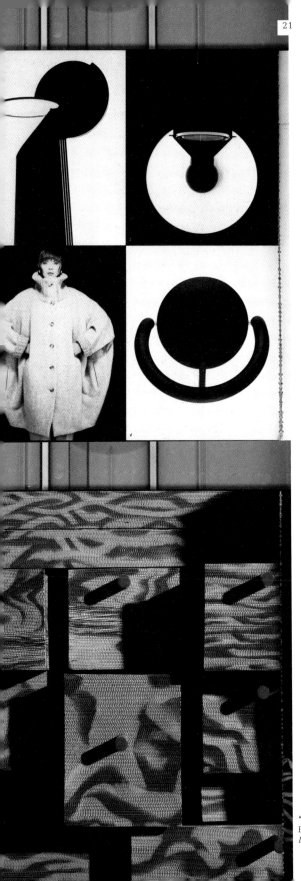

"La ricerca prende forma," feature Gilda Borioli, photo Giovanni Gastel. Pages from *Donna*, no. 57, September II 1985 ¬

Blade Яunner (Яidley Scott, 1982)

So, who was the first to introduce the aesthetics of cyberpunk, Яidley Scott with *Blade Яunner* or Mamoru Oshi with *Ghost in the Shell*? The replicant Daryl Hannah with her studded collar and shadowed eyes in Scott's movie or the robot policewoman with a soul in Oshi's animated film? The question is an intriguing one given that there is a gap of seventeen years between the two works, but it can be settled, if there were ever any need, by the fact that Scott's film was far ahead of its time and has had an enormous influence. In fact, its innovative character and above all the irreversibility of its impact was apparent right from the time of its release: after *Blade Яunner* the image of the city, and not just the city of the future but also that of urban reality *tout court*, would never be the same again. For this reason many consider it the true originator of cyberpunk, rather than Oshi's masterpiece of animation, which, to tell the truth, looks almost like an ideal sequel to *Blade Яunner*. Leaving the question of whether Scott's film was an example of cyberpunk or not in suspense, there can be no doubt that *Blade Яunner* marked the entrance of the postmodern into cinema. Everything is audaciously retro and at the same time intensified and given new meaning by a completely distorted context, riddled with pessimism and neurosis, twisted on itself in a spiral from which it emerges – perhaps – only at the end when it takes flight to the music of Vangelis. The movie draws on a variety of sources and operates on different levels: on the one hand there is the architecture of the city, on the other the appearance and essence of the characters and situations. If, in the first case, a direct comparison with *Metropolis* or with the extraordinary Babylonian sets of *Intolerance* is inevitable, the main influence for the rest seems to have come from the American film noir of the forties. And here it can truly be said that the movie looks to the past: in Яachel's look, a distinctly postmodern version of the Joan Crawford character in *Mildred Pierce*, with enormous shoulder pads and the square-cut outfits, a voluminous fringe framing a face in which the full, shiny lips stand out; in the splendidly cavernous interiors illuminated by shafts of light that recall the films noirs produced by Warner Brothers; and in the character of Harrison Ford himself, a revised and corrected Marlowe, more bitter and disillusioned than ever. Influences and references that, once transposed to the nihilist and perpetually rainy Los Angeles of 2019, fashion an almost hypnotic spectacle that even after twenty years continues to obsess us and to which we return every time we fantasize about our tomorrow. Besides, *Blade Яunner* makes it absolutely plain: he who has no past has no future.
Mauяo Tiиti

The set of Syd Meat and Sean Young (Яachel)
in **Blade Яunner**, USΛ 1982,
director Яidley Scott. © Grazia Иeri ¬

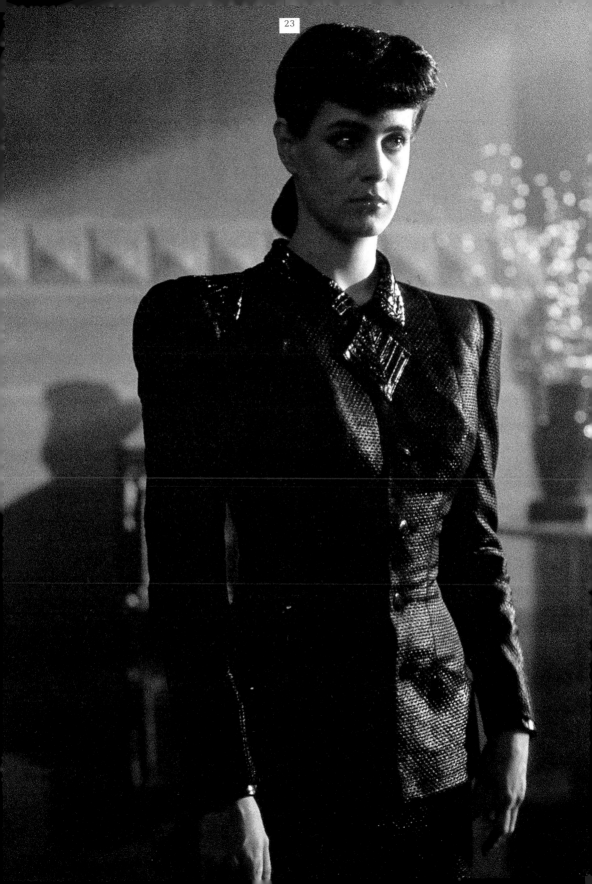

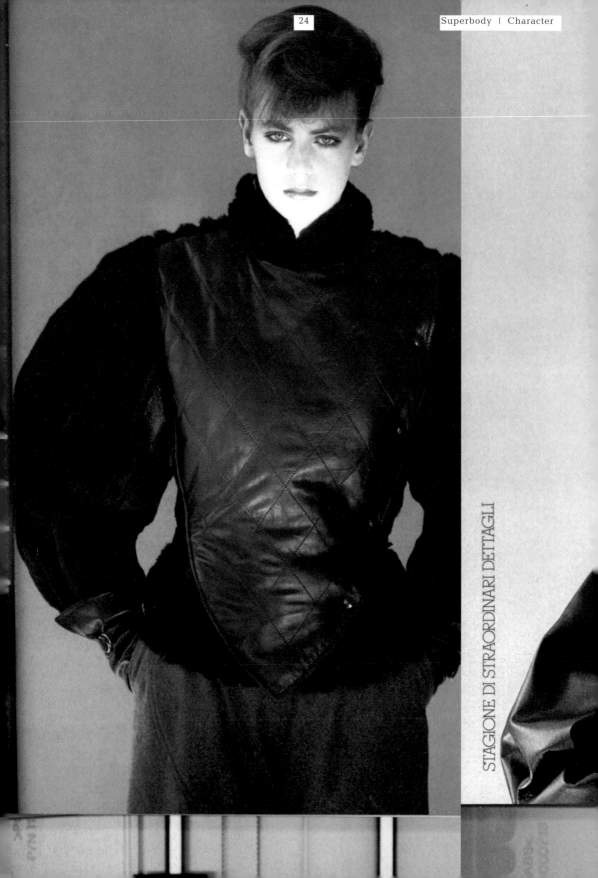

STAGIONE DI STRAORDINARI DETTAGLI

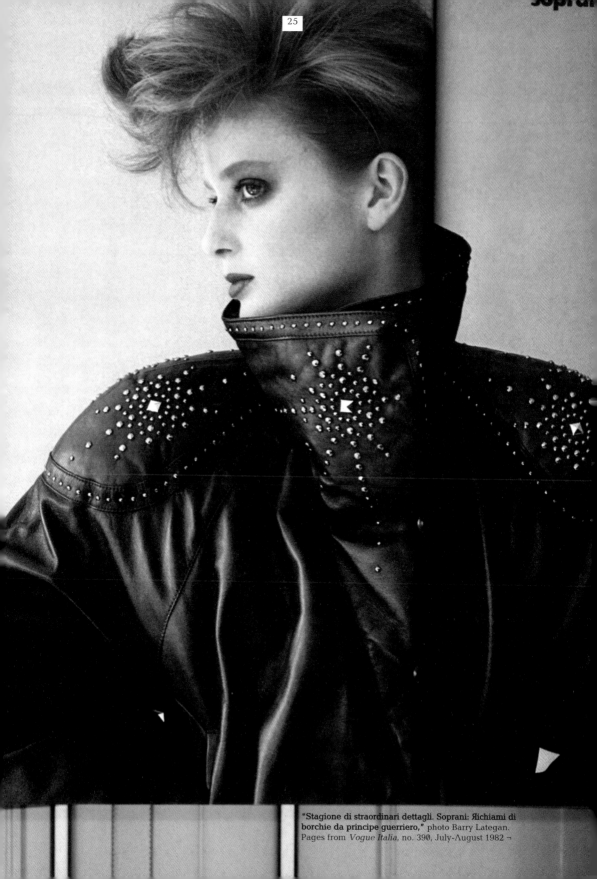

"Stagione di straordinari dettagli. Soprani: Яichiami di borchie da principe guerriero," photo Barry Lategan. Pages from *Vogue Italia*, no. 390, July-Λugust 1982 ¬

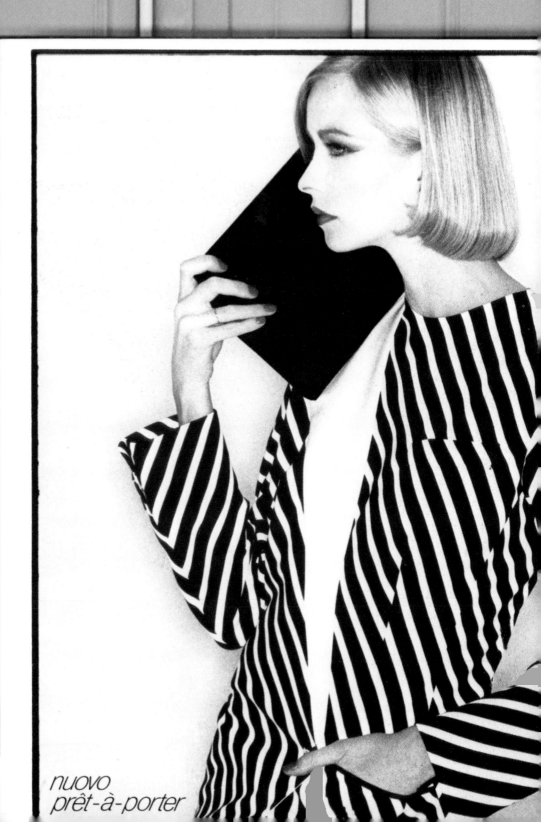

nuovo
prêt-à-porter

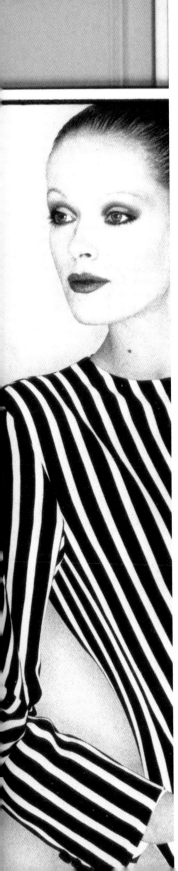

"Moda grafica in bianco e nero. Giorgio
Armani," photo David Bailey. Pages from
Vogue Italia, no. 352, January 1980 ¬

Gianfranco Ferré, fall/winter 1987-1988
couture collection. From Giusi Ferré (ed.),
Gianfranco Ferré Itinerario, Milan,
Leonardo Arte, 1999 ¬

Paris. Backstage at the fashion shows:
Jerry Hall. Photo Яoxanne Lowit

[p. 29] Paris. Backstage at the fashion
shows from above, Thierry Mugler,
March 1984; Thierry Mugler, March 1984;
Thierry Mugler, March 1983; Claude
Montana, October 1984; Thierry Mugler,
March 1984; Dumas, October 1982;
Chanel, March 1983; Claude Montana,
October 1984; Thierry Mugler, October
1985; Jean-Charles de Castelbajac, March
1984. Photo Яoxanne Lowit

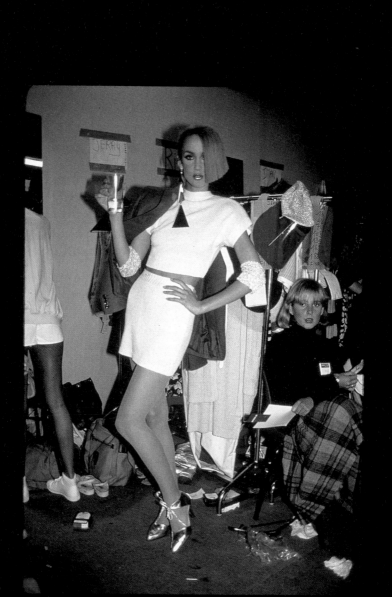

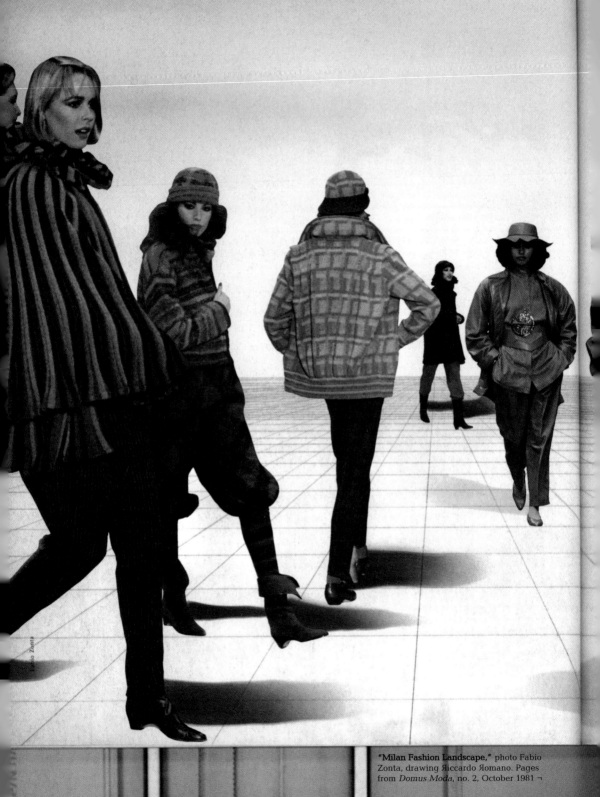

Fabio Zonta

"Milan Fashion Landscape," photo Fabio Zonta, drawing Riccardo Romano. Pages from *Domus Moda*, no. 2, October 1981 ¬

Gianfranco Ferré, fall/winter 1984-1985
collection, photo Attilio Concari. From
Bonizza Giordani Aragno, *Moda Italia:
Creatività, impresa, tecnologia nel sistema
italiano della moda*, catalogue of the
exhibition held at Pier 88, New York.
Milan, Editoriale Domus, 1988 ¬

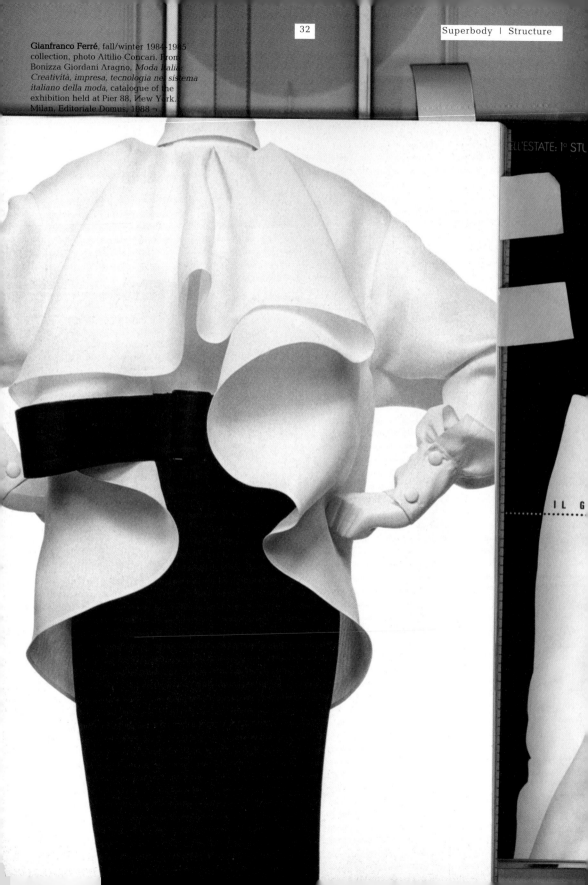

Gianfranco Ferré. "Il decalogo dell'estate:
1° ricordarsi di stupire," photo Giovanni
Gastel, feature Daniela Giussani.
Page from *Donna*, no. 74, May 1987 ¬

Gianni Versace, photo Oliviero Toscani.
Cover of *Donna*, no. 20, February 1982 ¬

ORE DEI TROPICI

DON

INTERNATIONAL FASHION MAGAZINE

100 PAGINE
PER CAPIRE TUTTO
E SAPER SCEGLIERE
IL MEGLIO

NUOVA
MODA '8

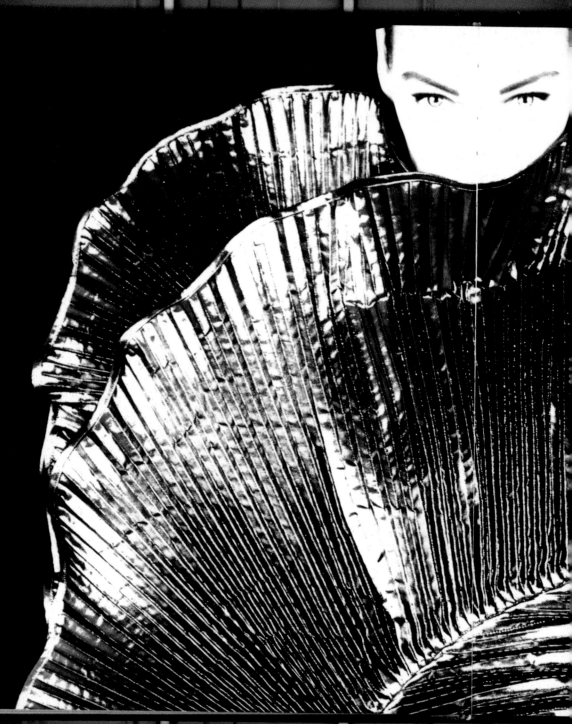

Krizia, fall/winter 1987-1988 collection.
From Isa Tutino Vercelloni (ed.), *Krizia*,
Milan, Leonardo Arte, 1995 ¬

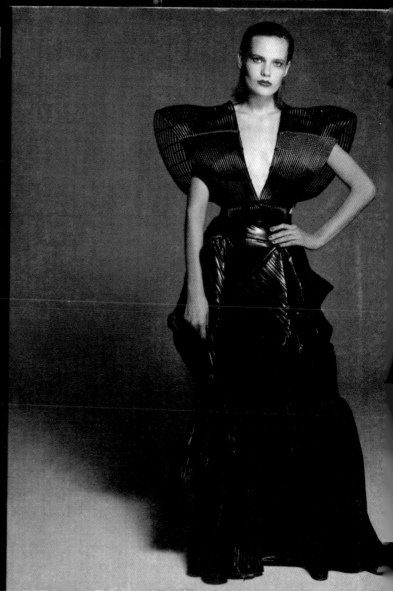

ARTFORUM

FEBRUARY 1982 **SPECIAL ISSUE** $6.00

LAURIE ANDERSON
▶ Record & Jacket

ANDY WARHOL
▶ Centerfold

MARIE COSINDAS
▶ Pinball Graphics

Advertising's Architecture

of Heaven...

Vulgar Modernism...

Bop Art... and more

Issey Miyake, spring/summer 1982 collection, photo Eiichiro Sakata. **Cover of** *Artforum*, special issue, February 1982 ¬

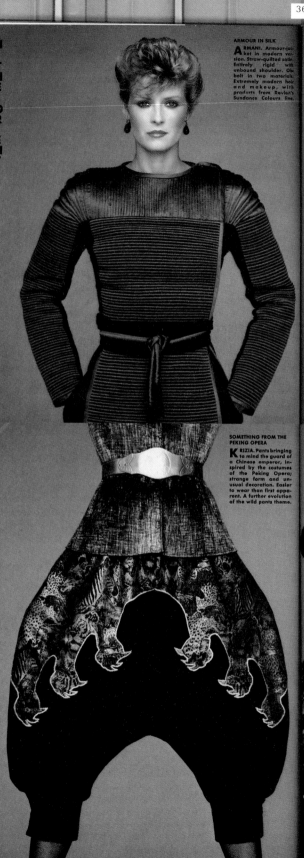

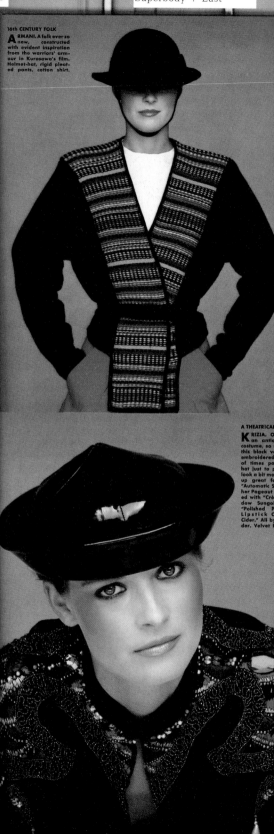

ARMOUR IN SILK

ARMANI. Armour-jacket in modern version. Straw-quilted satin. Entirely rigid with unbound shoulder. Obi belt in two materials. Extremely modern hair and makeup, with products from Revlon's Sundance Colours line.

16th CENTURY FOLK

ARMANI. A folk over so new, constructed with evident inspiration from the warriors' armour in Kurosawa's film. Helmet-hat, rigid pleated pants, cotton shirt.

SOMETHING FROM THE PEKING OPERA

KRIZIA. Pants bringing to mind the guard of a Chinese emperor. Inspired by the costumes of the Peking Opera; strange form and unusual decoration. Easier to wear than first apparent. A further evolution of the wild pants theme.

A THEATRICAL C

KRIZIA. Op an antique costume, so re this black velv embroidered w of times past. hat just to pla look a bit more up great for "Automatic Sou her Pageout Re ed with "Crèm dow Sungold "Polishd Per Lipstick Cir Cider." All by der. Velvet by

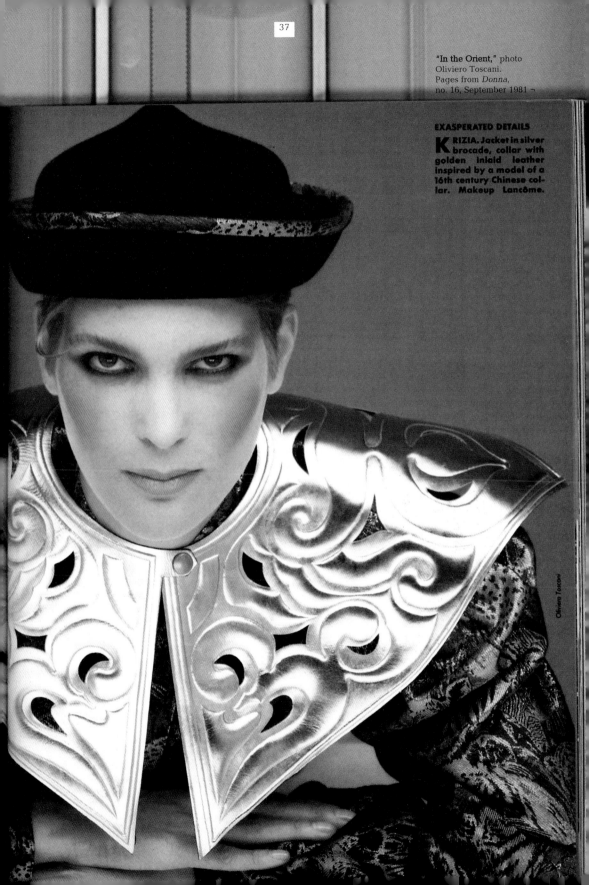

"In the Orient," photo
Oliviero Toscani.
Pages from *Donna*,
no. 16, September 1981 ¬

EXASPERATED DETAILS

KRIZIA. Jacket in silver
brocade, collar with
golden inlaid leather
inspired by a model of a
16th century Chinese col-
lar. Makeup Lancôme.

Oliviero Toscani

Lisa Lyon chez elle, Helmut Newton, 1981.
From Shozo Tsurumoto (ed.) *Issey Miyake: Body Works*, Tokyo, Shogakukan Publishing, 1983 ¬

Lisa Lyon

Between 1980 and 1982, Robert Mapplethorpe and Helmut Newton took a series of photographs of Lisa Lyon (international female bodybuilding champion in 1979 in Los Angeles). Both perceived the complete ambiguity and contrasts of gender and sexual tendencies that her body and identity revealed, at one and the same time a perfect object for their mechanical eye and a correspondingly objective ideal of the air they breathed. Lisa was the very epitome of a body developed to its fullest potential; it was the body itself that turned into sculpture, perfected form, a super-accessorized and super-structured machine. It was a postmodern, kitsch body, a symbol of the low culture intermingling rebelliously with the high culture of art and aesthetics (Lyon stubbornly insisted on defining herself as a *performer artist*, yet consciously attracted to the forbidden, she was the first bodybuilder ever to pose for *Playboy*).
Mapplethorpe's shots are lined up in *Lady: Lisa Lyon*. Anatomically and sexually, Lisa represented the perfect symbiosis for him: her body is statuary, sculptured, undeniably masculine, powerful and undoubtedly formal (to such an extent that it is reminiscent of Edward Weston's nudes), yet it coexists with a face that is alienating in its elegance, its charm and therefore its absolute femininity. While making her strike the conventional pose of a lady bodybuilder on Bond Street, Mapplethorpe employed the same words already used to describe Patti Smith: "It's like she comes from another planet." Like Smith, there was something hybrid and hermaphrodite about Lyon, even though Patti physically appeared to be the exact opposite of the super-endowed Lisa, being so skinny, androgynous, fragile and sexless. And yet both were borderline cases compared with the stereotypes and established codes of female identity, both were educated and committed and, on account of their fascinating, perverse diversity, both were Mapplethorpe's companions in life and art. Lisa manifested the dialects of form and concept: her physical form was Michelangelesque, academic and hyper-classic (Mapplethorpe compared her to a heroine from the Old Testament), yet at the same time she was contaminated, paradoxical, completely postmodern in terms of sexual individualism: on one hand, purely perceptive satisfaction, and on the other, both participatory and identifiable experience.
For Helmut Newton too, Lisa Lyon epitomized an articulated imaginary world, composed of muscular explosion, exhibitionism and erotic ostentation. He was unable to remain indifferent to her brazen physical perfection; he could not exclude that sculptured body from the gallery of viragos he was assembling. And this recuperation of technical quality, the same already experienced by Mapplethorpe, saw Newton likewise focused on this female bodybuilding champion as the perfect alchemy between the perceptive pleasure of forms and an allusion to possible sexual ambiguity. Lisa entered Newton's temple and boldly joined the ranks of his artificial, sidereal feminine universe, which was inhabited by aggressive extraterrestrial beings wearing miniskirts and garter belts, radiating an inhuman, unattainable beauty. Influenced by the undertones of that S&M dimension typically based on the erotic fantasies of Germanic tradition (which Newton incidentally adhered to), enveloped in leather bonds that pulled her muscles ever tighter, or ready to attack a shadowy male silhouette, Lisa became a blood sister of Newton's other Amazon women. And just like those icy, indestructible models, she too underwent the same destiny: they were all so totally exaggerated by sexual codes and stereotypes that paradoxically they became unwitting victims, explored erotic objects, to be archived by the phlegmatic, cold and slightly cynical eye of their fetishist-voyeur.
FEDERICA MUZZARELLI

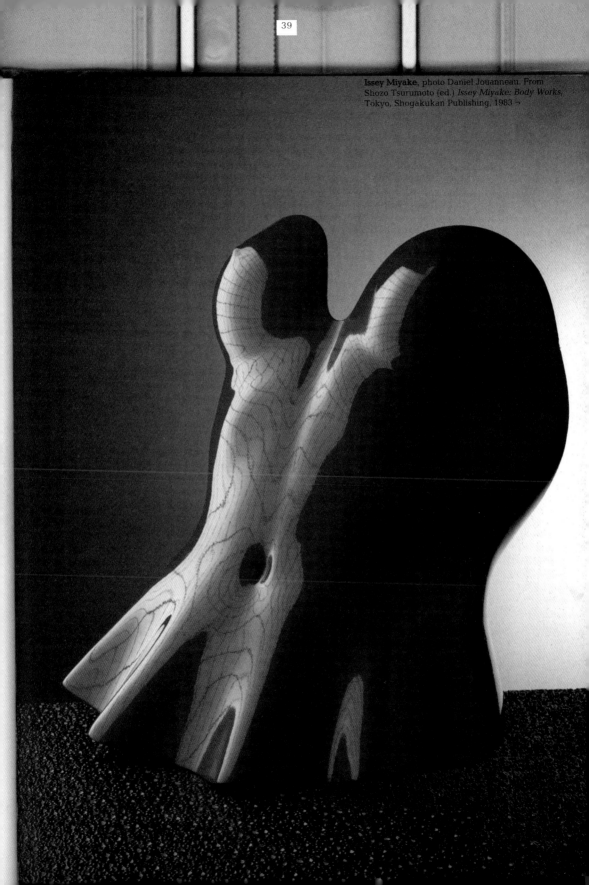

Issey Miyake, photo Daniel Jouanneau. From Shozo Tsurumoto (ed.) *Issey Miyake: Body Works*, Tokyo, Shogakukan Publishing, 1983 ¬

Яobert Mapplethorpe,
insert for *Parkett*, no. 8, 1986 ¬

Chantal Thomass. "Parigi: Novità prêt-à porter," photo Roxanne Lowit. Page from *Vogue Italia*, no. 401, July-August 1983 ¬

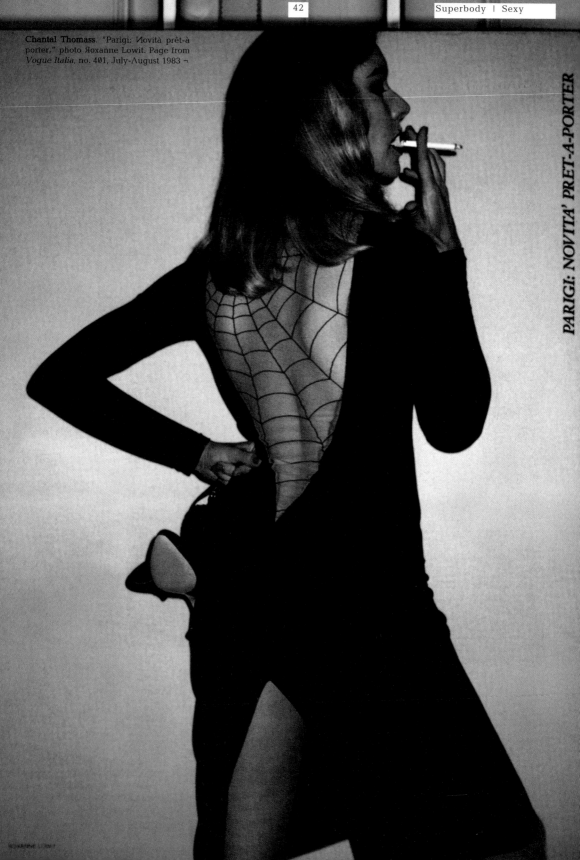

PARIGI: NOVITA' PRET-A-PORTER

Thierry Mugler advertising campaign,
fall/winter 1988, photo Thierry Mugler ¬

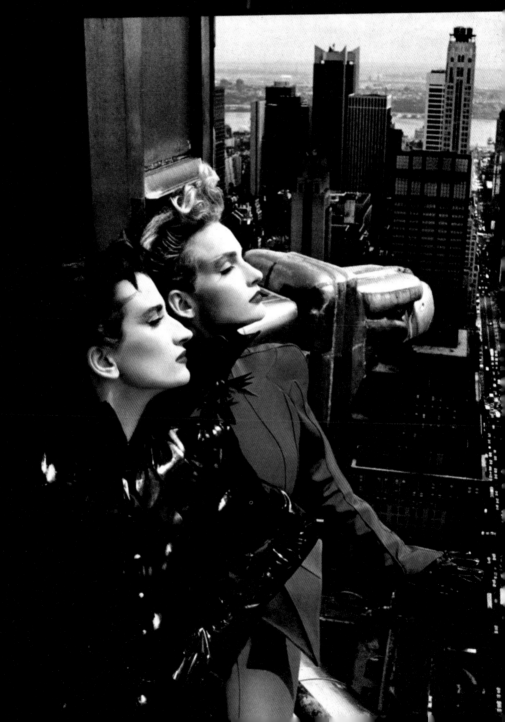

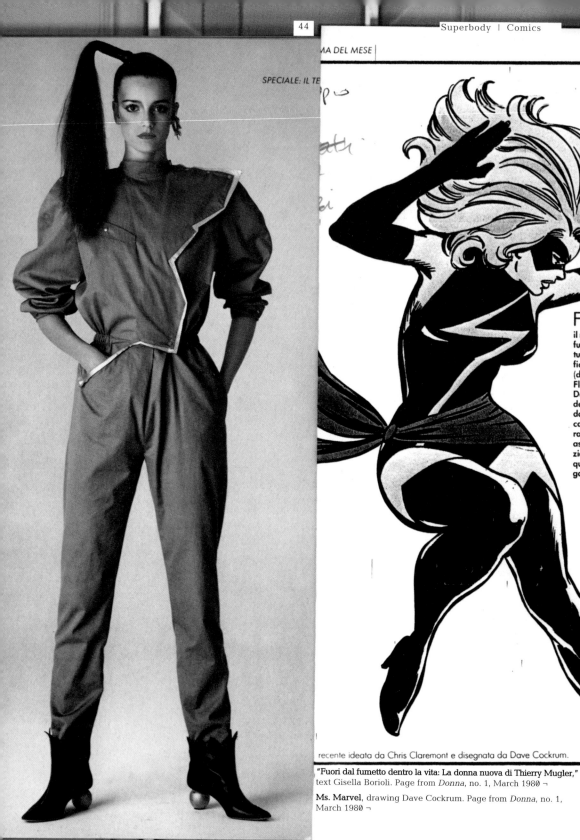

SPECIALE: IL TE...

...MA DEL MESE |

Fi
p
il re
fum
tutt
fico
(do
Fla
Da
den
da
car
rate
ass
zial
qua
gal

recente ideata da Chris Claremont e disegnata da Dave Cockrum.

"Fuori dal fumetto dentro la vita: La donna nuova di Thierry Mugler," text Gisella Borioli. Page from *Donna*, no. 1, March 1980 ¬

Ms. Marvel, drawing Dave Cockrum. Page from *Donna*, no. 1, March 1980 ¬

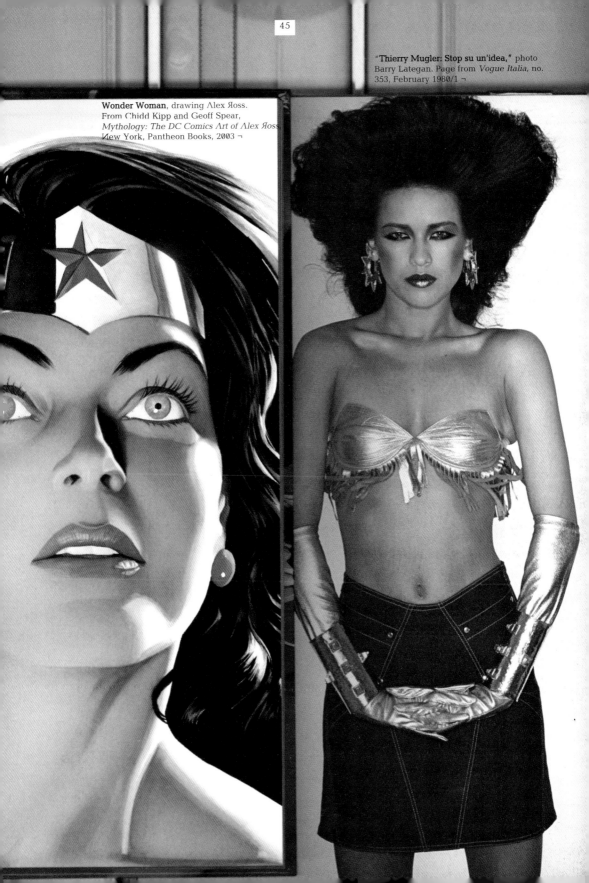

Wonder Woman, drawing Alex Ross.
From Chidd Kipp and Geoff Spear,
Mythology: The DC Comics Art of Alex Ross,
New York, Pantheon Books, 2003 ¬

"Thierry Mugler: Stop su un'idea," photo
Barry Lategan. Page from *Vogue Italia*, no.
353, February 1980/1 ¬

**Valentina, created by Guido Crepax, wears
Krizia**, fall/winter 1983-1984 collection. From
Isa Tutino Vercelloni (ed.), *Krizia*, Milan,
Leonardo Arte, 1995 ¬

[p. 47] **Krizia advertising campaign**, fall/winter
1982, drawings Harumi ¬

L.VERGA

Krizia

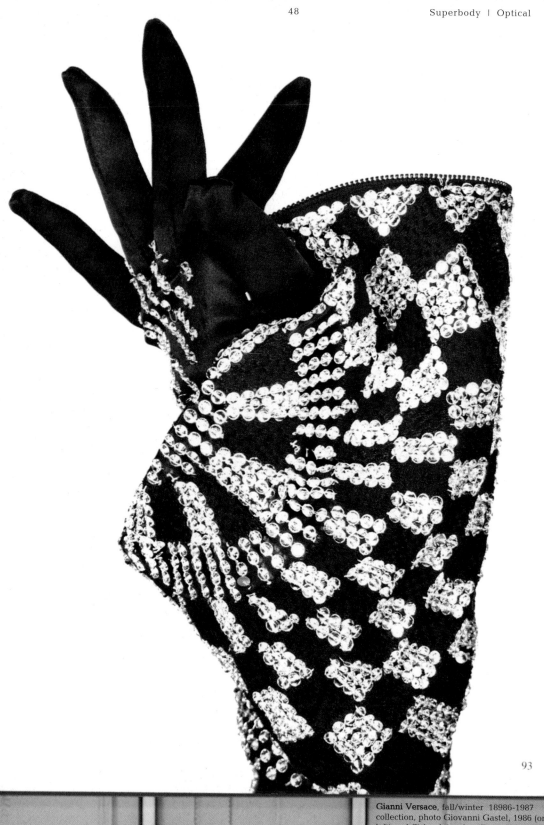

93

Gianni Versace, fall/winter 18986-1987
collection, photo Giovanni Gastel, 1986 (on the
left) and Яichard Аvedon. From *Designs Gianni
Versace*, Milan, Leonardo Arte, 1994 ¬

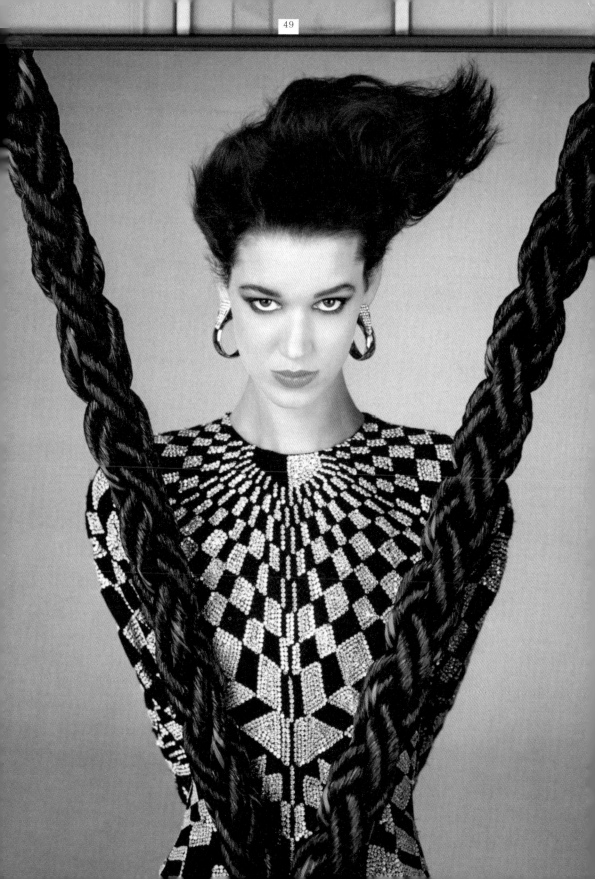

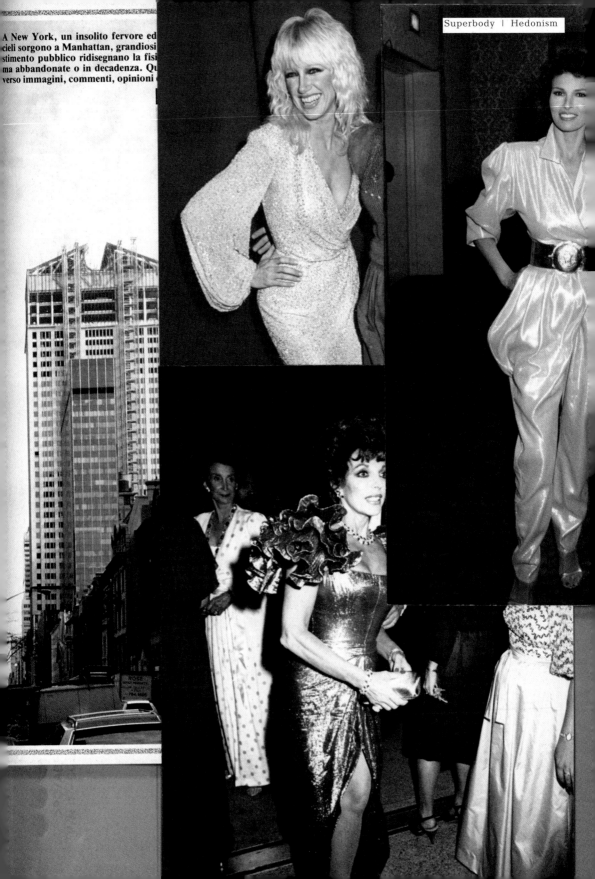

A New York, un insolito fervore ed
cieli sorgono a Manhattan, grandiosi
stimento pubblico ridisegnano la fisi
ma abbandonate o in decadenza. Qu
verso immagini, commenti, opinioni

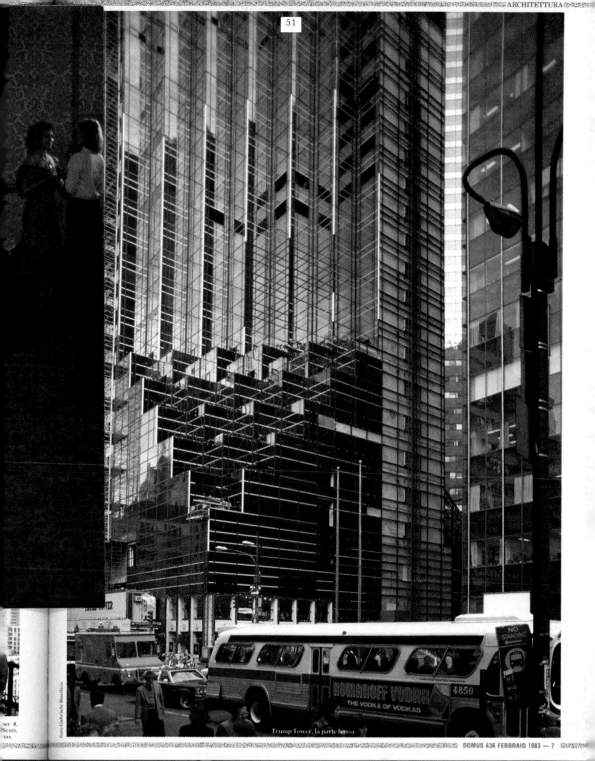

foto Gabriele Basilico

Trump Tower, la parte bassa.

[From above] Las Vegas, 1983, **Suzanne Somers** and **Charlene Tilton** at the Nevada Special Olympics; Los Angeles, 1980, **Raquel Welch** at the 38th Annual Golden Globe Awards at the Beverly Hilton Hotel; Denver, 1984, **Joan Collins** at the Carousel Ball benefit. © Janet Gough /Photo Masi (Somers); © Photo Masi (Welch and Collins) ¬

Trump Tower. "New York Strikes Again," text Fulvio Irace, photo Gabriele Basilico. Pages from *Domus*, no. 636, February 1983 ¬

[p. 52] **"Metallo che veste come seta. Gianni Versace: una puntata vincente,"** photo Barry Mc Kinley. Pages from *Vogue Italia*, no. 392/I, September 1982 ¬

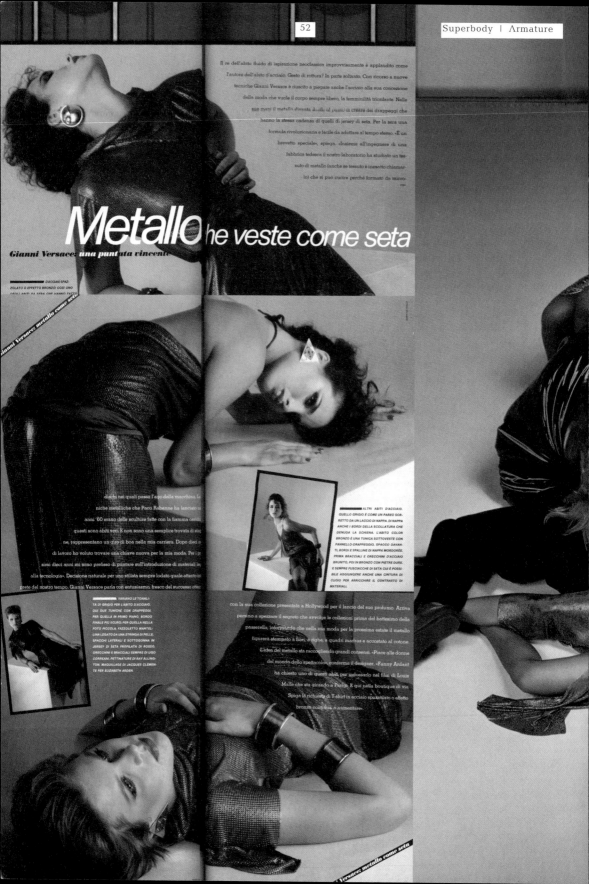

Il re dell'abito fluido di ispirazione neoclassica improvvisamente è applaudito come l'autore dell'abito d'acciaio. Gesto di rottura? In parte soltanto. Con ricorso a nuove tecniche Gianni Versace è riuscito a piegare anche l'acciaio alla sua concezione della moda che vuole il corpo sempre libero, la femminilità trionfante. Nelle sue mani il metallo diventa docile al punto di creare dei drappeggi che hanno la stessa cadenza di quelli di jersey di seta. Per la sera una formula rivoluzionaria e facile da adottare al tempo stesso. «È un brevetto speciale, spiega. «Insieme all'ingegnere di una fabbrica tedesca il nostro laboratorio ha studiato un tessuto di metallo (anche se tessuto è inesatto chiamarlo) che si può cucire perché formato da micro-

Metallo che veste come seta

Gianni Versace: una puntata vincente

D'ACCIAIO SPAZ-
ZOLATO O EFFETTO BRONZO: COSÌ UNO
DEGLI ABITI DA SERA CHE GIANNI FATTO

dischi nei quali passa l'ago della macchina. Le
niche metalliche che Paco Rabanne ha lanciato
anni '60 erano delle sculture fatte con la fiamma ossid
questi sono abiti veri. E non sono una semplice trovata di stag
ne, rappresentano un giro di boa nella mia carriera. Dopo dieci a
di lavoro ho voluto trovare una chiave nuova per la mia moda. Per i pr
simi dieci anni mi sono prefisso di puntare sull'introduzione di materiali le
alla tecnologia». Decisione naturale per uno stilista sempre lodato quale attento int
prete del nostro tempo. Gianni Versace parla con entusiasmo, fresco del successo otten

ALTRI ABITI D'ACCIAIO.
QUELLO GRIGIO È COME UN PAREO SOR-
RETTO DA UN LACCIO DI NAPPA. DI NAPPA
ANCHE I BORDI DELLA SCOLLATURA CHE
DENUDA LA SCHIENA. L'ABITO COLOR
BRONZO È UNA TUNICA SOTTOVESTE CON
PANNELLO-DRAPPEGGIO, SPACCO DAVAN-
TI, BORDI E SPALLINE DI NAPPA MORDORÉE.
PRIMA BRACCIALI E ORECCHINI D'ACCIAIO
BRUNITO, POI IN BRONZO CON PIETRE DURE.
E SEMPRE FUSCIACCHE DI SETA CUI È POSSI-
BILE AGGIUNGERE ANCHE UNA CINTURA DI
CUOIO PER ARRICCHIRE IL CONTRASTO DI
MATERIALI.

VARIANO LE TONALI-
TÀ DI GRIGIO PER L'ABITO D'ACCIAIO.
QUI DUE TUNICHE CON DRAPPEGGI,
PER QUELLA IN PRIMO PIANO, BORDO
FINALE PIÙ SCURO; PER QUELLA NELLA
FOTO PICCOLA, FAZZOLETTO MANTEL-
LINA LEGATO DA UNA STRINGA DI PELLE,
SPACCHI LATERALI E SOTTOGONNA IN
JERSEY DI SETA PROFILATA DI ROSSO.
ORECCHINI E BRACCIALI SEMPRE DI USO
CORREANI. PETTINATURE DI RAF ALLING-
TON. MAQUILLAGE DI JACQUES CLEMEN-
TE PER ELIZABETH ARDEN.

con la sua collezione presentata a Hollywood per il lancio del suo profumo. Arriva persino a spezzare il segreto che avvolge le collezioni prima del battesimo della passerella, informando che nella sua moda per la prossima estate il metallo figurerà stampato a fiori, a righe, a quadri madras e accostato al cotone. L'idea del metallo sta raccogliendo grandi consensi. «Piace alle donne del mondo dello spettacolo, conferma il designer. «Fanny Ardant ha chiesto uno di questi abiti per indossarlo nel film di Louis Malle che sta girando a Parigi. E qui nella boutique di via Spiga la richiesta di T-shirt in acciaio spazzolato o effetto bronzo continua a aumentare.

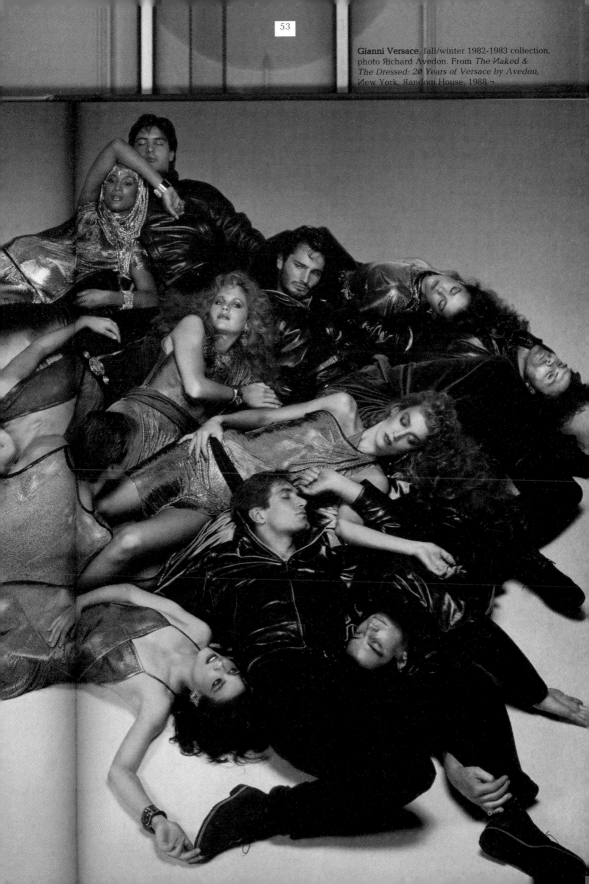

Gianni Versace, fall/winter 1982-1983 collection,
photo Richard Avedon. From *The Naked &
The Dressed: 20 Years of Versace by Avedon*,
New York, Random House, 1988 ¬

"L'arte marziale della seduzione: La collection fall-winter di Chiara Boni," photo Skrebneski. Pages from *Vanity*, no. 26, July-August 1987 ➝

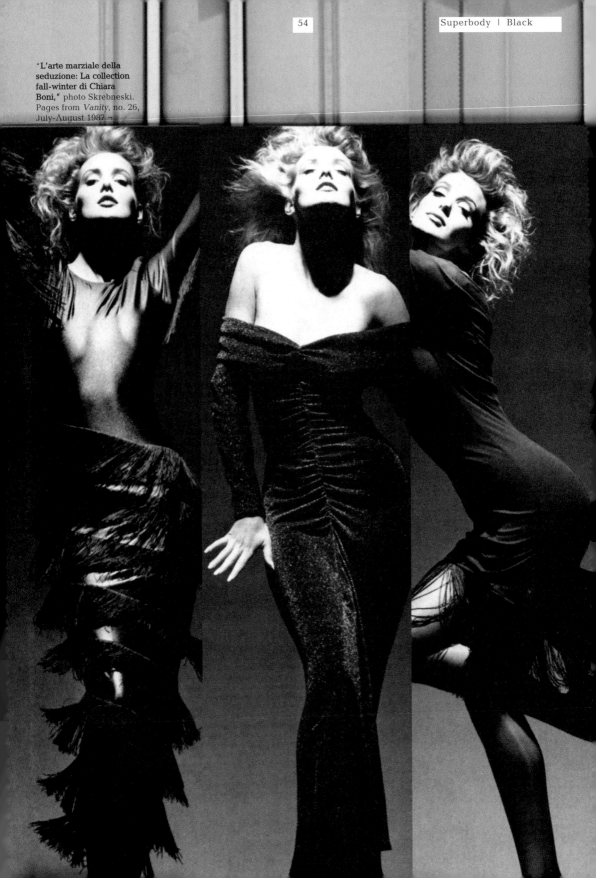

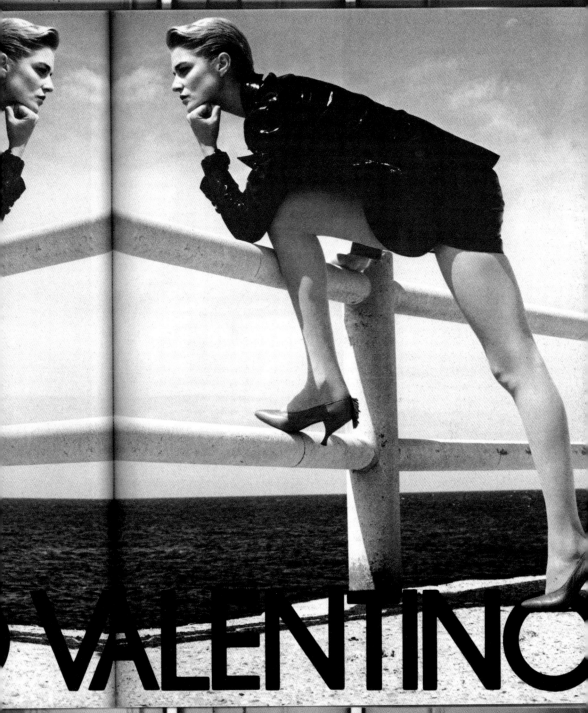

Mario Valentino advertising
campaign, fall-winter 1987-
1988, photo Helmut Newton ¬

VALENTINO

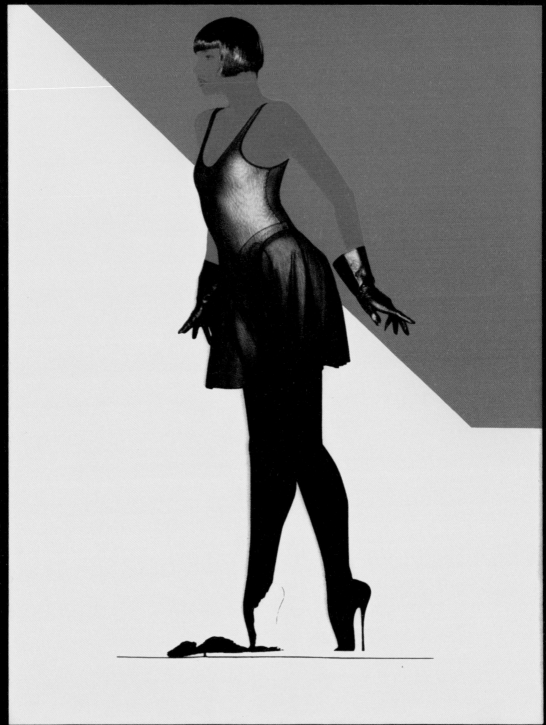

Azzedine Alaïa. Sexy – ironico, come nella tradizione dell'artista inglese, l'abito in filo con panta-gonnellina. Guanti Pancaldi per Alaïa.

Λlaïa dress, 1986 ¬

[p. 56] Λzzedine Λlaïa. Page from "Omaggio a Λllen Jones," text
Tommaso Trini, photo Giovanni Gastel, design Яoberto Carra, *Donna*,
no. 51, March 1985 ¬

Azzedine Λlaïa, polaroid Helmut Newton, 1982. From *Helmut Newton Pola Women*, Monaco-Paris-London, Schirmer/Mosel, 2000 ¬

Azzedine Λlaïa, spring/summer 1987 collection, photo Jean-Baptiste Mondino. From *Alaïa*, Göttingen, Steidl, 1998 ¬

Azzedine Λlaïa, photo Gilles Bensimon, From *Alaïa*, Göttingen, Steidl, 1998 ¬

The dating can't be right—it was 1982. Arielle was one of my favourite girls at the time. She made my camera sizzle.

VERSACE: CAPPOTTI D'AVANGUARDIA

Gianni Versace.
Nella pagina accanto, in alto a sinistra. Abito in jersey di lana (Dondi Jersey) con allacciatura laterale e doppia cintura. A destra. Cappotto in panno rosso con collo incrociato e tutto impunturato; orecchini Pellini Bijoux. In basso a sinistra. Abito in jersey di lana (tessuto Be.Mi.Va.) con collo a sciarpa. A destra. Cappotto in duvetine (tessuto Ricceri) con martingala doppia e profili in pelle. Tutto di Versace, anche i guanti.

Gianni Versace.
In questa pagina. Cappotto informe di panno rosso (tessuto Ricceri) con dettagli in pelle, chiuso di lato con un leggero drappeggio. In vendita nella boutique Versace a Milano, da Ina Prato a Catania, da New Galles a Verona. Guanti Versace, anello Pellini Bijoux, telefono a tastiera "Contempra/N.T." in vendita da Austel, Milano.

"Puntualmente in grigio: La donna d'oggi vincente nella vita e nel lavoro," photo Avi Meroz, feature Micaela Sessa. Pages from *Donna*, no. 68, October 1986 ¬

[p. 63] **Giorgio Armani advertising campaign**, fall/winter 1984-1985, photo Aldo Fallai ¬

LA DONNA D'OGGI VINCENTE NELLA VITA E NEL LAVORO

PUNTUALMENTE IN GRIGIO

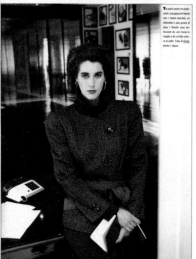

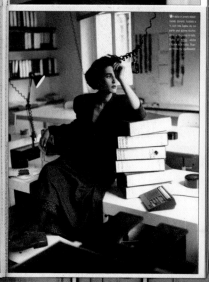

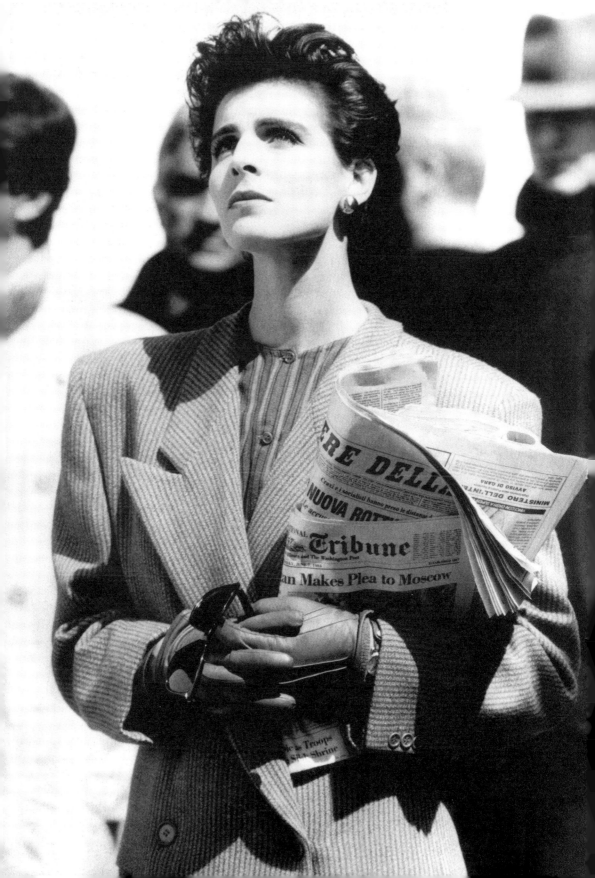

Working Girl (Mike Nichols, 1988)

To really understand *Working Girl* you have to start from the last frame and, even before that, from the title. The words have a covertly sexual connotation: a "working girl" can mean not just a career woman but also one who is ready to do anything in order to get what she wants. And in the end, in fact, Melanie Griffith smiles with satisfaction in the office she has won at such a high price, while the lens frames her from outside the building and zooms back. To show her buried in a skyscraper filled with thousands of offices like her own, among a myriad of skyscrapers filled with other offices, just one ant in the anthill. So, after all those ups and downs, was it really worth it?

Nichols's film is a much more complex study of sociology than it appears. It hovers on the verge of comedy, but has sharp claws. It could almost be a remake of *Wall Street* at a year's distance, in a romantic key and with a nod to Cinderella on the one hand and Pygmalion on the other. But the cynicism and greed are the same and the picture that is presented to us is much more complicated: there is talk of equality between men and women, of class conflict, of clothes making the man, of sex used to promote or get promoted. "I have a mind for business and a body for sin," Griffith murmurs languidly to an embarrassed but excited Harrison Ford in an attempt to pick him up. He is the man with whom she will clinch the deal that is going to change her working life. And it is precisely on change, especially a change of look, that the heart of the film turns, starting out from a basic assumption: if you want to be taken seriously you have to dress seriously. And if you're a woman in a world of men you have to adopt their uniform. So the *tailleur*, female version of the male suit is *de rigueur*: it gives confidence, its sharp and elegant lines exude class and its androgynous air serves to augment the sensual component rather than diminish it. Thus its seductive power is paradoxically increased. To this must be added all the rest: hairstyle, shoes, jewelry and makeup, conveying an overall impression of sobriety and taste.

In the film Sigourney Weaver is the character who most clearly reflects what has been said so far: assertive and confident in her Donna Karan suits, sure of her upper-class accent, a successful female executive, an insincere feminist and therefore a real bitch. In reality the decisive sequence is not the final meeting, but the one in which Griffith and Ford gatecrash an exclusive wedding reception to which they have not been invited, in order to "butter up" the man on whom the deal depends. To do it they need attitude, but above all the right clothes and well-padded shoulders. It is the apotheosis of mimicry, the moment in which the characters in the movie, and the viewers with them, all at once discover the power of the code that is dress, and perhaps grasp the full depth of its ambiguity: at one and the same time distinction and leveling, social elevation and cancellation of your own identity, if you ever had one. An almost dizzying discovery, just like the image of Griffith, now secure and elegant, lost in the jungle of offices and skyscrapers at the end of the film.

Mauro Tinti

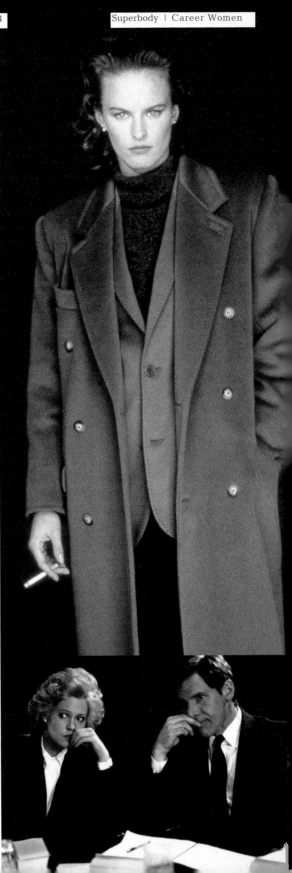

Max Mara, fall/winter 1983-1984 collection,
photo Mike Yavel ¬

Melanie Griffith and Harrison Ford in
Working Girl, USA 1988, director Mike Nichols.
© Photo 12/Grazia Neri ¬

[p. 65] **Max Mara**, fall/winter 1987-1988
collection, photo Paolo Roversi ¬

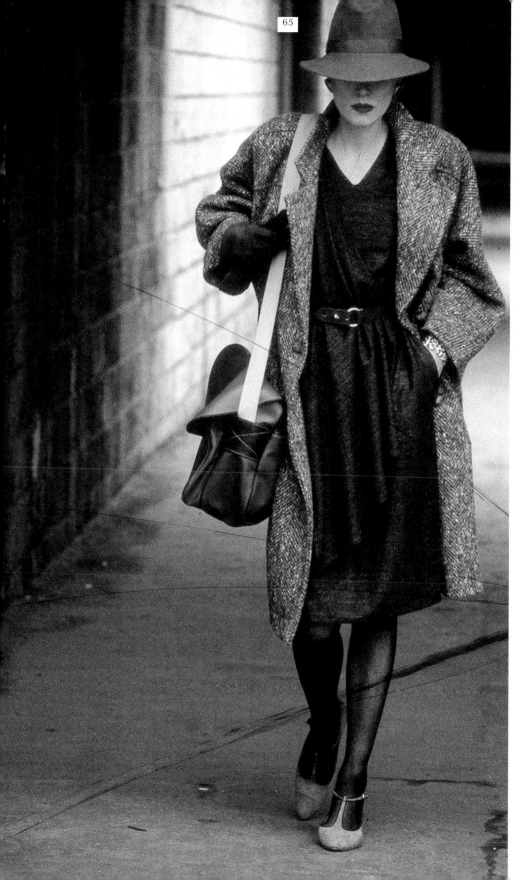

Donna Karan advertising campaign, fall/winter
1988-1989, photo Peter Lindbergh ¬

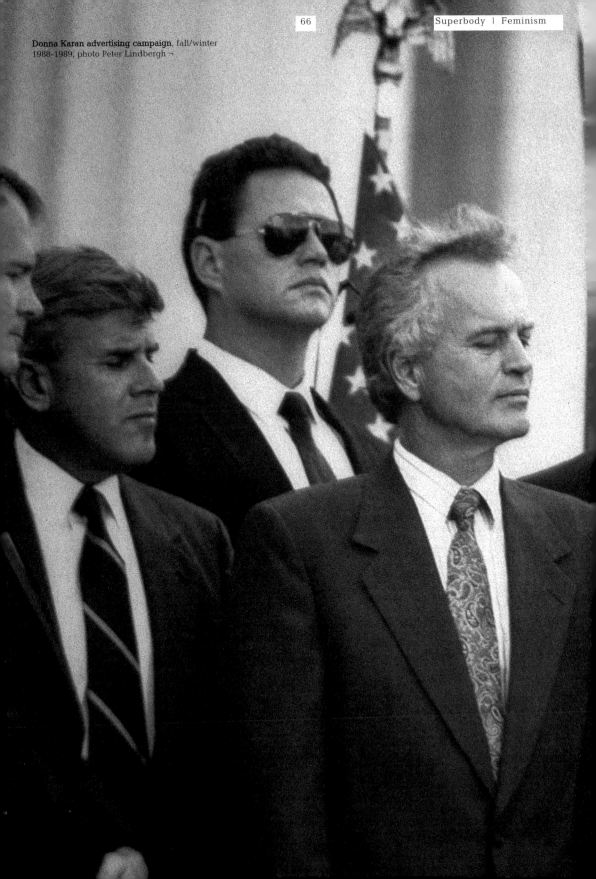

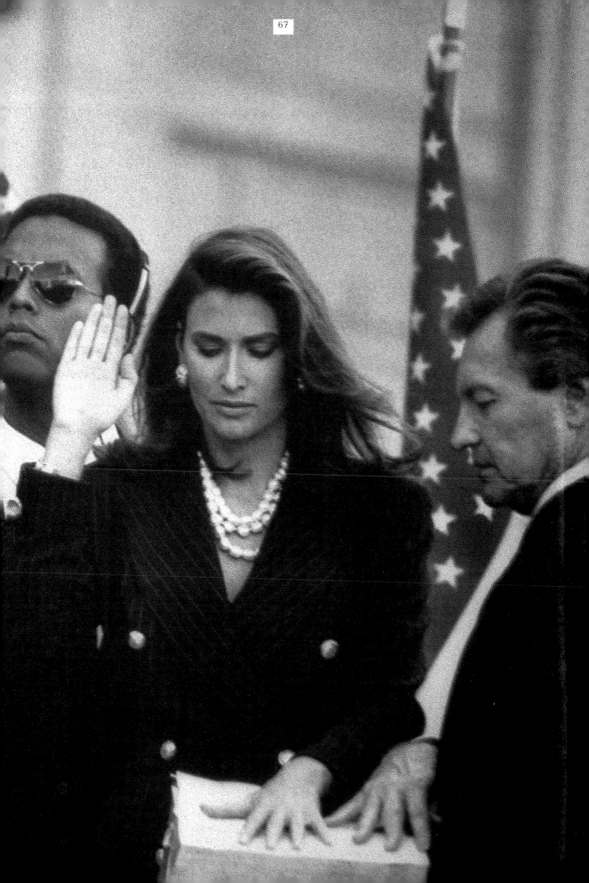

Classico in progress, a comincia-
re dalla ricerca puntigliosa di
temi tessuto: flanelle e pettinati,
a minuto grafico disegno, i famo-
si «inglesi» degli anni Cinquanta,
ma disancorati da interpretazio-
ni troppo formali: dunque cami-
cie azzurre con colletto a punte
ravvicinate e cravatte in seta,
fantasia. I tessuti degli abiti ma-
schili sono, da sinistra, di Fila, di

Ferla e della Manifattura Lane
Carignano. Stesso, contagioso
stile serio-disinvolto anche per
lo spezzato versione femminile:
blazer e pantaloni in gabardine
di lana, blusa di picchè bianco,
con cannoncino e scialle a bar-
chetto. Tutto porta la firma Gior-
gio Armani (le camicie sono rea-
lizzate da Bagutta; le cravatte
distribuite da G. EMME)..

Classo sì, come esercitazio-
ne cilile, e grigio come ine-
vitale corollario. E poi l'in-
tenzione reale di smitizzare e
irontare il tutto per avere
un'esito al più possibile an-
tiirozionale e soprattutto
antiitaioso. E allora la giacca

doppiopetto, la sahariana di
gran classe, lo spolverino blu,
lo jacquard a rombi su cash-
mere e seta, la pelle ritaglia-
ta a patchwork... il look Ar-
mani come punto di partenza
al più anticonvenzionale e at-
tuale traguardo.

GIORGIO ARMANI

REPORTAGE DA UNA COLLEZIONE

Riga-gesso bicolore su fondo blu
'tessuto di Torello Viera', rigaro-
sa nello duplice rigatura, cravat-
ta a strisce diagonali con riveren-
te omaggio al classico con una
gran carica antinoia. Per lei blu,
bianco e una manciata di rosso
per la blusa in seta (di Menta)
con il gilet-jacquard e la cravatta
fiocco, sulla gonna in gabardine
di lana (di Carisia). Tutto di Gior-
gio Armani (camicia realizzata
da Bagutta; cravatta distribuita
da G. EMME)..

Capitolo determinante nel re-
portage da una collezione:
pelle, straordinariamente ta-
gliate e ricomposta in
patchwork, che creano curiose
curatele illusione del giaccone.
Per lei, pantaloni in gabardine
di Carisia e blusa in seta (di
Menta) per i ragazzi blusotti in
cashmere, camicie ricciate
sate da Bagutta; cravatte in
seta (distribuite da G. EMME)
pantaloni in gabardine (tessuto
Fila). Tutto Giorgio Armani.

REPORTAGE DA UNA COLLEZIONE

Giorgio Armani advertising
campaign, fall/winter
1984-1985, photo Aldo Fallai ¬

[p. 69] "Giorgio Armani.
Reportage da una collection."
Pages from *L'Uomo Vogue*,
no. 92, February 1980 ¬

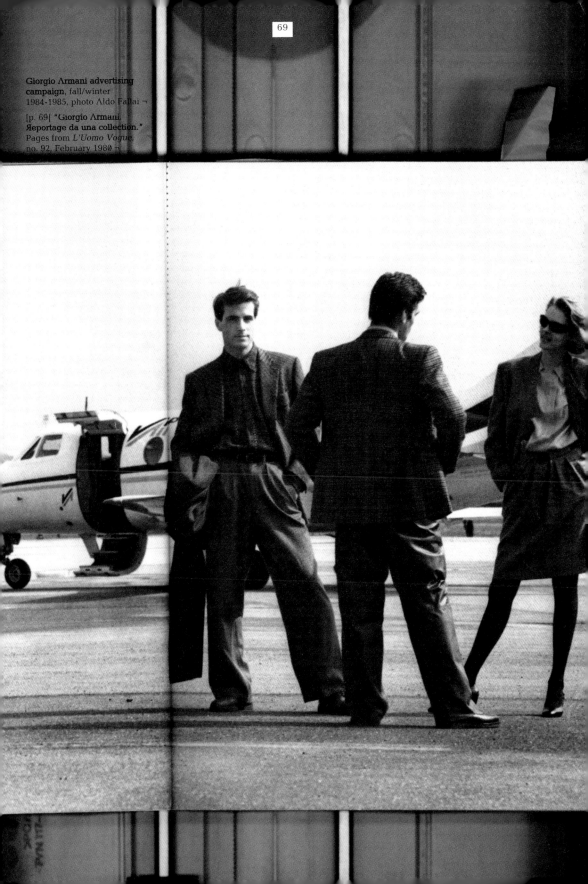

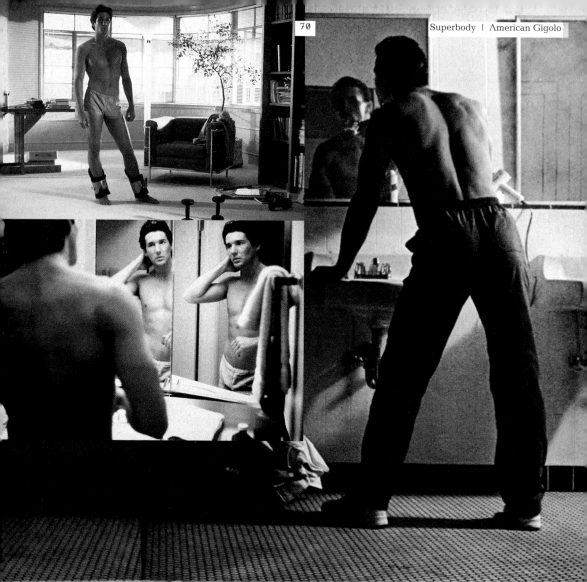

American Gigolo (Paul Shrader, 1980)

That *American Gigolo* "is a clothes movie" and that the object of the fetishism is not so much Richard Gere's sexuality as his Giorgio Armani wardrobe is quite clear. His clothes were essential for the definition of the lead character, Richard Gere/Julian Kay, a smooth charmer maintained by rich, bored women. "Those clothes were my character," Gere himself declared. Consider the scene in which Julian Kay rummages though his wardrobe, throwing a collection of shirts, jackets and ties on the bed, with the camera lingering over each item. Harold Koda, director of the Fashion Institute at the Metropolitan Museum, has this to say about that very scene: "I saw *American Gigolo* in a cinema on the Upper East Side, and the viewers were jumping up and down with every choice . . . when the right combination came out, everyone applauded." Up until then, fashion creators who dressed the stars had, with more or less successful results, created costumes made to fit a character, but suddenly this mechanism was overturned: it was Armani, with his style, who created the character and so sanctioned the triumphal entry of prêt-à-porter into cinema. Everything in that film is closely linked to fashion, but one explored as the distorting mirror of an upwardly mobile society in which everything revolves around money, the one true obsession of the early eighties. With this in mind, the film's casting is illuminating: the glossy-mag sensuality of supermodel Lauren Hutton as the quintessence of the futility of "beautiful living," the voluptuous, good-looking body of Richard Gere, forced into this cynical mise-en-scène of appearances. And over it all, the naughty-sweet voice of Blondie ordering or imploring, "Call me." The only figure to emerge as a winner from all this, apart from Armani, was Richard Gere; he was chosen by chance for the part after John Travolta turned it down, and he succeeded in branding himself into the sexual memory of a whole generation of viewers – women mainly, but also men. After all, *American Gigolo* is a film that flirts outrageously with the prevalent image of gays at that time, comprising a shameless hedonism and the ostentation of a newly acquired empowerment during a period of sometimes violent struggle, coming and going in waves and reaching a culmination that the spread of AIDS would soon undermine.

Sofia Gnoli

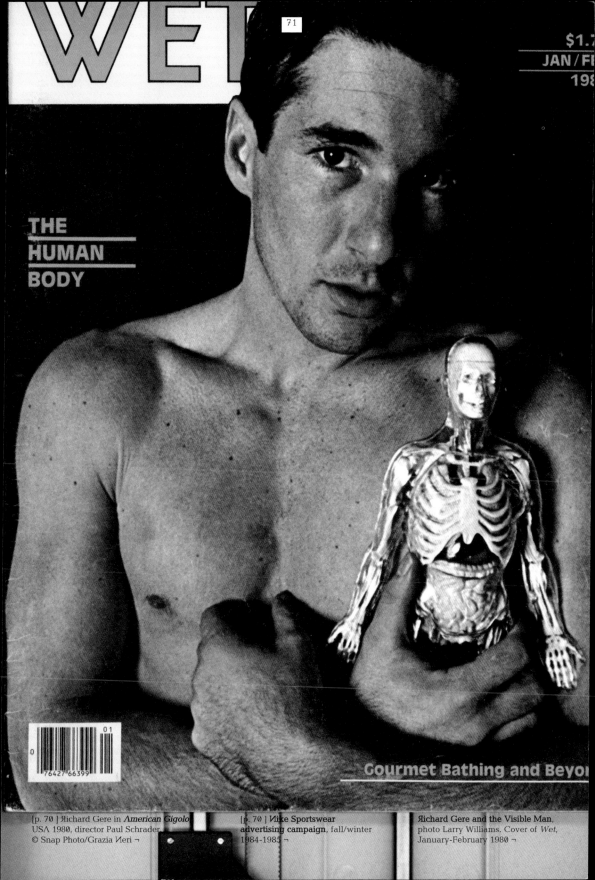

WET

$1.7

JAN / FE

198

THE
HUMAN
BODY

Gourmet Bathing and Beyor

[p. 70 | Richard Gere in *American Gigolo*
USA 1980, director Paul Schrader,
© Snap Photo/Grazia Neri ¬

[p. 70 | Nike Sportswear
advertising campaign, fall/winter
1984-1985 ¬

Richard Gere and the Visible Man,
photo Larry Williams. Cover of *Wet*,
January-February 1980 ¬

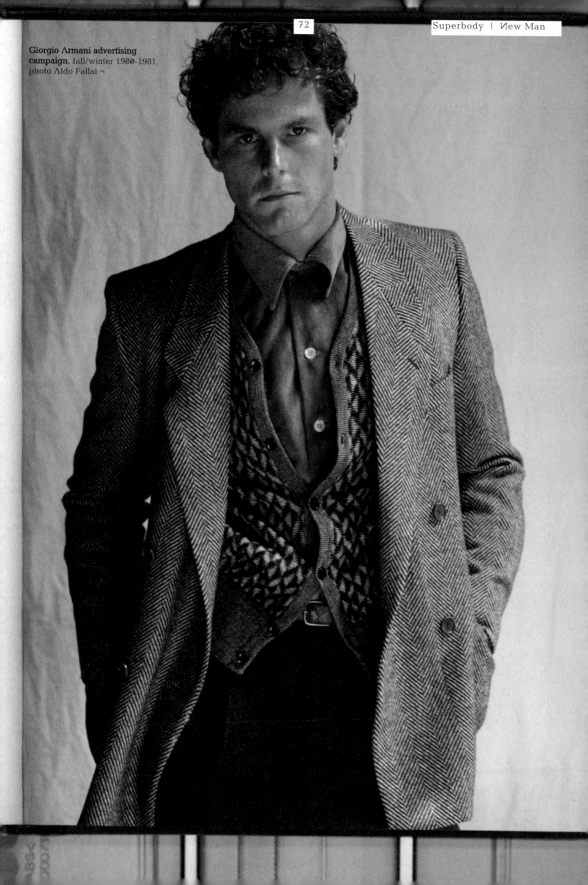

Giorgio Armani advertising
campaign, fall/winter 1980-1981,
photo Aldo Fallai ¬

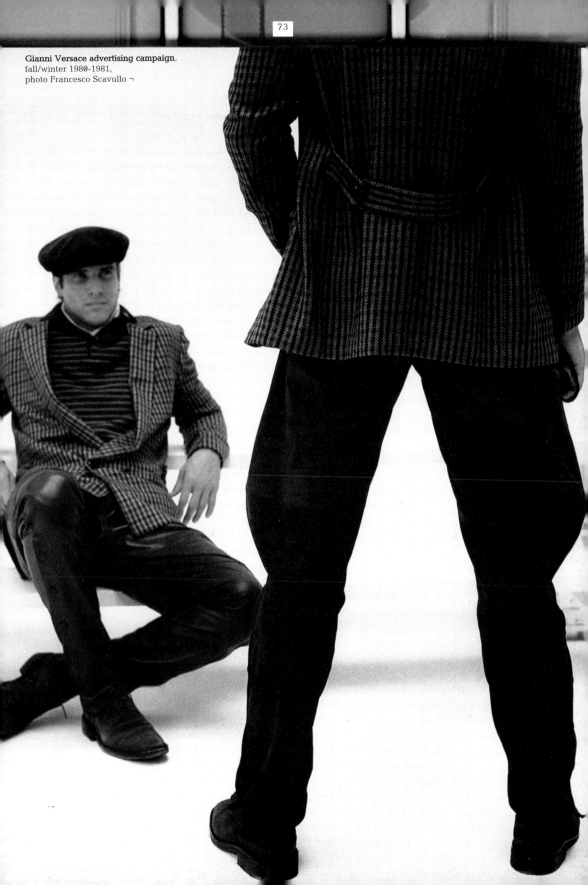

Gianni Versace advertising campaign,
fall/winter 1980-1981,
photo Francesco Scavullo ¬

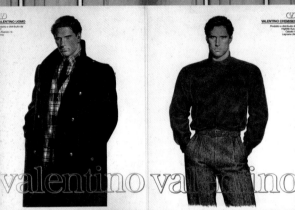

GIANMARCOVENTURI

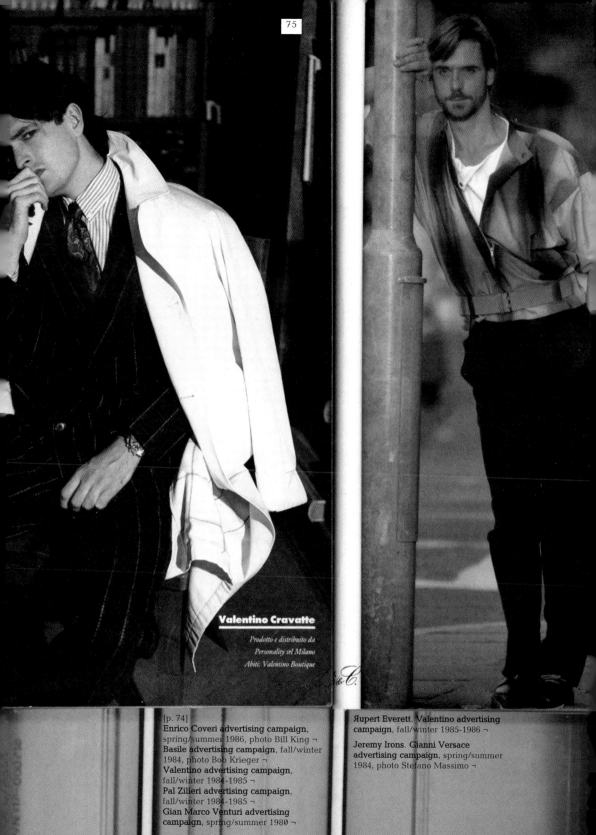

Valentino Cravatte

*Prodotto e distribuito da
Personality srl Milano
Abiti: Valentino Boutique*

[p. 74]
Enrico Coveri advertising campaign,
spring/summer 1986, photo Bill King ¬
Basile advertising campaign, fall/winter
1984, photo Bob Krieger ¬
Valentino advertising campaign,
fall/winter 1984-1985 ¬
Pal Zileri advertising campaign,
fall/winter 1984-1985 ¬
Gian Marco Venturi advertising
campaign, spring/summer 1980 ¬

Яupert Everett. Valentino advertising
campaign, fall/winter 1985-1986 ¬

Jeremy Irons. Gianni Versace
advertising campaign, spring/summer
1984, photo Stefano Massimo ¬

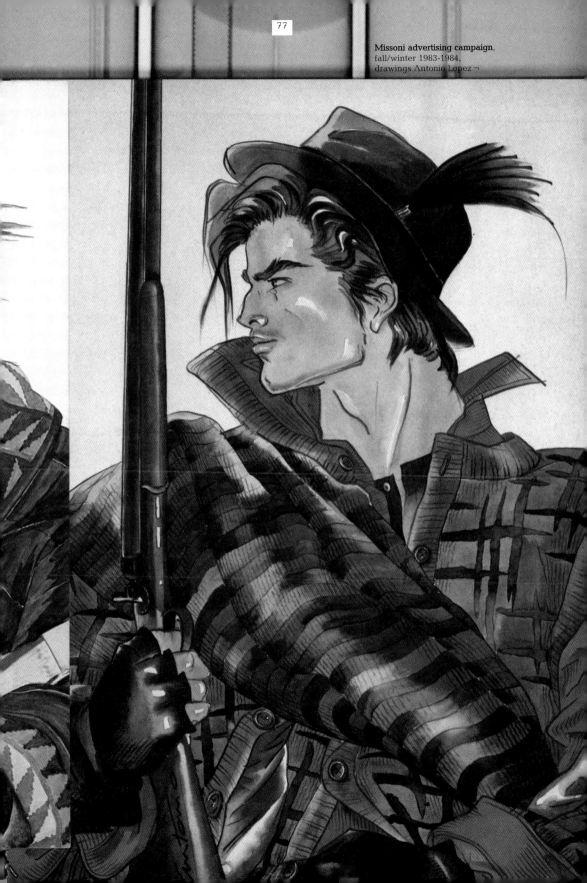

Missoni advertising campaign, fall/winter 1983-1984, drawings Antonio Lopez ¬

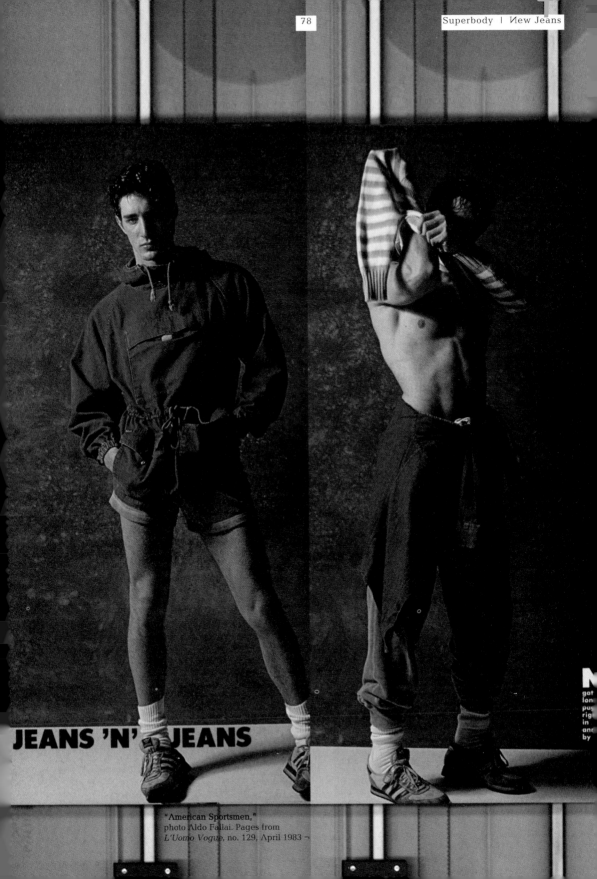

JEANS 'N' JEANS

"American Sportsmen,"
photo Aldo Fallai. Pages from
L'Uomo Vogue, no. 129, April 1983 ¬

Enrico Coveri advertising campaign, spring/summer 1986, photo Gilles Tapie ¬

Marithé François Girbaud/ Closed advertising campaign, spring/summer 1985, photo Fabrizio Ferri ¬

accanto.
denim
aloni ri-
panta-
questa
cotone a
antaloni
jeans
tto Polo

265

Marithé François Girbaud/ Closed advertising campaign, spring/summer 1986, photo Fabrizio Ferri ¬

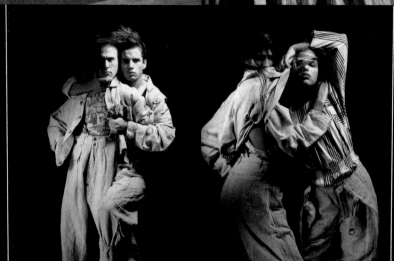

*ROMANCE DEGLINGED PANTS

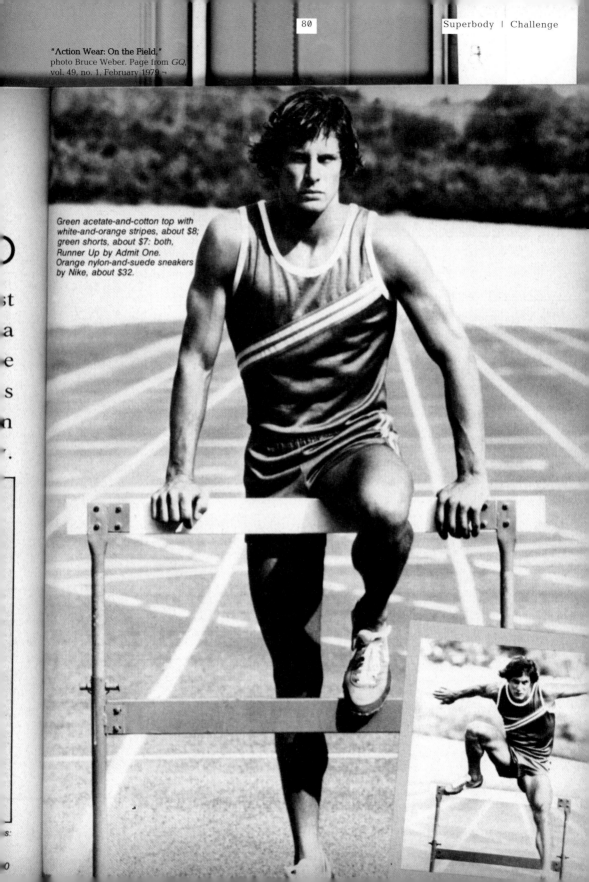

"Action Wear: On the Field,"
photo Bruce Weber. Page from *GQ*,
vol. 49, no. 1, February 1979 ¬

*Green acetate-and-cotton top with
white-and-orange stripes, about $8;
green shorts, about $7: both,
Runner Up by Admit One.
Orange nylon-and-suede sneakers
by Nike, about $32.*

"Getting Their Kicks," text Jerry Trecker, photo Bruce Weber. Page from *GQ*, vol. 53, no. 2, February 1983 ¬

its problems: there are more players than qualified coaches, more games than good referees, more results than local newspapers want to print. But these are the difficulties of development, reflecting the happy circumstance of a game catching the population's fancy far beyond anyone's expectations.

As America's developing players begin to push beyond the scholastic level to make an impact nationally, soccer will have secured a firm foothold in the United States. It certainly won't challenge baseball as the national pastime or displace football's popularity. Indeed, it has no need to, since soccer shows every sign of assuming a position as a viable sports alternative. GQ

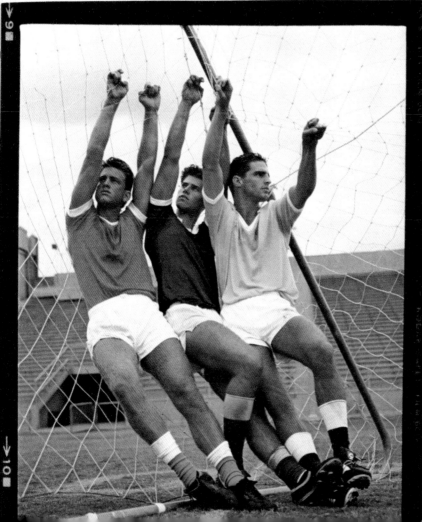

EMPORIO ARMANI

Blazer in cotone rettinato e colorato; camicie button-down a righe pigiam; calzoncini in tela navy; scarpe in ca-
moscio e pelle. Emporio Armani.

ALDO FALLAI

Perry Ellis advertising
campaign, spring/summer
1984 ¬

Corneliani advertising
campaign, spring/summer
1979, photo Aldo Ballo ¬

"Blu, bianco, blazer:
Emporio Armani,"
photo Aldo Fallai. Page
from L'Uomo Vogue,
no. 149, February 1985 ¬

[p. 83]

"Tennis," photo Vanni
Burkhart. Pages from
L'Uomo Vogue, no. 129,
April 1983 ¬

Boris Becker, photo Gabo.
Cover of L'Uomo Vogue,
no. 208, June 1990 ¬

TENNIS

BORIS BECKER

Da sinistra. Nell'ormai diretto. T-shirts in cotone. Frec-
Pants di tela. Martini Sport Lise. Pants
elasticizzati, racchetta, round-neck, tutto Fred Perry.
Polo a righe, pantaloncini con risvolti pullover bianco,
tutto Maxima. Scarpe in pelle. Dunlop.

"Sportissimo a tutta birra," photo Giorgio and Valerio Lari. Pages from *Lei*, no. 41-42, July-August 1980 ¬

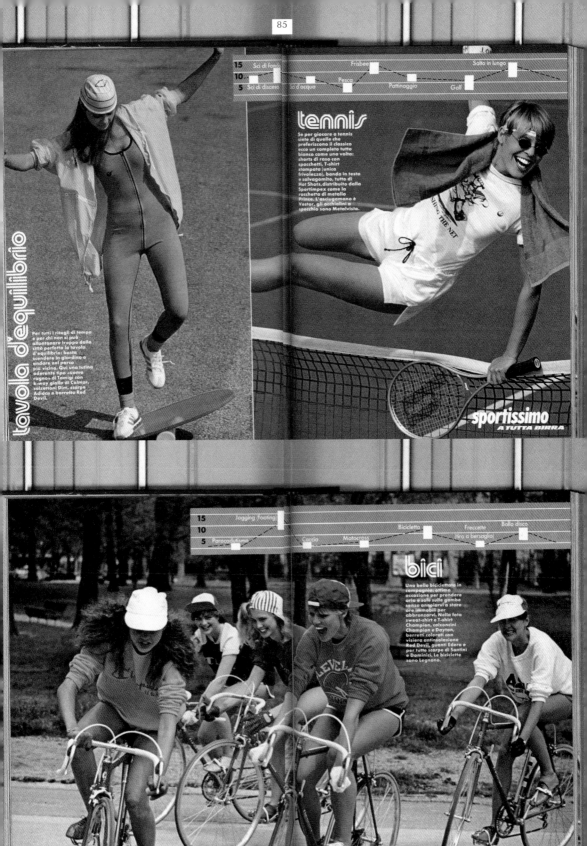

15	Sci di fondo		Frisbee			Salto in lungo
10				Pesca	Pattinaggio	
5	Sci di disceso	Sci d'acqua				Golf

tavola d'equilibrio

Per tutti i ritagli di tempo e per chi non si può allontanare troppo dalla città perfetta la tavola d'equilibrio: basta scendere in giardino o andare nel parco più vicino. Qui una tuta aderente tipo «uomo ragno» di Tomigi con k-way giallo di Colmar, calzettoni Dim, scarpe Adidas e berretto Red Devil.

tennis

Se per giocare a tennis siete di quelle che preferiscono il classico ecco un completo tutto bianco come una volta: shorts di raso con spacchetti, T-shirt stampata (unica frivolezza), banda in testa e salvagomito, tutto di Hot Shots, distribuito dalla Sportimpex come la racchetta di metallo Prince. L'asciugamano è Vestor, gli occhialini a specchio sono Metalvista.

sportissimo A TUTTA BIRRA

15	Jogging (footing)				Bicicletta		Ballo disco
10						Freccette	
5	Paracadutismo		Caccia	Motocross		(tiro a bersaglio)	

bici

Una bella biciclettata in compagnia: ottima occasione per prendere aria e sole sulle gambe senza annoiarvi a stare ore immobili per abbronzarvi. Nella foto sweat-shirt e T-shirt Champion, calzoncini Champion e Dayton, berretti colorati con visiera antinsolazione Red Devil, guanti Edera e per tutte scarpe di Santini e Dominici. Le biciclette sono Legnano.

sportissimo

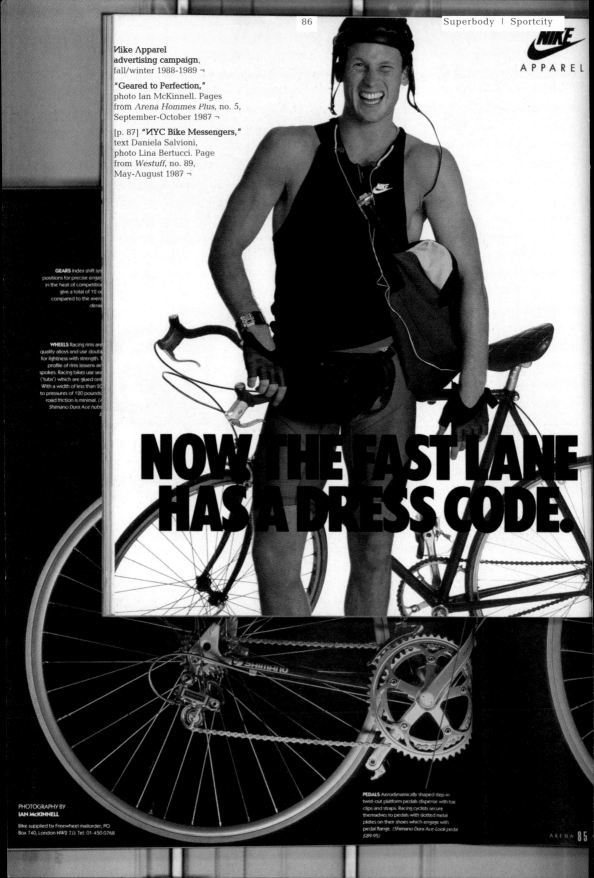

**Νike Λpparel
advertising campaign,**
fall/winter 1988-1989 ¬

"Geared to Perfection,"
photo Ian McKinnell. Pages
from *Arena Hommes Plus*, no. 5,
September-October 1987 ¬

[p. 87] **"ИYC Bike Messengers,"**
text Daniela Salvioni,
photo Lina Bertucci. Page
from *Westuff*, no. 89,
May-Λugust 1987 ¬

NIKE
APPAREL

GEARS Index shift sy
positions for precise engag
in the heat of competitio
give a total of 12 o
compared to the avera
derail

WHEELS Racing rims are
quality alloys and use doubl
for lightness with strength. 1
profile of rims lessens air
spokes. Racing bikes use sea
('tubs') which are glued on
With a width of less than 20
to pressures of 120 pounds
road friction is minimal. (A
Shimano Dura Ace hubs

NOW THE FAST LANE
HAS A DRESS CODE.

PEDALS Aerodynamically shaped step-in
twist-out platform pedals dispense with toe
clips and straps. Racing cyclists secure
themselves to pedals with slotted metal
plates on their shoes which engage with
pedal flange. *(Shimano Dura Ace-Look pedal
£89.95)*

PHOTOGRAPHY BY
IAN McKINNELL

Bike supplied by Freewheel mailorder, PO
Box 740, London NW2 7JJ. Tel: 01-450 0768

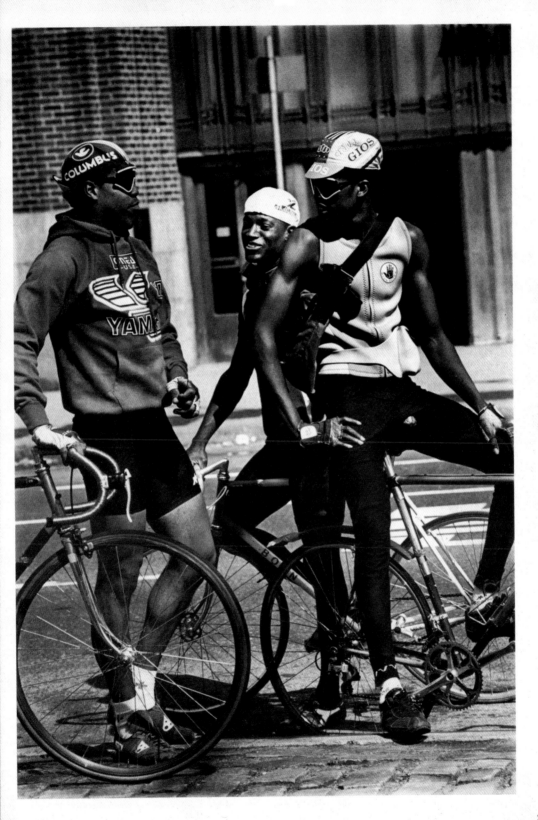

Bruce Weber, *Peter Schifrin*, Epée Fencer, Colorado Sports
Festival, 1983. From Bruce Weber and Jean-Christophe Ammann
(ed.), *Bruce Weber*, catalogue of the exhibition held at the
Palazzina Magnani, Fiesole. Milan, Idea Book Edizioni, 1986 ¬

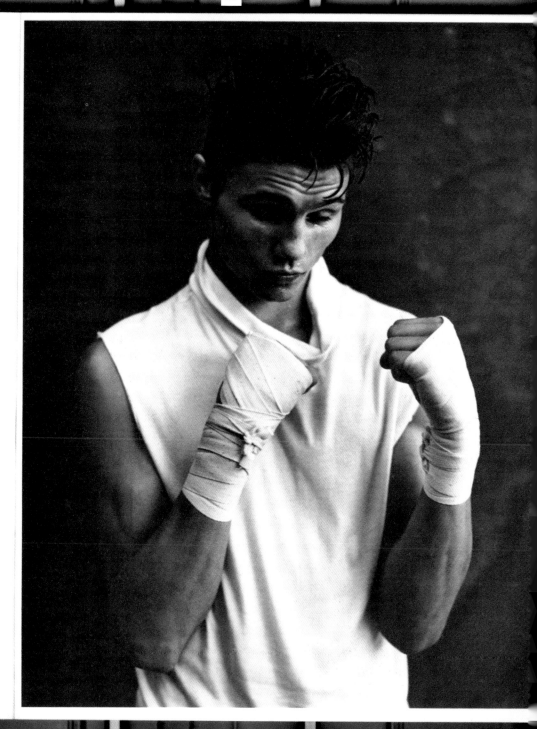

Bruce Weber, *Andrew Minsker,*
Lightweight Boxer, Colorado Sports
Festival, 1983. From Bruce Weber and
Jean-Christophe Ammann (ed.),
Bruce Weber, catalogue of the exhibition
held at the Palazzina Magnani, Fiesole.
Milan, Idea Book Edizioni, 1986 ¬

Bruce Weber

One day in the late seventies, Bruce Weber, today one of the world's greatest fashion photographers for whom fashion is a kind of trap to flee from, took a photo of Jeff Aquilon, a water-polo player at Pepperdine University. The article was commissioned by the American monthly *GQ* and the photo depicted the young champion bare-chested, lying on an unmade bed with his hands playing "inside outside" in his long johns (not boxer shorts, as is so often written). There was a scandal. The magazine refused to print it and later the *SoHo Weekly News* published it as a double-page spread.

Chance put the newspaper into the hands of Calvin Klein, already well known in America as a sportswear designer. Impressed, he called Weber and persuaded him to do the advertising campaign for his line of men's underwear. The photographer depicted a muscular model, the pole-vaulter Tom Hintnaus, who broke off training for the Olympics, wearing nothing but a white "Y-front fly brief" with the Calvin Klein logo on the elastic. Against a backdrop of a whitewashed house on a Greek island, with the muscles and detail of the male anatomy heightened by the low camera angle, the image of the athlete, transformed into a demigod in undershorts, was blown up into an immense poster measuring twenty by thirty meters on a billboard in Times Square, New York. It was stolen overnight. In the three months following the launch of the advertising campaign, sales of Calvin Klein underwear reached the record high of two and a half million dollars.

The eighties began with that story. And, for lovers of exactitude, right there, on that billboard in Times Square, where unknown hands stole a photo of a man in his underpants.

Though a photographer of extraordinary bravura, Bruce Weber – class of 1946, a pupil of Diane Arbus and later Lisette Model – before coming to photography studied music and painting and modeled for Richard Avedon. He has always loved dogs more than photography and bodies more than clothes. If these pointers are not enough, let's just say he was the major figure responsible for the renewal – actually the refoundation – of the fashion image in the eighties. Our visual memory connects his name with the advertising campaigns for Calvin Klein and Ralph Lauren, as well as Gianni Versace (with whom the collaboration, begun in 1981, was to become a close partnership that endured for over a decade). It also includes photos of Olympic athletes commissioned by *Interview* and then published also in *Per Lui* – an Italian monthly for young people in the eighties – which eventually formed the book *Bruce Weber Photographs the 23rd Olympic Athletes* in 1984, and the numerous assignments for *L'Uomo Vogue*.

But through this extenuating work of constructing the images of others – magazines and designers – with varied facets and even more varied results, Weber invented the whole image of a period, focusing his attention on an absolutely unprecedented interpretation of the male body. Whether models, athletes, actors or street kids (in both senses of the world), the men portrayed by Weber are reborn in his lens. Their bodies, often naked, at other times only half clad, rarely wholly covered by clothes, express a very provocative male sensuality, in a way that was then only permitted to women's bodies in the pages of men's magazines. But in those relentless photos, destined to open up a new world with an image that could not stop at the eighties, Weber's gaze annulled all vulgarity, all sex-shop temptation, to reveal the aspect of a masculinity wounded by centuries of sexophobic obscurantism, in which heterosexual men can also recognize themselves. In the Whitney Museum of American Art's 1987 Biennial – an exhibition fundamental for the eighties – his work, flanked by that of Julian Schnabel, Barbara Kruger, Jeff Koons and others, was described as "the comfort of myths," precisely because his photos reinvented an athletic body whose precedent is still found in the classicism of the myth of Olympus.

Perhaps for this reason, homosexual imagery has taken over his images, at the same time forcing us to change our outlook, attitudes and aptitudes. In a certain sense, precisely from the start of the eighties, Weber compelled even gays to refine their tastes, almost obliging them to form themselves more on the fantasies of Gore Vidal (*The Pillar and the City*, 1948) and the complicities of the tribal friendships of adolescents, than on those of porno cinema. The encroachment produced by men who are – true – muscular, but also just anybody, good-looking but also scowling and disquieting, always smeared with life and youthful bitterness (even when they are actors like Matt Dillon and later Keanu Reeves and River Phoenix, the beautiful and damned in Gus Van Sant's *My Own Private Idaho*) has been so profound that fashion and its advertising have never been able to go back. And twenty years later, even third-millennium man recognizes himself in that muscular young guy who, completely naked and vain without vanity, is ironing himself a shirt.

MICHELE CIAVARELLA

Calvin Klein Underwear billboard, Times Square, New York, 1984, photo Silvia Kolbowski and Pat Bates ¬

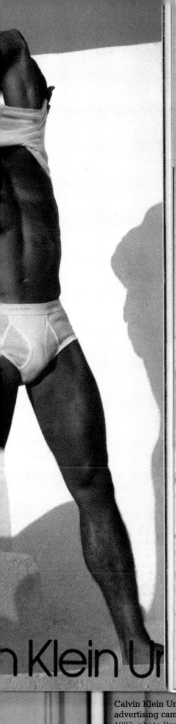

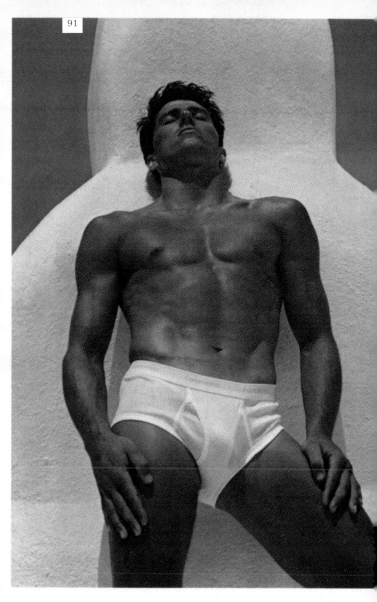

Calvin Klein Underwe

Calvin Klein Underwear
advertising campaign, spring
1983, photo Bruce Weber ¬

Calvin Klein Underwear
advertising campaign, spring
1985, photo Bruce Weber ¬

"Moda: La biancheria di Иikos.
Estetismi eccellenti," photo
Skrebneski. Pages from *Vanity*, no.
25, May-June 1987 ¬
"Moda: Иikos. Mitiche privacy,"
drawings Edland Man. Pages from
Vanity, no. 23, January-February
1987 ¬

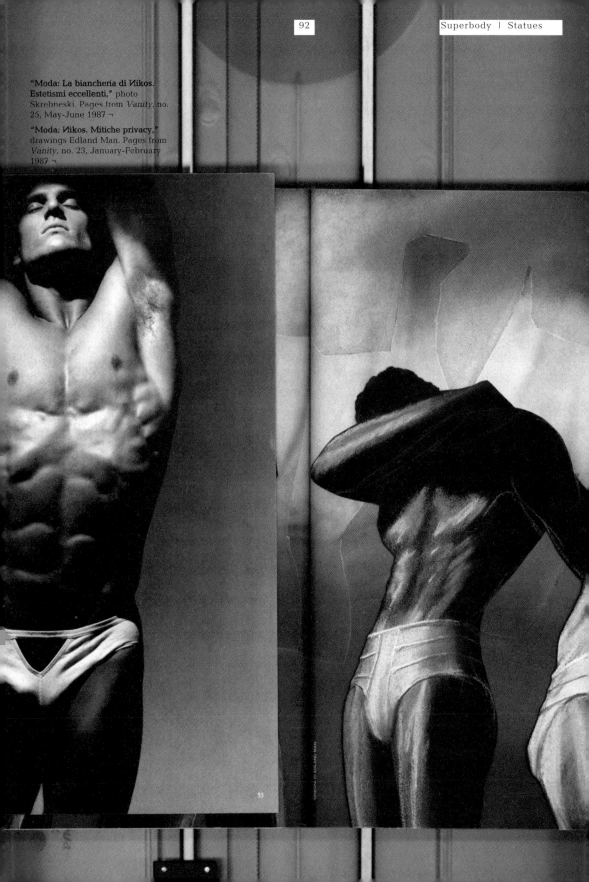

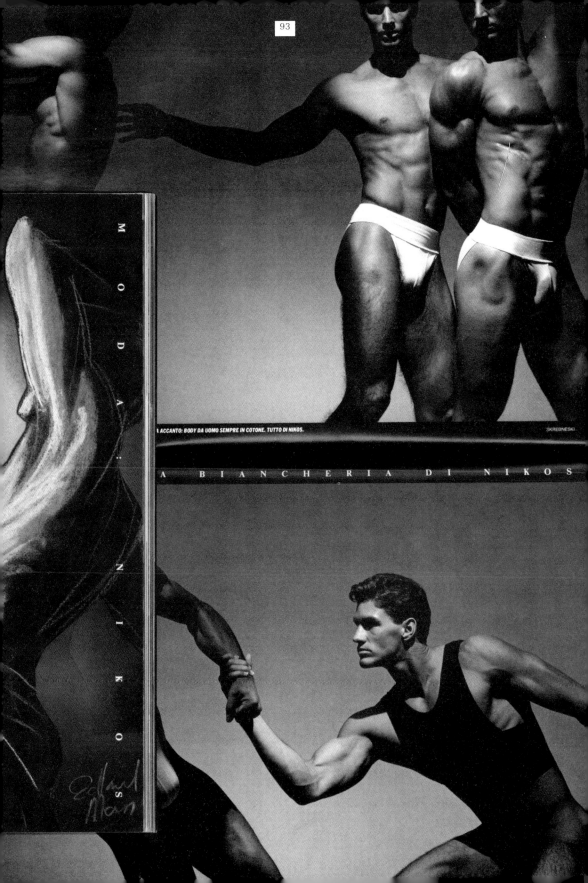

ACCANTO: BODY DA UOMO SEMPRE IN COTONE. TUTTO DI NIKOS.

SKREBNESKI

MODA: NIKOS

LA BIANCHERIA DI NIKOS

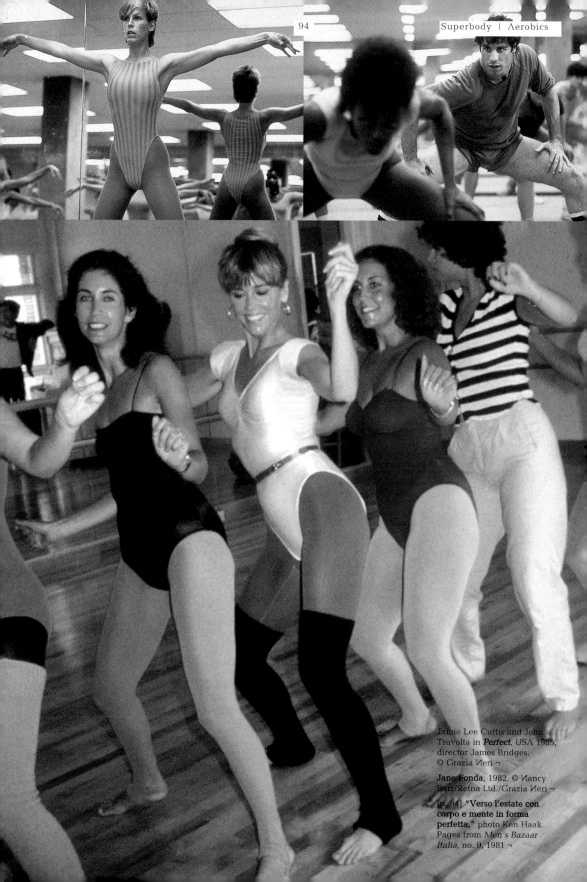

Jamie Lee Curtis and John Travolta in *Perfect*, USA 1985, director James Bridges. © Grazia Neri ¬

Jane Fonda, 1982. © Nancy Hart/Retna Ltd./Grazia Neri ¬

[p. 94] **"Verso l'estate con corpo e mente in forma perfetta,"** photo Ken Haak. Pages from *Men's Bazaar Italia*, no. 9, 1981 ¬

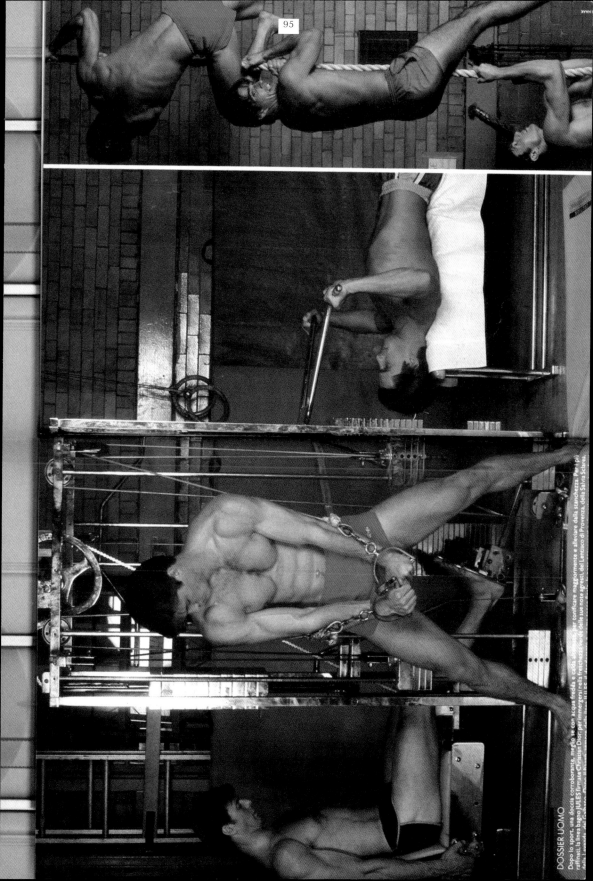

DOSSIER UOMO

Dopo lo sport, una doccia corroborante, meglio se con acqua fredda e calda alternate per tonificare maggiormente e alleviare dalla stanchezza. Per più rafinati, la linea bagno JULES firmata Christian Dior per immergersi nella freschezza viva delle sue note agrumi, del Lentisco di Provenza, della Salvia Sclarea.

A fianco. Collo alto chiuso da press-button per l'abito di UFO; cintura Vacher, calze
ng, stivaletti Free Lance. Sotto. Di Diesel le felpe c
pantaloni Sarah Lou come i braccialetti, cintura Va

anco. Gonna ampia con tasche di Herma come la blusa senza maniche; scar-
Surplus Bensimon. Sotto. Duepezzi jogging: felpa By American, pantaloni Sa
Lou, guanti Barnier.

look felpato

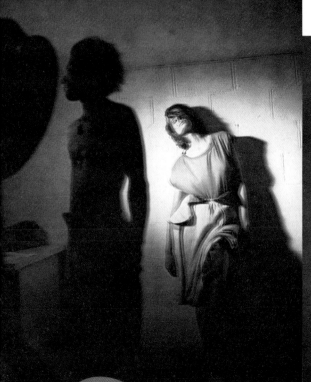

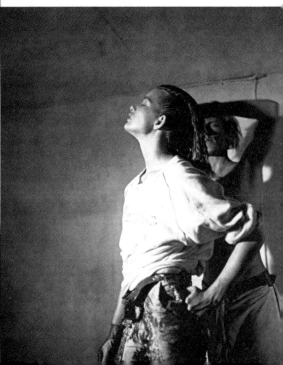

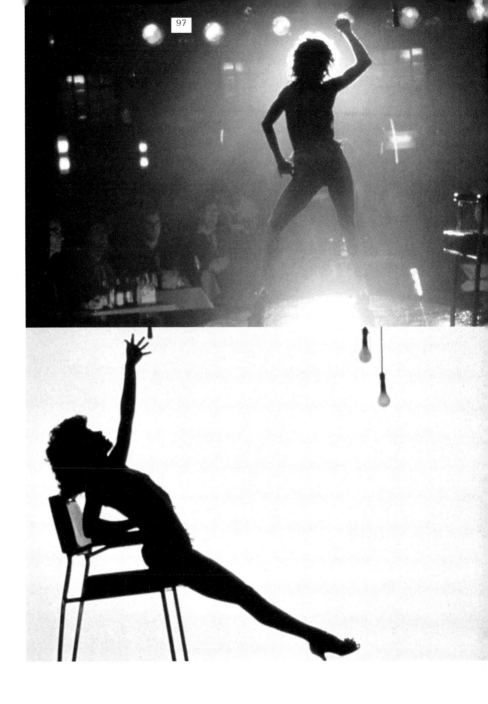

Jennifer Beales in *Flashdance*, USA 1983,
director Adrian Lyne. © Photo 12/Grazia Neri ¬

[p. 96] **"Look felpato,"** photo Jean François
Lepage. Pages from *Lei*, no. 78, October 1983 ¬

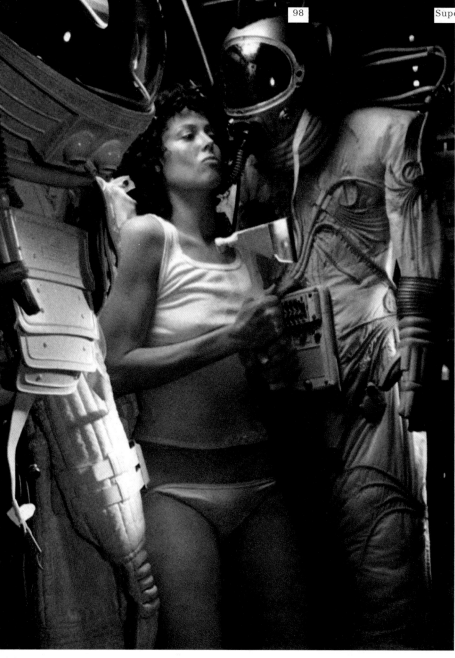

Sigourney Weaver in *Alien*, USA 1979,
director Ridley Scott © Photo 12/Grazia Neri ¬

[p. 99] **Calvin Klein Underwear advertising
campaign**, spring 1983, photo Bruce Weber ¬

Calvin Klein Underwear

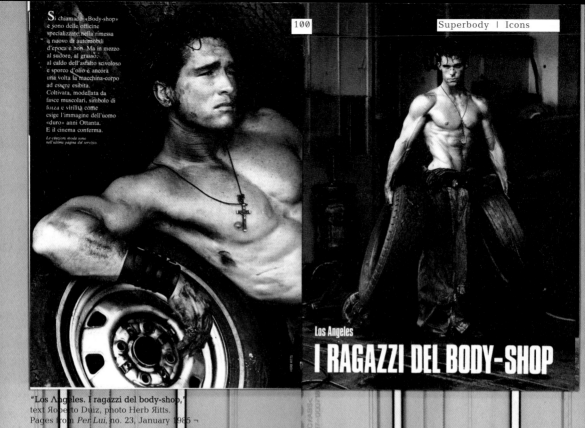

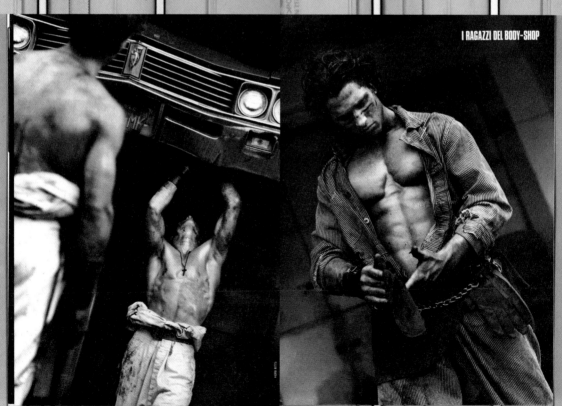

Si chiamano «Body-shop» e sono delle officine specializzate nella rimessa a nuovo di automobili d'epoca e non. Ma in mezzo al sudore, al grasso, al caldo dell'asfalto scivoloso e sporco d'olio è ancora una volta la macchina-corpo ad essere esibita. Coltivata, modellata da fasce muscolari, simbolo di forza e virilità come esige l'immagine dell'uomo «duro» anni Ottanta. E il cinema conferma.

Le citazioni moda sono nell'ultima pagina del servizio.

Los Angeles

I RAGAZZI DEL BODY-SHOP

"Los Angeles. I ragazzi del body-shop," text Roberto Duiz, photo Herb Ritts. Pages from *Per Lui*, no. 23, January 1985 ¬

I RAGAZZI DEL BODY-SHOP

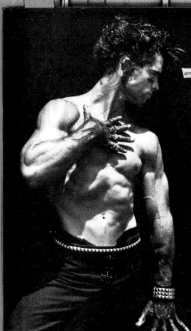

He Works Hard for Your Money

arresting, arousing, avant-garde.

grease monkeys & gang violations

NEW YORK PICK UP LINE

"Grease Monkeys," photo Herb Ritts, styling Michael Roberts. Pages from *The Face*, no. 54, October 1984 →

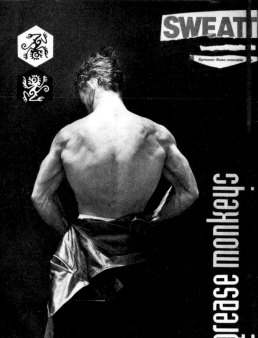

SWEAT!

Sprouse: Sooo wearable

grease monkeys

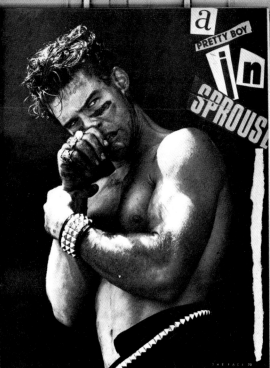

a PRETTY BOY in SPROUSE

Cover of *Per Lui*,
special issue, "Album.
Photo Tour 1985," photo
Bruce Weber, no. 29,
July-August 1985.

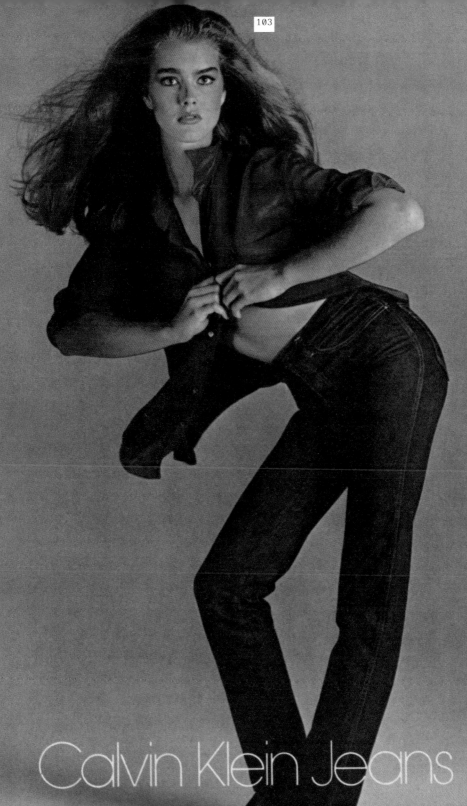

Calvin Klein Jeans

Brooke Shields. Calvin Klein Jeans
advertising campaign, fall 1981,
photo Яichard Avedon ¬

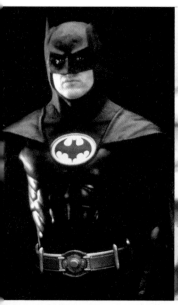
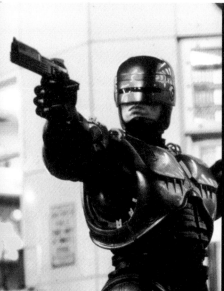
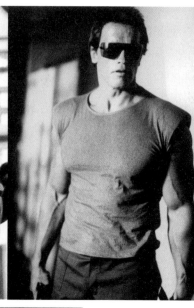
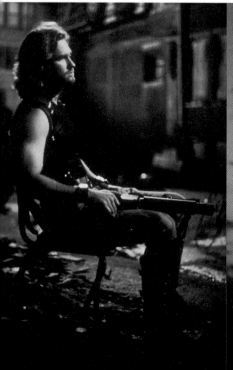
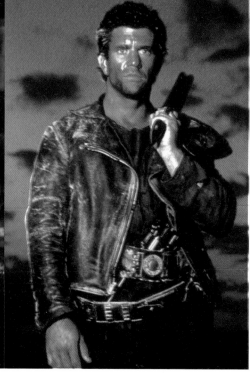

Яanxerox, by Stefano Tamburini
and Tanino Liberatore. Page from
the supplement to no. 34 of *Frigidaire*,
Milan, Primo Carnera, 1983 ¬

[p. 104]

Michael Keaton in *Batman*, USΛ 1989,
director Tim Burton. © Photomovie ¬

Peter Weller in *Яobocop*, USΛ 1987,
director Paul Verhoeven. © Photomovie ¬

Λrnold Schwarzenegger in *Terminator*,
USΛ 1984, director James Cameron.
© Leonelli/Grazia Νeri ¬

Kurt Яussell in *1997 Escape from
Νew York*, USΛ 1981, director John
Carpenter. © Photo 12/Grazia Νeri ¬

Mel Gibson in *Mad Max Beyond
the Thunderdome*, USΛ 1985,
director George Miller.
© Photo 12/Grazia Νeri ¬

V. M. 18

DOUBLE-SPLIT SYSTEM

3

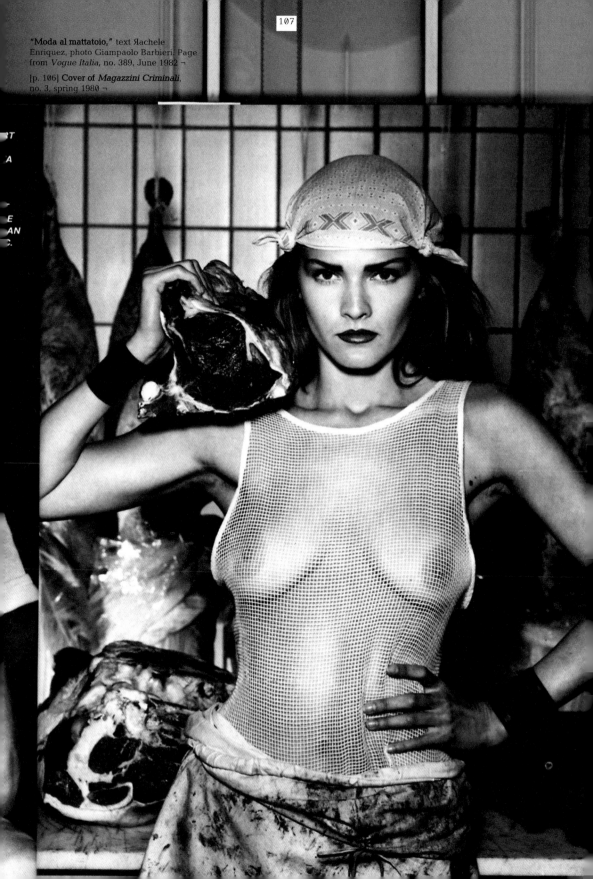

"Moda al mattatoio," text Яachele Enriquez, photo Giampaolo Barbieri. Page from *Vogue Italia*, no. 389, June 1982 ¬

[p. 106] Cover of *Magazzini Criminali*, no. 3, spring 1980 ¬

[p. 109]

"Le cuir en souplesse," photo Snowdon.
Page from *Vogue Hommes International*,
no. 6, fall/winter 1987-1988 ¬

"Samurai 2000, Anteprima summer:
Parachute," photo Fabrizio Ferri. Page from
Mondo Uomo, no. 16, November 1983 ¬

Claude Montana advertising campaign,
spring/summer 1984, photo Bob Krieger ¬

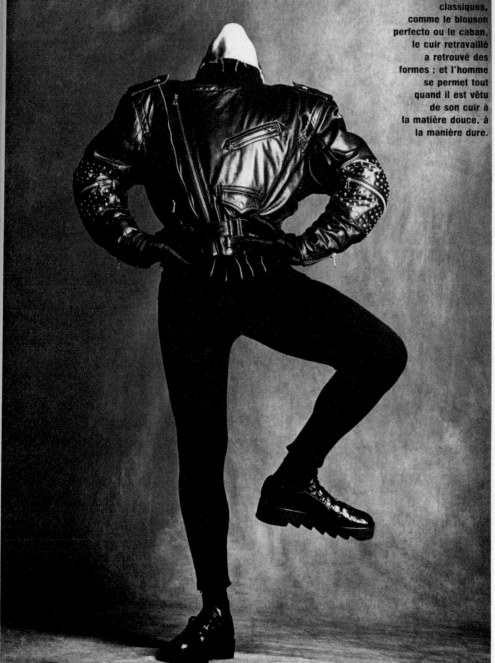

Dérivant de bases
classiques,
comme le blouson
perfecto ou le caban,
le cuir retravaillé
a retrouvé des
formes ; et l'homme
se permet tout
quand il est vêtu
de son cuir à
la matière douce, à
la manière dure.

JEAN-PAUL GAULTIER : blouson court en agneau plongé noir, pull-over à col montant rayé noir et blanc ; caleçon en laine noire. Gants en agneau matelassé, Claude Montana. Chaussures, Patrick Cox.
JEAN-PAUL GAULTIER : short jacket in black lambskin; high collar pullover in black-and-white striped wool; black wool long johns. Quilted lambskin gloves, Claude Montana. Shoes, Patrick Cox.

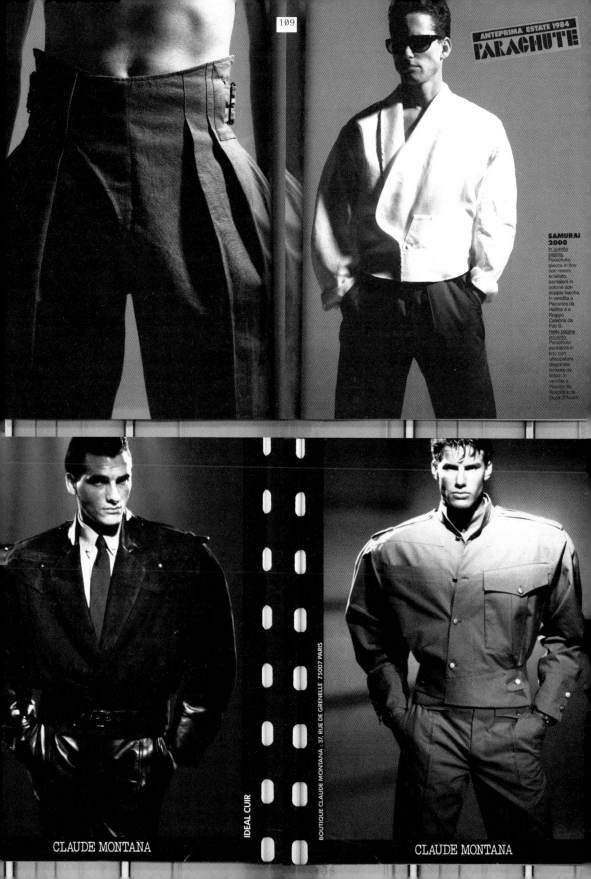

ANTEPRIMA ESTATE 1984

PARACHUTE

SAMURAI 2000

In questa pagina, Parachute: giacca in lino con revers scialloto, pantaloni in cotone con doppia tasca. In vendita a Piacenza da Halifax e a Reggio Calabria da Foti G. Nella pagina accanto, Parachute: pantalone in lino con allacciatura diagonale formato da fibbie. In vendita a Firenze da Raspini e da Duca D'Aosta.

IDEAL CUIR

BOUTIQUE CLAUDE MONTANA : 37, RUE DE GRENELLE 75007 PARIS

CLAUDE MONTANA

CLAUDE MONTANA

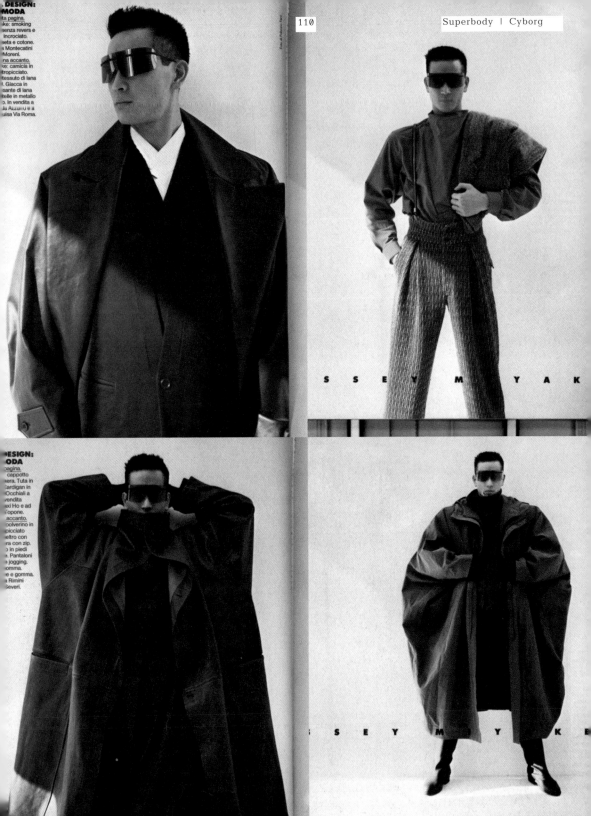

THE WALKING OFFICE

Il progetto di un microcomputer personale da applicare sul corpo per lavorare ovunque. ■ **The design of a personal microcomputer to wear on the body as ornament and work everywhere: the decorative component of the technology.**

Progetto di Salotto Dinamico (Vincenzo Javicoli, Maurizio Pettini, Maria Luisa Rossi, Maria Letizia Schettini & Paolo Bettini)
Graphic computer Mario Lovergine
Graphic Cosimo Melani
Il Walking Office è indossato da Gennaro Piazza

La scelta del soggetto nasce da due presupposti: la constatazione che la telematica, con le sue capacità di elaborare le informazioni, sta modificando l'organizzazione della nostra vita quotidiana nonché il modo di ragionare, ed il fatto che gli elaboratori, aventi prima dimensioni tali da essere destinati all'immobilità, ora possono facilmente essere trasportati in modo da modificarne radicalmente l'uso.
Su queste basi è nato il «Walking Office», un oggetto studiato non come componente della famiglia degli arredi, bensì di quella degli accesssori per il corpo.
In questo senso l'oggetto coinvolgendo aspetti quali la «portatilità» e la «componente decorativa» cerca di instaurare con l'uomo seduzione e legami, così come già avviene con altri oggetti personali quali gli occhiali, l'orologio, la penna.
Il Walking Office è composto di quattro elementi: due di questi formano la tastiera, il terzo è il display, il quarto un registratore a cassetta con incorporato l'accoppiàtore acustico. Per rendere operativo il sistema vanno unite le due metà che costituiscono la tastiera ed a loro il display.
Il registratore consentirà la memorizzazione dei dati, mentre l'accoppiatore acustico, tramite un qualsiasi apparecchio telefonico, renderà possibile trasmettere e ricevere le informazioni.
Salotto Dinamico

■ Design choice is based on two assumptions: the verification that telematics, with their capacity to process information, are changing the organization of our daily life and way of reasoning, and the fact that the computers, formerly so large they had to stay immobile, can now be transported with ease, radically modifying use.
It is on these bases that the «Walking Office» was created, an object that refers to the body wearing it, contrarily to the traditional office which refers to a delimited physical space.
In this sense the object does not look like a small computer, but, involving more complex, articulated aspects, such as «portability» and «decorative component», it tries to establish ith man seductions and ties, as already happens with other personal objects like spectacles, watches, pens. The Walking Office consists of four elements: two form the keyboard, the third is the display, the fourth a cassette recorder with built-in sound coupler. To make the system work, the two halves of the keyboard are linked and the display connected to them. The recorder memorizes data, while the sound coupler, with any telephone set, will make it possible to transmit and receive information, communicating in both directions with the data collection centres.

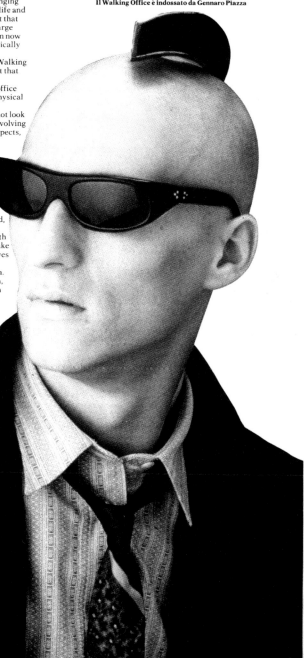

foto Alberto Petra

[p. 110] "Issey Miyake. Oltre il design: una moda," photo Fabrizio Ferri. Pages from *Mondo Uomo*, no. 25, May 1985 ¬

"The Walking Office," project Salotto Dinamico. Page from *Domus*, no. 665, October 1985 ¬

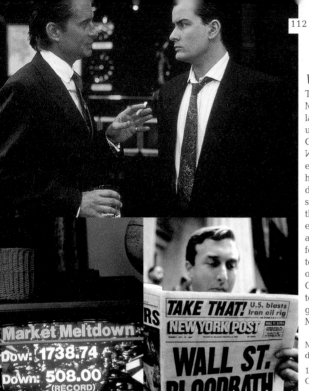

Wall Street (Oliver Stone, 1987)

The lust for power in eighties New York blinded by money. More than a film, almost a period documentary. Fifteen years later everything has acquired the power of an icon: the unbridled luxury of the coastal home of the broker Gordon Gekko, crammed with artworks from Picasso to Louise Nevelson; the "uniform" of the powerful, impeccable suits, elegant suspenders silhouetted against immaculate shirts, the hair slicked back and the brand-name cigarillo always lit; the décor of the offices, white and aseptic for the lower echelons, sumptuously post-déco and with a view over Manhattan for those who really count. Wall Street depicted the lifestyle of excess even in seemingly ordinary yet revealing details, such as the sequence showing the "rewards" for young Fox in the form of a limousine, cocaine and a high-class call girl, or the total refurbishment of his apartment, transformed into an orgy of faux marble stucco, rich drapes, and hi-tech furniture. Oliver Stone's film has become the archetype and the touchstone for any self-respecting office drama. There's no getting away from it.
Mauro Tinti

Michael Douglas and Charlie Sheen in **Wall Street**, USA 1987, director Oliver Stone. © Grazia Neri ¬

19 October 1987, New York, **Black Monday**. © Franck Fournier-Contact Press and © Tom Sobolik/Black Star ¬

Giorgio Armani, spring/summer 1984 collection, photo Aldo Fallai. From Lo Stilista e i suoi fotografi, catalogue for the exhibition held at Galleria Civica d'Arte Contemporanea, Suzzara. Verona, Grafiche AZ, 1987 ¬

STUDIO POLI · FOTO HERB R

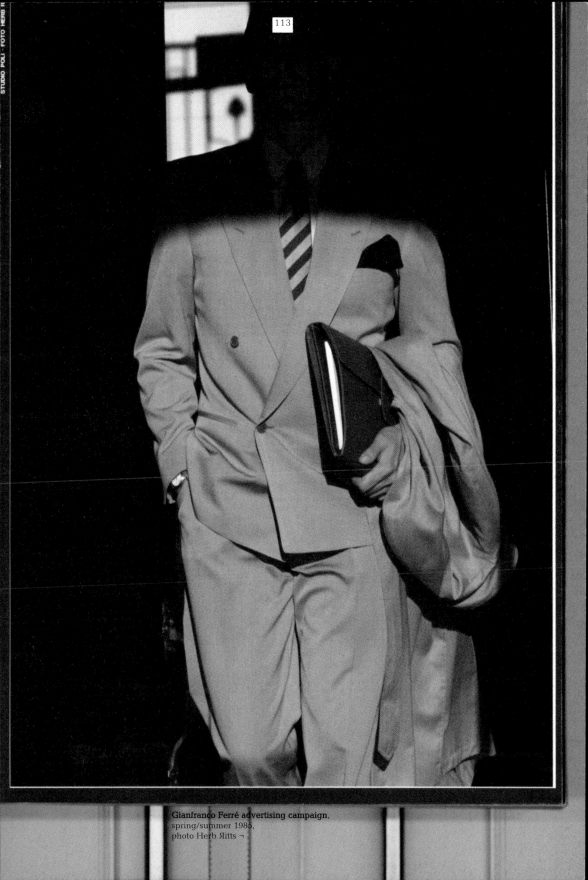

Gianfranco Ferré advertising campaign,
spring/summer 1985,
photo Herb Ritts ¬

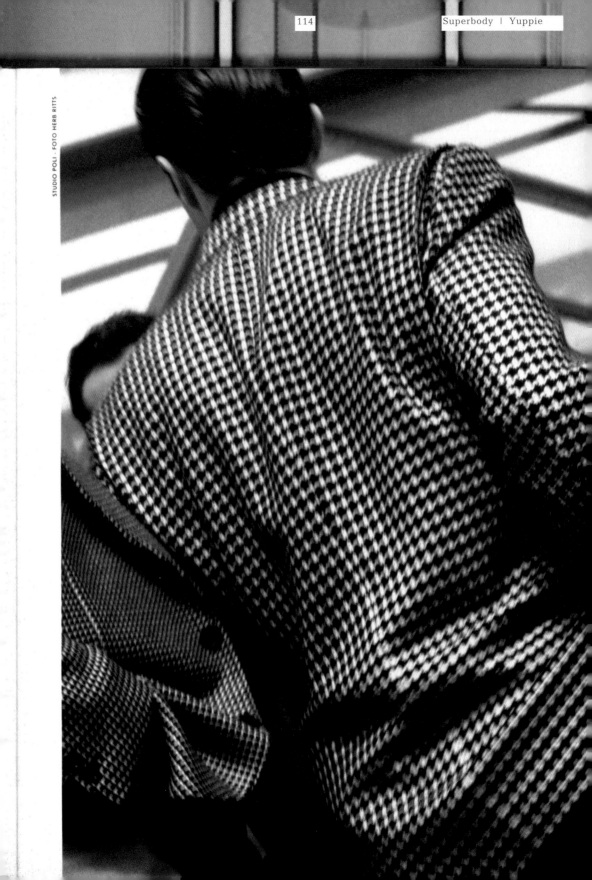

STUDIO POLI · FOTO HERB RITTS

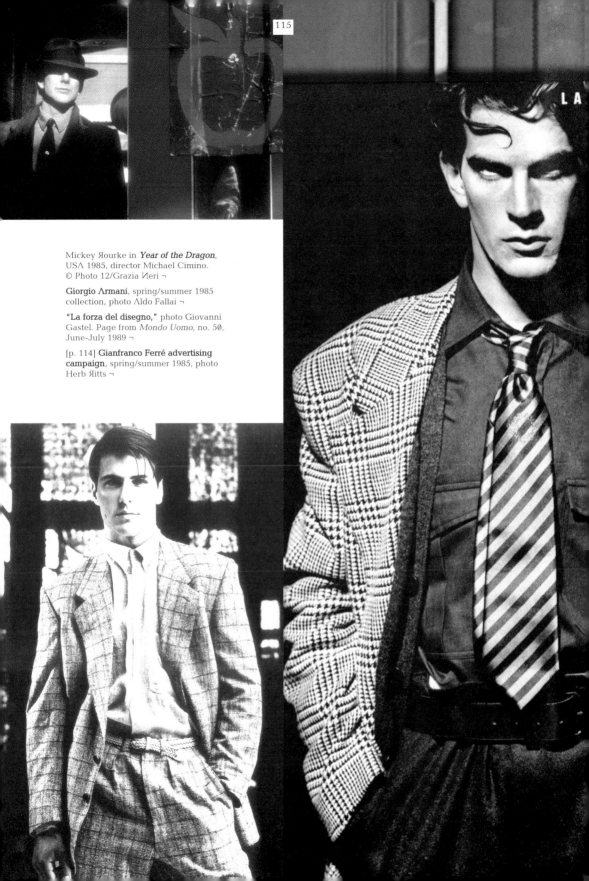

Mickey Яourke in *Year of the Dragon*,
USΛ 1985, director Michael Cimino.
© Photo 12/Grazia Νeri ¬

Giorgio Λrmani, spring/summer 1985
collection, photo Λldo Fallai ¬

"La forza del disegno," photo Giovanni
Gastel. Page from *Mondo Uomo*, no. 5Ø,
June-July 1989 ¬

[p. 114] **Gianfranco Ferré advertising
campaign**, spring/summer 1985, photo
Herb Яitts ¬

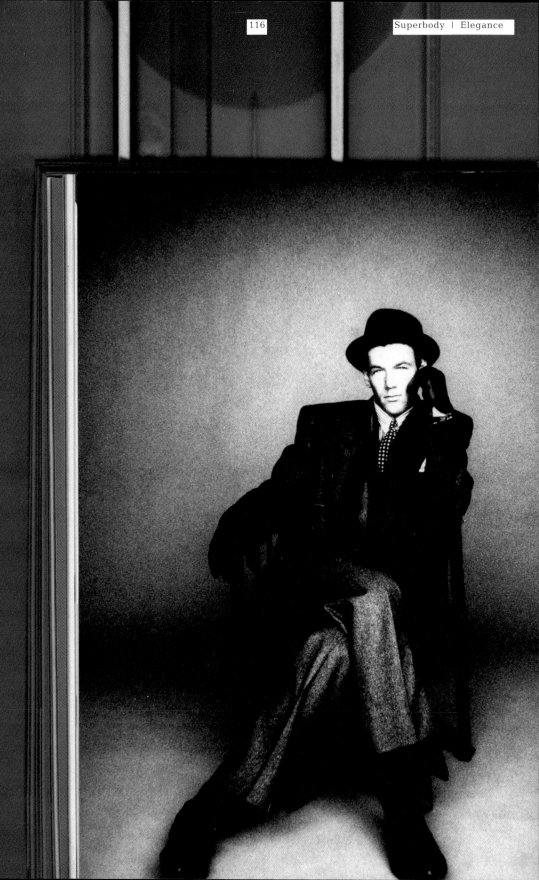

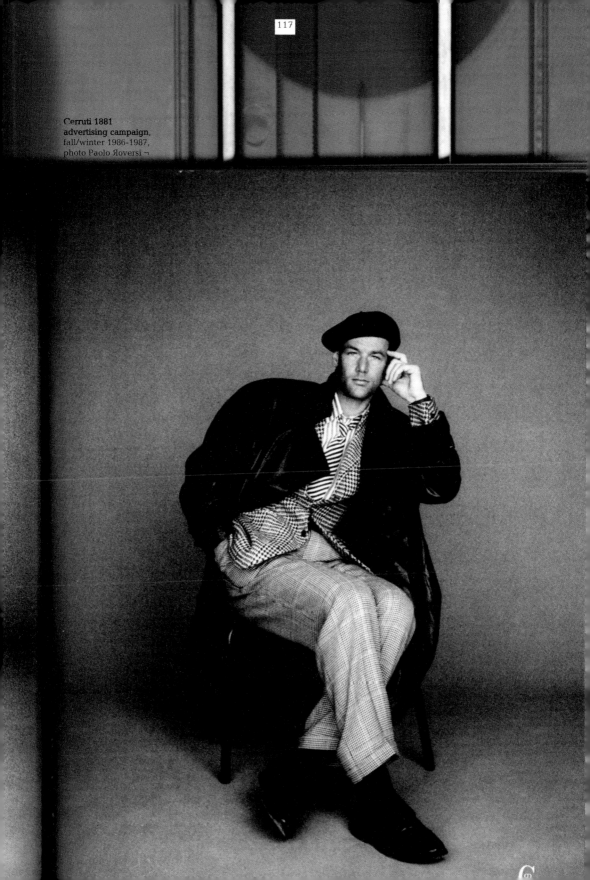

Cerruti 1881
advertising campaign,
fall/winter 1986-1987,
photo Paolo Яoversi ¬

|

[pp. 118-119] **Яobert Longo**, from the series *Men in the Cities*, *Untitled*, 1980, charcoal and graphite on paper, 275 x 152 cm. From Яobert Longo, *Men in the Cities*, Иew York, Harry И. Λbrams, 1986 ¬

Яobert Longo, from the series *Men in the Cities*, *Untitled*, 1981, charcoal and graphite on paper, 244 x 152 cm. From Яobert Longo, *Men in the Cities*, Иew York, Harry И. Λbrams, 1986 ¬

Poweя Suit / Sex Suit

\
\

Maяia Luisa Fяisa

I'm not sure. The images are many and I risk losing the thread. This often happens. Λ photograph catches your attention, you start to look at it and before you realize it you find yourself entering a story. Λ tale. Each of us is linked to tales, to stories that reveal the multiple truths of life.

Then there are a few succinct and crystalline images that encapsulate the thinking of their own time, giving glittering and tangible form to what is in the air. So that if we look today at Helmut Νewton's twin images, the famous

"Sie kommen" Dressed and "Sie kommen" Νaked, of 1981, we are at once disoriented and dazzled by the force and by the peremptory, confident boldness conveyed by those bodies. Νaked without shame. Dressed without constraint. Λ common, close-knit and conscious confidence. They are women who have just emerged in triumph from the fierce feminist struggle that, starting out from the protests of the sixties in Λmerica and Europe, culminated in the political and social conquests of the seventies.

It was 1968 when Valeria Solanas, founder and sole member of SCUM (Society for Cutting Up Men), shot Λndy Warhol at the Factory and then gave herself up to the police a few hours later. She earned herself lasting fame by attacking the man who perhaps more than any other had succeeded in foreseeing the evolution of the society

ectacle, going along with it and constructing its universal iconography. Capable, above all, of fueling peoples' dreams with the world of celebrities. Everyone can be famous for fifteen minutes, claimed Andy Warhol, stimulating our basest instincts and anticipating the degeneration of the media to which we are now exposed. But this did not apply to Valeria. She would be famous forever for having expressed in a sensational and enduring way the anger that she, and all other women, carried within them. *Your Body Is a BattleGround* is the title Barbara Kruger gave to one of her works, summing up in a single phrase all the feelings and all the words that surrounded the female body in those black and white years. It was as if everything had been accumulated at those crucial points that were the moments of transition from one decade to the next. It was the feminist movements ("the only revolution of our time that has not failed") of the seventies that, by radically questioning all aspects of the female condition, gave a name and identity to those sexy women who, for their own pleasure and out of a sense of challenge, were to make the fortune of the photographer Helmut Newton.

It was the provocative actions, like burning bras in the streets, the battles for control of their own bodies, their own feelings and their own time – and which required political clarity and unity – that led to the legalization of divorce and abortion, to the new civil status of women, to equality in the workplace . . . And more. A real and direct understanding of the body led to a more reliable form of contraception. At the same time, the establishment of self-awareness groups and the opening of advice centers revealed that individual problems were shared by all, and transformed the breakthrough of a few into common knowledge. Because, according to the theorists of feminism, like the Lacanian Luce Irigaray, "The feminine does not exist except within models and laws enacted by males."

"Between screams and silence we choose words" was the official declaration of the "March 8" Tribunal, set up in Rome in 1979. It proposed to give a voice to women and reveal the blatant and hidden conditioning that prevented women from gaining full freedom. At the dawn of the eighties, the image of hysterical, angry and radical feminists gave way, little by little, to that of the new women, to a different image that the media have helped to spread. Now women had reconciled themselves with men and achieved success in their professional careers, they were the ones taken as role models. Marisa Bellisario, the first Italian woman to become the managing director of a large company (Italtel) became the icon: Giorgio Armani suit, punk hairstyle, eyes that gazed straight into yours. A perfect look for the media.

Four women on the march, beautiful, nude, wearing nothing but high heels on their feet. Their slim and athletic bodies are not intended to stir desire. These are not bodies that open themselves up passively to male penetration. But neither are they self-referential bodies that have to choose solitude in order to feel free. They are women who stand in front of men and fearlessly look them in the eyes, aware of their own value. In the accompanying image the same women are dressed. In crisp, precise clothes. Designed and constructed to give shape and form to this new heroine who wants to get ahead in the world, to go straight to the heart of things.

Women needed a uniform that would make them independent and authoritative in the workplace. They did not want to dress like men, but realized that if they wanted to escape the role of secretary, assistant and employee, they had to find the armor that would protect them and stop them from feeling out of place. The women in Newton's photograph are wearing beautiful jackets whose padded shoulders lend an imposing touch to the figure, pants that are comfortable but perfectly cut to suit the female figure, straight skirts with no frills that leave the legs exposed.

And their march went on. Democratic fashion offered women the means to go down any road they wanted to take. Fashion that was not just clothing but already a matter of lifestyle came to play a dominant role in defining the character of individuals. There was a garment for every kind of woman, just as there was one for every occasion. If it was for daytime, for work, the prime necessity was to have a uniform that would convey calm authority; if it was for evening, for having fun, then the woman wanted to seduce. She wanted to savor the pleasure of the hunt at last. In her best-selling book *Fear of Flying*, Erica Jong sang the praises of the zipless fuck. So the garment was sexy, but able to preserve a structure that followed the female body, making the most of it as well as rendering it autonomous of the man's gaze. They were clothes that did not require a body reshaped by gyms and plastic surgeons because they had a design, a form that complemented the figure, that presented it as an erotic icon and not as a caricature of the *femme fatale*. At last every woman could draw up a list of her desires. Awareness and passion at one and the same time. Pleasure in finally having the opportunity to satisfy her desires on a par with men and to transgress a series of diktats imposed by male-chauvinistic society. Sex was not yet the fundamental element of life that the contemporary world wants to make us believe, in order to glorify it and then sublimate it in consumption and in glossy marketing. It was still a dark and secret thing that responded to the energy and the aggressiveness of nature.

1983: the Miss Italia contest returned after an absence of twelve years. In the yuppie Italy that was then emerging, the cult of the image took hold. A poll held by Makno on the theme of the body and seduction showed that 80% of Italians, men and women, considered physical appearance decisive to their assessment of themselves and others. It was the beginning of the era of the triumph of the body, of appearances, of the pleasure of being looked at. Seduction was no longer just a female prerogative. And in advertising, the bodies of men appeared alongside those of women. The categories of sex and gender and their respective roles, viewed according to a strictly binary scheme that inflexibly identified individuals as belonging to one or the other group, assigning them obligations, duties and pre-established models of behavior, came under reckless attacks that echoed the words of Virginia Woolf, speaking of *Orlando*: "The change of sex, although it altered their future, did nothing whatever to alter their identity."

*Our translation from the Italian editions

In Our Still Innocent Eyes

\
 \

Giusi Ferré

The eighties – defined by the writer Sebastiano Vassalli as *banal*, by the singer Antonello Venditti as *plastic*, by the semiologist Omar Calabrese as years of *citation* and by the post-intellectual and pre-moralist Roberto D'Agostino as a time of Reaganite and/or Craxian hedonism – have been caught, as if frozen in a still, by an ambiguous and dazzling film, at once melancholic and seductive: *American Gigolo*. A cruel fable about the destructive power of money, this movie offered a foretaste of a symbolic language that was to become more common, a mix of design and fashion, hi-tech objects and gym equipment, gleaming furniture and clothes of surprising elegance. New forms for a new mode of being, emerging in an as yet unsuspecting society, which was burning with the desire to turn its back on the acrimonious eruptions of the seventies, the political extremism, confusion and permanent rebellion that, aesthetically speaking, had found expression in anti-fashion and in a vague concept labeled as "alternative": military jackets and jeans, short skirts and vests, a great deal of folklore and very little rigor.

Richard Gere was dressed entirely by Armani; Lauren Hutton in clothes by Basile and carrying bags by Bottega Veneta. By their mere appearance on the screen they announced that times had changed. Richard Gere wore suits in soft and mellow colors that had never been seen before, shirts with microscopic patterns, long and narrow neckties that went along with the unusual proportions of his flimsy jacket: light as a shirt, loose, flowing with the actor's sensual movements, with his erotic and unmistakable gait. Lauren Hutton too wore dresses and jackets of soft silk, but always pumped up at the shoulders, lifted by that delicate support, the shoulder pad.

So if the man looked more relaxed and at his ease, less stiff than in the armored jack-
ets of the past, the woman acquired more tone, more force, a different presence. In one
sense, their roads had diverged sharply. And yet, at the same time, their images
became mixed up, each borrowing some of the other's characteristics. This was the
direction taken by Giorgio Armani, influencing an entire decade and creating that
Armani woman who was not the man's other half but his antagonist, capable of reliev-
ing her rival of substantial chunks of his dominant position. The name coined for this
style was the "power look," accurately encapsulating the phenomenon of the career
woman, her aspiration to get to the top, the authoritative nature of her professional
choices.

The jacket was crucial for the new masculine look: by eliminating padding and empha-
sizing and altering proportions, it gave men a naturalness, a fluidity that belonged
more to the feminine realm than the masculine one. Redrawing the line of the female
figure and balancing the relationship between shoulders and hips brought out an ener-
gy and strength in women that were almost virile.

Redrawing the silhouette after the happy chaos of the hippie years and the spontane-
ity of the student protest movement was the goal of a generation of designers who were
making their debut on the fashion scene. For there were new designers, just as there
were new philosophers and the new novel: cultural categories that had as their com-
mon denominator creativity (now an end in itself), originality, the unprecedented and
the novel. It was amidst this ferment, in which the ground was being prepared for the
conservative revolution of Reagan and Thatcher, that the official world of fashion
regained its guiding role: no longer an applied art that sought to satisfy the desires of
the few, like high fashion, but design widely distributed, like prêt-à-porter when it first
made its appearance.

Sustained by the diffusion and ever-growing power of the media, fashion became an
art of appearances, with its rights and its duties celebrating the success and the social
status of the individual. This clear and unblemished image that it set out to present of
itself went hand in hand with the return of structure, with a precise design of the gar-
ment that led to the revealing of the body. A body emphasized, made heroic by the
thrust of high heels and the potent symmetry of the shoulders, which recalled forties
Hollywood (in the cartoon women and vamps of Thierry Mugler), as well as the purer
and more abstract concept of architecture (Claude Montana, Gianfranco Ferré).

Revealed by skintight clothing and leggings (Azzedine Alaïa, Gianni Versace), pro-
tected and covered up by the flowing looseness of dresses and cloaks that represented
the exact opposite of the European concept of style (Yohji Yamamoto, Rei Kawakubo),
transformed into a fantastic projection somewhere between sculpture and animal
(Cinzia Ruggeri, Krizia), exalted by lingerie – the solid and sturdy lingerie of the fifties
– worn on top of the clothes (Jean-Paul Gaultier, Dolce & Gabbana) and rendered poet-
ic by timeless garments (Romeo Gigli, Dries Van Noten), the female figure was
redesigned and reinvented.

It was an operation that had more to do with culture than with nature, unlike what
would happen in the late nineties, when fashion no longer focused on clothes but on

the body. A body slimmed down and tamed in the gym, the breasts reshaped with silicon and the belly flat, or the bottom rounded and the bust slight: from season to season, depending on which celebrity was taken as a model, the body changed. Clearly visible behind veils and transparences, illustrating a fashion of the body and not one of clothing, whose last frame of reference was located back in the eighties. Where the rigor of a structure that we might call architectural was tempered by the refinement of the fabrics and the softness of the material.

In the second half of the eighties men's fashion also emancipated itself for once and for all from the concept of the suit – pants plus jacket – to discover color, patterned shirts and vests, a fantasy that shook off formality and conventions by playing with models from outside Western culture. One example will serve for all: the Futurist-Maoist line of Thierry Mugler, which found its most convinced prophet in France's socialist minister of culture, Jack Lang, who went so far as to turn up at Cabinet meetings in a red jacket with a collar standing at attention.

In the landscape outlined by fashion, extending from France to Italy, from Japan to Belgium with the school of Antwerp and from the eccentric English to the unexpected Spanish, we saw the first hints of globalization emerge. It no longer mattered where you were, where your production was based, but whom you were aiming at and what you were offering, in a sort of aesthetic Esperanto that mixed everything up and assigned it new meaning, in accordance with those criteria of ingenuity, originality and creativity that were the powerful motors of the fashion system of those years. The watchword – for this fashion conceived, born and manufactured in a thousand different places – was "international." So there was an international style, an international woman, an international taste. Without rules, without borders, without complexes. Global was beautiful, in our still innocent eyes.

The Great Fashion Theater

Olivier Saillard

To the little theater of fashion, a traveling exhibition organized in the immediate post-world war period under the aegis of the Chambre Syndicale de la Couture Parisienne, the eighties responded with a grand theater of artifice with multiple aims. What the 1946 event presented in terms of miniatures – slender dolls dressed in exquisite designer clothes and *mises-en-situations* at the heart of picture postcard formats – seemed to have been afflicted with gigantism by a decade consecrating full powers to the fashion designer. Real models with heavy-duty makeup replaced the wire and finely modeled plaster masks of Elianne Bonnabel's mannequins. A splendid, spectacular wardrobe that periods of shortage could no longer prevent answered clothes cut to the dimensions of a handkerchief. Heavy curtains serving as a preamble to impressive fashion shows that were to become increasingly grandiose throughout the eighties, were pulled across the paintings of Jean Cocteau, Christian Bérard and Boris Kochno that decorated the sets. This silent troupe was to consolidate the dominant position of French haute couture in the eyes of the world. Furthermore, the discreet elegance of the forties designers, recognizable only by the labels differentiating them, was surpassed by the fashion creator who designed in a new language of bold strokes. Whether it was a vocabulary of forms, here broadened by tyrannical padding, there by an oversized neck, elsewhere by overblown volumes, or whether it be the mechanisms of advertising and distribution of fashion, we can now examine the eighties through the magnifying glass that succeeded in transforming the framework of a system into entertainment at risk of alienating its public.

New publications appeared, adding to the mass of fashion magazines that then coexisted, such as *Elle*, *Marie Claire*, *Jardin des Modes*, *Dépêche Mode* and *Glamour* in France, the Condé-Nast group of titles including *Vogue*, *i-D* in Britain, *Details* in the United States and *Hi Fashion*

in Japan. Sometimes they were destined to be short-lived, as was the case for *City* or *Façade*, or sometimes better ensconced, as in the case of *Interview*. Their task was to depict, beyond fashion, a certain idea of fashionable society through a gallery of portraits of its representatives, even if they looked that way only for a single evening. From capital to capital, from boutique to discotheque and from *vernissage* to private *soirée*, the diary of the perfect *mondaine* seemed to unfold before the reader's eyes. The end of writing in the fashion scene was also marked by the supremacy of the photographic and purely media-conscious angle reporting events. Henceforth, there would be room only for visionary editors, and very little for incisive pens . . . Of all the publications in this field, *L'Egoïste* and *La Mode en Peinture* stand out for a definitively aesthetic stance that was symptomatic of a period that clung to producing sleek packaging. In black and white, with its disturbing format and improbable texts, the first of the two managed to ban the all-pervasive artifice and perpetuate a style coarsened by the vulgar attributes of the "chic and showy" decade. For all that, it remained a magazine of photos. The second title, although less influential and authoritative, proposed a plastic vision of fashion through the illustrators it invited, who were enjoying a period of renewed interest. Despite being extremely short-lived, *La Mode en Peinture* imposed itself as the gilt-edged, pompous frame of a discipline that the following decades would dislodge from its position in the hierarchy of major or minor arts without, however, bringing forth any convincing replacements. Illustrated dress by illustrated dress, the magazine crystallized all the excesses of a creation, the illustration of which seemed to stress the impossibility of its being used in everyday life and prefigure its future fate on the walls of galleries.

Once upon a time, when *Vogue* magazine was still a point of reference, and mixed photographs and fashion sketches with method, one would have found in the French August 1930 edition a spirited series of maps in the form of simplified plans of the buildings, squares and roads of each fashion capital. The typography of the sites poetically blended the reality of the locations and fiction, the exactitude of a town plan and creative itineraries, the whole dotted with the doubts and digressions that each *couturier* met along the way. Barring a few details, the drawing with its fine, pure lines could very easily have appeared in the pages of *La Mode en Peinture*, so similar were the uses of urban space in the eighties. An imposing road with the soothing name of "great street of good taste" divided an uncrossable, hostile area filled with precipices, "swamps of ugliness," "cemeteries of dead ideas," and "crossroads of indecision" from a more welcoming one. This last had a miniature "village of *couturiers*," a "rose garden of makeup," a "castle of etiquette," a "river of distinction" . . . Although the adjectives have changed, the geography conforms to that of the eighties. We can read in them the Faubourg Saint-Honoré in Paris greeting the Place des Victoires with new ideas, or Via dei Condotti in Rome or Fifth Avenue in New York.

Three decades later, a talented illustrator could have adopted the thirties drawing, and added the caricatures of each of the figures that were to animate what would soon be called a fashion tribe to this puppet theater, which seems to spring to life on the double-page spread. It goes without saying that the creators-sorcerers would have found their place in this cartoon as they readied themselves to become veritable pictograms. A fringe of black hair in the style of Louise Brookes is enough to identify Chantal Thomass, a kilt and sailor shirt for Jean-Paul Gaultier, a mop of red hair would set the scene for Rykiel fashion, while Anne-Marie Beretta would han-

dle the creation of a plait of hair ending in a brush. Elsewhere, a ribbon barely emerging from a fan would leave no doubt as to its owner. The Chinese costume of Azzedine Alaïa would hold the chair at the university of the science of fashion under the tender gaze of a Madame Grès in a twisted turban. In the margin, the clown, Popy Moreni, would scatter her ruffled collars, before which Moschino would project his slide show of the history of fashion. These creators could not have remained anonymously outside the frame. If their elders were conspicuous by their absence in the 1930 sketch by Я. de Laverie, their worldly recognition still impossible because of their status as suppliers, the creators of the eighties filled the media stage, whose borders went well beyond the fashion catwalk. Ever since Yves Saint-Laurent had the audacity in 1972 to appear naked to embody his eponymous scent, the designer has entered the era of the image, leaving behind the archetype of a creator in a white shirt, with pins stuck in his cuffs. At times, he had to become his own advertising medium with a striking but stable look in the eyes of the public. He was his own creation, since he had to be the vehicle of his own creations within an ambiguous, televisual system in which legislation as yet forbade the showing of commercial brands.

Coveted, invited, adulated, consumed and sometimes rejected, the creator-product tapped into every trend. Beyond his physical appearance, which authenticated the creation as a brand or logo, his organization of a fashion show, its mise-en-scène, his planning of a collection and its distribution helped to build ever-higher catwalks.

The eye of the journalist or buyer was itself extremely different. Until the fifties, before the birth of prêt-à-porter, the presentation of a collection would take place in the fashion house before a floor of buyers first, and journalists afterwards. Among the gilt chairs dotted here and there, at the foot of the stairs, around the edge of a *salon*, the models would make their way amid a silence that would today seem solemn. The potential customer and the model would be very close. Sometimes the former would feel free to touch the fabric of a dress to ascertain its quality, without provoking the slightest indignation.

In the sixties, the "Courrèges bomb" would explode, both at a level of the fashion revolution imposed by the designer, who razed the past, and at that of the means used to present his collections. André Courrèges shortened the duration of the fashion show, introduced pop music and required his models to move naturally through a space that was sometimes transformed into a dance floor. Where once eyes dropped to watch, now they had to lift to see the show. The designer laid the foundations for putting the show into the fashion show. All emerging prêt-à-porter designers saw this method of presentation as a perfect vehicle for presenting fashion targeted at the daughters of the haute-couture customers, who were diminishing in number.

The street at this point seemed to take over the catwalk. Kenzo had fun, threw parties; people ran, laughed. The catwalk, perhaps a little perplexed, acknowledged this new form. Building on these changes, the eighties redoubled the insistence on excess and theatricality. They borrowed from opera and classical theater the dépassés gestures of a form of drama that was becoming pastiche just at the time that street arts were pushing new frontiers forward. Faithful to the universe of the commedia dell'arte, Italian creator Popy Moreni would claim that there could be no fashion show without stage curtains. In black or red velvet, in cotton or plastic, these would be a constant feature in her shows; likewise the use of a blackout to accentuate a sense of surprise and wonder.

Thierry Mugler, designer and former dancer at the Яhine Opéra, was one of those for whom, clearly, the vocabulary of the fashion show could be subjected to every sort of emphasis. The models had to embody the dress that was carefully chosen for them. Λ succession of tableaux vivants were created, in which they appeared as goddesses, queens at a witches' gathering or heroines straight out of a Hollywood film. This sort of superproduction culminated in 1984 with Thierry Mugler's anniversary show, celebrating ten years of collections. The fashion super-show, open to the public with a paid ticket just like a rock concert, was held at the Zénith in the presence of almost six thousand dumbfounded onlookers.

On top of the astounding décors from an apocalyptic world, the casting affecting all the fashion shows of the period surprises us today. In groups of ten or twenty, the models would roll on to the stage, creating a particularly *recherché* scenic effect; to such an extent, indeed, that often the dress was not accorded the attention intended. The re-appearance of the same garment, sometimes in different colors and in numerous groups, would remain typical features of fashion shows in the decade.

The gestures and slow gait of the models was equally astonishing. With Claude Montana's shows, they took on an air of ritual. The designer went so far as to tell each of the models the poses and turns they were to make in order to effect the apotheosis at the end of the catwalk. The jubilant crowds learned to applaud as each model passed. There was no talk as yet of top models, but the first names of those who added spice to shows were already being bandied about. Pat Cleveland spun on her heel, Inès de la Fressange gamboled, the successors to Jerphanion or Violetta Sanchez!

Installed beneath the ephemeral tents in the courtyard of the Louvre in Paris, the great fashion circus prepared to invest in other locations in a search for an accelerated striving for uniqueness and singularity that would characterize the subsequent decades. Jean-Paul Gaultier confirmed the trend by taking his collection to the Cirque d'Hiver, the Salle Wagram and, above all, to the Grande Halle at La Villette. With him, the decision to opt for large spaces was not in response to a desire for theatricality, as with Mugler or Montana. Instead, it enabled a greater openness to a hybrid fashion that fed from other, perhaps less princely sources, but certainly more contemporary ones. For the *Cyrillic* collection of fall/winter 1986-1987, the curtain rose on scaffolding serving as the stage for the models, most of whom had never set foot on a catwalk before. Λtypical figures and unusual models formed the cast of a house opening up to the perspectives of the eighties. Jean-Paul Gaultier destroyed the sacred aura while introducing new expressions to the fashion show. The invitation sent to the actress, Sylvie Joly, falls within this scope. In the presentation of *Le charme coincé de la bourgeoisie* collection for fall/winter 1985-1986, which could be worn normally or backwards, Sylvie Joly became the protagonist of a reversible life that only fashion could boast.

Indeed, irreversibility is not the principle attribute of fashion. Λn example that illustrates the contrary: while Mugler and Montana rivaled each other with the bold and sensational, Λzzedine Λlaïa and Marc Λudibet concentrated all their attention on authentic garments with no stage set to get in the way. The arrival of Japanese designers such Yohji Yamamoto or Яei Kawakubo for Comme des Garçons, appeared as a strong counterpoint. Their fashion shows served as makeup remover on the caked-up skin of the past. However, the conceptual fashion they created, sustained by the founding of boutiques in which clothes were absent, was to

maintain a strong sense of intimidation with regard to the general public, and so created a limbo inhabited only by initiates.

Whereas all human presence, including designers and public, was effaced from thirties design, the prophetic vision of fashion museums was already sketched out. To this end, the road was opened by an opulent building flying a friendly flag. Although to the thirties illustrator, this could only be a whim, as no fashion museums yet existed, by the eighties all, or many, had come to light: in Paris, the Musée des Arts de la Mode, later renamed the Musée de la Mode et du Textile, inaugurated by ministerial decree within the buildings of the Louvre, and the Musée de la Mode et du Costume at Palais Galliera; in New York, the Costume Institute at the Metropolitan Museum of Art and the Fashion Institute of Technology; in Kyoto, the Kyoto Costume Institute; in London, the costume department at the Victoria and Albert Museum . . . Official recognition of fashion, witnessed by the accelerating creation of museums dedicated to the subject, arrived via the organization of large retrospective exhibitions, including that dedicated to Yves Saint-Laurent by Diana Vreeland at the Metropolitan Museum and around the world; this one show acted as a beacon for the entire decade. The new existence of "static" costume dialogued with the terms typical of theater. It was only at the end of the eighties and in the nineties that a vocabulary shared with that of plastic installation would evolve under the influence of Issey Miyake, and then of Martin Margiela.

Although the last decade of the twentieth century would appear as a blank page in the history of fashion, marked by a minimalism that spread through all the sectors of creativity, the eighties succeeded in holding high the banner of baroque they had made their own.

For fall/winter 1987 and for Chanel, Karl Lagerfeld created a red and gold bustier-dress directly inspired by the curtain-raising that one sees at the Paris Opéra. Worn by Inès de la Fressange, it was the image of a decade that ended with other paradoxes. Independently of the decreasing number of customers, haute couture, which was absent in creative terms at the beginning of the eighties, returned to its former position. Karl Lagerfeld at Chanel and Christian Lacroix at Patou and subsequently on his own from 1987, swept in a couture spirit at a time when creative prêt-à-porter was itself becoming unwearable for most potential customers. Historic references, close-fitting suits, cocktail dresses and evening dresses all recreated a wardrobe torn between novelty and classicism.

In 1980, Madame Grès, in 1947 already present under the name of Alix in the little theater of fashion, agreed to design the prêt-à-porter collection she had refused until then to countenance. It remained faithful to the sartorial desires of the lady with the turban and laid out with increased rigor the crêpe drapes and folds skillfully developed by the *couturière*. On the advertisements accompanying this new direction, Madame Grès wrote in her own hand: "I have not descended to the road; I have risen to it!" With the second-hand quotations of the eighties over, we are convinced that this work, a pure moment of grace in a flashy decade, will be a source of quotations and a reference point for designers to come.

BEHIИD-THE-SCEИES ЯECOLLECTIOИS

\
\

Iиgяid Sischy

Magazines are objects like no other. Whether they have a short life or a long one they can end up in anyone's hands and be agents of consciousness and of change. That's why I go to work every day – to send those messages in a bottle, as it were. Dig up the right old magazine and it'll be as illuminating as an archaeological treasure – you'll be holding an artifact that can tell you the kinds of things about a given period that might not make it into official history. Whenever I want to know if there has been a shift in perspective and in collective consciousness, I pull out old magazines and peruse not just the editorial content, but the advertisements, too. I think of these old issues as snapshots of culture as it once was.

One such time machine is the February 1982 issue of *Artforum* magazine. I was the editor of *Artforum* through most of the eighties, and over the course of the decade we experimented often, but this is the issue that people seem to return to over and over again. Maybe because it broke a taboo. This was the first time a piece of contemporary fashion – a rattan and bamboo bodice and nylon polyester skirt by Issey Miyake from his 1982 spring/summer collection, produced with the collaboration of the bamboo artist Kosuge Shochikudo – landed on the cover of an art magazine. It's an understatement to say it was a scandal to spotlight fashion by featuring it so prominently in an art context back then. But the reaction we got was telling, too, with some in the art world applauding the move, especially artists, and others claiming this development represented the end of civilization. Иowadays one might flip through an art magazine and come across interviews with designers, or ads for Prada, Helmut Lang, Gucci, and others – in fact, nowadays fashion and its systems have become a bona fide subject for

art – but in the early eighties the predominant view was still that fashion was the enemy of art, and should have nothing to do with it, a notion that had prevailed for much of the twentieth century, notwithstanding the Futurists, Constructionists, and the Bauhaus. Only recently has that Hegelian view of fashion and art become obsolete.

The inclusion of fashion wasn't the only transgression of that 1982 issue of *Artforum*. There were articles on comics, advertising, political posters and news photography. There was a pullout designed by Andy Warhol, which featured his now famous paintings of dollar bills, as well as Christopher Makos' now well-known portraits of Andy in drag. The magazine also explored the then budding relationship between pop music and performance art; it contained a flexi-disc record by Laurie Anderson, which went on to become a significant hit. I hadn't been the editor for long when we produced this issue, but I was chafing at the bit to do it, because it was on a subject that has always interested me: the gamut of visual languages that are often treated as the second-class citizens of art. I had always wanted to pick up the gauntlet thrown down by Duchamp when he shocked the world with his ready-mades and showed that one man's bicycle wheel is another man's art. I wanted to devote an issue to the many visual forms – such as comics, advertising, news photography – which are intrinsic to contemporary visual culture, but which exist outside the pearly gates of art.

Our goal with this particular issue was not to elevate all these other mediums so that they, too, could sit on art's pedestal. We weren't trying to say that fashion or news photography or advertising should be thought of as art. Indeed part of their chemistry is that they are *not* art! And we weren't making a metaphor for contemporary art – in other words we weren't making the case that art has become like fashion. I, for one, believe that they are two very different genres – that's what makes them so interesting to each other, and to us. But we were saying that each of these other means of visual communication has its own systems and language, and each has an enormous impact on mass culture, popular culture, and even high culture – and vice versa. A number of years later the Museum of Modern Art in New York organized its high/low exhibition, which explored some of the same territory, but in a much more sterilized and academic way.

It's hard to say if we would have landed on fashion with such a bang with that 1982 issue of *Artforum* if it hadn't been for Issey Miyake's remarkable collection for that season. For our cover we chose a piece that looked to us as if it was part samurai armor, part iron butterfly, part pioneer woman and part space invader. To us it was a "modern convergence of signs," and therefore the right emblem for our special issue. Because Miyake and his Japanese colleagues Rei Kawakubo and Yohji Yamamoto were basically deconstructing fashion at the time, it seemed to us that what they were doing had enormous, obvious pertinence to anyone who was interested in the visual world and in issues of identity and the figure. But still, having said all that, we did not choose Miyake's work lightly. We looked at it, debated it, and really struggled with the question of whether it was right to put a fashion designer's work on the cover of an art magazine. We talked a lot about what was going on then in art, especially the recycling of earlier historical styles that was such a theme at the time, and about how all

this had a kind of parallel in fashion. Λfter we had convinced ourselves that fashion was the proper vehicle for the journey we wanted to take the reader on with the February 1982 issue of *Artforum*, I sat up all night with Germano Celant, who was a contributing editor of the magazine with whom I worked closely, and we co-wrote our editorial. Ultimately the thing that made the cover controversial and reverberate through the culture, as well as be a turn-on for certain artists, was the fact that we put *that* season's fashion on the cover. It would not have been nearly such a big deal had we simply put a historical piece of clothing or a fashion photograph on the cover. While photography may not have had an easy road as a medium that deserves to be looked at in the same galleries that exhibit painting, drawing and sculpture – fashion hadn't even been part of the conversation. We thought it was time that changed. Λ footnote to this recollection is that soon after our issue came out, Issey Miyake's clothes became the uniform of choice for the art world for exhibition openings and other important events. In the last few years many of them have since moved on to other designers. Hey, it's fashion, not art!

Style and Business

\
\

Minnie Gastel

Those of use who lived through the eighties and wrote about them as insiders have conflicting memories. It's hard to feel regret for the social climbing and brazen careerism of the decade, with hedonism elevated to a way of life, the "retour à l'ordre" and the new espousal of petit-bourgeois values that gained ground after the revolutionary and transgressive impulses of the seventies. But it's equally impossible for those who experienced the excitement of certain fashion shows and knew the quality of so many of its leading figures – designers, industrialists – to forget the ferment of that period, the desire and capacity for action, all convinced that – before the conquest of markets – what counted was to design and produce just one thing as best they could: fashion.

The early eighties was characterized by a process very similar to the one that, twenty years earlier in the sixties, led to the birth and development of Italian design. At that time, on the wave of the economic and industrial boom, the collaboration between a generation of architects – Achille Castiglioni, Enzo Mari, Ettore Sottsass – and enlightened furniture-makers – Cassina, Gavina, Busnelli – produced a new domestic decor, powerful and refined, that was exported worldwide. In the eighties, the synergy between those who had shortly before begun to call themselves designers and textile and garment manufacturers who felt the need for innovation, gave rise – within a few years and on a far greater scale – to all things later covered by the label "made in Italy."

Not that everything began then, out of nothing. The eighties gave the major impulse and consolidated a phenomenon whose origins went back a few years. Take 1978, a golden year for Italian style, given that Gianfranco Ferré and Gianni Versace produced their first collections. For Giorgio Armani, who was a few years older, his big break came that year,

as well. Marco Яivetti, then at the head of one of the most important Italian garment man-
ufacturers, GFT (Gruppo Finanziario Tessile), wanted to cut a deal with him. Armani was
on the crest of the wave: in 1976, with Sergio Galeotti, he had founded the Giorgio Armani
company after the big success of his first women's collection the year before. He had the
wind in his sails, but without any proper business structure he couldn't keep up with
orders. "A phone call came from Milan telling us about a young designer in trouble
because he was expanding too fast," recalls Carlo Яivetti, at the time assistant marketing
manager of the family firm, now president of the Sportswear Company) and Marco
Яivetti's's cousin. "Marco, who was running the women's fashion division, had an historic
line, Cori, then in deep trouble. His uncle's orders were clear: either find a way to solve
the problems or close it down." Иegotiations with Galeotti were long, but they produced
an unprecedented deal: GFT would produce the prêt-à-porter line with the Giorgio
Armani *griffe*, which was to remain the property of the Giorgio Armani firm. It was a high-
ly advantageous agreement for the designer, who was not required to break off his con-
sultancy deals with other firms, while the Giorgio Armani firm continued to control the
design of the products licensed out. GFT, for its part, was able to draw freely on certain
techniques devised by Armani and apply them to all its product lines, which, driven by its
top collection, would also benefit by a far more chic image. "Marco's extraordinary insight
was that you could make style industrial," notes Carlo Яivetti. "But at the start the change
was disruptive because GFT found itself having suddenly to excel not only at its tradi-
tional strong points – repetitive production, the wearability of its models – but also at tech-
niques it had never attempted before."
In the early eighties the company's strategy was fundamental for the designer's growth.
Carlo Яivetti's words take us back to the excitement at Armani's international debut: "We
went to Иew York. Saks Fifth Avenue bought the Armani collection, put it on the floor,
and the product became the store's bestseller. The same thing happened the next year.
Armani was invited to do a 'trunk show,' one of those traveling fashion shows in depart-
ment stores that enable you to meet the customers directly. There were four hundred seats
and four thousand people turned up. For the American newspapers, Giorgio Armani was
'the master of the sophisticated cross-fertilization between male and female fashion, able
to feminize the severely tailored blazer for the new woman who worked, and develop a
more understated jacket for the younger, less traditional executive.'" In 1982, *Time* put
him on its cover.
In the early eighties, the relationship between industry and designers, established a few
years earlier, was fully consolidated. A particularly emblematic example of this Italian
phenomenon was that of Franco Mattioli and Gianfranco Ferré. The relationship between
the two figures perfectly sums up the whole history of the unrepeatable alchemy between
the business flair of a certain advanced and dynamic Italian region, and the solitary genius
of the great modern designer. The two met in the late seventies. Franco Mattioli was from
Bologna, very ambitious, a sometime delivery boy and sometime textile salesman who
had set up a small garment firm and was aiming high. He wanted to relaunch his Baila
line, which was losing out because he had another line, called Dei Mattioli, which was too
similar and its prices too low. Ferré was an architect who had already begun working in

fashion. He accepted the collaboration. He liked Mattioli and it was a challenge. He was given *carte blanche*: Mattioli didn't see the collection until it was finished. He organized a show in a Milan *crêperie* and it was a great success. "It was the collection I'd dreamed of producing all my life," recalled Mattioli in Edgarda Ferri's book *Ferré*. "Those clean lines, those colors, that fluidity. And then its look: decisive, powerful, capable of creating an atmosphere, enchanting." But the collection failed to sell. It was too avant-garde, they said. Mattioli refused to give up. In 1978 the businessman and the designer became fifty-fifty partners and Gianfranco Ferré's first prêt-à-porter collection was presented at the Principe & Savoia Hotel in Milan. It was an immense success. The handmade buttons and buttonholes, the hems whipstitched by seamstresses, whom Mattioli got to finish the items to be sent across the Atlantic, bewitched the Americans, who loved the show. The first Ferré boutique in Milan's via della Spiga opened in 1981; and within ten years the exclusive Ferré shops worldwide grew to over a hundred. Mattioli and Ferré were among the first to run them directly. In the meantime the ultimate consecration arrived for Ferré and also for Mattioli: in 1986 the designer presented his first, very beautiful haute couture collection in Яome, and in 1989 he was invited to become art director of Maison Dior. After the press conference, the partners were sitting on the terrace of the Hotel Crillon. Mattioli remembers: "A crush we'd never experienced before. All the newspapers, all the TV stations. In the evening, when we met up again, I was there with Ferré and his cousin Яita, we three alone on that extraordinary terrace, by then deserted, with Paris out there at our feet. We looked each other in the eye and, astonished, moved, asked each other: 'But did you expect all that?'"

Different, but equally successful in producing a kind of fashion that was more realistic and genuine, compared with French couture and London provocations, was the Max Mara model. Max Mara was the first Italian garment manufacturer to become part of the prêt-à-porter industry and to choose to keep control of its design by promoting its own brands. Based in Яeggio Emilia, it had a very close rapport with its designers – from Luciano Soprani to Guy Paulin, Jean-Charles de Castelbajac and Anne-Marie Beretta (who is still on their staff) – with its roots in the culture of tailoring and the family history, but also representing a distinctly Italian quality. Luigi Maramotti, president of Max Mara, recounts, "We really did work together: we started from the fabrics, the lengths of cloth, from what we heard through the grapevine. The start of a creative process is always abstract; it's never connected with precise marketing decisions. We try and imagine what people want and translate it into sketches, ideas. But there's never anything contractually predetermined." In the eighties the firm extended its approach to the students of two of the most renowned English fashion schools, the Яoyal College of Arts and Kingstone College, developing a kind of tutorship for the most gifted students and receiving in exchange ideas and valuable pointers for a more sophisticated and international vision.

In 1980 another family business (the textile and garment industry numbers a lot of dynasties) made the big leap forward. This was the Aeffe firm run by the Ferretti family in Cattolica. Alberta, who had some boutiques in her hometown, presented her collection in Milan for the first time in 1981. The Ferretti family decided that they had a small firm but a lot of know-how; it could be made available to other designers. They got their first break

by producing a line for Enrico Coveri. Then came Moschino. "It was 1983. I met Franco Moschino, who was then designing Cadette, in a small office he had on via Santo Spirito in Milan," recalls Massimo Ferretti, now the firm's managing director. "He talked about the collection he was working on, a collection with few models, few fabrics and few colors, which would then become quite different, rich and deliberately excessive. Franco looked smart; you at once got the impression of a person who had a lot to say. I liked the project and we began working together. He still wasn't a big name. We wanted to offer our clients collections that were each individually different." Moschino was the first success, and then came Яifat Ozbek, Jean-Paul Gaultier (whom they still produce) and Иarciso Яodriguez. "Λeffe was structured in 'islands,'" says Ferretti. "In this way each designer could count on a fully available, exclusive staff. Because you have to create a harmony with the designers, share a kind of complicity with them, have the same kind of feeling. This is the only way to interpret their designs to the best effect. Λnd we Italians are first rate at this."

Someone else who excelled at this was Donatella Girombelli, who commissioned Gianni Versace to design Genny, and was flanked for many years by the French designer Claude Montana in designing the strong style of her other line, Complice. Montana's first work was produced (along with the first Jean-Paul Gaultier collection) by another Italian firm, Gibò, which focused on emerging talents (and still does).

In the later eighties, the extraordinary and highly successful partnership between businessmen and designers gave rise to the phenomenal success of the *griffe*. Groomed, followed step-by-step by the mother-firm, the designers – it's astonishing to think that just ten years before theirs was an almost unknown profession – became stars who attracted TV audiences like Hollywood stars. The big museums and the international institutions hosted their fashion shows (the first was Valentino, at the time produced by GFT, at the Metropolitan Museum in Иew York) and dedicated sumptuous, highly fashionable exhibitions to their garments. They put their names on everything: perfumes, glassware, tiles, sheets, desk diaries and armchairs, and raked in millions in royalties through licensing contracts. Even Marzotto, the world leader in men's clothing, who had always promoted its own brand names, signed the first agreement with a famous designer, in this case Missoni, for a line of men's and women's garments. Иewcomers in this period, skilled at catching the wave even when they were playing at home (as the owners of the manufacturing company), were Mariella Burani with her collections of luxury fabrics, Иicola Trussardi with his greyhound printed on everything, Gimmo Etro, from great textile-maker to prêt-à-porter designer, and Λnna Molinari with her hyper-feminine Blumarine line.

The end of the decade saw designers and firms engaged – still in partnership – on the fronts of distribution and marketing, intent on promoting and multiplying single-brand stores worldwide to better monitor the increasingly difficult tastes of consumers and fostering brand image through advertising campaigns entrusted to famous photographers. Fashion, a sixty-billion-lire business, was in these years the second largest contributor to Italy's economy, with profits of twelve thousand billion lire, and it employed 840,000 people. It was truly the age, as Gillo Dorfles wrote, of "the fashion of fashion."

UOMO80
In the Name of Fashion

\
 \

Stefano Tonchi

Andy Warhol in tuxedo and jeans. Franco Moschino wearing a necktie under his black leather biker jacket. Giorgio Armani with a hooded sweatshirt under a Prince-of-Wales-check jacket. Ray Petri in military bomber jacket and pinstriped pants.

These are all images from the eighties. And each of those images, in its own way, dialectically juxtaposes the two terms that have defined and still define male fashion, its birth and its evolution: sartorial tradition and sportswear.

Even today designers from Dolce & Gabbana to Tom Ford and from Hedi Slimane to Martin Margiela still express their vision of the male by seeking a synthesis of tradition and innovation, in some way chasing after that magical balance that made the eighties the starting point of men's fashion as a mass phenomenon.

Not that tailors and dandies hadn't been launching fashions and trends since as far back as the end of the eighteenth century, when, following the bourgeois revolution, most men rejected color and decoration. But these were elitist fashions, marginal variations. The vast majority continued to wear the male uniform *par excellence*: dark suit, jacket and pants, coupled with shirt and tie. The classic suit. And what is classic by definition is not fashion.

On the contrary, sportswear, an expression that covers everything in the male wardrobe that is not a suit or formalwear, has had a much more varied and radical evolution, closely related to changes in civil society, but without ever turning into true fashion—even when, in the sixties and the seventies, men dressed exclusively in sportswear. In fact, no one would have thought of following fashion by donning a parka, a pair of jeans or a tracksuit.

Up until the seventies, the tailored suit and sportswear remained separate categories for the ordinary man: one for formal occasions and work, the other for leisure and sports. By this time the tailored suit had been standardized in a mediocre line of mass-produced garments, its consumers growing older and older. Sportswear, on the other hand, was the area of experimentation with forms and technology, a new way of dressing with a return to a marked preference for color and for more extreme materials—from rubber-soled sneakers to jackets made of artificial leather—that became increasingly common among the young.

Even before the emergence of the designers, SEHM in Paris and Pitti Uomo in Florence had begun to propose new solutions, following the radical changes that had taken place in women's clothing, when couture was eclipsed by prêt-à-porter. It is no accident that the first official men's fashion show in Italy, held at Palazzo Pitti in 1969, was born out of the need to dress men to accompany the female models on the catwalk. And so Brioni and the other tailors presented their luxury sportswear, and Missoni caused a sensation with their stunning colorful men's knitwear.

From Europe to America a new middle class was emerging, a generation of men who wanted to dress elegantly, showing off their wealth and power, but without going back to the tradition of elegance and elitism of their fathers. The new man rejected the uniformity of the dark suit, and challenged the lack of color, decoration and display of luxury as a useful symbol of his status. He rediscovered the value of the body, the pleasure of the physical form, (cultivated by practicing sports and working out at the gym), as well as an awareness of his own sexuality after the advent of feminism and the liberation of homosexuals. Above all, he asserted his right to wear comfortable clothes, denied him by the sartorial tradition of the past.

In 1978 a group of designers, including Giorgio Armani and Gianni Versace, decided to show in Milan, while in the same year Daniel Hetcher founded the Men's Fashion Designer's Club in Paris. Freed from the rules and limits imposed by industrial production, these designers personally took on the task of responding to the demand for a comfortable and nontraditional elegance, colorful and imaginative, sophisticated in its materials and details. In the end, it was something not so different from what women wanted. It was the birth of men's prêt-à-porter.

The eighties took what has been defined as "the quiet revolution" to the masses. The commercial success of sportswear, the emphasis on comfort and naturalness, wrote the obituary of tailoring. The proportions and volumes that had characterized men's clothing for decades changed radically, and the new look was to reign supreme until the counterrevolution of the second half of the eighties. The new figure had two focal points: the pleated pants, wide in the leg and narrow at the ankle, and the jacket, without a definite waistline and with unpadded shoulders.

The tailored pants and jeans of the seventies, narrow at the hips, close-fitting in the leg and more or less wide at the ankle, were replaced by their opposite. An extremely comfortable pair of pants, in which the pleats were multiplied from two to four or six, (straight or inverted depending on the talent of the designer), and generous in the leg but narrow at the ankle, an effect accentuated by the cuff. Almost a transposition of

plush tracksuit bottoms into cloth. The more avant-garde designers like Gian Marco Venturi and Yohji Yamamoto even went so far as to propose Turkish pants. Gianni Versace made pants the fulcrum of his stylistic research, playing with proportions: from riding pants to the type worn by courtiers in the past, with infinite variations on the more classical multi-pleated pants. But he kept them all sexy around the pelvis, thanks to a high band that emphasized the waistline. Even jeans, the most utilitarian of pants, underwent a thousand mutations, especially in the hands of Marithé and François Girbaud, who, in the name of comfort and design, invaded the world of jeans with geometric cuts and exaggerated proportions under their label Closed.

The cult of the athletic body that spread from America to the rest of the world and the demand for comfort brought the era of sartorial disquisitions about the relative merits of the English or Neapolitan shoulder to a close, and created the iconography of the loose and flowing jacket. Not just on the catwalks, but in the streets of all the world's cities, the male figure changed its shape. The new jacket had a relaxed feel, with rounded shoulders, ample and lower armholes, and buttons (or often just one button) under the waistline to close long, broad lapels. The jacket was short and without vents, the coat long and shapeless: it was the translation of the new post-seventies way of life into the form of clothing: more comfortable, relaxed and informal. It was the triumph of the hooded parka, the geometric sailor's pea coat, the raincoat with a gigantic collar, the sheepskin jacket turned inside out, the enormous duffle coat, the maxi quilted jacket. Above all it was the apotheosis of the leather jacket, of the *blouson* in a thousand different combinations of color and fabric, but always with exaggerated proportions: the biker's Perfecto jacket of *Terminator*, the flight jacket of *Top Gun*, the Buffalo nylon bomber jacket, the zipped jacket worn by the punks in *Rumble Fish*.

But just when the suit seemed destined for extinction, Italian designers invented the concept of the "soft suit," in which the form and the material were perfectly integrated to clothe the muscular body of the new man.

The other focal point of the "quiet revolution," which often passed unobserved under the lights of the catwalk, was the change that took place in the world of fabrics. The Italian manufacturing industry was its protagonist and whoever worked on the idea of the loose and flowing garment was obliged to acknowledge the fact. In these years the industrial center of Prato, utilizing recycled wool mixed with new synthetic fibers, supplied fabrics whose price and characteristics revolutionized the market for menswear. Biella and Como would soon extend their use to the upper end of the market. As result of experimentation and research, "light and comfortable" were no longer terms incompatible with "elegant and sophisticated." And the versatility of this system permitted the industrial cycle to multiply patterns, colors and mixes ad infinitum, offering men the same variety and speed that had hitherto been the exclusive prerogative of the market for women's fashion.

More than anyone else, it was Giorgio Armani who grasped these possibilities and exploited them to the full. Armani showed his first collection in 1975, after working for a short time with Nino Cerruti. His interest in sportswear and secondhand military clothing immediately demonstrated his awareness of the importance of the body and

of the changes that contemporary man was going through. Right from the start he celebrated the new, sporty and muscular image of the body and pandered to its needs, revealing it instead of imposing a structure on it. Comfort and lightness, key concepts of the contemporary world, were achieved through the elimination of all padding and completely unprecedented research into the structure and surface of fabrics. Armani did not just work on patterns, magnifying or blurring checks, and on colors, creating tone on tone combinations with unusual shades like violet, pink and ocher, but considered the feel of the fabric, its capacity to follow the lines of the body with the softness of new structures and mixtures of fibers. His choice of typically feminine fabrics like crêpe for men's clothing was revolutionary, as was, later on, his use of patterns and structures characteristic of men's fabrics for women, translating into fashion the interchangeability of male and female roles that was the new social diktat of the eighties. Basile, Valentino, Gianni Versace, Gianfranco Ferré and the whole of the male fashion industry followed his example and carried on with the experimentation. For an entire generation this comfortable, moderately deconstructed style, based on fabrics of quality but with a worn, if not downright crumpled look (a time when linen took over the male wardrobe for the summer), became the uniform of the successful man: the double-breasted suit, its jacket with low buttoning and elongated lapels and its pants loose and relaxed. The *American Gigolo* look – an expression of a break with the past and of the explosive sexuality of the late seventies – gave way to a new formal elegance, completely different from that of the old establishment.

From Giorgio Armani to Jean-Paul Gaultier and from Gianni Versace to Yohji Yamamoto, the theme of the oversize garment was constant, all the way through the eighties. Not only because it satisfied the desire for comfort expressed in sportswear, but also because it responded to a precise social change. The generation that emerged from the protests and rebellions of the sixties and seventies had developed a revolutionary taste for the outsized, through dressing in secondhand clothes. Men and women, driven by necessity but often by a desire for aesthetic transgression as well, had for years pillaged the flea markets in search of original garments coming from Far Eastern countries or American army surplus stores or, more simply, dug out of the attic. For this generation, even Armani's loose and modest jacket could seem too flashy, close-fitting, conventional. Hence the popularity of the oversize clothing of Japanese designers as the minimalist uniform of the new post-seventies intelligentsia. And vice versa, as if to contradict the course of history, there also came the success of the superstructured oversize garments of designers like Thierry Mugler and Claude Montana, who broadened the shoulders, reshaping the thorax in the form of an inverted triangle, with short jackets known as spencers worn over tapering pants, with clean and geometric lines. The avant-garde went back to playing with tradition, taking its canons to extremes: if the shoulders were to be padded, then they had to be padded to excess, stuffed, gigantic, oversize; if the pants were not going to be wide, then they had to be really narrow, like stockings.

The balance between the taste for exaggeration and excess and, on the contrary, the desire for measure and tradition swung schizophrenically back and forth throughout

the eighties. This was reflected in the contradictory attitude of designers and the industry toward color, decoration and the flaunting of luxury. After centuries of black uniforms, if we exclude the rare exceptions of dandies clothed by English or Italian tailors, color burst back onto the scene with sportswear and in the youth market. Missoni was the first to grow beyond that, bringing color first to leisure and then to work. Their knitwear, to which the jackets produced by Marzotto were added in 1985, was also a perfect response to the demand for an elegant but understated casual wear, being almost folk in its patterns, sophisticated in its materials, but never flamboyant. Perfect for the post-'68 man, well-off but no traditionalist: for him luxury had to be expressed through the quality of the materials, the comfort of the cut and accessories that took on increasing importance. At the beginning of the decade luxury was almost something to be concealed: as Armani did, dyeing the most expensive cashmere and camelhair fabrics an ordinary blue color for his coats; or as did Ferré, embroidering tuxedo shirts in white on white. Over time, however, the opulence of the decorations and the ostentation of luxury grew more and more evident and less and less embarrassing: fur linings, dyed sheepskin and fine leather were no longer attributes of clothing for eccentric dandies, but a common sight in the windows of boutiques. Versace and Ferré were the masters of the renewed taste for precious fabrics, embroidered vests and vivid colors: pink and purple, gold and crocodile. Everywhere nostalgia surfaced for the dandy, an emulation of the elite clothed by the tailors of Savile Яow, the snobbish cult of the detail "that makes the difference." In this neo-traditionalist atmosphere, like that of the Merchant/Ivory films, the tailored suit seemed to provide a response to the desire to be unique, even though in reality it was now called "made-to-measure" and was the product of an industrial program that companies like Ermenegildo Zegna created to meet the new demand. In the second half of the eighties men – like women, with the return of the popularity of couture – seemed to be looking backwards, seeking to regain privileges and pleasures lost with the French revolution. Color, luxury and fantasy appeared to be the trump cards of Italian designers, still capable of expressing themselves in sophisticated ways. But all-black was just around the corner: it was the uniform of the night and of the new avant-garde.

Executives in pale *aubergine* pinstriped business suits or dandies in smart black suits, but with lace shirts? The nineties would sweep away these existential doubts in the name of the democratic "casual Friday."

The desire to be different. To be unique and extraordinary. Being beautiful doesn't matter but it is absolutely necessary to be someone. The setting is the nocturnal one of discotheques and clubs that hold themed events. The body is transfigured to render it unforgettable. Leigh Bowery is the icon of all those artists in the vanguard, who choose their own bodies and dressing up as a way of expressing themselves and fighting their battles. Excess becomes a means of communication and experimentation. Creativity and individualism are the watchwords of this moment. Anyone can turn into a stylist, an artist, a designer, even if it is just for one night. There is no longer a single point of view and fashion is a seismograph that registers the accumulation of movements and changes.

TЯ∧ИSBODY

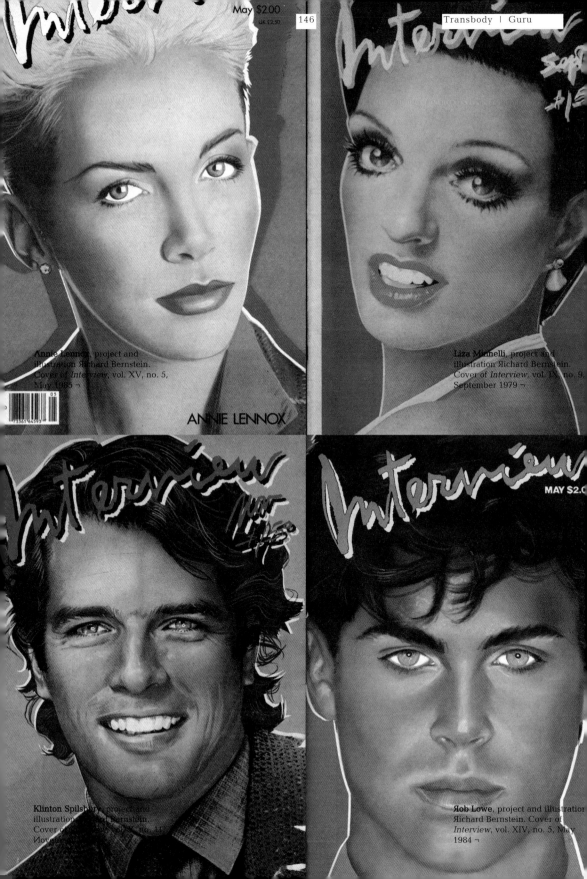

Annie Lennox, project and illustration Richard Bernstein. Cover of *Interview*, vol. XV, no. 5, May 1985 ¬

ANNIE LENNOX

Liza Minnelli, project and illustration Richard Bernstein. Cover of *Interview*, vol. IX, no. 9, September 1979 ¬

Klinton Spilsbury, project and illustration Richard Bernstein. Cover of *Interview*, vol. X, no. 11, November 1980 ¬

Rob Lowe, project and illustration Richard Bernstein. Cover of *Interview*, vol. XIV, no. 5, May 1984 ¬

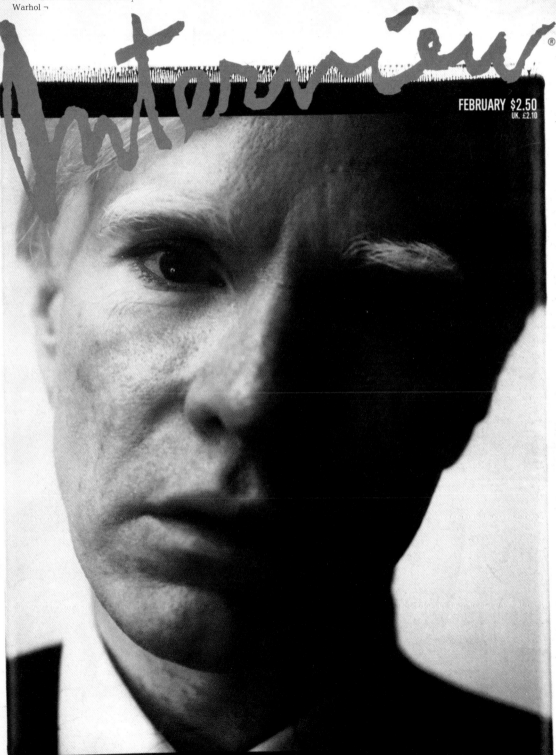

Andy Warhol, *Self-Portrait*, 1979, Polaroid. Cover of *Interview*, vol. XIX, no. 2, February 1989. © The Estate and Foundation of Andy Warhol ¬

FEBRUARY $2.50
UK. £2.10

Andy Warhol

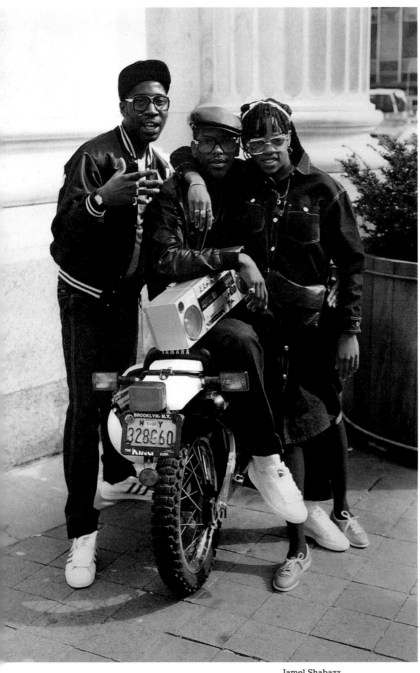

Jamel Shabazz,
Word Is Bond, 1982-1983, color
photograph, 49 x 33 cm.
Courtesy Le Case d'Arte, Milan ¬

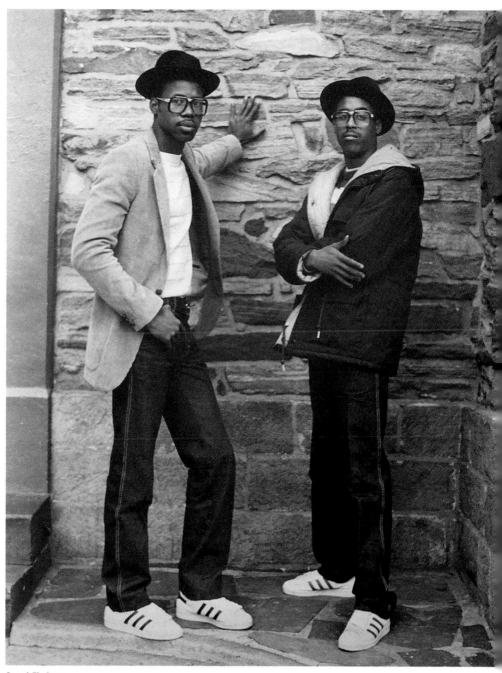

Jamel Shabazz,
Divine and Shockwave, 1982-1983,
color photograph, 49 x 39 cm.
Courtesy Le Case d'Λrte, Milan ¬

Frontier Art

Just as in America and Europe we are celebrating the triumph in art of tradition and fine painting, here comes another eruption of the impetuous underground, shooting up like a boiling geyser. Not only is avant-garde art not dead, it has dug up its war hatchet and is beating the drums in the Manhattan borderlands. 1982: escape from New York! The art of the future is gazing from the suburbs with big, dark eyes towards the center, blended with the detritus and rubble of the decayed city, confused amongst the ghettos of racial minorities, fed by the hot blood of expanding negritude. Reagan has given the States the image of his hyper-realist, plastified face, a macabre version on human scale of a sculpture by Duane Hanson, and artists have dived back into reality or social issues. Or better, into the detritus of reality and the rubble of the social, into ruins, garbage, decomposition. The satisfaction of a neo-primitive regression towards the space of the uncultivated, and of a chaotic man-things-animals jumble and voluntary self-degradation of the self. But the whole is sustained by the full awareness of a long-acquired hardened culture, of a hypercivilization of domestic computers, of a dilated, omnivorous intelligence, fed by the mass media and the uninterrupted circulation of information. Today's avant-garde art is not so much underground as frontier art, both because it literally rises from the areas along the geographic margins of Manhattan (Lower East Side and South Bronx), and because, even metaphorically, it appears in an intermediate space between culture and nature, mass and élite, white and black (I allude here to skin color), aggressiveness and irony, garbage and refined delicacies. These artists are simultaneously "black feathers and pale faces," and they are the new kids of New York: kids with a mocking and kind air about them, who cover the city with signs and graffiti but also present well, even in galleries. They cross the worst districts of New York like war bands, and then appear as the latest fashion at the most elegant, exclusive parties. The kids are the new dominators of the New York art scene, the bearers of an aesthetic of eternal infancy playing at cops and robbers but risking their own skins. They raid the city, putting it to the fire and the sword, sacking every conceivable item from amongst its garbage.
Excerpt from *Flash Art*, no. 107, February-March 1982

Twenty-First Century Slang

The blacks, sanctified by the success of graffiti, have literally invaded the New York art scene, sparking off unpredictable chemical chain reactions in the painting milieu. For the first time in history, after taking over the field of music and dance, the blacks have moved in to conquer the art world.
If you really want to feel alive when you spend a few months in New York, you have to venture along the unfamiliar maps traced by black paths – the subway trains and crumbling walls of the South Bronx are a must. But take a look at the huge roller rinks transformed into megagalactic arenas for rap concerts (concert-exhibitions organized even in such temples of culture as the Squat Theater), and go along to the bars, discos, clubs and markets at the heart of the Lower East Side or the South Bronx.
On Friday evenings, at the crowded Roxy – the huge roller skating rink where weekly rap concerts are held – you can meet the big names in official art who show up relaxed and smiling for the occasion, and former new wave idols like John Lurie or Eric Mitchell. But the real attraction is the extraordinary, uniform mass of teenagers of all ages and extractions dancing to the rhythm of the orgiastic, spoken music, interspersed by lightning exhibitions of breakers, smurfers and electric boogie dancers – those supple, spectacular black street dancers who would shame any pupil of the Merce Cunningham Dance Company. The energy of these blacks is incredible and infectious, but is only partially connected to what has been called the "wild" style.
"Wild" is not the right key for interpreting black power. Rap music, for instance, is spoken music, a narrative of events, a transmission of mental stories and cries from the body. Smurfin' and electric boogie dancing is an electric discharge through the nerves in which the body disconnects in schizophrenic gestures remote-controlled by the convolutions of the brain. Black culture is not just body culture, or biological culture, or non-thought culture. Black culture, like that of their white friends, is a culture of the acculturated body, of contrived biology, of thought that follows a different logic, but is still based on the culture that has accumulated in the Western world.
Black culture, of course, also has a background of submerged culture that is impenetrable to us because it has been neglected so long by the inquiring eyes of white information channels. But it is the grafting of white on black that produces the really fantastic encounters, those linguistic prodigies who arc the potential future masters of the magical interrelationships between the new human species.
That graffiti, or a certain kind of graffiti is not "wild" but derives from the development of a form of "higher;" pataphysical, sci-fi or surreal culture, is demonstrated by Rammellzee, a degenerate offshoot of "wild style" graffiti who is establishing himself as an enigmatic, elusive protagonist of the new art. Rammellzee is a tall, lean, coffee-colored twenty-four-year-old who emerged from the dark subterranean depths after years spent in the bewildering labyrinths of the subway. He finally surfaced with a pamphlet, paintings and sculptures, and an amazing voice that animates rap concerts with cartoon duck talk. He also appeared with a young army of combative, dark-skinned artists who together wage a war of language.
Excerpt from *Flash Art International*, no. 114, November 1983
Reprinted in Francesca Alinovi, *L'arte mia*, Bologna-Ravenna, Galleria Neon and Danilo Montanari Editore, 2001

Vulcan. From Stampa Alternativa/IGT Times, *Style: Writing from the Underground. (R)evolutions of Aerosol Linguistics*, Viterbo, Nuovi Equilibri, 1996 ¬

[p. 151] **Jean-Michel Basquiat** in *Downtown 81*. Flyer for the exhibition *Downtown 81 The Show*, held at Deitch Projects in July 2001 with visual and audio materials in the early eighties in New York, photo Edo Bertoglio and Maripol ¬

DOWNTOWN 81

OPENING THURSDAY JULY 12, 2001, 6 PM

"...Y(O)U GO WITH ME, MY GENTLE BOY?"

PHOTOGRAPHY BY **EDO BERTOGLIO** AND **MARIPOL**

MORE PHOTOGRAPHY BY DAVID ARMSTRONG/LUCA BONETTI/MARINA D/B-DUBB/BOBBY GROSSMAN/LOUIS JAMES/RICKY POWELL/KATE SIMON/MARK SINK/NICK TAYLOR/STEPHEN TORTON

FILM AND VIDEO GLENN O'BRIEN'S TV PARTY/VINCENT GALLO 'IF YOU FEEL FROGGY JUMP'/MICHAEL HOLMAN 'HEADS'/BECKY JOHNSON 'SLEEPLESS NIGHTS'/ERIC MITCHELL 'BIKERS'

MUSEUMS MAGAZINES

Grace Jones painted by Keith Haring. Page from "Stati Uniti Body Painting," text Daniela Morera, photo Robert Mapplethorpe, *Vanity*, no. 14, April 1985 ¬

ROBERT MAPPLETHORPE

Stati Uniti
Body painting

GRACE JONES

different strokes

● IF ALL STYLISTS are artists and all artists have style, a collaboration between the two on the supremely stylish and artistic fashion pages of THE FACE seemed like a good idea. The ubiquitous New York graffiti artist *Keith Haring* set his dancing figures and sense of humour in motion for photographer Mario Testino. Closer to home, young Scottish artist *David Band*, already versed in the art of the crossover through his work for The Cloth and his album sleeve paintings for Spandau Ballet and Altered Images, adds a dash of abstraction to Joe McKenna's equestrian outfits . . .

A

Photography **Mario Testino**
Styling **Keeble/Cavaco**
Paintings **Keith Haring**
Hair **Oribe** for John Dellaria, NY
Models **Olenick** at Click, **Fabian** and **Stacy** through NAME

B

Fashion **Joe McKenna**
Photography **Andrew MacPherson**
Drawings **David Band**
Hair **Denise** for Pluto
Models **Victoria Lockwood**, **Stephane Michaelis**

THE FACE

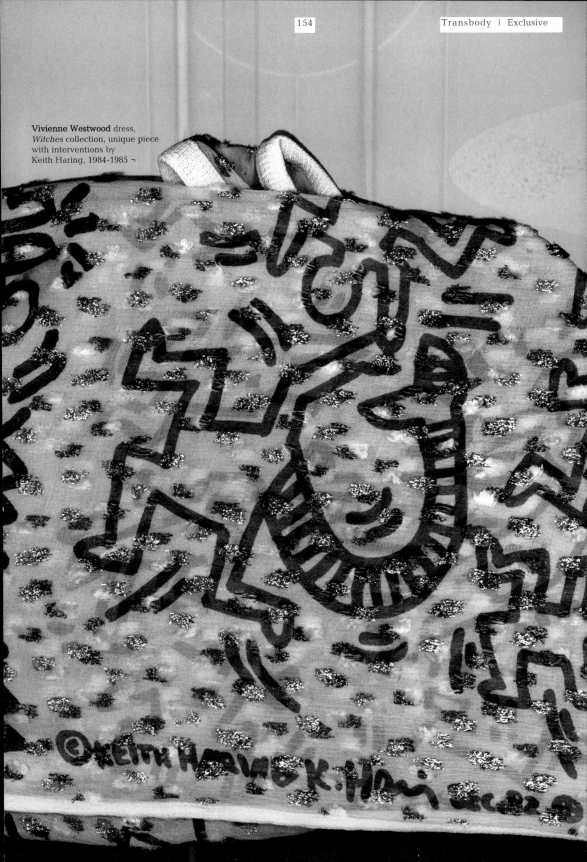

Vivienne Westwood dress,
Witches collection, unique piece
with interventions by
Keith Haring, 1984-1985 ¬

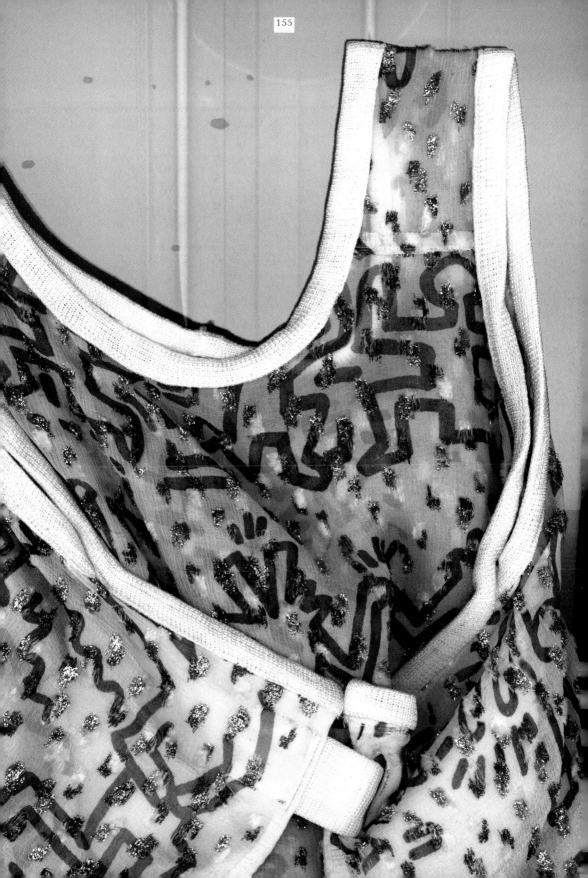

"Sixties Revisionist,"
text James Truman,
photo Kate Simon. Page from
The Face, no. 48, April 1984 →

[p. 157] "Stephen Sprouse,"
text Stefano Tonchi, photo Luca
Babini, art director and styling
Isabella Tonchi. Pages from
Westuff, vol.II, no. 1, April 1985 →

STYLE

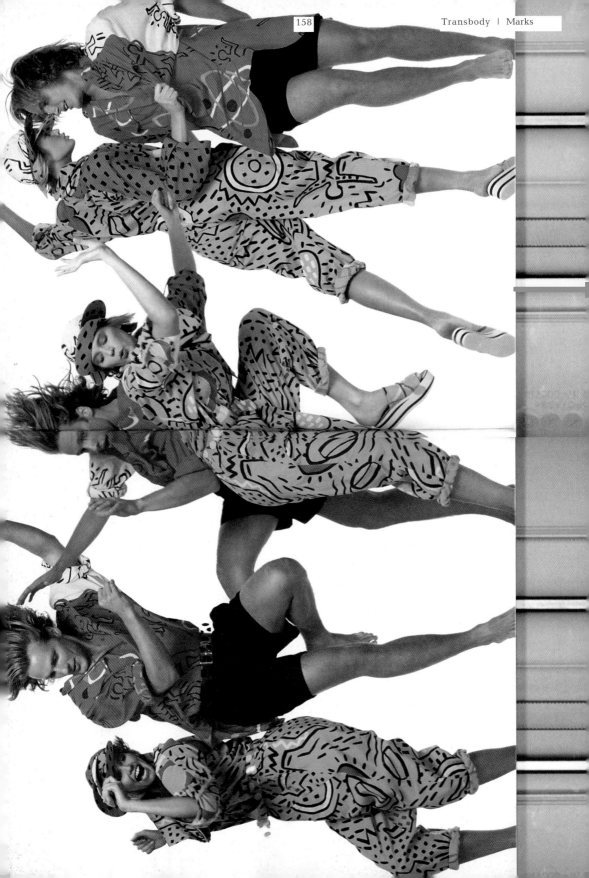

Enrico Coveri advertising campaign, spring/summer 1985, photo Bill King ¬

[p. 158] **Enrico Coveri**, spring/summer 1985 collection, photo Bill King. From Paolo Landi (ed.), *Omaggio a Enrico Coveri*, catalogue of the exhibition held at the Museo d'Arte Contemporanea Luigi Pecci, Prato, 1991 ¬

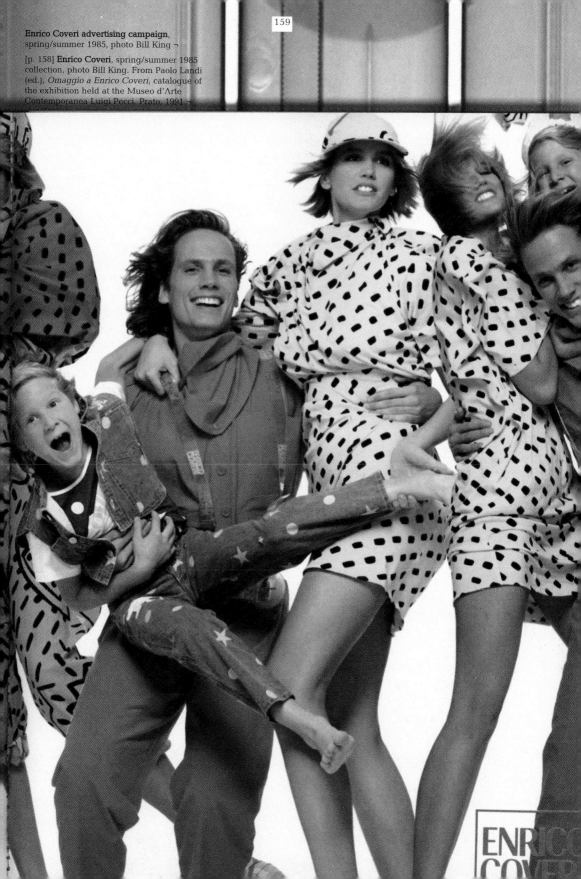

[p. 161]

Cover of *Zulu Groove*, album by **Shango**
(Celluloid), 1983, written and produced by
Material and Afrika Bambaataa ¬

Cover of *Street Dance*, album by **Break
Machine**, 1983 ¬

Cover and folder of *Duck Яock*, 1983, album by
Malcolm McLaren, illustrations Keith Haring ¬

Malcolm McLaren and Vivienne Westwood,
June 1983, photo Steven Meisel. From *On the
Edge: Images from 100 Years of Vogue*, New
York, Яandom House, 1992 ¬

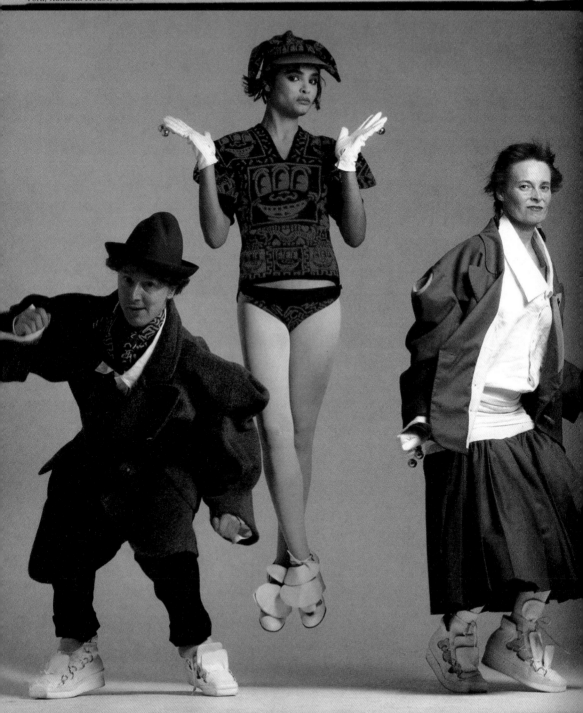

BARRY (17)

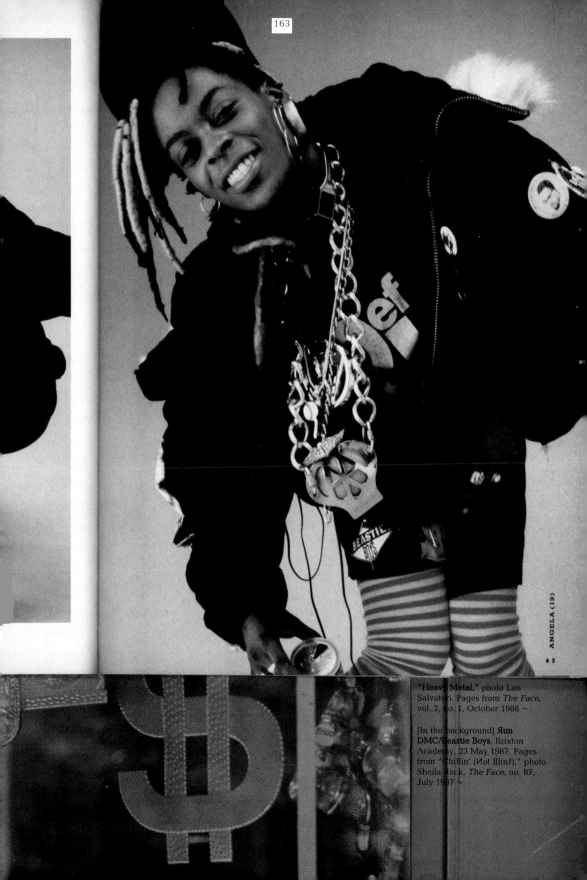

ANGELA (19)

6 5

"Heavy Metal," photo Lou Salvatori. Pages from *The Face*, vol. 2, no. 1, October 1988 ¬

[In the background] Яun DMC/Beastie Boys, Brixton Academy, 23 May 1987. Pages from "Chillin' (Not Illin?)," photo Sheila Rock, *The Face*, no. 87, July 1987 ¬

DISEGNI DI FRANÇOIS BERTHOUD

"La ricerca decorativa dello stile,"
drawings François Berthoud. Page from
Vanity, no. 21, September-October 1986 ¬

Cover of *Vanity*, no. 14, April 1985,
drawing Lorenzo Mattotti ¬

Trimestrale di moda e stilismo – aprile 1985

n. 14 – lire 4

SPECIAL
PRIMITI
AFFINIT
TRA MO
E CULTU

*Abito djellaba in cotone
stampato, con maniche a
imbuto e ampio cappuc-
cio. Di Missoni.*

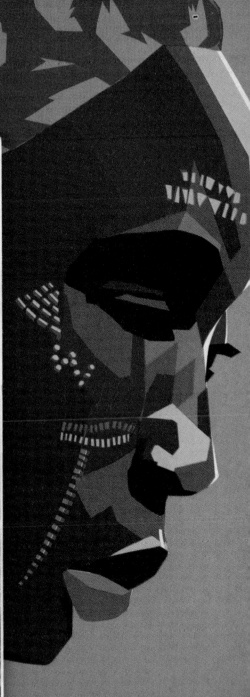

Cover of *African Queen (pour la Grace)*, 1981, album by Allez Allez, design Pierre Pourbaix ¬

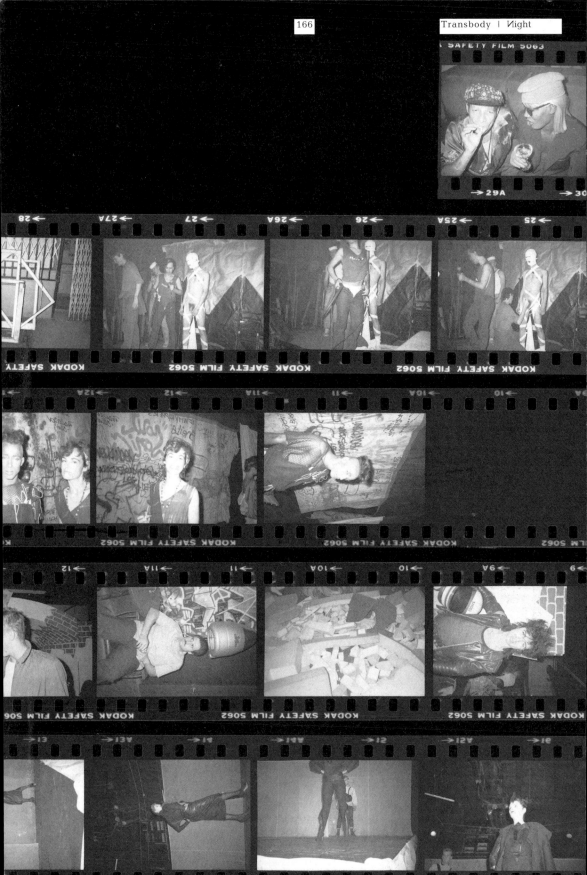

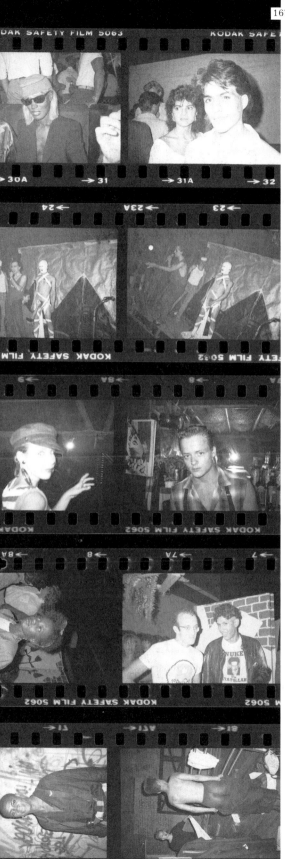

Яemembrances of Иightlife Past

Writer Victor Brokis had this really boisterous rude girlfriend. One night a press member was at Mudd Club on White Street below Canal. She was covering a story on the underground scene in the bowels of Manhattan for a local TV station. Literally, Victor's girlfriend spent the whole night screaming at her. "Look at that ugly face, what does she know. Get the fuck out of here!" I think we all felt the same way she did – we resented outsiders. We especially resented outsiders trying to do a report on a scene that they didn't understand.

On the second floor of Mudd Club there were a few vinyl-covered diner-style banquettes that were greatly coveted. Certain people literally parked themselves there all night. Some came to hawk their wares. You could find Jean-Michel Basquiat selling his paper scribbles in the bathroom for a few dollars! Others came to show their looks. Иeke Carson, famed for sticking a paintbrush in his rectum to paint a portrait of Λndy Warhol, utilized the environment by recruiting us to his modeling agency, La Яocka. We actually got some paying gigs.

There's nothing better than taking a walk through the seedy part of downtown Manhattan during the steamy summer nights. I distinctly remember the smell of cigarettes, alcohol, garbage and cheap perfume. On the way to Keith Haring and Juan Dubose's cluttered apartment on Broome Street, hookers lined the blocks of Chrystie Street. We always knew that we were near because we could hear the sound of their vinyl hot pants snapping back and forth and their heels clicking. Once we got there, we would smoke, drink and party in their kitchen before moving on to Paradise Garage. Food wasn't the only thing cooking. It wouldn't end until the next afternoon.

Paradise Garage was a gigantic warehouse close to Varick on King Street. One has to walk awhile before one gets to the entrance, like walking on an airport tarmac during the night. Once inside there would be a blue haze of smoke amidst tons of sweaty people either socializing or dancing. It was a place where our mental state and the music created that TIИGLE that lasts awhile.

Other nights started right after Mr. Chow closed. Tina Chow would hurry upstairs to her art deco-filled apartment and change. One night she came down in a green sweat suit and carrying a boom box on her shoulder blaring "Яapper's Delight"! We didn't go anywhere. We just walked around the city. It was our playground and her hood.

The Pyramid on Λvenue Λ was the haven and birthplace of a new breed of Drag Queens. They poked fun at the whole notion of being a girl in contrast to the traditional ones of yesteryears. Ethel Eichelberger, Hapi Phace, John Kelly, ЯuРaul, Lypsiиka, Lady Bunny and Tabboo! were some of the marquee names that performed regularly. They jump-started a drag fest called Wigstock. It was where balls and panties united. For those of us that had an engagement there, writer Chi Chi Valenti always cautioned us "to bring our own roll of toilet paper."
BEИJΛMIИ LIu, edited by Sidney Prawatyotin

Иightclubbing in ИYC, photo Benjamin Liu.
[From above] Zoli Party, Studio 54, 1983;
Pyramid, Joey Λrias performance, 3 Λpril 1984;
Island/Яoxy, 8 Λugust 1983; Keith Haring
party, 1983; Island/Яoxy, 9 Λugust 1983 ¬

The East Village was once hippie heaven. Free love, free sex, free drugs.
Well, times have changed. For starters, nothing's free anymore.

A, B, C, IN THE 60'S

★ ★ ★

COME TO THE PAPER PARTY — DANCETERIA 10 OCTOBER —

★ ★ ★

★ SIXTIES ★ OCTOBER 1984 50¢

PAPER

THE SIXTIES STILL A HIT IN THE EIGHTIES

★ NEWS ★ CLUBS ★ MUSIC ★ STYLE ★ ART ★ MOVIES ★ FOOD ★

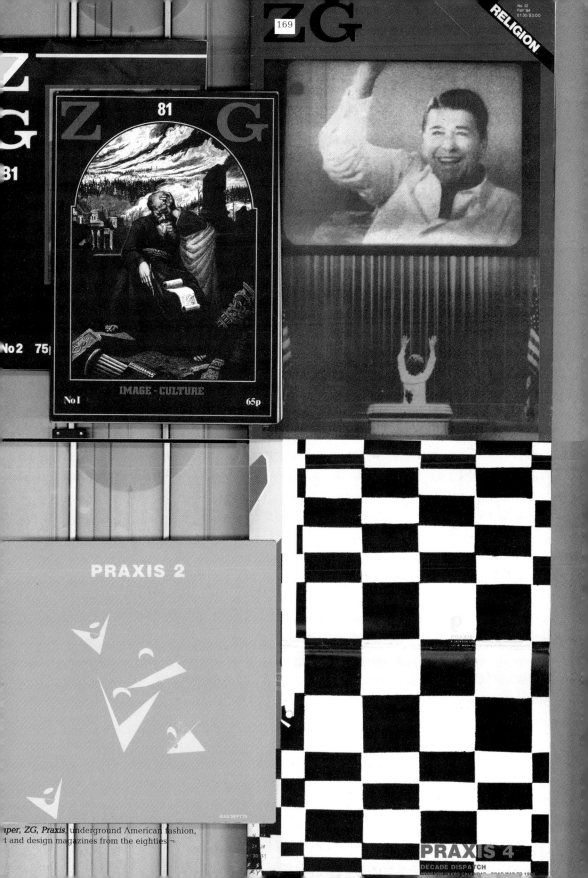

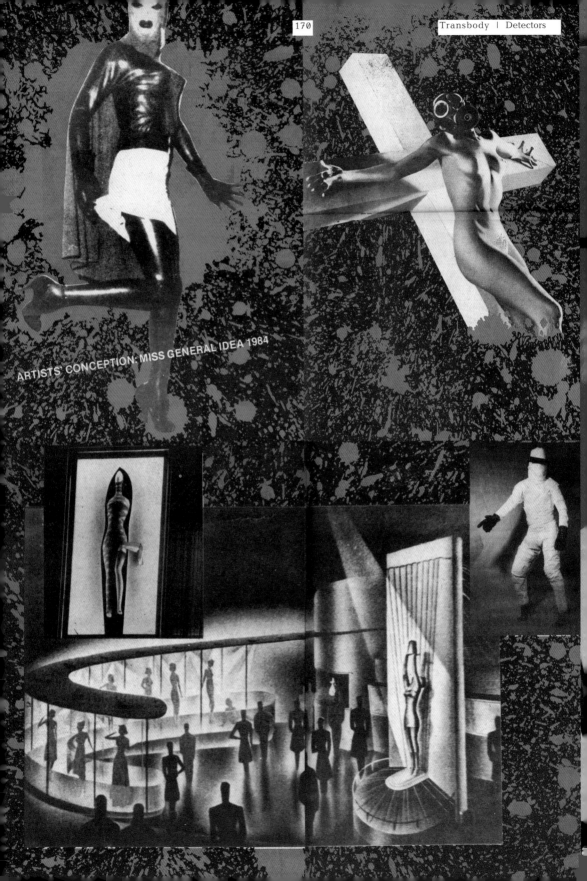

ARTISTS' CONCEPTION: MISS GENERAL IDEA 1984

SPECIAL

GLOBAL DOWNTOWN
ISSUE!

COSMOPOLITAN GIRLS

CONDOMINIUM GIRLS

PSYCHOLOGICAL INTERIORS
FOR POST-(POST-MODERN) LIVING

HOW TO PLAY THE PIANO BENCH
(see Centerfold)

NINO LONGOBARDI'S

TRIP AROUND THE WORLD WITH GENERAL IDEA

Vol. 4, No. 3, Sun

And Klaus Nomi's
news from the Global Downtown in
BZZZ BZZZ BZZZ

e Colour

The famous Mary-lou Greene sheds a tear for post-modernism in this high-rise dedicat downtown. See Bzzz Bzzz Bzzz, page 58.

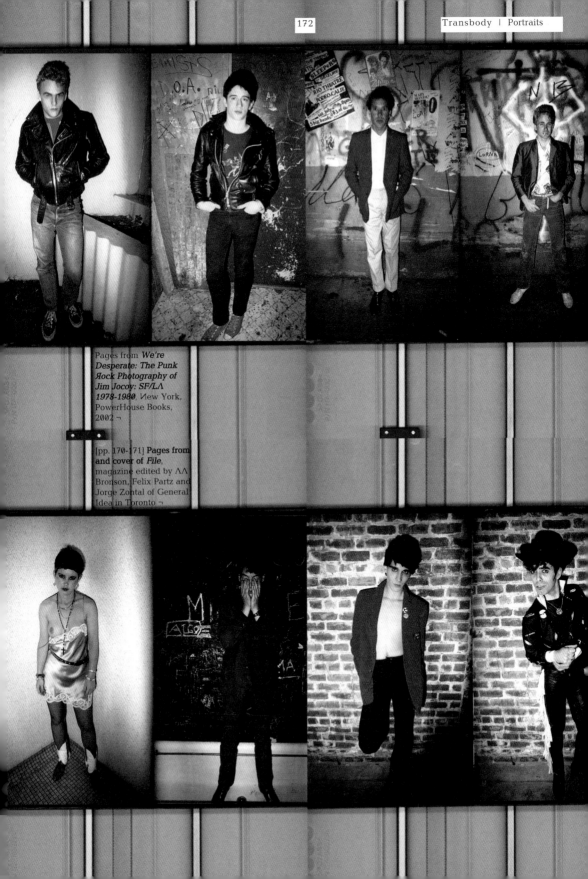

Pages from *We're Desperate: The Punk Rock Photography of Jim Jocoy: SF/LA 1978-1980*, New York, PowerHouse Books, 2002 ¬

[pp. 170-171] **Pages from and cover of** *File*, magazine edited by AA Bronson, Felix Partz and Jorge Zontal of General Idea in Toronto ¬

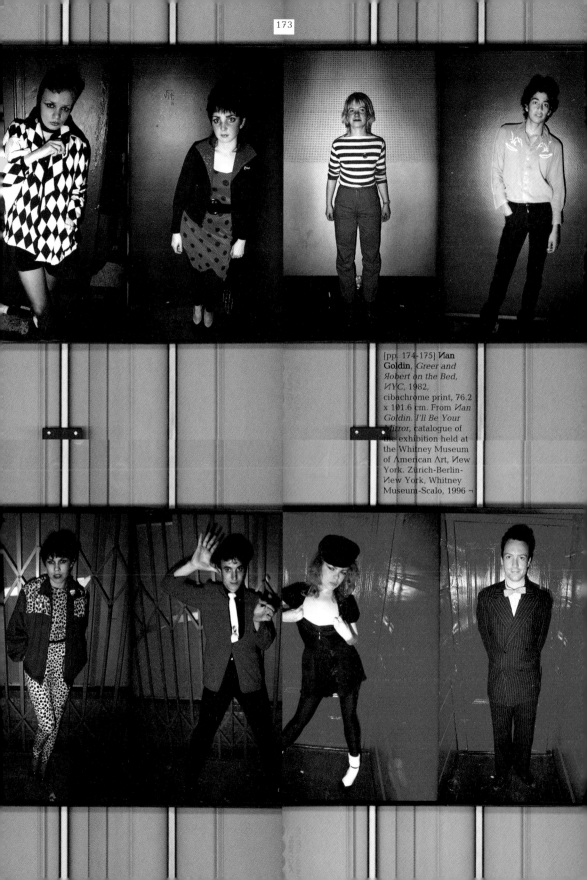

[pp. 174-175] **Nan Goldin**, *Greer and Robert on the Bed*, *NYC*, 1982, cibachrome print, 76.2 x 101.6 cm. From *Nan Goldin. I'll Be Your Mirror*, catalogue of the exhibition held at the Whitney Museum of American Art, New York. Zürich-Berlin-New York, Whitney Museum-Scalo, 1996 ¬

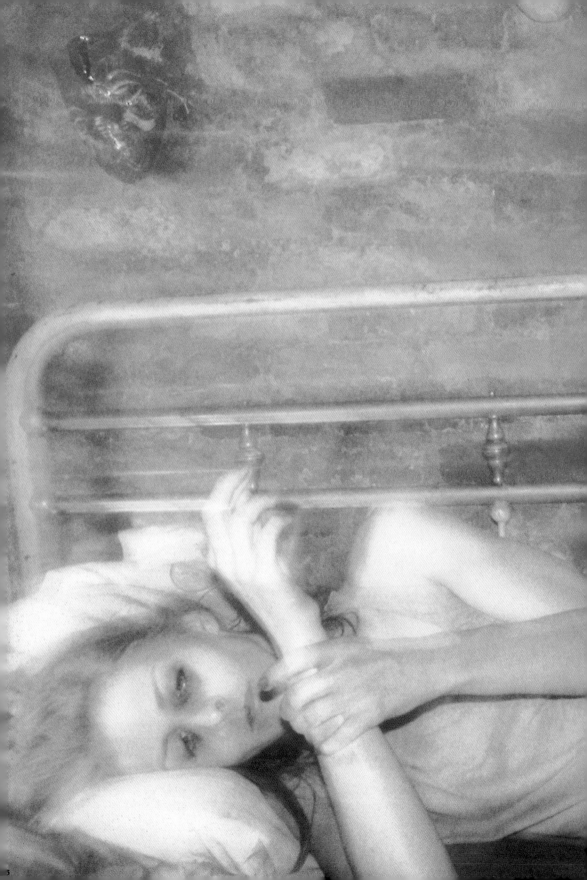

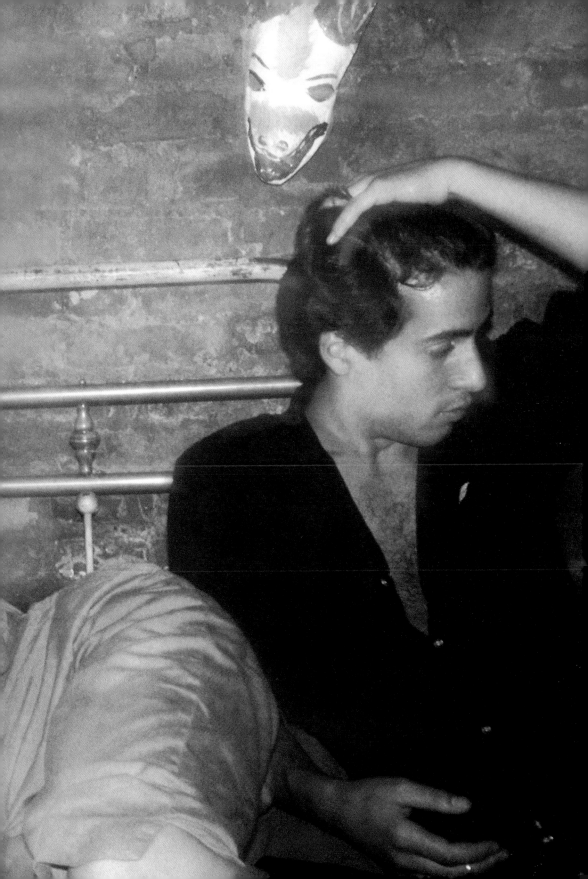

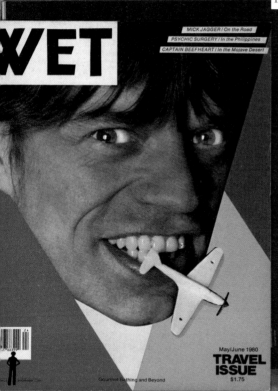

WET

MICK JAGGER / On the Road
PSYCHIC SURGERY / In the Philippines
CAPTAIN BEEFHEART / In the Mojave Desert

May/June 1960
TRAVEL ISSUE
$1.75

Gourmet Bathing and Beyond

WETRO-SPECTIVE

A look at our first fifteen issues.

The first issue of WET appeared in May of 1976 and consisted of two seventeen-by-eleven inch sheets of paper folded over twice, printed in an edition of 600 copies. By comparison, WET number two looked like a real magazine. It was 16 pages long and sold over 1,000 copies. The first letter to the editor complained that perhaps said writer was being overcritical, but he couldn't figure out any reason for WET's existence. Wetman replied "A raison d'etre for WET can't be expressed shortly and sweetly, but alot of love and dedication goes into the making of this magazine." Meanwhile, a tiny ad in the back of the issue read "Investor sought — WET needs funds for development."

The first few issues were an almost scientific investigation of the properties of water in relationship to human beings. There were articles on how to build redwood tubs, surveys of the world's bottled waters, architectural features on bizarre bathrooms, and the ever-popular soap reviews. And then, too, there were lots of naked people interacting with water in various exotic, erotic and ridiculous ways. Artist Peter Alexander, whose daughters were seen dousing each other with soap bubbles on the cover of WET number four, says, "I used to chuckle before I even opened the magazine. I mean, it was such an absurd idea, a magazine about water. Yet at the same time I felt threatened by WET, the barrage of images was disorienting. What I really felt threatened by, I think, was WET's embrace of the ephemeral."

In its first fourteen issues, the WET logo changed seven times. With issue sixteen, Jan/Feb '79 the size of the magazine changed from 8½ x 11 to 10½ x 13¾ (and with the next issue WET will return to its original format). With each issue an attempt was made to begin afresh, as if nothing had gone before. By issue thirteen, WET began to move beyond the concept of Gourmet Bathing. By issue fifteen, WET's subtitle read **"Gourmet Bathing and Beyond."** In issue eighteen, Gourmet Bathing lost its innocence entirely. In his "Long Overdue Introduction" to the subject, contributor Charlie Haas spoke the words that broke the spell: "Gourmet Bathing is a means for enjoying the world... It's a parody of all other enthusiasms... Then again, Gourmet Bathing is the willingness to be silly." WET, says designer and photographer Jayme Odgers, barely hiding a smile, "has charted a very fluid course."

This issue represents a crossroads time for our magazine, the twenty-fifth issue, a chance to look back over the first four years to see if where WET has come from will give a clue to where WET is going. WET has certainly become a more commercial magazine over the last four years, measured in the most basic ways: each issue has sold more copies than the one before; WET has spawned at least a dozen imitators; and now our bimonthly magazine is about to go monthly. The question is, what happens next?

There are two signs in the WET offices. One says, **"WET = Not Cynical."** The other says, **"Doing Without Knowing."** And that's the way it is, as the magazine gears up for the next phase. Luckily, there has always been a sort of restlessness at the heart of WET, an infatuation with absurdity, a discontent with formula. So in answer to the question, What's next?, we can only reply, How should we know? It hasn't happened yet!

THE BEST IS WET TO COME!!

wetrospective
15 WET

Pages from and cover of *Wet,* The Magazine of Gourmet Bathing and Beyond, California magazine published in Venice in the eighties ¬

Covers of albums by **The B-52's** ¬

B-52's
wild planet

HIGH FIDELITY

the **B-52's**

The Palladium: Immaterial Building

What I was most interested in was that the discotheque as a building type almost extends beyond the conventional idea of architecture and that even substance is lost in its space. Needless to say, however, its space is naturally built and affected by forms and their material composition as in a usual traditional building. Nevertheless, these greatly lose their importance in a disco space, and, instead, momentarily passing lights, sounds and visionary images come to the fore. Although lighting, video and music are elements of an architectural space, they come to play the main roles in a discotheque. Each of these elements is the material and media of a new type brought forth by the technology of this age. If it is confirmed that space can be transformed by such elements, it will be quite a rare case in the sphere of contemporary architecture where a field of experiment has been lost. Above all, in a discotheque, such technologies pour over the whole body of a person like a shower and stimulate all the senses. It is as if hidden desire is evoked. Rather it would be better to say that a shower of technologies gives birth to successive desires.

ARATA ISOZAKI, *Domus*, no. 666, November 1985

The Palladium: Immaterial Building

We couldn't wait for it to open. It was going to be the most sophisticated club in New York: the one with space done by an architect and the décor done by artists. It was going to have more speakers, more video screens, more lights, more DJs, more space than any other club in New York. It does. It has more speakers and video screens and lights and DJs and space than any other club in New York. But who has more than one perfect body to take it all in? Who has more than one pair of eyes to see it all? Who has more than one pair of ears to hear it all? Who has more than one brain to sift through it all? Who can see another's face in that kind of machine gun light? Who can talk to another in that kind of industrial noise? Who can find a friend in that dark smoky factory of entertainment?

Are the seventies already being revived? Who's heard your joke? Who touches your elbow? Who can see you dancing? Who knows it's you? Who is the man sitting at the bar? Where is the man who was sitting at the bar a minute ago? Look at that green hair. Look at the scenery going up. Look at the video screens coming down. Look at the tiny people swarming up and down the stairs. Look at those people like fluttering confetti on the dance floor. Who are you here?

A feverish molecule in a disco dictatorship trying to catch desire by the tail. But dictatorships think only of the masses (consisting of all those who think more is better and that it's the only place to be if you have to line up outside to get in). It's like a large department store: they have everything but you can't find what you are looking for. It's like an airport, or a train station (without planes or trains to take you places): a space so huge you become anonymous in it. It's like the first day at school, only at night, and in a class of 3000. That's entertainment in the post-Orwell metropolis. Rumor has it that Big Brother furtively swings at the old El Morocco.

GINI ALHADEFF, *Domus*, no. 666, November 1985

Palladium, the lobby frescoed by Francesco Clemente and the glass staircase, project Arata Isozaki. Pages from "The Palladium: Immaterial Building," texts Arata Isozaki and Gini Alhadeff, photo Shigeo Anzai and Katsuaki Furudate, *Domus*, no. 66, November 1985 ¬

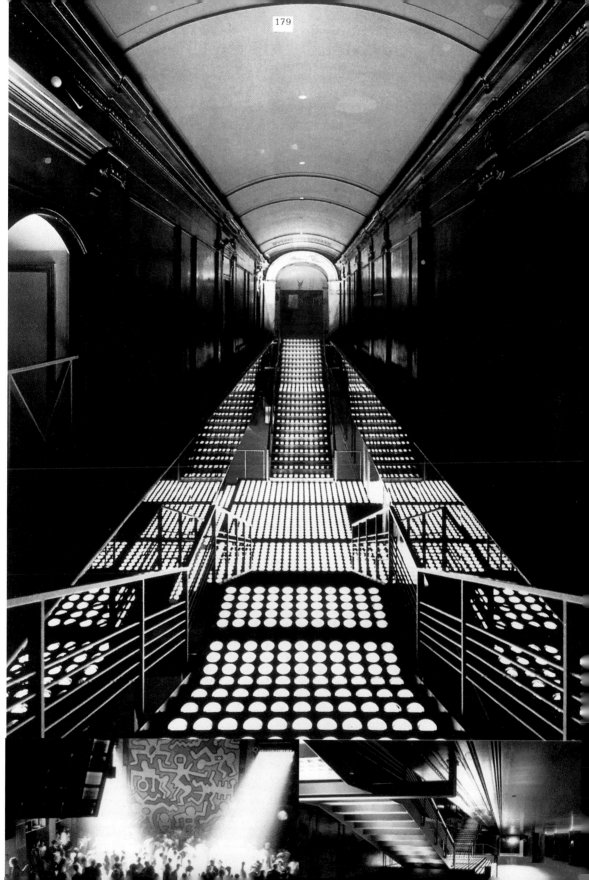

The Strain of Being Madonna

Gone are the fine times when cultural critics used to extol the Ciccone phenomenon. You feel sorry for them, seeing them there in the middle distance, from where we are now. Sometimes they make you laugh, sometimes melancholy. Whole shelves have been filled, often with little point, with books on Madonna feminist theory, Madonna and gender representation, Madonna and the deep Dionysian spirit that pervades her (that's Camille Paglia). Madonna and erotic imagery in general, just think about it. Madonna here and Madonna there.

Try and leaf through the pages of *The Madonna Connection: Representational Politics, Subcultural Identities, and Cultural Theory*, just to pick a subject at random. You'll never find anything that seriously succeeds in illuminating you. The question is probably this: there is nothing to illuminate. Madonna is someone for whom things have gone well, an artist capable of treading water in the market, with the ability to direct her talent and taste and to turn them into popularity and money. That's about it. We know it's not easy. But some people manage it. Madonna did manage it; she wasn't the first and she won't be the last. Theories, inevitably, followed after, including the collapse of a certain feminist theory about her when it confused intelligence and camp. Child's play.

If we scan her career now, knowing it falls exactly into two decades (from the album *Madonna* of 1982 to *The Immaculate Collection* of 1990, the one with "Vogue"; and from the scandal book *Sex* of 1991 down to the present, more or less), we can hardly help noticing a perfect adherence to the economy in the same time span, with the origins and rise of the immaterial economy of signs and language.

Madonna is simply the perfect representation of all this. Hence the melancholy.

We all thought so then: look around you, go to the capitals of the West, see what's happening and anticipate it on your own ground. That will be enough. And so she did. And it was. Madonna has systematically (re)constructed, often reinvented, her own past, setting her stubby feet on the high heels of ambition, indifferent of the means used to achieve her ends, and in this she is highly Italian.

She organized the cult of herself, designing it on the drawing board for all possible audiences, using religious scandal for the purpose and simply turning the widespread aptitude of her generation for sexual self-exhibition into pop. The technique of a smart shop worker (but also used by her colleagues, now running concept stores) and it paid off. Her second film as an actress (Susan Seidelman's *Desperately Seeking Susan*, an inspired mainstream representation of the New York counter-culture from 1978 to 1985) is simply a record of this.

What an effort, though, always being up to the mark, always abreast of the times. What a burden of responsibility, all resting on the shoulders of that poor girl, all alone, without a context to protect her any more (just what Alain Ehrenberg has recently described as the effort of being ourselves).

The culture of narcissism as adaptation to the flexible market is an issue in which everyone has been involved for the last twenty years. In this Madonna is neither more nor less than one of us. "In contemporary work," writes Paolo Virno in *Grammatica della moltitudine*, "we find exposure to others' eyes, the start of unprecedented processes, the constitutive familiarity with contingency, the unexpected and the possible." In short, the career strategy adopted by Ciccone, far from personal, is, if anything, general, to some extent anonymous today. And the skillful double-dealing of the progressive exposure of one's intimacy, the permanent expression and reappropriation of one's self, which are at the heart of the contemporary identity. Like being a contestant in a late nineties reality show, preceded by Alek Keshishian's sycophantic documentary (*Madonna: Truth or Dare*, 1991) with the backdrop of the colossal *Blond Ambition Tour* of the year before (the one with Gaultier's conical bra, to be perfectly clear).

She sang "Everybody" at the start of her career. Yes, everybody's in the same boat. What bliss.

In ten years' time we'll be looking at the images of *Like a Virgin* with the same nostalgia that used to overcome us when we held the photos of our grandparents' life in the factory. Those were hard times.

CARLO ANTONELLI

Books cited

Alain Ehrenberg, *La fatigue d'être soi: Dépression et société* (Paris: Editions Odile Jacob, 1998).
Paolo Virno, *Grammatica della moltitudine: Per una analisi delle forme di vita contemporanee* (Rome: DeriveApprodi, 2002).
Cathy Schwichtenberg, ed., *The Madonna Connection: Representational Politics, Subcultural Identities, and Cultural Theory* (San Francisco: Westview Press, 1993).

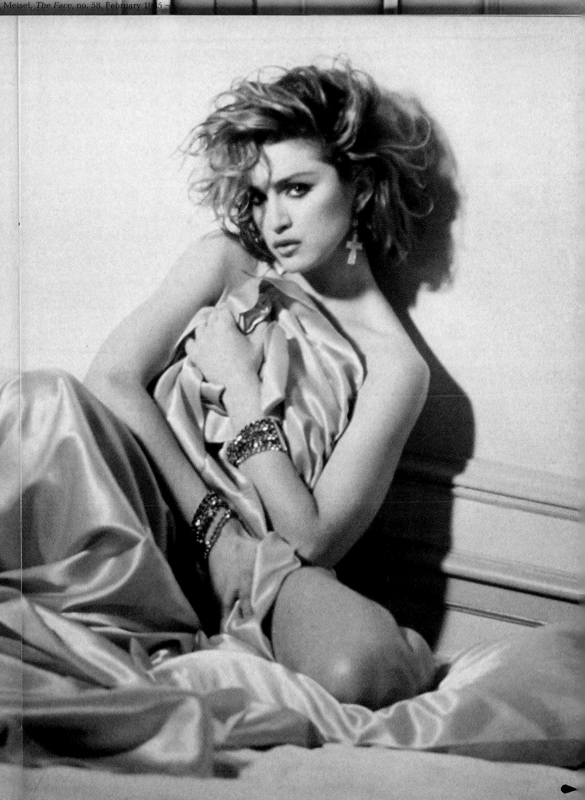

Madonna. Pages from "The Glamourous Life," text Jeffrey Ferry, photo Steven Meisel. *The Face*, no. 58, February 1985 →

Fiorucci: eighties memorabilia ¬

Anjelica Huston,
photo Helmut Newton. Page
from "Inside Hollywood: Shades
of Summer," *Vogue*, June 1985 ¬

"Chic grafico, graffiante," photo
David Bailey. Page from *Vogue
Italia*, no. 395, January 1983 ¬

CADETTE.
VIOLENZA GRAFICA
DELLO STAMPATO
«LICHTENSTEIN»

Le stampate gigan-

[p. 185]

**Jean-Charles de
Castelbajac.** "Hommage à la
bande dessinée" garments,
summer 1982 collection, photo
Jean Pierre Peersman. From *JC
de Castelbajac*, Paris, Michel
Aveline Éditeur, 1993 ¬

"U.S. ЛЯТ: L'avanguardia abita
a New York," text Gillo Dorfles,
photo Oliviero Toscani. Page from
Donna, no. 51, March 1985 ¬

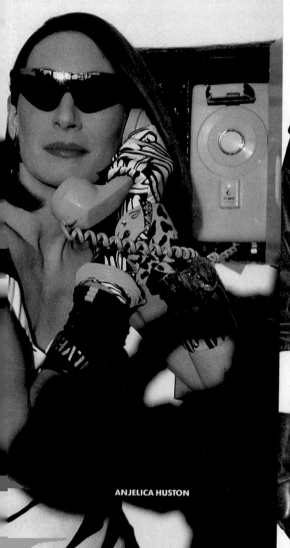

ANJELICA HUSTON

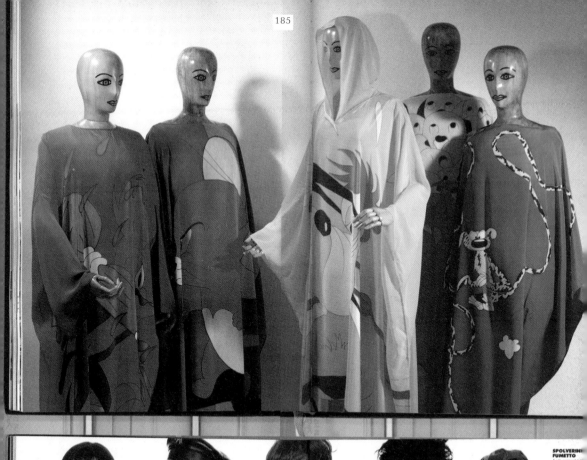

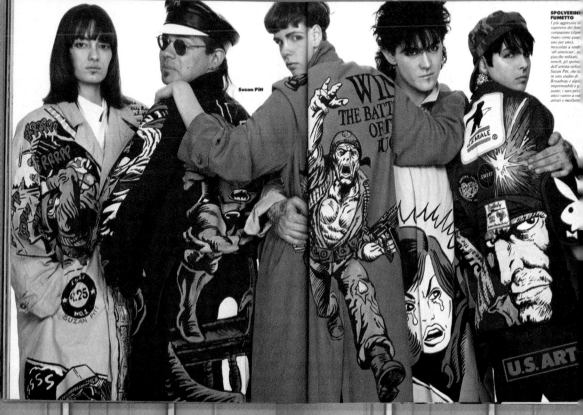

Suzan Pitt

SPOLVERINI FUMETTO
I più aggressivi t[...] superano dei fum[...] compaiono (dipin[...] mano come quan[...] uno per uno), mescolati a simb[...] 'all americani', su[...] giacche militari, trench, gli spolver[...] dell'artista-stilis[...] Suzan Pitt, che l[...] in uno studio di [...] Broadway e dipin[...] impermeabili e g[...] usate; i suoi pezz[...] unici vanno a ru[...] artisti e intellett[...]

ODA: PROPOSTE DA PARIGI

Nella panoramica della moda presentata a Parigi spiccano senza dubbio alcune presenze per la loro forza e sostanziale innovazione nello spirito dell'abbigliamento. Jean-Paul Gaultier, Comme des Garçons, Kenzo abilmente mescolano elementi dissacratori e stretto rispetto formale. Castelbajac e Daniel Hechter sono riconoscibili per la vivacità con cui trattano il classico informale.

IN QUESTE PAGINE SONO TUTTE DI JEAN-PAUL GAULTIER LE MAGLIE DI LANA A COLLO ALTO CON SCRITTE IN CIRILLICO.

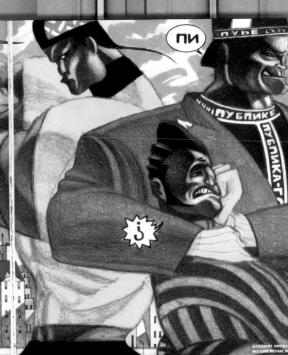

ALL'ESTREMA SINISTRA, IMPERMEABILE VERDE MILITARE, MAGLIA A COLLO ALTO, CINTURONE E PANTALONI IN PELLE ROSSA DA MOTOCICLISTA. AL CENTRO, MAGLIA DA CICLISTA IN LYCRA GIALLA. A DESTRA, BLAZER MARRONE CON AMPI REVERS RIFINITI DA SALVAPUNTE E MAGLIA MARRONE SEMPRE CON SCRITTE IN CIRILLICO. CASACCA A RIGHI MARRONE E OCRA, CHIUSA DA UNA CERNIERA, TUTTO DI JEAN-PAUL GAULTIER.

ODA: PROPOSTE DA PARIGI

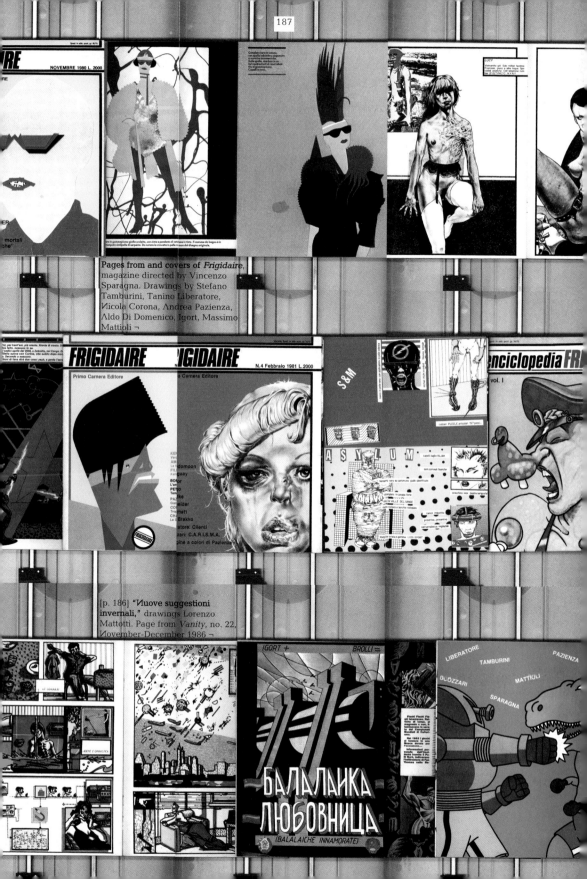

Pages from and covers of *Frigidaire*, magazine directed by Vincenzo Sparagna. Drawings by Stefano Tamburini, Tanino Liberatore, Nicola Corona, Andrea Pazienza, Aldo Di Domenico, Igort, Massimo Mattioli ¬

[p. 186] "**Nuove suggestioni invernali**," drawings Lorenzo Mattotti. Page from *Vanity*, no. 22, November-December 1986 ¬

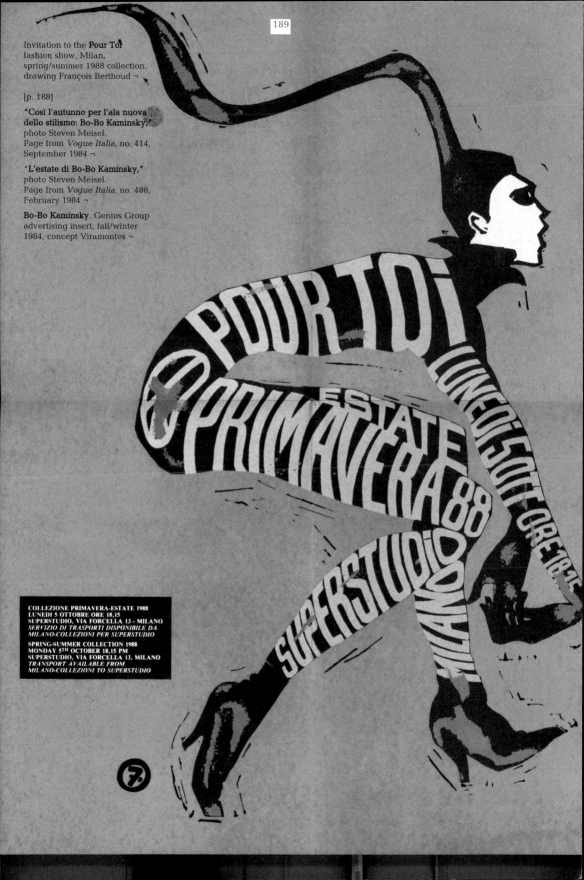

Invitation to the **Pour Toi**
fashion show, Milan,
spring/summer 1988 collection,
drawing François Berthoud ¬

[p. 188]

**"Così l'autunno per l'ala nuova
dello stilismo: Bo-Bo Kaminsky,"**
photo Steven Meisel.
Page from *Vogue Italia*, no. 414,
September 1984 ¬

"L'estate di Bo-Bo Kaminsky,"
photo Steven Meisel.
Page from *Vogue Italia*, no. 408,
February 1984 ¬

Bo-Bo Kaminsky. Genius Group
advertising insert, fall/winter
1984, concept Viramontes ¬

THE MANIPULATOR

WORLDWIDE MANUAL OF STYLE i-D NO.19 OCTOBER 1984 £1.4

THE INSIDE OUT ISSUE

i-D

ALL THE
LATEST
TRENDS
PLUS FAB
COLOUR
SCHEMES
YOU CAN DO
YOURSELF

SPECIAL INTERIOR
PULL-OUT SUPPLEMENT

D·I·Y

The Manipulator, the largest magazine in the
world, no. 9, 1987, and *i-D*, The Worldwide
Manual of Style, no. 19, October 1984 ¬

Trendsetting Magazines

One of the lightest revolutions of the eighties was that of the style magazines, but it is often these soft revolutions that have the longest-lasting consequences: after all, they constitute not moments of rupture, but of unanimous, simultaneous change over a vast range of given variables. Fashion magazines have more or less always existed. Back in 1672, the ladies of the European courts were already reading *Mercure Galant*. *Harper's Bazaar* and *Vogue* were founded in the United States in the latter half of the nineteenth century (1867 and 1892 respectively). Pedigree apart, essentially there were two crucial moments for fashion publishing in the twentieth century: the invention of photography, which opened up a whole new world of expressiveness, and the birth of prêt-à-porter, which instead opened up a new market. Aside from this, the magazines did not change much: they essentially remained catalogues for the use of dressmakers and their customers. It was only with the post-war boom that this cozy couture world began to fall apart, and with the advent of the sixties, the street and news entered fashion magazines: 1965 saw the founding of *Nova* in London, and in 1969 Andy Warhol produced the first issue of *Interview*. Glamour became accessible to all – at least as a concept. In the seventies, this trend came to a momentary halt: fashion came to be seen as one of the features of the establishment: empty and frivolous. The young were no longer thinking about clothes, but about demonstrating in the streets. The publications that covered fashion could do nothing else but adjust, and pretend that they too were angry; it was a sterile game, and too artificial a ploy truly to succeed.

Towards the middle of the decade, disco began to emerge, not by chance from parallel and secondary sources: blacks and gays. Almost at the same time the shock came – a real one, this time – of punkdom: hardcore nihilism, universal rebellion, rage. And above all, a corrosive, explosive irony. Forget political programs: this was "no future, but in the meantime, let's dance." In their parkas and jeans (once upon a time, this was a trend-breaking choice, then it became a standard uniform), they were invited to get lost. Studio 54 was already the home of extravagance, and rock stars' wardrobes were filled with fishnet stockings (worn by males as well), with Marlon Brando-type leather jackets (worn by girls as well), outrageously dyed hair and safety pins. They came from different worlds, but shared a rejection of mass culture. And the cult of the personality. This is where the short circuit blew.

In both the disco and punk scene, the Warholian concept of being famous for fifteen minutes triumphed: fed up with an egalitarianism that had become an empty shell, the new icons of style claimed their right to be transformed into public figures . . . and succeeded. Their publications could no longer cover only clothing: they had to broaden their field of vision. New reviews blossomed at a rapid rate, mainly emerging from the magma of the young artistic/musical scene that was sweeping across Europe. To speak of new subjects (club culture, the reciprocal influences of music on fashion, or fashion on entertainment), they invented a new language, which increasingly began to resemble newspapers like *New Musical Express* or *Rockstar* rather than the various *Vogues*.

A new generation of journalists, designers and graphic designers emerged: figures who shared the same enthusiasms, who gravitated around the same world. But above all, a new style was born, which worked hand in hand with the latest technological revolutions and led to that syncretic product that is the music video, a concentration of signals that speaks simultaneously of fashion, music, choreography, film directing, graphic design. Fashion immediately appropriated the languages of all these rebels, these not-so-clueless dandies, for itself. It sensed the immense potential of collaboration between sectors that until then had followed different paths. Without codifying it, it elaborated the concept of lifestyle. Or perhaps the opposite is true: it was these new rules that imposed themselves alone, strengthened by their subversive charge, their coherence, their being "here and now." These rules were the New that was forming, and fashion had only to exploit its most developed sense: flair. Whatever the case may be, the third great revolution for fashion magazines in the twentieth century, following those of photography and prêt-à-porter, was this: the subject they covered has become one of the great protagonists of society. The fashion press is no longer a minor sector but an authoritative observer. Or, better, laboratory. So fashion, as the crystallization of a *zeitgeist* that can be perceived so clearly nowhere else, had suddenly become a locomotive pulling an infinity of other sectors. And the magazines that have in the meantime sprung up (it is a long list: *Acte Gratuit, Blitz, Details, i-D, Instant, Jill, Lei, Manipulator, Per Lui, The Face, Vanity, Viz, Westuff, Wiener*, etc.) write about the birth of new fashions and styles from the inside – and it is this last point that is the great, true novelty. With the awareness that by their simple existence, they are contributing to the history of fashion.

Ruben Modigliani

Cover and pages from
Westuff. [From above] *Westuff*
"La realtà," no. 4, June-
August 1986; *Westuff*, "Cieli,"
no. 7, March-April 1987;
Westuff, "The Future," no. 1,
June 1985; *Westuff*, "Surface,"
no. 2, September 1985;
Westuff, "Navigare," no. 5,
September-November 1986 ¬

QUADRIMESTRALE DI ARTE, MODA E SPETTACOLO/BIMONTHLY MAGAZINE OF ART, FASHION AND MUSIC

WESTUFF

ENGLISH TEXT

APPELLI

Luigi Ontani

Neville Brody, cover proposal for the album *Parliament The Bomb* by Parliament, 1905. From Jon Wozencroft, *The Graphic Language of Neville Brody*, London, Thames & Hudson, 1988 ¬

[p. 195] **Album covers:** *Killing Joke*, Killing Joke, 1980, design Neville Brody; *Never Mind the Bollocks*, Sex Pistols, 1977, design Jamie Reid; *Unknown Pleasures*, Joy Division, 1979, design Joy Division and Peter Saville ¬

Unknown Pleasures

Manchester, early eighties. Tony Wilson's Factory Records appeared on the music scene with two very interesting albums: *Flectricity* by Orchestral Manoeuvres in the Dark, and *Unknown Pleasures*, Joy Division's first album. Peter Saville, a young man whose big dreams were completely misunderstood by the local advertising agencies, designed the record covers. He used to hang out in the clubs and occasionally tossed off the graphics for the independent labels of friends and acquaintances.

The same thing happened to Malcolm Garrett. Having studied typography at the University of Reading, he moved to the city and began working for the Buzzcocks, thanks to his friend Saville's contacts. The industrial images used for their record covers instantly became a style phenomenon and Garrett's fame was only somewhat obscured by Jamie Reid's work for the Sex Pistols. Garrett later worked for Culture Club, Duran Duran and Simple Minds, giving them a corporate identity as if they were so many industrial products. But he did it with a charm and irreverence that proved instantly irresistible to the record companies, bored by the vacuous ideas of their usual design consultants.

Music was one of the expressive mediums that best recorded the ongoing cultural changes of the period. Abandoning the intuitive approach of the seventies, a new generation of designers fed off of the typographic ideas of Herbert Spencer, Jan Tschichold and Piet Zwart, and squared up to the dynamics of marketing and brands.

Along with Peter Saville and Malcolm Garrett, Neville Brody and Vaughan Oliver served as the creators of this mindstyle. The quartet not only defined the wave of the eighties, but actually transformed design – then a language invisible to most people – into a universal code of creation and imagination. Although Neville Brody only worked for a brief period on record cover designs before applying himself exclusively to publishing graphics, his covers for Cabaret Voltaire, 23 Skidoo and Fetish Records define the style of those years far better than any manifesto or scholarly disquisition. As art director of Fetish Records he experimented with a new typographic language that he applied from 1981 to 1986 to the design of *The Face*, and then from 1987 to 1990 to the magazine *Arena*. In fact, together with Terry Jones, the art director of *i-D*, Brody defined a new publishing scene that within a few short years had spread like an oil slick across Europe. The two British "bibles" became the paradigm for publications like the French *Actuel*, the Austrian *Wiener*, the German *Tempo*, *Frigidaire* and *Westuff* and the Italian *Dolce Vita*.

In the meantime another tendency was emerging. On both sides of the Atlantic, music and fashion were discovering previously unexplored alchemies. Steven Meisel, Herb Ritts and Annie Leibovitz slipped from the pages of *Vogue* to record cover designs for Cyndi Lauper and Madonna, although the icon that sealed this partnership was indisputably Grace Jones, redesigned through the flair of Parisian photographer Jean-Paul Goude. While Barcelona was emerging from the Franco dictatorship and within a few years had defined a graphic restyling that involved the whole urban network, from industry to cultural institutions and nightclubs, the globalized imagery of MTV was replacing the graphic experiments of the early eighties. And while Peter Saville continues to design covers and is still in demand with fashion gurus like Yohji Yamamoto, Stella McCartney and Givenchy for their advertising campaigns, Neville Brody is exploring the changing nature of the material supports for contemporary visual communications. The paper mediasaurs are acquiring the look of distant memories, fonts are becoming electronic and liquid like the mediascape in which we are immersed. Signs of the times.

LORENZA PIGNATTI

NG
KE

ID
CKS

OLS

34,000

JOY DIVISION · **UNKNOWN PLEASURES**—Inside 33⅓

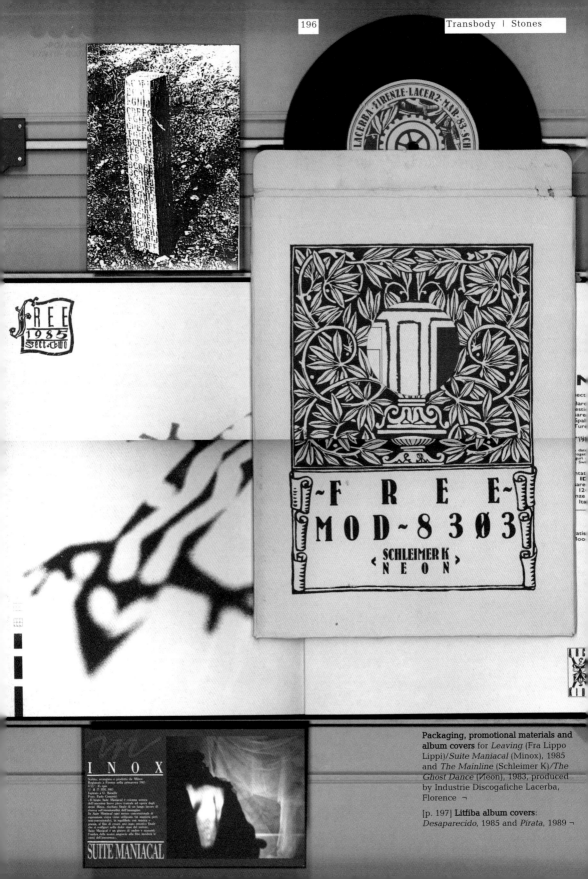

Packaging, promotional materials and
album covers for *Leaving* (Fra Lippo
Lippi)/*Suite Maniacal* (Minox), 1985
and *The Mainline* (Schleimer K)/*The
Ghost Dance* (Neon), 1983, produced
by Industrie Discogafiche Lacerba,
Florence ¬

[p. 197] **Litfiba album covers:**
Desaparecido, 1985 and *Pirata*, 1989 ¬

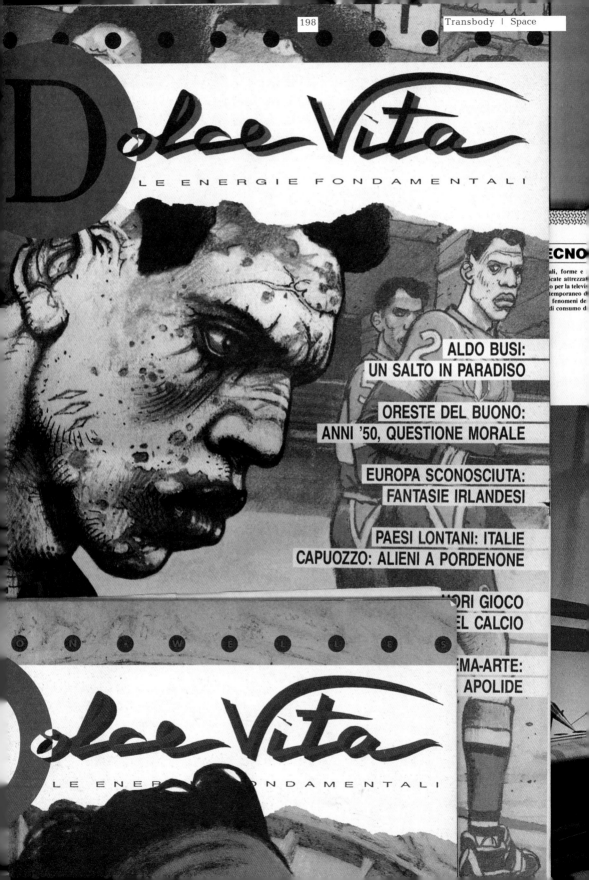

Massimo Iosa Ghini, scenographic project for "Obladì Obladà," Яai 1, 1985, photo Wist Thorpe. Pages from "Technological Ephemerality," *Domus*, no. 664, September 1985 ¬

[p. 198] *Dolce Vita*, comic and current cultural events magazine directed by Oreste del Buono ¬

[p. 200] Pages from *The Book With Νo Νame*, London, Omnibus Press. "The first book of the Νew Яomantics" ¬

[p. 201]

Adam and The Λnts. From *The Book With Νo Νame*, London, Omnibus Press ¬

Spandau Ballet in Νew York, 1982. © Marcia Яesnick/Яetna Ltd. ¬

Duran Duran, photo Paul Edmond. Pages from *The Face*, no. 11, March 1981 ¬

TECHNOLOGICAL EPHEMERALITY

■ An artificial mix of materials, forms and structures: from papier maché to the most sophisticated electronic equipments. A scenographic project for Italian television. An indicator of a contemporary aspect of ambient projection connected to the phenomenon of communication and their rapid image consumption times.

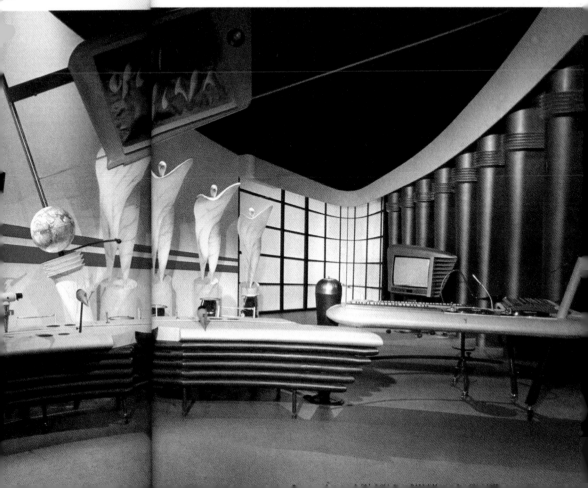

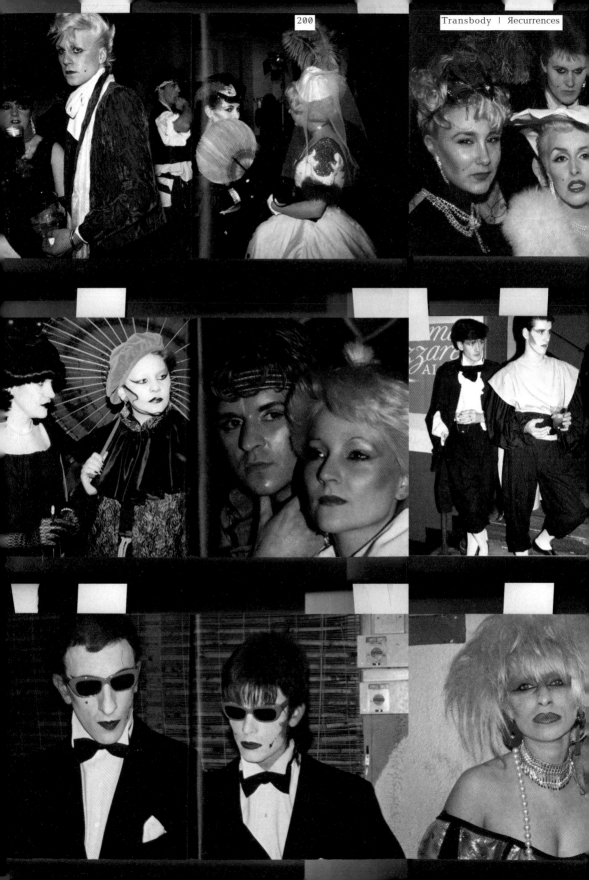

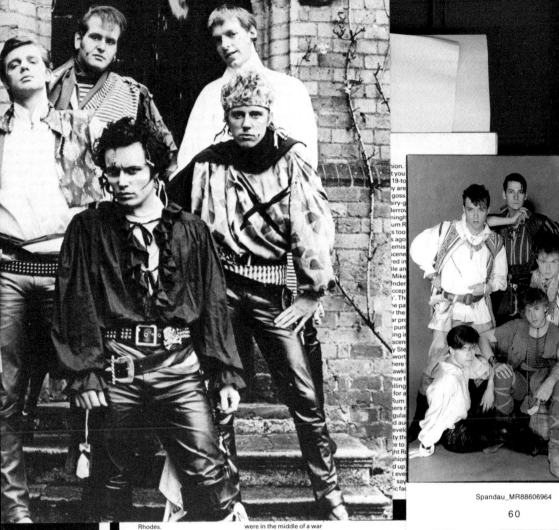

hion.
t you
19-to
y are
goss
airy-g
Berrov
ning
um R
s too
s ago
emis
cene
red in
le an
Mike
Inder
ccep
'. Th
e pa
r the
ar pro
n pun
ing i
scen
y Ste
wort
here
awki
nue f
elling
for a
Rum
ers r
gula
d au
evelo
ty th
ce to
ht R
hion
d up
t eve
say
ic fac

Rhodes. were in the middle of a war

Spandau_MR88606964

Above: John Taylor

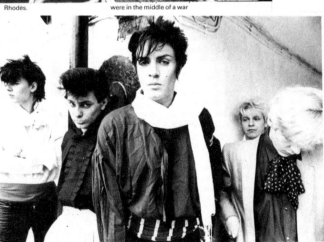

Duran Duran (l to r): John Taylor, Roger Taylor, Simon Le Bon, Andy Taylor, Nick Rhodes.

Cover of *Queen of Siam*, album
by **Lydia Lunch**, 1980 ¬

Billy Idol, photo Richard Croft.
Cover of *Blitz*, no. 33,
July-August 1985 ¬

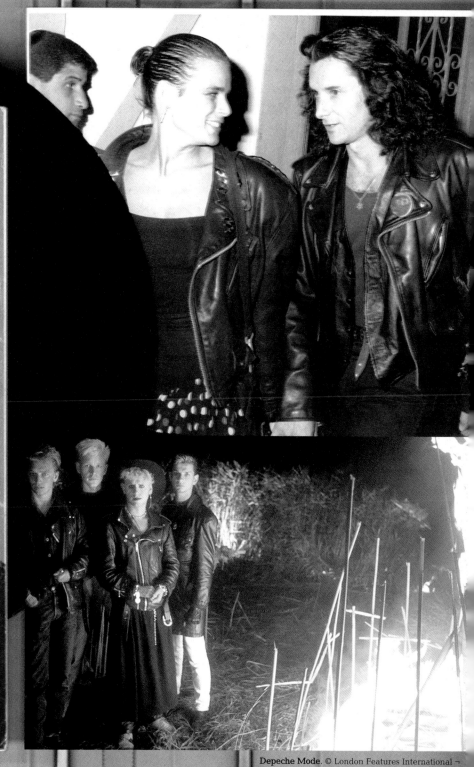

Stephanie of Monaco with her boyfriend Яon Bloom, Hollywood, 15 June 1988. © Photo Masi ¬

Depeche Mode. © London Features International ¬

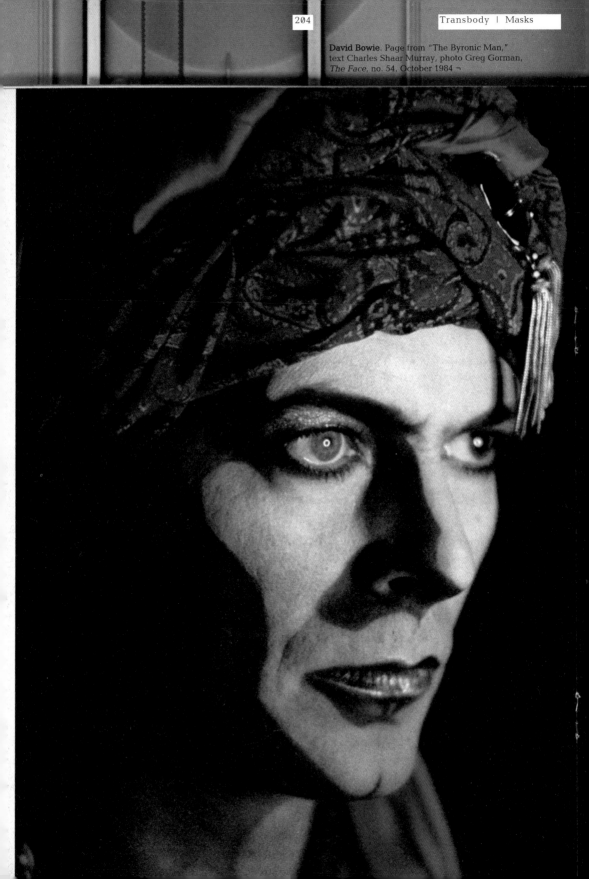

David Bowie. Page from "The Byronic Man,"
text Charles Shaar Murray, photo Greg Gorman,
The Face, no. 54, October 1984 ¬

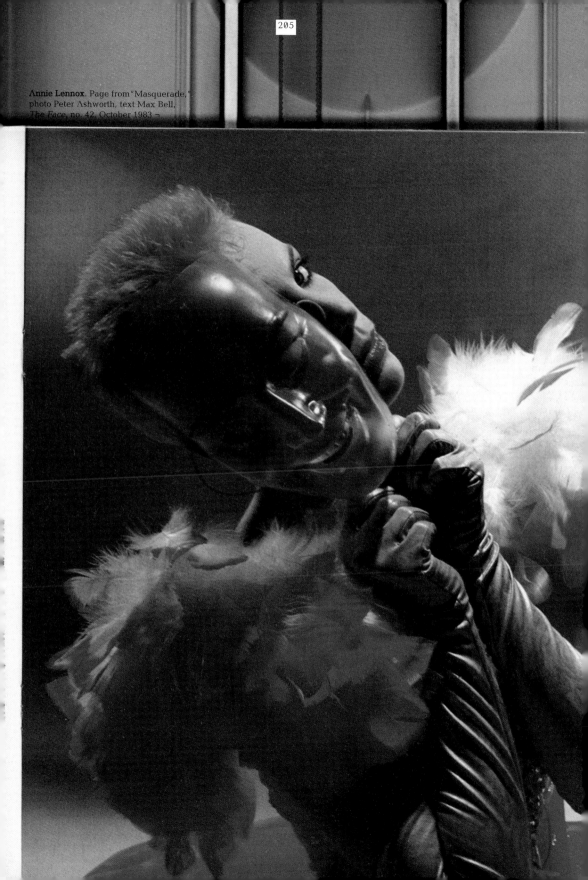

Annie Lennox. Page from "Masquerade,"
photo Peter Ashworth, text Max Bell,
The Face, no. 42, October 1983 ¬

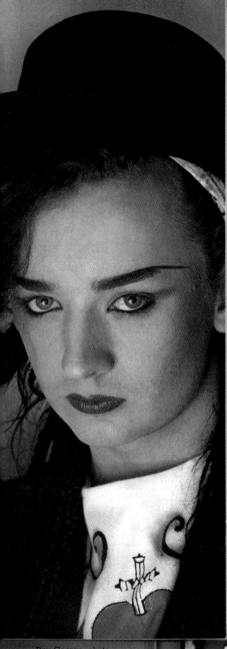

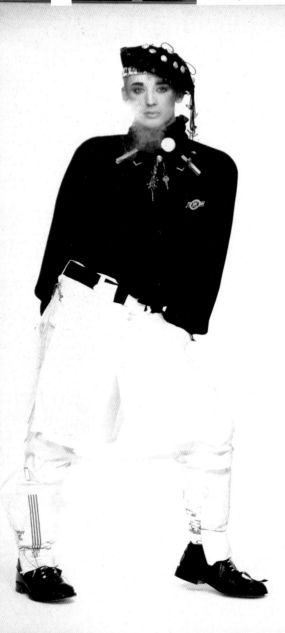

Boy George, photo
Jill Furmanovsky. Page from
The Face, no. 31, November 1982 ¬

Boy George. Page from "From
Luxury to Heartache,"
photo Paul Gobel, text Tim Hulse,
Blitz, no. 45, September 1986 ¬

LONDON TOKYO

153 KINGS ROAD 610 BANKAN
LONDON SW3 6 10 14 JINGUMAE
 SHIBUYA KU 150
10/11 MOOR STREET TOKYO
SOHO LONDON W1

BOY
LONDON

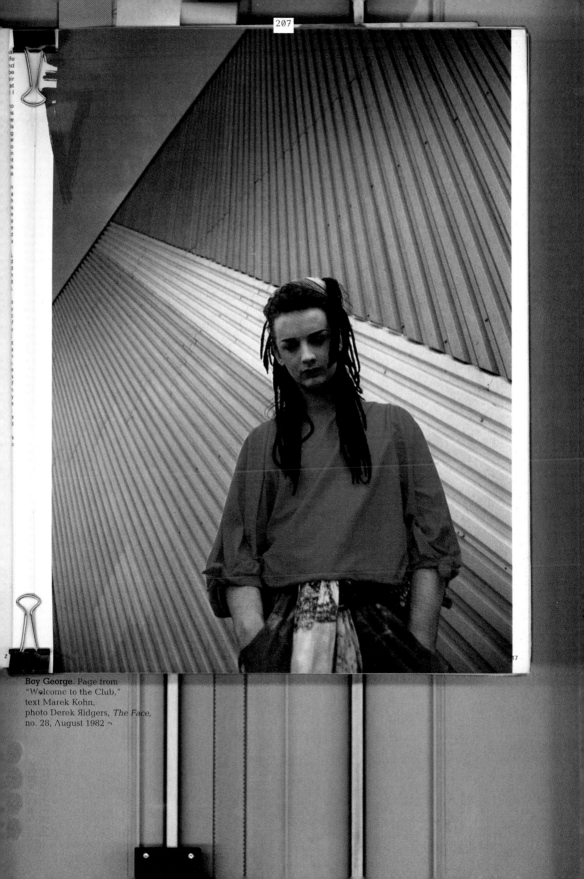

Boy George. Page from
"Welcome to the Club,"
text Marek Kohn,
photo Derek Ridgers, *The Face*,
no. 28, August 1982 ¬

IDERS OF BEAUTY?

SCARLETT

THE FACE No. 42 ● OCTOBER 1983 75p

THE FACE
BODY AND SOUL

THE HIDDEN FACE OF FANTASY SEX
IN THE MIX: SEARCHING FOR N.Y'S PERFECT BEAT
EXCLUSIVE: INSIDE FIORUCCI'S PRIVATE MUSEUM

ANNIE LENNOX UNMASKED · JAMIE REID · BRIAN ENO
GWEN GUTHRIE · MEL GIBSON · CUSTOM SCOOTERS

GRACE JONES: *Living My L*

HER NEW ALBUM ON CASSETTE AND RECORD
HER NEW VIDEO: GRACE JONES /A ONE MAN SHOW
A CONTEMPORARY MUSICAL ENTERTAINMENT FOR TELEVISION

23

ISLAND RECORDS & ON CASSETTE

RACE JONES/NIGHTCLUBBIN'

HER NEW ALBUM
AVAILABLE NOW
ON **1+1** CASSETTE
ALSO AVAILABLE ON RECORD

PRODUCED BY CHRIS BLACKWELL AND ALEX SADKIN

1+1 THE CASSETTES THAT GIVE YOU THE BONUS OF A FREE SIDE OF BLANK CHROME TAPE

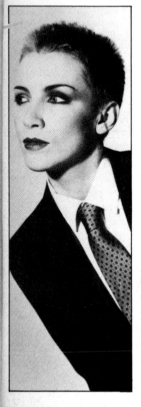

◆ "Sexual alienation, one of
capitalism's foundations,
implies that the social body is
polarised in masculinity,
whereas the feminine body is
transformed into an object of
lust, a piece of merchandise . . ."
Felix Guattari, **'Polysexuality'**
Semiotexte 10

THE FACE 23

A Certain Ratio: radical, intelligent, danceable. Photo KEVIN CUMMINS.

210

Transbody | Λfro

appealing inno... ...n ZE b
the music is sa... ...ntort Y
by a mile. There are others though, gone on to create a
people are beginning to learn. Let's perverse world...

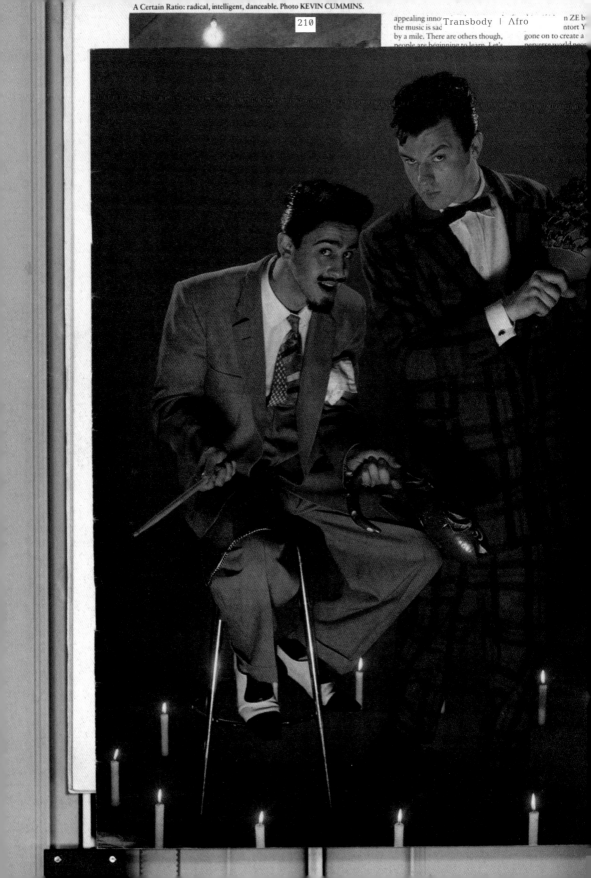

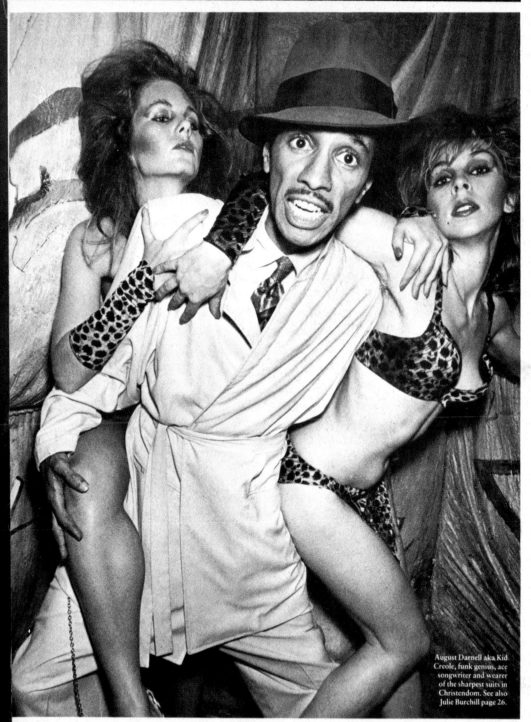

August Darnell aka Kid
Creole, funk genius, ace
songwriter and wearer
of the sharpest suits in
Christendom. See also
Julie Burchill page 26.

The Face 47

[p. 210] **Blue Rondo à la Turk**. Page
from "Rise of the Young Turk,"
text Robert Elms, photo Mike Laye,
The Face, no. 20, December 1981 ¬

August Darnell aka Kid Creole.
Page from "The Mutant Disco,"
texts Steve Taylor and Robert Elms,
The Face, no. 11, March 1981 ¬

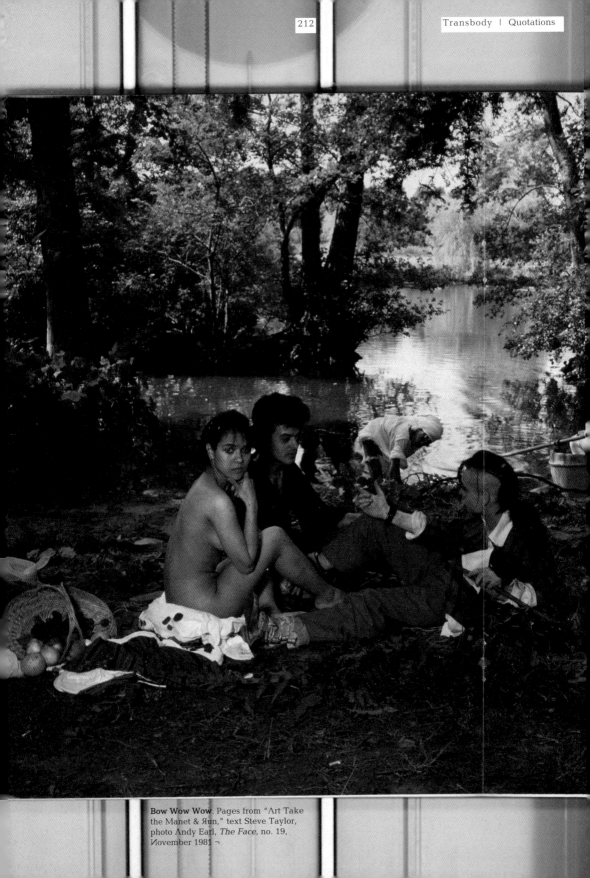

Bow Wow Wow. Pages from "Art Take the Manet & Яun," text Steve Taylor, photo Andy Earl, *The Face*, no. 19, Иovember 1981 ¬

MUSIC MOVIES STYLE

THE FACE

NUMBER 13　MAY 1981　65p
EIRE 91p (INC. VAT)

80 PAGE SPECIAL FIRST BIRTHDAY ISSUE
BOWWOWWOW　MALCOLM McLAREN　DEPARTMENT S
KILLING JOKE　HAZEL O'CONNOR STRAY CAT STYLE　GRACE JONES RONNY

ANNABELLA BY MIKE LAYE

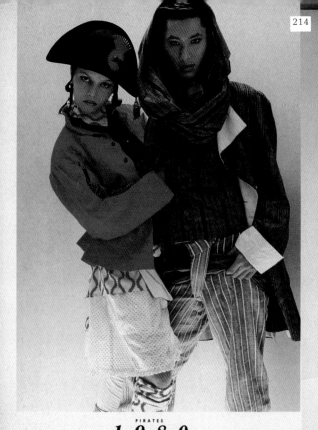

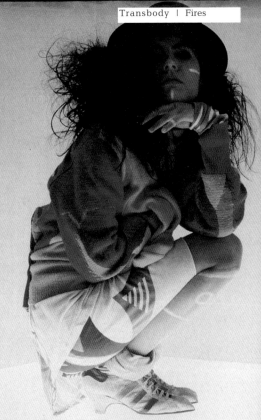

PIRATES
1980

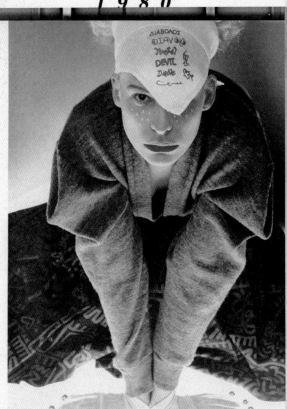

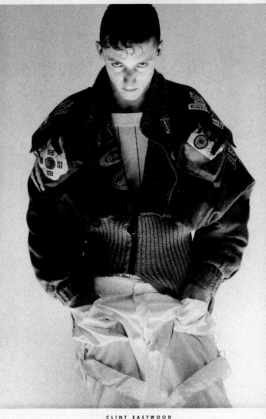

CLINT EASTWOOD
1985

Punkcouture revisited. Bondage trousers and flourescents

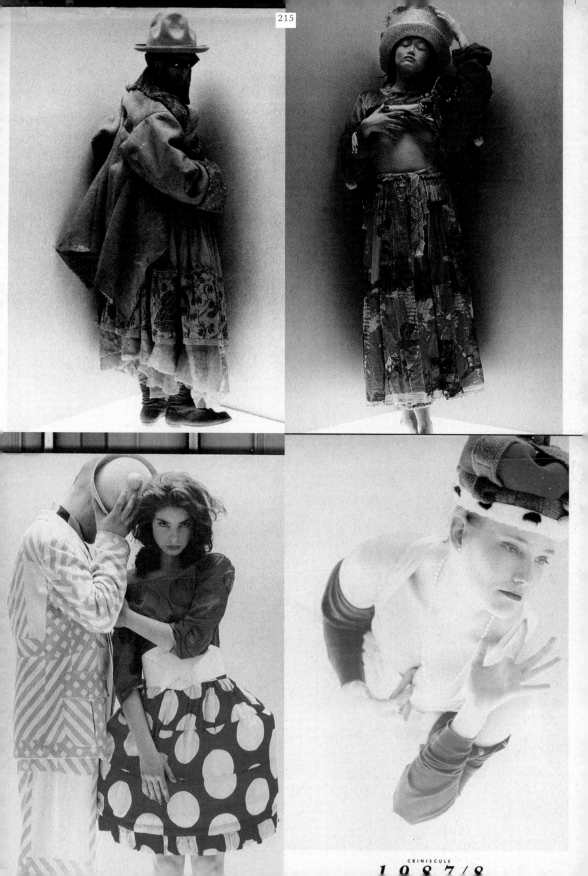

CRINISCULE
1987/8

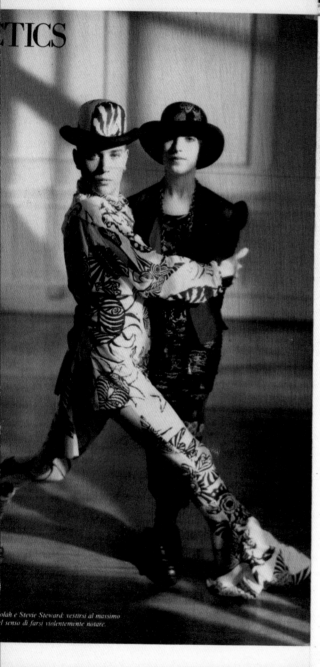

ETICS

olah e Stevie Steward: vestirsi al massimo
d senso di farsi violentemente notare.

[214-215] "**Vivienne Westwood**," photo
Laura Branovan, styling Paul Frecker,
pages from *The Face*, no. 85, May 1987 ¬

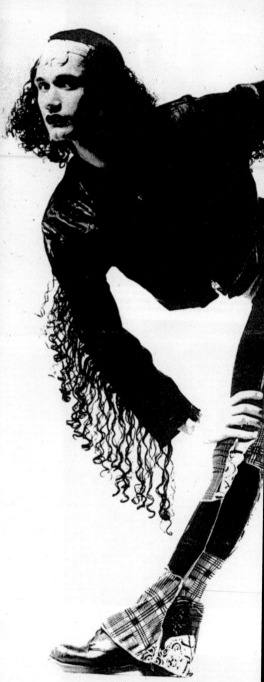

LITZ

(608)

MICHAEL CLARK OFFER — FREE TICKETS

In September the Sadlers Wells Theatre in London will present the world premiere of a brand new show by Michael Clark & Company. Judging by Clark's past reputation (he has been called "the first punk superstar of ballet"), the show will be nothing if not controversial. It runs from 17th-27th September and we have ten pairs of tickets to give away free for the performance of the evening of Saturday, September 20th. Apply on a postcard to Michael Clark Offer, Blitz Magazine, 1 Lower James Street, London W1R 3PN. The first ten received will win a pair of tickets.

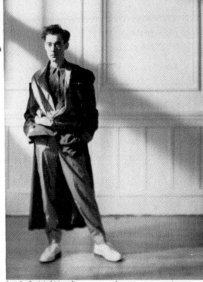

...inard. «I miei abiti vogliono essere molto sexy, provocatoriamente ...skinheads degli anni '60: quelli erano veramente eccitanti. Mi di-...segnare capi apparentemente poveri da vendere ai veri ricchi».

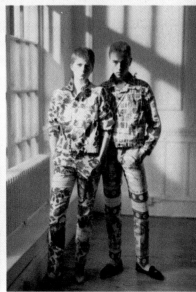

Baba. Da sinistra, Syrie Panton e Mark Lascelle: alla ricerca di un ...gio primordiale tradotto in forme elementari. Per la primavera-esta... zione alla prima infanzia.

...Hayford. Un finto classico esasperato da un tocco di trasgressio-...icolari (per esempio gli enormi revers) e nell'accostamento con-... dei colori.

Bernstock & Speirs. Da sinistra, Thelma Speirs e Paul Bernsto... da-happening per gli habitués di quei locali di Londra che la sera si... mano in sorprendenti fashion-show e passerelle di sperimentazione.

Michael Clark. Page from *Blitz*, no. 45, September 1986 ¬

"Da Londra: Moda come provocazione. Eclectics," photo Tony Meneguzzo. Pages from *L'Uomo Vogue*, no. 158, December 1986 ¬

Leigh Bowery

I met Leigh at the Pyramid Club, at Heaven, when he and Trojan
were doing their *Pakis from Outer Space*, painted blue like Indian
gods. Every time I went out I'd just go up to them and say, "My
God! You look so incredible! You look so fabulous! You look so
genius! Who are you?" and we started talking. Leigh loved to be
adored and worshipped, and I couldn't help myself. I would ask
him, "Where are you going tonight, girl? What clubs are you
doing?" He'd say, "I'm gonna go here, gonna go there, end up at
Daisy Chain." Daisy Chain was a great period for Leigh. He was
there every Tuesday night. All I did was wait for him to arrive.
Every week I thought that he couldn't possibly surpass himself but
he always did. I've never seen him in a look that did not work. He
used to sparkle – I loved his sparkle period. He was like a disco
goddess, half-vogueing, running round like mad in the middle of
the dance floor. Then there were the Taboo years, when he had
"broken egg" on his head or polka dots everywhere; then the
Michael Clark years, and Body Map. We all used to go to clubs
all the time, like a huge disco family: Pearl, Nicola Bateman,
Baillie Walsh, John Maybury, Les Child, David Holah.
Leigh and I became close and started talking on the telephone a
lot, hour-long conversations. We used to talk about everything:
girlies, sex, what he did, what I used to do, from intimate sex to
arts, to movies, this and that, people, gossip. When we started
working together we talked about ideas. That's what I really miss.
The year before Leigh died he worked with me on two collections
– I wanted to have his idea of something totally different. Because
I design ready-to-wear, I wanted someone from the outside who
had a different sense of proportion, of body distortion – to have
his mind in my collection. We traveled to Italy once or twice a
month to look at fabrics. His eye was very good. We would talk
about an idea then I'd sketch it. He'd say, "If you're going to slit it
high, slit it higher! If it's short, make it really short! If it's long, put
a train on it!" *Always* extreme.
Everyone was so surprised about the way Leigh looked during the
day; he was articulate and polite. He used to open the doors for
all the girls who work for me. He was so knowledgeable,
intelligent. You didn't expect it. You'd think, Oh he's just another
disco freak. He certainly was a disco freak, but there was much
more to Leigh than that. He was good at adapting himself to
different situations, like a chameleon. When we went to see the
Italians he was immaculately behaved. But he could be a total
monster to his close friends, or really bitchy, which was fun too.
For example, he always wanted to separate me from my
boyfriend. He would go on and on, on the telephone, until I had to
put the phone down to get him to stop. But he'd ring again. "If
you're gonna start again about Barton, Leigh, I'm gonna put the
phone down!" He'd start again, of course, so I'd put the phone
down and then refuse to answer it. Leigh would easily find
something that would annoy you and just carry on, obviously
trying to string you up. You also never knew when he was telling
the truth and when he was lying. Habitual liar, bless him. I
believed so many of Leigh's stories. He once spread a rumour
that a mutual friend, Brad Branson, had died. He called up Sue
Tilley and said, "Hey, Brad's dead, you know." At the time, Sue
was working the door at the Café de Paris some evenings and so
told everyone who came in. Suddenly, Brad came down the stairs
and Sue nearly fell off her chair! What an extreme thing to say,
that someone had died when he hadn't. Despite all of his
provocations, Leigh was always kind, sweet, inspirational and
magical to me, and I miss him.
Rifat Ozbek, in *Leigh Bowery*, London: Violette Editions, 1998

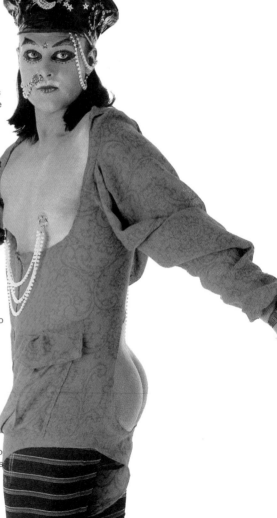

Leigh Bowery, London 1983, photo Sheila Rock.
From *Leigh Bowery*, London, Violette Editions, 1998 ¬

BRIGHT AT NIGHT!

T he Road Safety Council would approve. Be safe be bright, wear something light at night. Fluorescence doesn't come much more extreme. Originally assembled for a fashion show at the Titanic Club, and re-staged as fashion plates by *Tom Dixon*, the stylist, and *Cindy Palmano*, the photographer ● Elise Brazier, of Premier, is the girl modelling the striped lime dress which she made herself. The all-over suit and checked tabard is industrial wear from Neon Safety Products. Socks and scarves from Pink Soda at Hyper Hyper, High St, W14 ● Makeup by Mark Borthwick at Askews ● With thanks to Georgina Godley, Nick Jones for research, the Titanic for location, and Bee Kay Products, Catford, for the signs ●

Extreme fluorescence at the Titanic Club,
London 1984. Pages from "Bright at Night!"
photo Cindy Palmano, *The Face*, no. 48,
April 1984 ¬

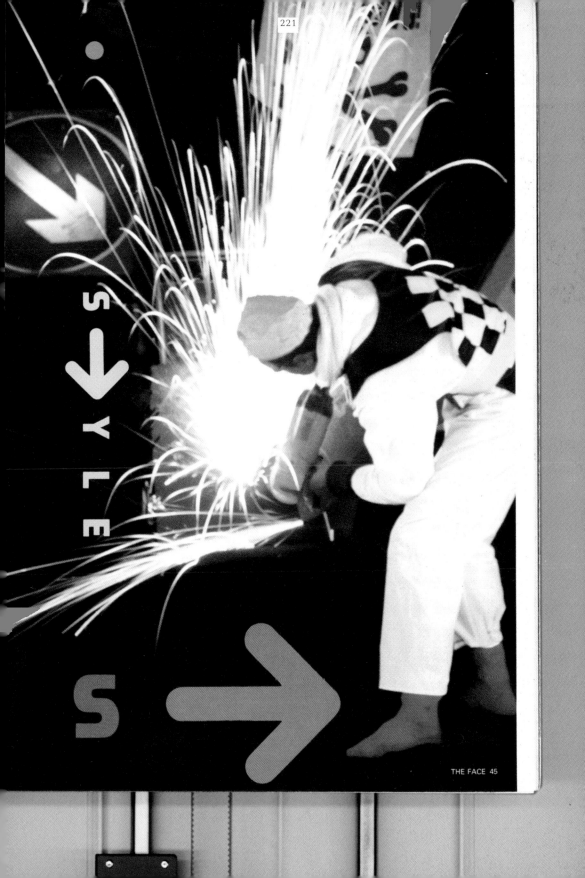

S
↓
Y L E

S →

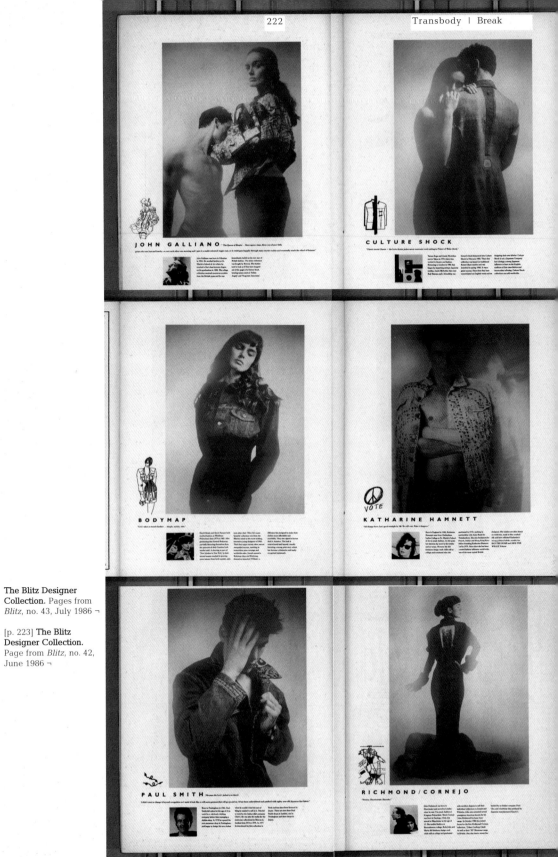

The Blitz Designer Collection. Pages from *Blitz*, no. 43, July 1986 ¬

[p. 223] The Blitz Designer Collection. Page from *Blitz*, no. 42, June 1986 ¬

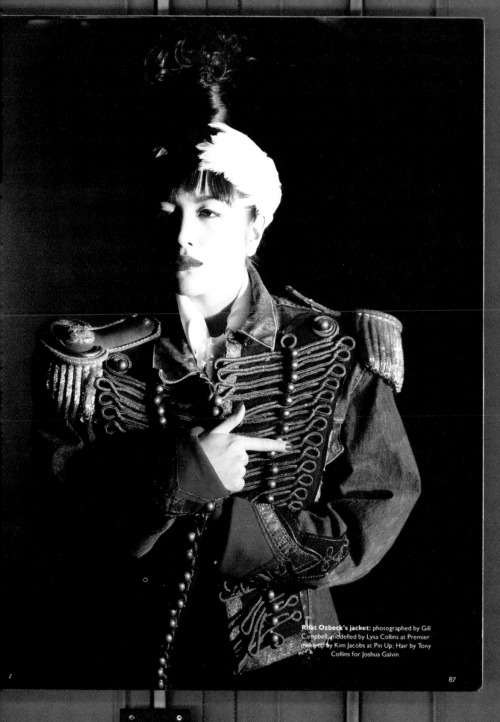

Rifat Ozbeck's jacket: photographed by Gill Campbell, modelled by Lysa Collins at Premier: make-up by Kim Jacobs at Pin Up; Hair by Tony Collins for Joshua Galvin.

WORN OUT
(and about)

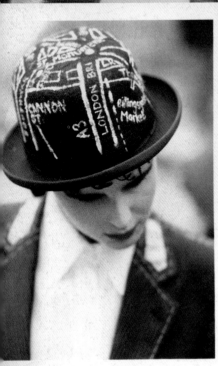

KERRY, singer from a band called Baby ("We play Euro Disco trash"), wears standard issue jacket £25.00 and rubberised kneesmock £15.00 customised by Wigan. "He paints a white square of acrylic onto the jacket and then his own design on top." (Wigan, who has adorned these pages before is currently one of London's hottest types). Skirt £25.00 from Kensington Market, woolly tights £5.00 for The Sock Shop and DM's £34.00 from Camden Market.

Wigan is available for commissions and can be contacted at 26 North Villas, Camden NW1

You'd think the British dandy is spoilt for choice when it comes to commercially-available, idiosyncratic clothes, but in London and the major cities these sharp-dressed (wo)men are so thick on the ground that, in order to stand out, the insatiable high stepper has to resort to drastic creativity.

From the structural transformations wrought – using hooks and eyes – by the ingenious fashion student, to the mass-scale painting, deforming and customizing of clothes that a quick look around any hip watering hole should reveal, one thing is clear: the glorification of imagination over wealth is popular endorsement of the i-D fashion ethics of ADOPT and ADAPT!

SANDY, a model at Wildell Agency, wears bowler £64 £15.00 from Mansfields with fabric dye painted over crown. "I chose a section out of the A-Z for my city look, but next month I'm going to dye it black and put a zip around the top of the crown." Jacket £7.00 from a selection at Twentieth Century Box, customised with cotton and violets. "Just like a railroad jacket before it's finished." To compliment this look Sandy wears shirt £100.00 by Betty Jackson from her new spring collection available from Joshna's Toni and Harvey Nichols in London, also Pinky-thru flat pants £15.00 from Hyper Hyper and DM's from Camden. See our stockists section in Shopping Guide for full addresses.

FRANKIE, a stylist wears her own customised DM's. "It all started when the dog chewed round the edges and I had to use string to tie them to my feet. I gradually started to add things to them and cut a plague out of the leather with a scalpel." DM's worn with white knee high socks £2.00 from The Sock Shop and adjustable length skirt £99.00 by Joe Casely Hayford from both branches of Jones, Harvey Nichols and Hannels in London also Idki No San, Square Changing Room, Primo Vera and Willy's. See our stockist section in Shopping Guide for full addresses.

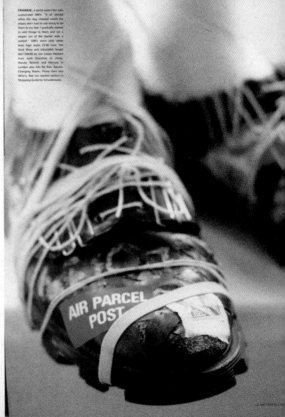

Photography Sandro Hyams
Assisted by David Ross
Hair and make-up Ellis Wakematsu at Z Agency

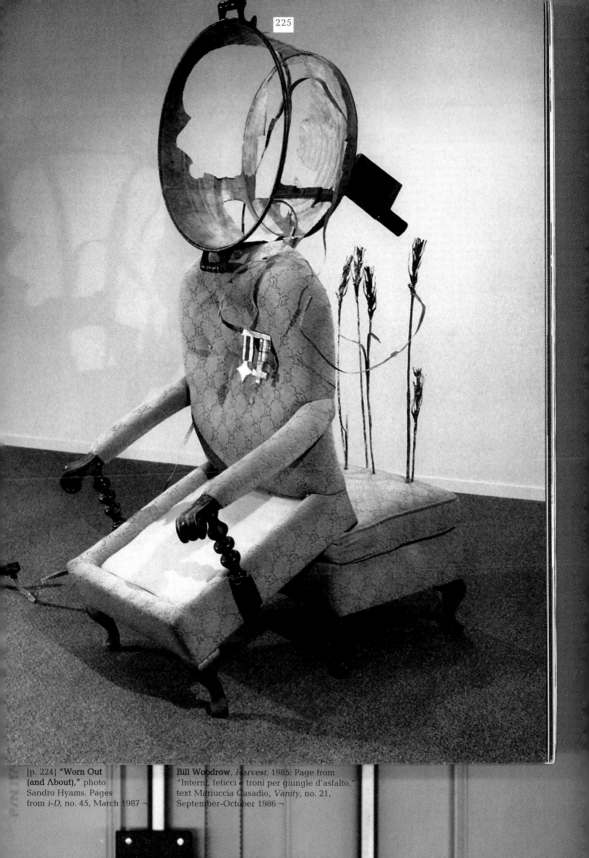

[p. 224] "Worn Out (and About)," photo Sandro Hyams. Pages from *i-D*, no. 45, March 1987 →

Bill Woodrow, *Harvest*, 1985. Page from "Interni, feticci e troni per giungle d'asfalto," text Mariuccia Casadio, *Vanity*, no. 21, September-October 1986 ¬

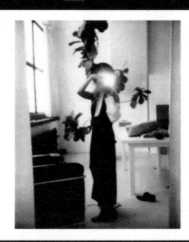

Ann Demeulemeester, self-portrait.
From Stephen Gan (ed.), *Visionaire's
Fashion 2000*, London, Laurence King, 1997 ¬

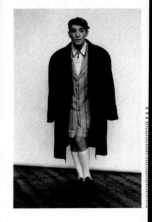

"Foreign Affairs – Antwerp,"
photo Willem Odendaal.
Pages from *Blitz*, no. 50, February 1987 ¬

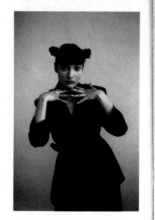

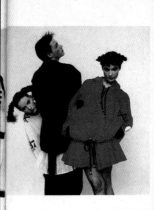

Martin Margiela, spring/summer 1989 collection, photo Marina Fausti. From *La Maison Martin Margiela: (9/4/1615)*, catalogue of the exhibition held at the Museum Boijmans Van Beuningen, Rotterdam. Paris-Rotterdam, La Maison Martin Margiela/Museum Boijmans Van Beuningen, 1997 ¬

Walter Van Beirendonck. Pages from "Primavera fiamminga: Da Anversa a Pitti Trend," photo Patrick Robijn, *Westuff*, no. 6, January-February 1987 ¬

Invitation to **Dries Van Noten**'s fashion show, *Not to Be Modern*, Paris-London, fall/winter 1988-1999 collection, photo Patrick Robijn ¬

EGOÏSTE

N° 6 30 F

DESTIN

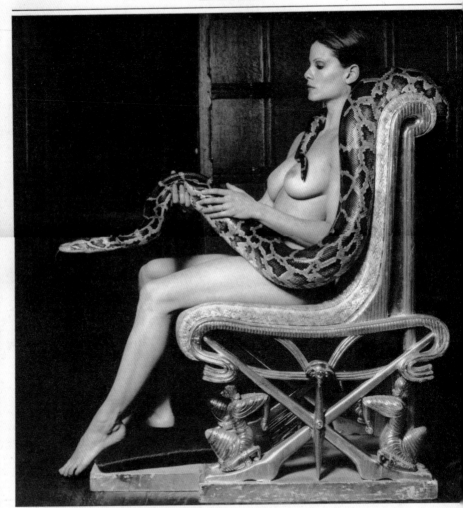

Cette photo, confiée en exclusivité à "Egoïste" est à paraître dans le prochain livre de Lisa Lyon et Robert Mapplethorpe intitulé "Lady" aux éditions Viking Press en mars 1983.

"Lisa Lyon. 'Le Sport est Dangereux' lui avait dit sa mère," texts Bruce Chatwin and Donald Richards, photo Robert Mapplethorpe. Cover and page from *Egoïste*, no. 6, 1989 ¬

[p. 229]

Jack Nicholson and Djemila, photo Martin Reavley and Didier Blanchat. Front and back covers of *Façade*, no. 7, 1979 ¬

"Perversion Fashion," photo Icare Kosak. Page from *Façade*, no. 7, 1979 ¬

Emile Aillau
Ricardo Bof
Roger Corb
Roy Lichte
Lisa Lyon
Abris anti-
Exposition

AUSTRIA : 100 S. / BELGIUM
KUWAIT AND AR. EMIRATES

FAÇADE

DJEMILA

JACK NICHOLSON 007

N° 7. 12 F. NEW YORK $ 4. LONDON £ 2. ROMA L 3000. TOKYO 1600 YEN.

PERVERSION FASHION

Michèle: Mademoiselle. Photo Icare Knsak. Robe, combinaison: Thierry Mugler. Baskets: Sacha. Maquillage J. Clément pour Elisabeth Arden. Coiffure: Guillaume pour Mod's Hair.

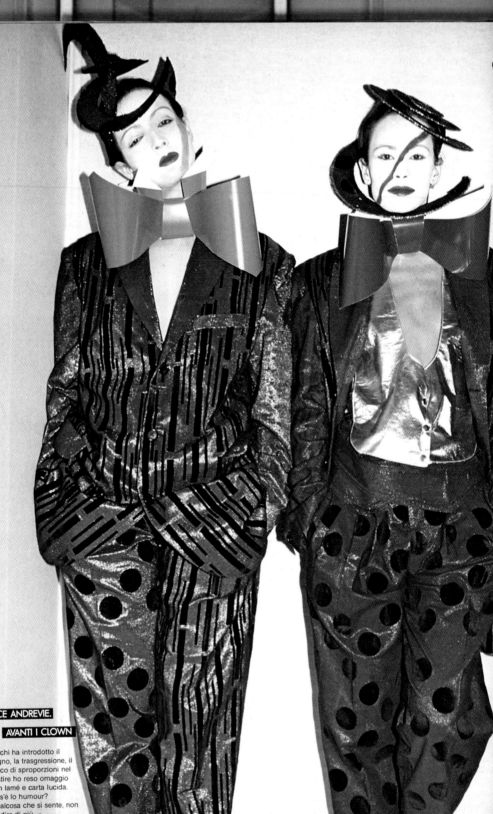

PARIGI AUTUNNO: OGNUNO FA A SE'

FRANCE ANDREVIE.
AVANTI I CLOWN

«A chi ha introdotto il sogno, la trasgressione, il gioco di sproporzioni nel vestire ho reso omaggio con lamé e carta lucida. Cos'è lo humour? Qualcosa che si sente, non so dire di più...».

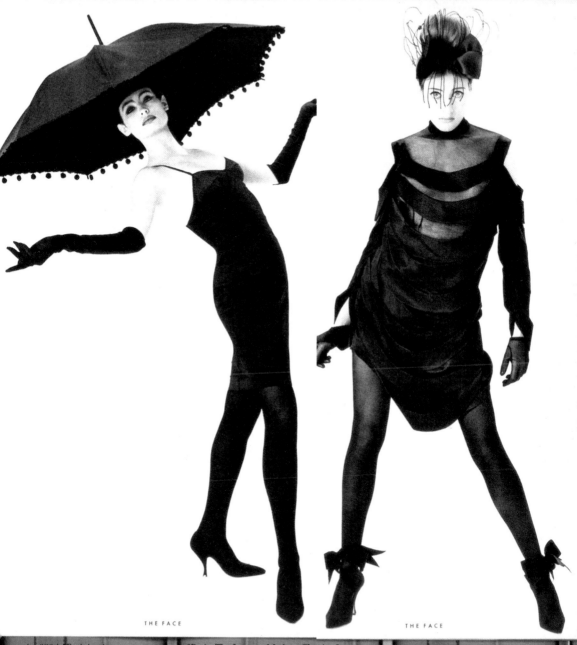

THE FACE

THE FACE

[p. 230] "Parigi autunno: Ognuno fa da sé," text Lele Acquarone, photo Roxanne Lowit. Page from *Vogue Italia*, no. 390, July-August 1982 ¬

"Paris: The Legacy. Modern Classics," styling Elizabeth Djian, photo Andrew Macpherson. Pages from *The Face*, no. 75, July 1986 ¬

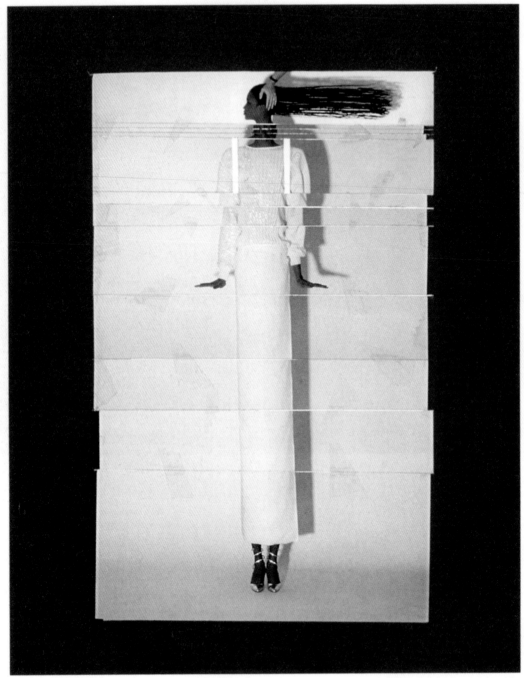

103

Grace Jones in Valentino, spring/summer
1983 collection, photo Jean-Paul Goude,
Valentino Archives. From *Valentino
trent'anni di magie*, catalogue of the
exhibition held at the Musei Capitolini,
Rome. Milan, Bompiani, 1991 ¬

Grace Jones. Pages from
"Jungle Fever: The Art of Jean-Paul
Goude," text Steve Taylor, photo
Jean-Paul Goude, *The Face*, no. 28,
August 1982 ¬

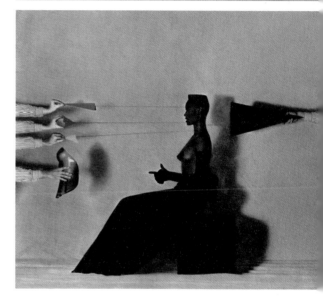

Jungle Fever: The Art of Jean-Paul Goude

It was Jean-Paul Goude who reinvented Grace Jones as "the first black new wave artist," that picture of her on the front of the *Nightclubbin'* album – the angular face topped with an extraordinary flat pill-box hat of hair and the muscular, androgynous torso framed by the exaggerated shoulders of an Armani jacket – which is credited on the back of the sleeve as *a painting!*

It's actually an example of Goude's favored medium, what he calls "true" photorealism, in which a photographic image is meticulously cut up and reassembled with the proportions idealized by airbrushed additions. Take Goude's picture of Grace and her "twin" brother standing facing each other, naked, in the window of a Paris apartment, the Eiffel Tower in the distance. OK, it's Grace's brother all right, but he's been given her face as the point of the picture is to answer once and for all the accusations that flew – when Grace was pumping the gay disco market for a kind of living with "I Need A Man" – that she *was* in fact a man. Certain other parts of the picture have been modified, too: "I gave him a couple of extra inches to his penis to make up for the fact that he was so upset at being given Grace's face," says Goude wickedly.

But, as the haircut indicates, Goude's obsession with recasting reality – which comes down to women's bodies most of the time – doesn't stop at the paste-up stage. Each of his love affairs/artistic projects involved a real woman that he has attempted to redesign sometimes literally in the flesh. Sylvia, Goude's first black girlfriend, was unfortunate enough to be born with a nose "slightly out of proportion to her body." Goude's solution was plastic surgery, to his own drawings, but the surgeon and he argued about aesthetics and "besides, Sylvia got scared."

It was Sylvia who first noticed and pointed out Goude's fascination with black women: "You know, you got jungle fever!" A phrase which has been knocking around in his mind as a "project" for several years and is about to be published here by Quartet Books as a stunning visual record of his work, accompanied by a somewhat narcissistic text cataloguing the women who were fortunate enough to be subject(ed) to Jean-Paul's abiding obsessions.

Steve Taylor, *The Face*, no. 29, September 1982

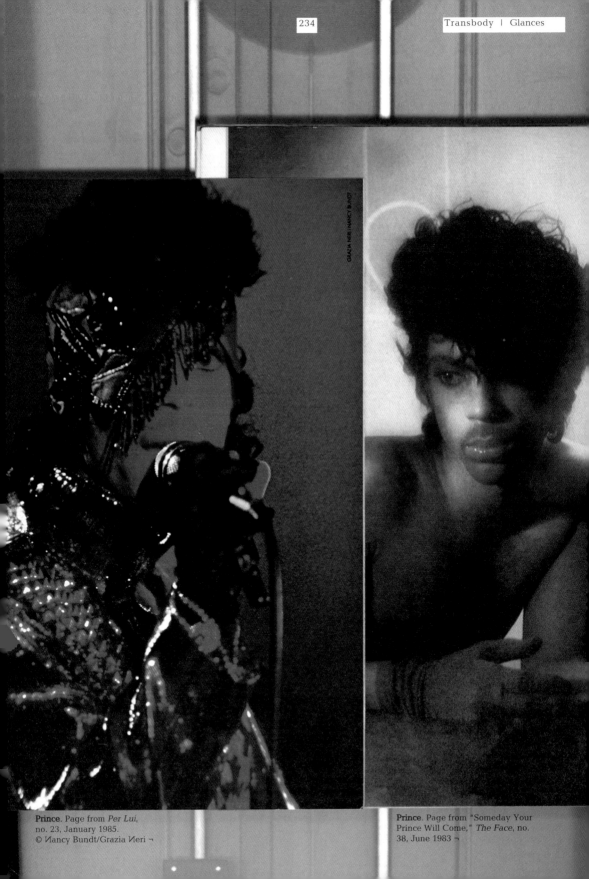

Prince. Page from *Per Lui*,
no. 23, January 1985.
© Nancy Bundt/Grazia Neri ¬

Prince. Page from "Someday Your
Prince Will Come," *The Face*, no.
38, June 1983 ¬

Jean-Paul Gaultier
advertising campaign,
spring/summer 1988 ¬

"La collezione primavera/estate di Gaultier Public:
Eclettismo aziendale," drawings Stefano Cairulli.
Pages from *Vanity*, no. 24, March-April 1987 ¬

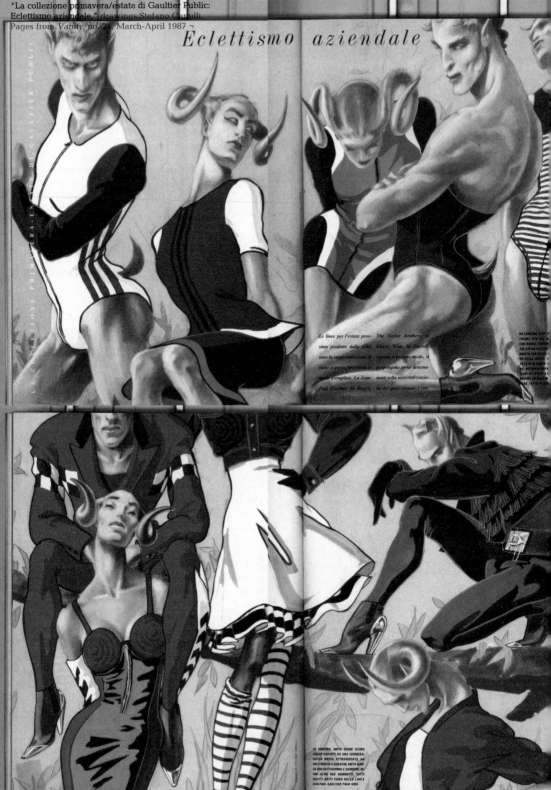

Eclettismo aziendale

Le linee per l'estate pros-
sima prodotte dalla Gibò
sono la rappresentazione di
come si passa fare moda in
modo esemplare. La Jean-
Paul Gaultier, M. Bogg's,

The Taylor Brothers, la
Elastic Wear, la Zuccoli,
usano il proprio modo, si
fregiano come determi-
nanti nella materializzazio-
ne del gusto attuale e con-

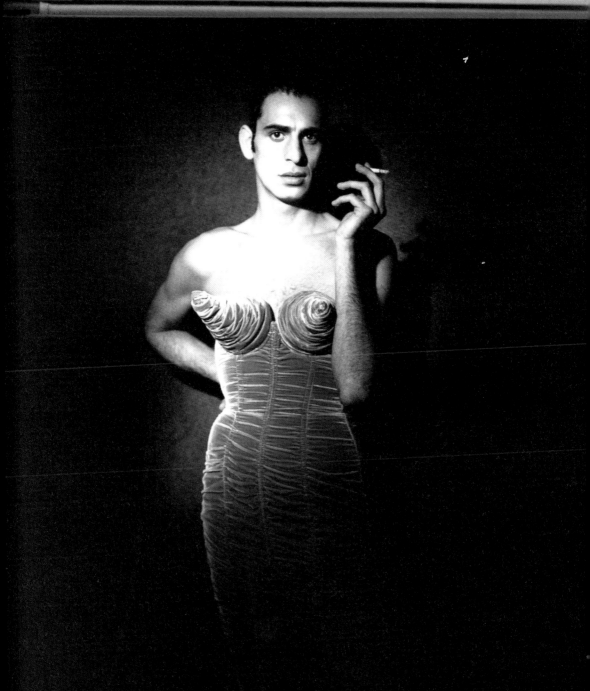

Jean-Paul Gaultier, *Barbès*, 1984
collection, photo Paolo Яoversi.
From Colin McDowell, *Fashion
Today*, London, Phaidon, 2000 ¬

A SINISTRA: BODY NERO CON APPLICA-
ZIONI IN METALLO. A DESTRA: MINI-
GIUBBOTTO IN PELLE CON FRANGE E
BOXER IN STOFFA. TUTTO DI JEAN-PAUL
GAULTIER.

PAGINA ACCANTO: PANTALONE E GIUB-
BOTTO IN PELLE. IN QUESTA PAGINA: LO
STIVALE IN PELLE NERA ADERENTISSI-
MA È RIFINITO DA UNA STRINGA ROSSA.
TUTTO DI JEAN-PAUL GAULTIER.

PAGINA ACCANTO: CANOTTIERA NERA
CON INSERTI COLOR ORO. IN QUESTA
PAGINA: PANTACOLLANT IN LYCRA
ROSSA CON BANDA NERA LATERALE.
LA GIACCA CHE SI CHIUDE CON UNA
ZIP HA AMPIE MANICHE DECORATE
CON MEDAGLIETTE DI METALLO. TUT-
TO DI JEAN-PAUL GAULTIER.

"La collezione primavera/estate di Gaultier.
Jean-Paul Gaultier pour Gibò," photo
Howard Baum. Pages from "25 anni di
Gibò," enclosed with *Vanity*, no. 24,
March-April 1987 ¬

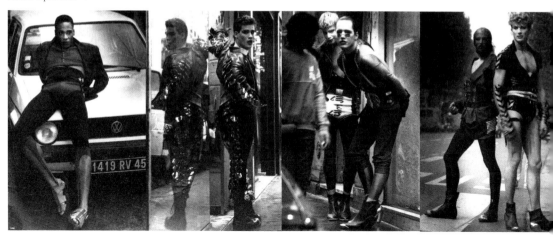

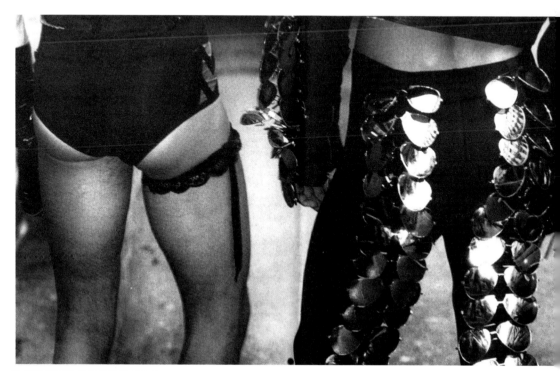

[p. 238] "Moda: Jean-Paul Gaultier pour
Gibò. Eccentiche osservazioni," drawings
François Berthoud. Pages from *Vanity*, no.
23, January-February 1987 ¬

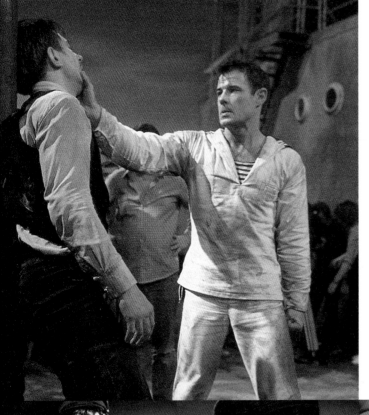

Brad Davis in *Querelle de Brest*, France
1982, director Rainer Werner Fassbinder
© Sygma/Grazia Neri ¬

Claude Montana advertising campaign,
spring/summer 1984, photo Bob Krieger ¬

[p. 241] **Pierre et Gilles**, *Le Marin –
Philippe Gaillon*, 1985,
tinted photograph, 52 x 37 cm.
Project for *X-Man* ¬

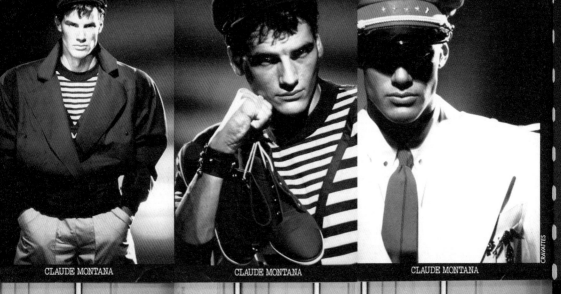

CLAUDE MONTANA CLAUDE MONTANA CLAUDE MONTANA

Le Marin - Philippe, 1985

GENERAL IDEA
FOR
PARKETT
VOL. 15/1988

GENERAL IDEA
FOR
PARKETT
VOL. 15/1988

GENERAL IDEA
FOR
PARKETT
VOL. 15/1988

GENERAL IDEA
FOR
PARKETT
VOL. 15/1988

GENERAL IDEA
FOR
PARKETT
VOL. 15/1988

GENERAL IDEA
FOR
PARKETT
VOL. 15/1988

GENERAL IDEA
FOR
PARKETT
VOL. 15/1988

GENERAL IDEA
FOR
PARKETT
VOL. 15/1988

GENERAL IDEA
FOR
PARKETT
VOL. 15/1988

GENERAL IDEA
FOR
PARKETT
VOL. 15/1988

GENERAL IDEA
FOR
PARKETT
VOL. 15/1988

GENERAL IDEA
FOR
PARKETT
VOL. 15/1988

GENERAL IDEA
FOR
PARKETT
VOL. 15/1988

GENERAL IDEA
FOR
PARKETT
VOL. 15/1988

GENERAL IDEA
FOR
PARKETT
VOL. 15/1988

GENERAL IDEA
FOR
PARKETT
VOL. 15/1988

GENERAL IDEA
FOR
PARKETT
VOL. 15/1988

GENERAL IDEA
FOR
PARKETT
VOL. 15/1988

GENERAL IDEA

General Idea
for *Parkett*, vol. 15, 1988 ¬

ondra: Katharine Hamnett!" photo
ero Toscani. Pages from *Donna*, no.
ecember 1983-January 1984 ➤

harine Hamnett

t Webb So do you think
one person can change the
?

arine Hamnett Yes, people
got to start using democracy
f they think something is
g they should form pressure
s. I'm totally opposed to
ce, and marching is stupid
use they cordon off the
hes and the media don't
them because they think it's
g. You should contact your
everyone did that it would
some effect. . . . The Parents
hers Association is wonderful
use all they care about is
children, and this is when
et concerned. . . . When
e young you tend to think,
shit, if it goes up now I've
a good time," but once you
kids you think "What about
?" I've got two boys . . . this
en I've changed. When you
me a mother to your own
you become mother to them
. Anyway the P.T.A.s are
ecause they are spread
ss the world. If putting
ure on your MP doesn't
you ought to form rotor
ems for telephoning
nizations who you feel are
ravening public safety, and
lock their telephone lines. All
do is get people to dial the
er, ring it, and when they
it up, disconnect. . . . Right?
hen you ring again . . . and
way, POW!

Do you think people
eive that there is more to
arine Hamnett than simply
ans on shirts?

Yeah, sure. I'm a
bination of a threat and a
num's hamper. They think I'm
. . . don't understand me at
ut they understand that my
es sell better than anybody
s . . .

R WEBB, *Blitz*, no. 29,
ch 1985

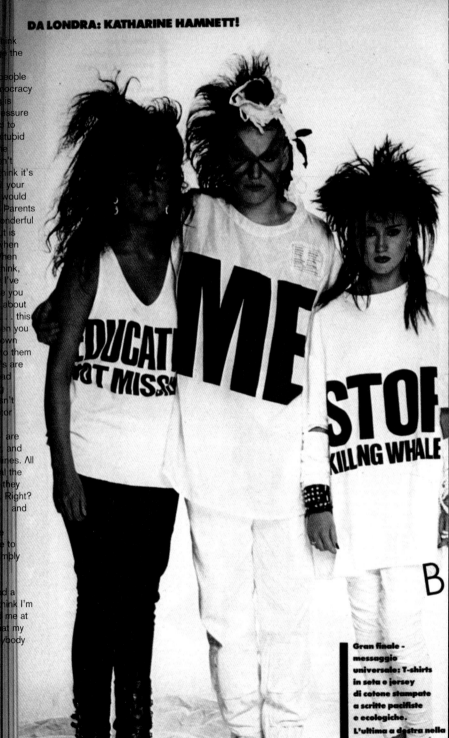

DA LONDRA: KATHARINE HAMNETT!

Gran finale -
messaggio
universale: T-shirts
in seta e jersey
di cotone stampate
a scritte pacifiste
e ecologiche.
L'ultima a destra nella
foto è Katharine
Hamnett, creatrice
di tutti i capi
fotografati in questo
numero di Fantasy.

Oliviero Toscani

WE'RE NOT HERE TO SELL CLOTHES

ONE CHOICE: NO CHOICE *t-shirt from Flip/customised; long zero london net 2, bandage pants by Schlimarzo, fabric from The Fabric Store.*

Pages from "No Nukes Is Good News," photo Mark Lewis, *Blitz*, no. 45, September 1986 ¬

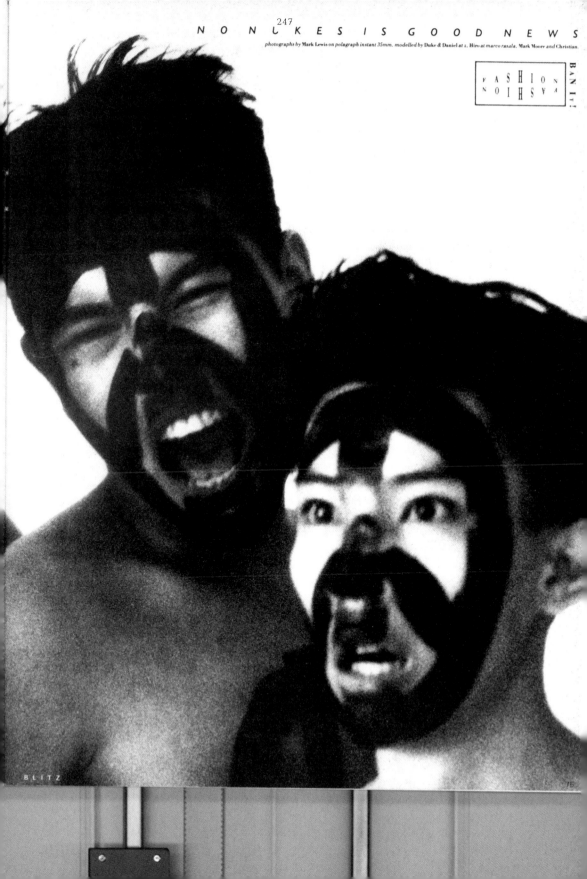

NO LKESIS GOOD NEWS

photographs by Mark Lewis on polagraph instant 35mm. modelled by Duke & Daniel at 1. Hiro at marco rasala. Mark Moore and Christian.

FASHION
BAN IT!

BLITZ

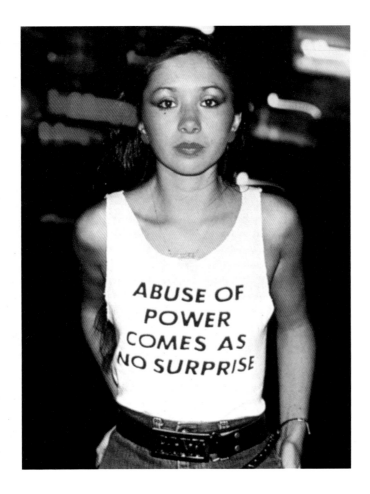

Lisa Kahane, *Lady Pink*,
T-shirt by Jenny Holzer, 1983,
color photograph, 45 x 35 cm.
Courtesy Le Case d'Arte, Milan ¬

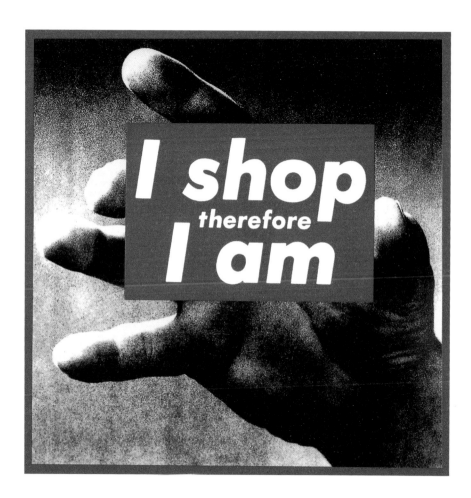

Barbara Kruger, *Untitled* (I Shop
Therefore I Am), 1987,
photograph silkscreened on vinyl,
305 x 305 cm. © Barbara Kruger.
From *Barbara Kruger*, catalogue
of the exhibition held at the
National Art Gallery, Wellington,
New Zealand. Wellington,
National Art Gallery, 1988 ¬

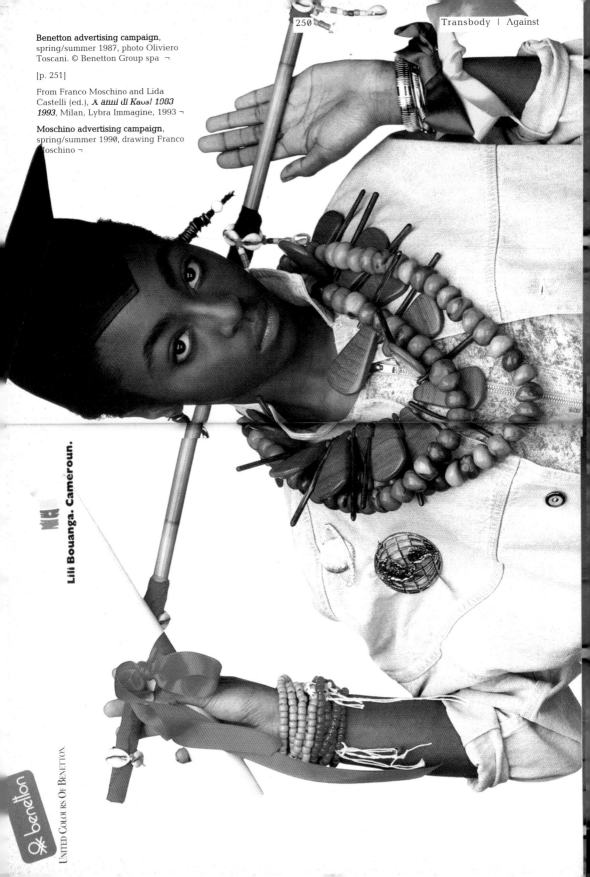

Benetton advertising campaign, spring/summer 1987, photo Oliviero Toscani. © Benetton Group spa ¬

[p. 251]

From Franco Moschino and Lida Castelli (ed.), *X anni di Kaos! 1983 1993*, Milan, Lybra Immagine, 1993 ¬

Moschino advertising campaign, spring/summer 1990, drawing Franco Moschino ¬

Lili Bouanga. Cameroun.

UNITED COLORS OF BENETTON.

CHI SFILA
AVVELENA
ANCHE TE
DIGLI
DI SMETTERE!

*Warning:
fashion shows can be
dangerous
to your health.*

STOP
THE
FASHION
SYSTEM
!

MOSCHINO

||

Graffiti of the Last Century

\
\

Stefano Pistolini

A few months ago. Rome. In the crowded, turbulent suburb of the Tiburtino, a nocturnal event strictly reserved for "VIPs" takes shape. A disused industrial hangar, suitably attractive and gloomy. Inside and beyond the fearsome bouncers at the doors, a vaguely inane happening will take place: an uncompromisingly "street-style" party, paid for and organized by the multinational Nike to promote the presentation of its umpteenth line of sneakers, which – at a price – flood the world as contemporary shoes-with-a-message. Within the hangar, there are a number of "entertainment moments," although there is nary a sign of naturalness, and the feeling is that everyone is behaving as though pre-programmed. Skaters from the capital are busily doing their thing on a pair of ramps; around rough baskets worthy of a Bronx playground, a few kids and the odd journalist lazily spar with brand-new balls; the free drinks proclaim the (new) word of the cooler; old models of high-cut basketball shoes, those in two-toned leather with the large Nike swoosh highly visible on the side, are shown off in soft-lit display cases, like pure icons of modern art.

It's all sort of fake, dismal, melancholic. When all is said and done, this is a commercial festival of the systematic appropriation of a fabulous idea that underlaid a cultural revolution no more than twenty years ago, and today is authoritatively controlled by the capital of generational hype. We end up watching from the sidelines, slightly saddened, and prepare to head for the large gated entrance and join the traffic jams into everyday Rome. However, just as we are about to leave this celebration of You Want America? I'll Give You America!, a well-known face appears out of the twilight. We draw nearer, trying to pierce the gloom with our eyes. It's definitely him: Futura 2000, the living legend of New York graffiti art, the uncatchable spray-paint kid who marked the Big Apple with the colors of an unstoppable, energetic, wild, underground, thrilling, fun, creative, consumable, exhibited cultural resolution in action. Futura is the founding father of hip-hop cul-

ture, a pure creative spirit. Now he's squatting there on a bench, alone, busily decorating a pair of shoes with a can of red paint, with the same ease a rock star shows in signing an autograph. He's small, with a café-au-lait complexion, slightly wrinkled at the age of forty, swallowed up in a parka with the hood pulled over his eyes – as though there were cops to avoid, guardians of respectability to deride or frame on the gaunt walls of a factory or the residual plastered walls of a metropolis that seeks oxygen from its youngest inhabitants. We walk towards him, draw near and succeed in making him talk. What on earth are you doing here, you, the acrylic public enemy number one, in this plastic happening in which the past is a faded dishcloth for mythologizing now inert products, recycled haphazardly like old bread for the imagination of those who, throgh no fault of their own, arrived late? I have to live, he replies, timidly, with a touch of shame. I have a family, you know? You can't make a living off graffiti. At forty I don't want to spend the nights out in the snow signing my name on a building's exterior; I can't carry on doing this if I don't believe in it any more or when popular history has emptied it of meaning, or sold it down the road of commercialization . . .

The graffiti of the early eighties was the exercise book of a formidable explosion of style. It contained cathartic factors such as the contemporanization of the word and of the colors of blues culture, the ransom of an urban marginality that ceased to revenge itself or complain about its subordination, instead taking hold of its own language, perfecting, modeling, reinventing it, obsessively updating it and making it into code and fashion, conferring an unpredictable, atomic allure upon it. Expressions from the sociological lexicon such as "suburb," "ghetto," "racial specifics," shifted weight in the resevoir of popular culture in the making, in its redefinition of psychic tensions circulating in the generational collective. Meanwhile, hip-hop was going stratospheric.

But Futura, so you really don't produce graffiti any more? Of course I do, he replies slyly, for my dear friends like Nike. They pay me well. I go around the world with this gravy train of promotional events, every evening we arrive in great places like this – if only we'd had them in New York when we wanted them. I have marvelous walls to decorate, free cans of spray-paint, journalists to interview me, photos to take with fans smiling in front of my tag. I'm happy, I'm not ashamed. I'm good at it, but that doesn't mean I've forgotten the poetry of the eighties; that doesn't mean I don't recall the fabulous thrill of those nights, with so many friends who now, perhaps, aren't even around any more. This is my life, and in this way I can keep the fire going, even though I know that here it's all like in a theater. Like Buffalo Bill when he used to go around the world with his circus and every evening put on the history of the Wild West for an enthusiastic paying public of unknown strangers. You want to know something? Not even the Bronx is the same as twenty years ago. Time doesn't stop and anyway: to hell with nostalgia.

Futura 2000 is now – as the leaflet states – a testimonial for Nike; he's a hero of style and a street inventor who is playing his last cards as a scribbler for a major player, but demanding at the same time respect for his desire for dignity – because when all is said and done he has opened no shops, doesn't ad-lib in tedious press conferences, nor has he written a book of memoirs. Today, when evening comes, Futura puts on his parka and scribbles his name on the wall, upon command and without risks, contradicting the sense of a gesture, but guilelessly and without betraying the daredevil aesthetic daring that was always required for the task. If exploration were to assume some sort of judicial weight, he would be freely absolved, because hip-hop culture today is where it must be: dissolved into the magma of heritage, contaminations and deflagrations of popular signs. It seems like just a moment ago there was break dancing in circles, the ironically oafish fun fash-

ion of the b-boys, moonwalking, and the world at large was content to note that yes, there were indeed signs of life even among the crumbling metropolitan disasters renamed racial ghettoes. The power of the increasing fashion of the "politically correct"! Besides, the homeland of hip-hop, the New York Bronx, at the time had a sorry fame, fed by the rough cinema caricatures of films like *Fort Apache: The Bronx*. The reality, for the few visitors venturing in to discover this new world, proved different, certainly turbulent but less laconic and humanly rundown than the newspapers and TV programs would obstinately portray it. In the early eighties (while everyone was celebrating the Thousand Lights of the city of rampant yuppiness), if you steered clear of the criminal inner circle, in the Bronx it was not the gangs who ruled the Bronx, but the crews – large, relatively peaceful groups composed of both sexes who were in competition, but not at war, with each other through a contest of style, visibility and creativity. The places where the "clashes" occurred were the schools, social centers, private parties and summer parties in the parks. Graffiti artists, disc jockeys and MCs (masters of ceremonies, those responsible for injecting life into a party) were the cutting edge of these groups' expression. The groups themselves were often divided by the block they lived in and belonged to ("oral and wall culture" was how the first rap sociologists would timidly define them, underestimating the iconographic tension hip-hop had from the outset, its desire to give itself a history and represent itself), with an increasingly dominant role played by music as the crew's language and common ground.

Soon, however, over the space of a few seasons, and once the expressive production of the crews reached levels of excellence, virtuosity and great entertainment – and once they began to be talked about outside the neighborhood and the ghetto – the decisive move was made: given that the city was still scared of the idea of meeting young blacks and Puerto Ricans, they would be the ones to launch an assault on the city with their fragmented image of toughness, their attitude and their dynamic, highly descriptive and exhibitionist language. With clothing that was itself provocation and spectacle, a fusion of past and present, technical and crazy, sport and soul culture, Africa and America. Mythical names immediately began enter circulation: Fatback, Sugarhill Gang, Enjoy Records, Grandmaster Flash. It didn't take much for the Zulu Nation of Afrika Bambaataa to spring forth and flourish beneath a simultaneously pan-cultural, religious, political and buffoonish umbrella. Fab Five Freddy and Jean-Michel Basquiat transported their art synchronically from the art galleries of the suburbs to those of chic Manhattan, and *Wild Style*, the great film by Charlie Ahearn (1982), easily served as ambassador of the new word far beyond the borders of New York City.

The most clued-in clubbin' managers in the city pricked up their ears: if there was an ever increasing number of night-birds prepared to undertake a voyage as far as the Bronx River Community Center to try out the latest the city had to offer, why not try to shift all those sounds and atmospheres to where entertainment and cultural exchange traditionally had always taken place night after night? The Mudd Club, one of the coolest in the city, opened its doors to rap and it didn't take long for Malcolm McLaren, an exile following the New Romantic flop in London and manipulator of trends *par excellence*, to sense the devastating potential of the latest trend to arrive from the black part of New York. It was a short step from there to accelerated contaminations of all sorts. Other legendary clubs such as the Roxy and the Negril hurried to join the trend, and the frenzy took off.

Other human factors of contamination penetrated what was by now a cultural wave rather than a racial one: Tom Silverman and Bambaataa founded Tommy Boy Records, white DJ Arthur

Baker began to produce one rap success after another, and the 1983 box-office success of *Flashdance* contained a sequence in which Crazy Legs of the Яock Steady Crew performs in the streets of Pittsburgh. Hollywood was already beginning to eye hip-hop. The acceleration was dazzling. Лnd the black intellectuals began to give out warning signals: watch out – these kids haven't been working in a vacuum. We need to look back; it is vital to pay homage to their forefathers. There would have been no rap, there would have been none of the thousand manifestations of hip-hop culture without the griots of Иigeria and Gambia, without toast, signifying and dozens, the songs of chain gangs and soldiers, the singsongs to make children play. Лnd, of course, without doo-wop, chapel choirs, Muhammad Лli and Gil Scott Heron, vaudeville, tap dancing, Cab Calloway and bebop, Bo Diddley, disco, not to mention the who's who of urban and country blues, the philosophers of jazz, and the experimenters of rock'n'roll. (Today the thought comes to mind that Eminem, the white and supreme media star produced by rap should, more or less unconsciously, also claim the same genealogy, adding a considerable baggage of European and even Teutonic origins, showing for the umpteenth time that popular culture is nothing more than a mixed, prehistoric soup, unable to stay still, confined, with clearly-defined ingredients . . .) Λ posteriori. The pleasure and shock of the original hip-hop lay in its skeletal essence. Hip-hop showed itself able to translate values and aspirations into a moment, presenting them through a series of distorting mirrors. Лfter all, hip-hop from the outset had no shame (and was in a hurry). Лt the very moment that it strengthened its system of communication beyond the instantaneous local event, it shamelessly took hold of the basic tenets of capitalism: aggressiveness and competition, the law of dog-eat-dog.

Criticism and the historicization of hip-hop have anyway always ranged themselves behind its double-sided nature. Too much, for example, has been written in populist tones in celebration of hip-hop as a spontaneous "voice" of the street (there is some truth in this, of course, but from the outset it was also characterized by sometimes merciless exploitation and a shameless, mocking impudence). Perhaps too much emphasis has been placed on the "truth" of the street that rap and hip-hop should have contained in a sort of spontaneous proto-socialist solidarity, "an aspiration to pride and dignity against a dehumanizing system that only judges people on the basis of their economic worth," as Simon Яeynolds writes in *Blissed Out*. Perhaps thereby leaving out an essential aspect of its nature, its "not being a harbinger of revolution, a resistance made of self-esteem, but rather an almost psychotic manifestation in its negation of vulnerability, romanticism and dependence" embodied in the figures offering themselves as proud promulgators of the idea. Essentially, in many of its manifestations, hip-hop projected itself as a hyperbolic reflection/distortion of the capitalist system. Иot by chance, in its most extreme forms (curiously, those destined to become the most commercial, those that were trendsetters) the hip-hop image was irresistibly attracted to the language of criminality – from Schooly D right down to the Tupacs and the Los Лngeles kingdom of Dr Dre. The criminality of gangsta rap is not a subversion of capitalism but its caricature, or access to the capitalist symbols that the use of conventional channels prevents for economic, social and above all racial reasons. Criminality forms a part of the expressive jargon of hip-hop as the nihilist metaphor of opportunity. But at this point, original hip-hop culture is already long gone, and even useless in its former innocence and serene local rhythm of former times. It is distant, seminal, unrepeatable: as far away – to adopt an analogy we might understand – as May '68, the sweet Parisian month, might seem in the eyes of some battered survivors of the psychotic travels of the seventies.

THE HIPPEST PARTY OF THE EIGHTIES

\
\

Alix Browne

Nostalgia is not, as the powers that be would have you believe, a sentimental yearn-
ing for the way things were. Nostalgia is that sinking feeling that the best party in the
history of the universe was the one you weren't invited to. And as far as fashion is con-
cerned, the best party in the history of the universe was the eighties.

A certain amount of embellishment in fashion is to be expected, the trend for rose-tint-
ed lenses being what it is. But reliable first-hand sources on what the eighties were
really like are few. Some fashion veterans, like designer Claude Montana, the cult of
cults, or performer Joey Arias who decked out in gold cowboy boots, masterminded
merchandising and chased down shoplifters at Fiorucci in New York City, are more
than willing to sit down over a cup of coffee, but quickly become vague when pressed
for details. "Sometimes I don't even remember what I did," Claude Montana once told
me. "I see a photo from an old collection and think wow, I did that? When? When was
that?" This can only be interpreted as proof of the time they put in the fashion trench-
es. The years, the parties, the people, the clothes, the music all crash together in one
big beautiful blur. Then there are those who are simply trying to live their own eight-
ies down. People who now have important jobs and normal haircuts and who don't
really care to publicize the fact that they used to run around in tights and something
that could have very easily been mistaken for a superhero's cape.

No, these are not the people who are nostalgic for that decade, but rather those who
growing up in far flung corners of the world – Kansas City, Cleveland, Los Angeles –
with MTV and *Dynasty* and *Details* magazine to feed their fashion-hungry imagina-
tions, could only wrap two or three or ten different colored Benetton scarves around

their necks and press their noses up against the glass. What would be for many the first glimpse of fashion was fashion at its all-time high. In impressionable minds every-where, the fashion capitols of New York City and London and Paris were populated by men in skirts and eyeliner and women dressed like something out of a Thierry Mugler sci-fi fantasy. (Were they not?) And most significantly, these people were not just sport-ing a total look, they were living a total life. New Wave wonder. New Beat freak. New Romantic rebel. Pirate, punk, supermodel. Madonna/Boy George/Robert Smith wannabe. It's not what you wore in the eighties, but who you were.

But by the time we all got out of high school and out of Los Angeles, or Kansas City, or some unpronounceable town outside of Vienna and arrived in Paris and London and New York, the party was already over. A young Jeremy Scott, visiting Paris for the first time in what were already the nineties, was profoundly disappointed to discover that the women on the streets weren't walking around like they'd stepped off the Thierry Mugler runway. "I guess they had already disappeared," he sighs. But not only did-n't we get to go to the party, we were enlisted to participate in the cleanup. Our age came in the so-called minimalist nineties. A sort of penance for sins of excess we did-n't get to commit. Not that the nineties were a total wash. I would not trade Helmut Lang for Thierry Mugler in a million years. And the industry is still feeling the reverb of Fabien Baron's *Harper's Bazaar*. But there is no denying that the climate had changed. The irrational exuberance of the eighties had become cool and, more impor-tantly, calculated.

Revivalism in fashion is often equated with creative bankruptcy. But eighties revival-ism is another creature all together. It has reared its head at various points and with various degrees of fleeting success over the past several years in different forms – the Michael Jacksonesque silhouette favored by Balenciaga designer Nicolas Ghesquière, Stephen Sprouse graffitied products at Louis Vuitton and for the mass chain emporium Target, stylist Katie Grand's brief, Claude Montanaesque turn at Bottega Veneta, the return of Le Sport Sac, anything with a logo on it. The list could go on for days. The eighties, it seems, are the prism through which all fashion ideas of a certain generation must first be refracted. But while this longing for the eighties is given material sub-stance in leather asymmetrically zipped jackets or sweaters with dogs on them, it is not the stuff of the eighties that we actually crave, it is the eighties themselves. That moment in time when everything was fashion and fashion was everything. Really, I don't care how nostalgic you are, nobody in their right mind misses those shoulders.

It has been up to this generation to create a new fashion fantasy in its own image. We are not apologizing for our nostalgia but making the most of it. Leading the movement are people like designer Jeremy Scott, whose motto has always been live the dream (and who actually has done the full shoulder pads thing), or the artist Francesco Vezzoli, who in his videos and embroidered installations is making up for lost time. "Basically when I was ten years old I wanted to go to Studio 54 and I tried to convince my grandmother to take me to New York," Vezzoli has said. "Here, I've made up my own Studio 54, made up for the nostalgia for Studio 54 or whatever may have been in my mind. Had I really gone to Studio 54 probably I would have turned up on the wrong

night, maybe they would have left me outside, maybe they would have not let in my grandmother or whatever, so it would have been a shattered dream."

If you don't believe in the driving power of this sentiment, consider this story: back in the fifties, a young American soldier returned to Chicago after having done his patriotic duty in the Second World War. Raised on tales from the roaring twenties he returned home to middle America in the fifties to find only disappointment and disillusionment. Where was the celebration? And why were hemlines going down? Right then and there he made it his lifelong ambition to make up for the party he was never thrown. His name was Hugh Hefner.

Malcolm McLaren, "Cannibal of Looks and Sounds"

\
\

Luise Neri and Malcolm McLaren

Louise Neri You're currently working on a new music project, *Fashion Beast*, which grew out of an idea for a screenplay that you hatched with Alan Moore in the late eighties when you were living in Hollywood. *Fashion Beast* explores the "chip music" phenomenon with Chinese girl rock band, Wild Strawberries, and will be released exclusively as a set of six vinyl 45s, each with an accompanying comic book. Interestingly, chip music derives from the sampled sounds of eighties Gameboy culture, and three years ago, the New York hip-hop community made an album in tribute to your eighties hit, "Buffalo Gals." So, given these events, it's the perfect moment to look back at this period and discuss the seedbed of creativity that you helped spawn.

Malcolm McLaren The eighties saw the arrival of the first video games, Space Invaders being probably the most popular. Everybody flooded to video and amusement arcades to play them. Those machines had a sound very different from the typical pinball machines that had come before. This sound was digital, very lo-fi, 8-bit.

Twenty years later, we live in a world of 96-bit, that is to say, incredibly refined digital sounds. Most pop music today is made on highly sophisticated digital machines. The resulting sameness has become for some people, myself included, very boring. In the pop culture of the new generation, as with any generation, there is a desire to return to the roots of the culture, or rather, what this generation may consider as being "authentic." For them, this authenticity is to be found in the new world game culture of the eighties, by listening to and playing early video games, the earliest source of digital sound – Nintendo's Game Boy, Space Invaders, Donkey Kong, and so on. The sound is, for all intents and purposes, much better than any other synthesized sound because every other synthesized sound is emulat-

ing a kind of analogic sound, like a church organ or a drum kit. This sound is a sound of itself; it's not trying to sound like anything else other than a video game from the early eighties. That *is* the sound. It has a desired authenticity. Up until now, it has been negligible, "unimportant," and not musical in the traditional sense of the word. It has not previously been incorporated into the pop culture, that is, it has not even been represented.

It will take this new generation to establish that sound. There are signs of it rumbling from Chicago to Stockholm to New York to Detroit and places completely off the map that all come together thanks to the information revolution of the Internet and available laptop technology. This is enabling them to create a sort of tribe or movement, described as "chip" music – "chip hop," "rock'n'roll Gameboy," and so on, all kinds of musical genres written on Gameboy programmes. Some kids just play the music; others are "reversible engineers." They hack into this antique technology that provided these sounds in the first place (Commodores 64s, Ataris. Amigas and Gameboys) and invent new software that can be easily downloaded and plugged in, thus converting these machines into musical workstations that allow one to compose at will.

It's as if the Nintendo generation is sampling its own youth. So this game technology gives to the laptop musician the same importance as a Fender Telecaster guitar gave to a sixties rock n' roll musician or a saxophone to a thirties jazz musician.

It's like a video arcade gone mad. It's wonderful, very rock'n'roll, incredibly cheap. It's so bloody uncontrollable. That's what gives these sounds and their medium such an anarchic quality. You can't control it, it's constantly shifting, a soundtrack that remains a perpetually unfinished body of sound that can be constantly interacted with, updated, changed.

LM So, in fact, it's stochastic rather than digital, no longer confined to the grid?

MMcL That's right. The digital has been made organic. This is what these kids love about 8-bit, its organic nature, to the extent that their preferred format for the finished work is the standard analog of vinyl 45, just like the singles market in the eighties. In a world that has become so virtual, where you're i-podding this and downloading that, where CDs have become nasty and disposable, not collectible, not exclusive, not cool, something about the black, fetishistic nature of the vinyl 45 has made it once more highly fashionable and sought after.

LM It's an antidote to the prophylactic nature of Internet and CDs. Vinyl puts sound back into a "fleshy" form. Unlike ether (Internet) or digitally recorded polycarbonate (CDs), vinyl is susceptible, vulnerable, able to be scratched, used, played.

MMcL A collectible must be a real object, one that is exclusive, not easily reproducible. Over several decades, the vinyl 45 gave rise to a particular kind of crude, do-it-yourself sleeve artwork that became associated with what we call "underground." The new underground movement of chip music and its expressions is what is currently suggestive of the "look of music" of today and the "sound of fashion" today.

LM When you talk about the roots of this new music, what about experimental electronica from an earlier time?

MMcL This new music is experimental in the same way that Kraftwerk was. Kraftwerk, a typically eighties group, could be considered to be the grandfathers of this new generation, because Kraftwerk invented their own instruments. So yes, chip music is electronic music taken to a different level. It's very anarchic.

LИ But what about the even earlier period in avant-garde electronic music – of Яeich, Cage, Stockhausen, Xenakis?

MMcL Sure, they've always been around on the scene and they can always be brought in to give a scene some credibility. Some of the more artistically leaning creatures of the chip-music world would probably know who you are talking about, much more than they would know Elvis Presley. Does it matter? Иot really. Лfter all, it's pop music.

LИ Talking about do-it-yourself, let's go back to the days of your King's Яoad shop. There, you made unique clothes by reworking or recombining existing clothes. Л recombinative dictate of fashion followed, everyone started making their own version of this impulse, which expresses itself today, (that is, beyond the street) in labels like Maison Margiela and Imitation of Christ.

MMcL I customized and deconstructed clothes in order to learn how to make them. When I left art school at the dawn of the seventies, I ended up on King's Яoad and went into fashion. It wasn't unnatural or surprising because I came from a family of tailors and dressmakers. But the last thing on earth I was trying to do was to make fashion. My aim in life was to make trouble!

I saw that King's Яoad was a wonderful place to make trouble. It was like having a bridge between art school and the street. Лrt school was a very disenfranchised place in which we disenfranchised creatures could separate ourselves from the world, and be snobbish about it! It was a safety valve, a hermetic environment where you didn't have to think about the "real world." But when we were finally thrown out into this real world, what the hell were we going to do? That was the most astonishing revelation.

LИ Especially in England in the seventies, I imagine . . .

MMcL I was feeling thoroughly and utterly depressed, so I made myself a lamé suit, copied from the cover of an Elvis Presley record, and I walked down King's Яoad one Иovember day, a shining beacon in blue and silver, naively hoping that I would be "discovered"! But nobody bothered, until I got to the end of the street. Then suddenly – just as I was about to walk into a phone box to call my girlfriend Vivienne [Westwood] and complain to her that no one had bothered to say a fucking word, and I was going to have to walk all the way back – this kind of Mephistophelean, black-cloaked figure darted across the road and stopped me dead in my tracks.

He asked me what I was doing around there and I answered, "I've got *stuff*! Stuff to sell!" God knows what I had at the time, loads of records and things, I suppose. Лnyway, this mysterious man pointed across the road to a black hole in the wall and I rushed in. There, in the middle of the room, was a gleaming jukebox and a mirror-ball, a skirt and a pair of old jeans tacked up on the wall. It reminded me of old dance halls with flickers of light all over the

room. The jukebox was pumping out old fifties rock'n'roll tunes, so it was obvious that my "look" – my blue lamé suit that Vivienne and I had cobbled together – was what had attract- ed this character.

Suddenly my wickedness said to me, "Get out now while you're ahead, get out quick!" and I told the guy I'd be back at ten the next morning. I ran all the way home and phoned all my art school friends and said, "I've found this *place*! Λ place where we can do stuff! So I gath- ered all my speed-freak friends and we moved in. Λfter a couple of days the man disap- peared, leaving me the keys. I never heard from him again.

LИ Perhaps he really *was* Mephistopheles!

MMcL Λnd so there we were, left with this place. That's how I began my life after I left art school. My speed-freak friends disappeared in the panoply of King's Яoad life, but I trucked on and convinced Vivienne to leave her school-teaching job, taught her a little bit about tailoring, and started customizing old clothes. You see, my domain was becoming more and more rock'n'roll and suddenly I found myself thinking about how to exploit the ruins of a fifties rock'n'roll culture in some way, shape or form. It was this reality that start- ed me thinking about the more general question of how to "reconstruct the authentic." I had these old jackets but there were big holes in them. I thought, let's not repair them normal- ly, let's repair them abnormally; let's repair them like you would never repair anything. That was my typically "arty" way of thinking, which I began applying to everything. This atti- tude became my "technique."

Whenever the shop became too successful I'd close it down, because the idea of success was anathema to me in my world where failure was a romantic pursuit. I'd close it down the minute it became too much of a business. It had to be fun. The shop was a hive of activity, quite a magical place. It was to have many different incarnations and names: In the Back of Paradise Garage; Let It Яock; Too Fast to Live, Too Young to Die; Sex; Seditionaries; World's End; Иostalgia of Mud. The last name was my favourite of all, translated from the vivid French term that describes the bourgeois romanticising of underclass styles and values. The shop looked like an archaeological dig; I purposely make it look as if it was permanently closed or under construction.

So there I was, a little King Λrthur in his little oasis in King's Яoad, holding court to all these wannabe pop stars! Thinking about this time, I'm reminded of Christian Dior's famous words, that fashion is "the last repository of the marvellous" and the designer is the fairy godmother who can transform Cinderella into a princess with a touch of her wand. He was, of course, evoking the inextricable link between fashion and identity.

So, that's how I got into music. Οne thing led to another. I started making "sex clothing," defining fetishism by thinking about the narrow gap between being a teenager and know- ing what sex you are – that experimental moment.

LИ You mean polymorphousness?

MMcL Yeah. I thought that this indeterminate, adolescent moment was perfect for *rub- ber*. I would sell rubber and black leather, the *idea* of fetish clothing, to teenagers. So I just had to adapt fetish clothing to a young rock'n'roll look – black rubber T-shirts, black leather

T-shirts, black rubber jeans, black leather jeans, black rubber knickers, black rubber bras, black leather bras, dog collars. I just kept building and building and building, until suddenly I had the terrible thought that it was all becoming rather naf, and I had to do something more aggressive and clear. That's when I came up with the concept of a pair of trousers that you can't walk in: That was the clinch, and we [Vivienne and I] had to sell it! So we made a pair of trousers with a strap between the legs, which made it impossible to walk. I had always hated the idea of a zip that ends just below the balls, so I put in a zip that went right around and under the crutch and up to the top of the arse-crack. Marvellous! After this, we went from one thing to the next, always breaking everything down to its most basic components, the T-shirt that was just two squares of fabric sewn together, and so on. That activity became the Sex shop, which led to everything else – the wild success and subsequent collapse of the seventies, the tragedy of it all – the Sex Pistols being, of course, the most flamboyant failure possible against any threat of benign success.

LM For those of us growing up in the seventies, the story of the Sex Pistols had quasi-religious overtones – their iconoclastic style and charisma, their militance, their fervour and, of course, their final conflagration.

MMcL Well, punk was a form of anarchic dandyism, after Oscar Wilde.

LM So what happened when that whole local scene imploded?

MMcL I fled to Paris and worked in the porn industry, making soundtracks for movies. The producers always wanted to use Polish classical music (they wouldn't have to pay for stuff from countries that were still behind the Iron Curtain!) but I knew nothing about classical music, had no feeling for it. As there was little or no money available to make new music, I found my way to the Beaubourg archives in search of other, appropriate, existing musical sources. I discovered all kinds of forms of ethnic folk music, like Burundi tribal music or Indian panpipes. I just began instinctively sampling and combining all these different kinds of music.

I also remember being deeply attracted to the artwork of these ethnic record covers. One cover showed two girls with huge holes in their lobes that had big screws hanging out of them. I thought that was incredible and wondered, what if you were to put a bra on their heads as well? I just loved the way everything was turning upside down.

LM Were you aware at the time of following in the footsteps of disaffected or exiled English radicals in Paris, like Wilde, (Alexander) Trocchi and others (who, interestingly, also supported themselves via the porn industry, but in literature rather than music)?

MMcL Sure, they were inspirations of sorts. But it's also interesting to think about it from the other perspective: that the French Яevolution was clearly influenced by London's Gordon Яiots; Guy Debord's concept of *derives* was directly inspired by the writings of Thomas de Quincey, and so on.

LM So what other aspects of French culture influenced you at the time? Were you aware, for example, of the Situationists? Debord's "society of the spectacle"?

MMcL Debating the politics of boredom was the fruit of my student life and Guy Debord was the doyen of my youth. It was all about searching for the impossible, creating your own anti-world, an environment in which you could truly run wild. So Paris allowed me that freedom for a while.

LИ Punk was stripped down, monochromatic, lean and hungry.
How did you move from the "minimal" phase of punk into the next, "maximal" phase?
MMcL Eventually, I returned to London with all that new experience. Punk had since collapsed, Thatcher was in office, and Vivienne was looking at the eighteenth century via a pattern book that became her gospel. It semi-intrigued me, but not to the same extent as her. Anyway I thought, OK, the "look" is big blousons, giant shirts. I went to Foyle's bookshop in London and stole some books that I found there, one on Apache parchment saddlecloths, a couple of books on Geronimo (one of my heroes), and one about pirates. I was like a big kid, reading about cowboys and Indians and pirates. They became the foundation of the new look and, of course, another groove: Adam and the Ants, ethnic clothes, mix'n'match. It was the forging of another world, raiding the closets of world culture in order to take the world outside of itself.
Suddenly, after all the black of punk, I wanted *gold*. There was an unforgettable incident in those heady days of the late sixties when we took over the art school. A young sculptor, in a raucous student debate, shouted at the top of his lungs "Why can't we make our sculptures in . . . *gold*!!!" The outrage of such a suggestion in our context just thrilled me. So suddenly I thought, why don't we make everything in gold, pirates and so on? I'll dismantle the shop and turn it into a galleon, setting sail for the high seas! That's how the evolution from Sex to World's End happened, the floor at an angle, the big clock with its thirteen hours and its hands turning backwards. All this was part of our new look, as was the new emblem of the Saracen sword that came from the classic pirate flag from my pirate book.
Having got that far, it was just a question of how to put Geronimo, Bluebeard, and African music all together, to get away from the punk rock'n'roll aesthetic and into timbale drums and all that tribal stuff. I thought of mixing the gold braid of an old army uniform with a big, muslin petticoat to create an oversized shirt; soak it, dye it three times with hard, chromium yellow so that the colour was saturated, and then add more gold braid – and just keep adding.

LИ So it was kind of a baroque excess.
MMcL Yes, complex patterns and Apache motifs; asymmetry, like a T-shirt with the neck cut over to one side so that it looked as if it was falling off, the look "twisting" the body; huge patches, like a piece of old shirting, placed under the arms; making something new look old. Иew/old, that was the whole idea . . .

LИ As well as anticipating "retrofitting" (the technique that Яidley Scott and Syd Mead made famous a few years later with the heterogeneous *Blade Яunner* aesthetic), you're describing another baroque strategy: eversion, or making inner surfaces visible. In this case, you made the clothing-skin of the body almost anatomical, expressing areas that

were previously invisible, like the underarm area.

MMcL Completely. All these things made you much more aware of the body. But more simply, it was a very *tribal* look. The white line of face paint that I gave to Adam [and the Ants] is what the Apaches put on when they went to war, as well as braiding gold into their hair. I had this wonderful picture of Bluebeard the pirate, boarding the boats of the British or Portuguese navy with his hair alight so that he looked like the devil. I wanted Adam to do the same on "Top of the Pops." He was too scared, so I decided he was a tosser and I didn't want to work with him anymore!

LM What! You wanted Adam to set himself alight?

MMcL Yes. That was how, literally, I blew our relationship apart. I was such a maniac in those days. I tried to get Annabella [Bow Wow Wow] to do it too, but she wouldn't either. So we shaved her hair and turned her into a Mohican, which looked fine because she had an exotic look.

LM As I remember, she was quite androgynous . . .

MMcL Well, she was only thirteen at the time, not really so aware of her sexuality. So I kept marrying all these different ideas, trying, I suppose, to create an anti-world using all the information I had.

LM But why did this happen in the eighties?

MMcL Difficult to say, having been there myself. There was a bit of postmodernist thinking around the dawn of the eighties, that came about in the mid- to late seventies, bricolage and so on. But I suspect that for me it was born out of the desire to put fashion between music and painting. That was just my way. I was neither a musician nor a painter, but I could be both by being in fashion. Fashion became my canvas and my tools were my shop, my theatre, my playground, my own faith and my own laws. So anything that was established there would always be "anti-world."

LM Punk was distinctly British, an anarchic response to the local situation at the time and, ultimately, it had a nihilistic thrust. When you talk about going to Paris, trawling through the city's cultural archives and coming into contact with the sounds of other worlds, I'd like to suggest that there was a deeper impulse "calling" you. All these sounds were collected by other people at other times – whether out of pure curiosity, colonial desire for gain, we won't discuss here – and catalogued as archival material. So, in discovering this material, you were connecting to what could be called a romantic desire to assimilate the exotic.

MMcL Perhaps, but that desire was Byronic, those people were trying to escape from the muddy hole of England.

LM Then let's call it an "oceanic feeling" as Romain Rolland once described to his friend Sigmund Freud the feeling of belonging to a bigger world outside his own experience: that's Geronimo putting on a European military jacket over his ethnic clothes; Geronimo crossed with Bluebeard; Geronimo as a personification of anthropophagic desire.

MMcL Well, it was about power but perhaps even more importantly, it was about the fact that Яed Indian men didn't see anything wrong with wearing a white woman's cotton dress with a little short coat or waistcoat over the top. I just adored that *look*.

LИ It's a very positive, fertile concept of cultural mixing, the irrational exuberance and excitement of combining to make new forms. Obviously you were attracted to these ethnic combinations because they were iconoclastic, free, based on pure desire. To take things in their original state and recombine them to create an unstable efflorescence of meaning is a very powerful act. What Geronimo did is akin to the pivotal moment in your own work, where you expressed this desiring anthropophagic impulse in look and sound. It was about the world rushing in, or rather, what that other great artistic hybridiser, Alighiero Boetti, described as "putting the world in the world" (*mettere al mondo il mondo*).
MMcL That's absolutely right.

LИ Can you describe how this impulse manifested itself in the new underground scene of the early eighties?
MMcL For the kids who missed the punk rock scene, the fashion and dance-music scene became The Иext Big Thing. They climbed on the shoulders of punk, but they had a far greater sense of confidence, and they were determined to use the eighties, to use their teenage lives, their own time, in a way that previous generations had been too repressed to. The new generation was totally, unquestionably, more open and optimistic. The whole scene had changed. It was a big social supermarket. Club life had never existed like this before: more kinds of drugs were consumed in London than ever before; more people gathered on a Saturday night, *outside* mainstream pop culture, than ever before. It was a huge movement.

LИ How did what you have described so aptly as the "look of music" and the "sound of fashion" come to occupy such central importance in this period?
MMcL What had happened was that the youth culture that was considered more experimental or anti-establishment in the sixties and seventies became an acceptable business in the eighties. What was more, the business of it wasn't quite what you would have anticipated because it was *a business of the young by the young*. This had never existed before in this way, there had always been a division between the provider and the consumer. The generation of the sixties and seventies anticipated the eighties, and thus this decade became very commercially driven, in many different ways. But within this whole phenomenon there was far more outrage that was less media-led and less politically motivated, but more hedonistic and fashion-based, than in the seventies. Vivienne and I, for example, seized the available means, aspiring to put fashion into the world of business.

LИ How did the advent of MTV affect everything?
MMcL It definitely set the stage for an audiovisual age. Youth culture unleashed its ability to make more than a rock'n'roll record. Among the people who came to my shop, for instance, no one wanted to be a rock'n'roll star; instead they wanted to design the clothes,

or do the lighting, or make the video. Nobody wanted to be the bloke playing the guitar anymore!

LM What about your own evolution from selling unique clothes in a shop to taking the look to the catwalk, the shift from commodity exchange to performance, your emulation of the fashion ethos with "seasonal collections," "fashion stories" and so on. You were using the tools of yet another kind of image-making, the tools of the traditional fashion world.

MMcL You might see it like that, but there is a much more simple, pragmatic explanation: Vivienne was pissed off that these pop musicians were taking up my time, and she gave me an ultimatum that I had to focus on fashion. She wanted to create a business. No more changing the store every five minutes, no more mucking around with Adam and The Ants and Bow Wow Wow. Vivienne made me understand that while I had been doing all this, she had been toiling away in corner of the apartment and now her time had come, and we should concentrate on being fashion designers. I didn't dare tell her that I was getting a bit bored with it all. Instead I agreed to get our act on the catwalk. Vivienne made me realise that this was the way to make all our work worthwhile.

I had been in Paris and had a lot of friends in the fashion industry, so I set out to make a fashion show. The first one, predictably enough, was all about pirates. I put that one together with her, and we did another four or five shows on related historical themes. But I felt increasingly that I was in a costume drama or pantomime, and it didn't mean anything to me. It didn't have any relation to music, because Vivienne didn't feel it, whereas I always had the relation to music because I was *living* it.

It was hard because we weren't really making money with the fashion business, we never sold a lot, and we didn't have the production. But our name was established and every penny I made with Bow Wow Wow was being funnelled into it. As Vivienne was becoming more and more antagonistic to my spending time with Bow Wow Wow, I was thinking more and more about music, and about making my own records, which I finally did.

Duck Rock (1983) was an attempt to make a record like a radio show, my own radio show about folk dancing around the world. It was the first pop "world music" record, a childlike yet artful mixing of the Zulus of Africa, the happy Dominicans, the Hobos of Tennessee, and the hip-hop kids of the South Bronx. *Fans* followed in 1984, which was my tribute to Puccini's invention of the *prima donna*. Looking back, it's clear that both these ideas were inspired by my wanderings in those rich archives of Paris.

By this time, my relationship with Vivienne had become purely cerebral, and I wasn't focussing on the business, so we finally came to terms about what we were going to do. I hated London and I no longer had a relationship. So I left and went to Hollywood where I thought I could put music and fashion together . . . in the movies! That was where I met the writer Alan Moore and developed the earlier screenplay version of *Fashion Beast*.

LM Your relationship with Vivienne, as you describe it, is like the contrast between exploration and discovery that Paul Carter discusses in his brilliant study of South Pacific explorers in the eighteenth century. Exploring is travelling without the idea of return, for the pure experience of it, whereas discovery is travelling to name or own or make familiar. From

your earliest moment in King's Яoad through all the various incarnations of your fashion project, you seem to have always been more interested in the quality of the travelling. In music, as in fashion, you have applied your cannibalistic pop aesthetic to punk (Sex Pistols), romance (Λdam and The Λnts, Bow Wow Wow), folk (*Duck Яock*), opera (*Fans*), waltz (*Waltz Darling*, 1989), and jazz (*Paris*, 1994). Λnd now electronica (*Fashion Beast*, 2004). You travel quickly; you never stay in one place too long.

MMcL That's very true. Most people, even in the pop industry, opt for security and stability. I understand it, but I don't really share this concern.

LИ Well, it's evident that your lack of concern is to do with your political temperament.

MMcL In fashion, if you work in terms of form rather than concept (which is what most fashion designers do) and if your forms are based on precedents (like eighteenth-century patterns in Vivienne's case), then inevitably you become very immersed in that formal language, you want to see what it consists of, that's what gets you excited. The net result of such an attitude is that you can't stand back from it. Everything Vivienne subsequently did has been a variation on an eighteenth-century pattern. I never understood her deep interest in form; I was always wanting to *destroy* form.

Concept, on the other hand – in fashion, making clothes out of nothing, destroying form, constructing form, which Яei Kawakubo has spent a lifetime doing – is a very different, very new way of thinking, a new way of writing the story. It's a matter of synthesis, of combining elements from radically different sources, rather telling a traditional narrative.

LИ Well, this kind of poststructuralist attitude now pervades everyday life and thought, everywhere.

MMcL I remember giving interviews at the beginning of the eighties saying that *painting* was going to be The Иext Big Thing, when everybody else was still talking about pop music and fashion. I said that it would all be about painting and art, that art is what is going to affect people. I was ten years too early, but I think the reason I saw it then was because, in my heart of hearts, I was trying to return to my earlier roots.

LИ If I were asked to find a corollary for you in the world of painting, it would be Sigmar Polke. You are both obsessed with pop culture, with exploring cultural form in terms of the surface or "look" of things, with other worlds, or creating what you describe as "anti-worlds." You freely mix heterogeneous cultures, periods, influences, or different levels of distinction within a single culture (vulgar and sophisticated, for example). You create slippery meanings by being insistently playful, subversive, slick, sexy. You plunder history, bringing all the fragments together in an eternal present. Polke has been discussed in terms of *Kinderseele*, a term meaning literally "soul of a child"; I'll conclude with a quote from one of your earlier interviews where you claim, "Being an amateur is a necessary part of an artist's life. For an artist to be a professional is to lose the heart of a child."

Paris, October 2003

THE AGE OF STREET FASHION

Guy Trebay

Has there ever been a designer's runway that produced better fashion than a city side-walk? Is there a style, high or low, that has not felt the influence of Fifth Avenue or Bushwick Avenue in Brooklyn or Haight Street in San Francisco or the Rue Bonaparte, where I once saw Isabella Blow, an editor who is often described as a "muse" to dress-makers, appear as a windblown apparition, a cockaded hat on her head, her legs exclamations ending in stark points, a parachute silk cape bellied behind her like a jib in a stiff Parisian wind. Ms. Blow was teetering along on wet gray cobblestones that appeared to have been laid, centuries before, expressly to set off such moments of intensely premeditated and yet impromptu theater.

"Everything in fashion begins in the street," Diane von Fürstenberg once observed. Cargo pants, for instance, with their Vietnam War associations and their abundance of superfluous pockets, entered the mainstream of style well before the people self-appointed to decree what constitutes style even knew what was going on. "That did not come from anyone in 'fashion,'" Julie Gilhart, the fashion director of the New York department store, Barney's, once remarked. "It came from the street."

Of course it did. So, too, did buttocks-baring trousers, ironically worn preppie whale pants, field hand's do-rags, belt buckles with one's name spelled out in block letters, trousers with one leg rolled the way Rikers Island inmates used to wear them and . . . well, the point is that none of these notions originated on any overpaid designer's sketchpad. They were improvised for the pleasure of their wearers and for the eye of anyone who cared to stand still in the slipstream of visual imagery as it flowed along in the waning years of the twentieth century and watch.

This time, roughly the eighties to the mid-nineties, was particularly ripe for the daily exercise in the improvised identity that we call fashion. The dialogue between high and low has rarely been more alive. The legacy of social and political trends left an accreted and very public residue in people's way of expressing themselves outwardly. That is, a dedicated observer could pause at a Manhattan corner – say, Eighth Street and Broadway – and snap a mental picture later to be diagrammed for the unconscious influences on parade – social currents and movements from hippies to Black Panthers to feminists and homosexuals.

The street is always a potent source of inspiration for fashion makers, according to Harold Koda, the chief curator of the Costume Institute at the Metropolitan Museum of Art. What Mr. Koda calls inspiration is perhaps better termed data, since, as curator Nicolas Bourriaud has astutely pointed out, the core function of most creative people in an information-glutted age is not innovation but rearrangement.

"Even designers who seem as if they have their heads in the clouds are not functioning as business people if, at some level, they are not attuned to the street," says Mr. Koda. You do not have to look far for examples. To take a particularly odd one of recent note, there is the athletic sock. For quite a long time, this striped tube of white stretch cotton has signified not just the dregs of unfashionable dressing, but also a pretty intractable marker of class. Tube socks have always conjured images of clothes sold from bins to people not likely to have heard of Coco Chanel, must less the darlings of style cognoscenti like Alexander McQueen or Nicolas Ghesquière.

That was before a group of young urbanites got hold of the tube sock and subjected it to what in theoretical circles might be called a critique. Deciding that its lack of cool was in itself a kind of cool, and not altogether an ironic one, they put the tube sock into fashionable circulation.

Not long ago in London and New York, flashes of striped tube socks were to be seen flashing from beneath the cuffs of Balenciaga bell bottoms or worn with forties-style pumps from Prada or else pulled up the bony knees of coltish models, geek-style, unabashedly. Subversives like the socially conscious designer Tara Subkoff, of Imitation of Christ, suggested in her fashion shows that thick tube socks were just the thing to put on with a $1200 party dress made from a recycled thrift shop garment. (It is probably worth pointing out here that this aesthetic had been put into action twenty years before by the members of the San Francisco drag troupe, the Cockettes, but never mind.)

As if by cabalistic agreement, other designers seized on Ms. Subkoff's idea, and so tube socks turned up inevitably on the runways of designers with more commercial lines. At Anna Sui's show they were worn with demented country club clothing. At Dolce and Gabbana they were worn with tracksuits and hot pants. At Colette, the concept store and design laboratory on Яue St. Honoré in Paris, they were featured in a window, as though Paris were Memphis and Colette were where the coolest rednecks came to buy their clothes. It was no stretch then to predict that haute couture designers would soon claim them and of course they did. Soon enough socialites were to be seen strolling the streets with their Kelly bags from Hermès and their Christian

Louboutin heels, worn with a fancied up version of the striped things that most of our mothers used to buy in plastic three-packs back in seventh grade.

It has long been like that, according to Anna Piaggi, the cultural commentator who writes a column for Italian *Vogue*. "Since the courts of the eighteenth century, information was coming from the street and into the salon," says Ms. Piaggi, who in her daily costume has been known to combine articles of clothing from pet couturiers with vests from a McDonald's uniform. In the eighteenth century, Georgianna, Duchess of Devonshire, a leader of London fashion whose sartorial whims were chronicled as front-page news, made a fashion of wearing simple muslin frocks that she had first seen worn by her servants.

"This meeting of the high and low, this exchange, has always been occurring," noted Ms. Piaggi one morning before the start of a Jean-Paul Gaultier show at the Carrousel du Louvre in Paris, a show in which the designs were replete with quotations from the street. In a commentary on the way that some hip-hop fans wear their jeans slung low enough to expose their underwear, Mr. Gaultier showed women's trousers fastened below the hips, leaving the buttocks completely exposed.

"The peasant, the little maid, saw the dresses of the ladies and copied those in a way for themselves," said Ms. Piaggi, and it is true that, even as the Duchess of Devonshire slummed in her costume, the members of her staff were returning the favor by aping her theatrical taste in hats. Centuries before postmodernism formalized the relationship between high culture and low, Ms. Piaggi suggested, the street was already functioning as a bridge.

Not long ago, the American menswear designer John Bartlett remarked, "There is so much information walking down the street every day, you can't help but be inspired by it," adding that this is particularly true in pedestrian-friendly cities like London, Paris and New York. "I'm always checking out what people are wearing," said Mr. Bartlett. "Especially people that look a little marginal and who are less self-conscious and who put it out there more."

Bike messengers, neopunks, Rastafarians, gym bunnies and the homeless have all exercised their influence on fashion in some obvious and vital ways. The Chanel designer Karl Lagerfeld, always attuned to the street and youth culture, one season rendered the prim chain belts that have long been a signature of the house as weighty biker chains. Hedi Slimane, the designer for Dior menswear, invigorated the drowsy brand with a season of clothes inspired by skinny suits first seen on punks from the Lower East Side, and made a killing selling a "bloodied" shirt like one first worn by the rocker Richard Hell.

The dreadlocks that used to signify adherence to the Rastafarians, a millenarian Jamaican sect founded on the joint worship of ganja and Haile Sellassie, were once the mark of self-anointed pariahs. Now, of course, they are commonplace, on white men, it should be added, as well as black. The sleeveless T-shirts that turned up early on hypertrophied gay men in Manhattan's Chelsea are now a staple. Even their offensive name – wifebeaters – has become a mainstream turn of phrase.

Even the most voracious designer or the most culturally dedicated observer knows that

it is not always plausible to be in the street literally, any more than it is possible to know which is the right street to watch. Fortunately for history, there exists a small band of documentary photographers who have dedicated themselves to preserving the ephemeral cycles of street fashion – a group whose ranks include Bill Cunningham, Amy Arbus and Jamel Shabazz.

In the East Village of the eighties, Ms. Arbus specialized in photographing people one might generalize broadly as punks, the ones wearing Mohawks, shoes called brothel creepers, knee-belted bondage trousers, septum piercings and shredded schoolgirl uniforms long before those styles had made their way to MTV and the local mall.

During that same decade, Mr. Shabazz trained his camera on the young Brooklynites whom the writer Fred Braithwaite, a.k.a. Fab Five Freddy, later characterized as the "generation that gave birth to hip-hop." (Although hip-hop is generally acknowledged to have started in another, no less soulful borough of New York: the Bronx.) Mr. Shabazz's pictures documented street fashion, but also an effusion of cool, of the sort that the Yale scholar Robert Farris Thompson meant when he poetically traced the meaning of that overused word to the ancient African empire of Benin. In that distant place, where Mr. Thompson has said that the term as we understand it originated, cool signified ritualized dignity and poise. That same poise would armor an entire generation during a decade when crack and AIDS were atomizing cities.

Before Mr. Shabazz's pictures were assembled in a 2001 book entitled *Back in the Days*, they languished for twenty years. To Mr. Shabazz's surprise the book became a big seller and what Jefferson Hack, the editor of *Dazed & Confused* and *Another Magazine*, called "one of the biggest influences" on style in years. Whether or not that is so, Mr. Shabazz's collection served as an insistent reminder to those who might find it easier to forget that no focus group, designer, market guru or prophet of style can ever hope to outpace the onrush of ideas that seem to arise spontaneously, simultaneously from everywhere and nowhere – that is to say, come up from the street.

Underground & Mainstream

\
\

Francesco Bonami

I can't exactly remember when the world stepped out of the underground and entered the unceasing flux of consensus. It happened, I guess, around 11 o'clock on the evening of December 8, 1980, uptown New York, on the sidewalk in front of the Dakota building. David Mark Chapman, twenty-five years old, from Hawaii, popped out from the underground of his mind and fired five shots at John Lennon. When Lennon died at St. Luke's-Roosevelt Hospital Center, the underground ended and the eighties began. The seventies were the subsoil of our culture, maybe not really the sub-soil but only a sad basement , one of those with windows at sidewalk level, from where you can see people's ankles passing by. The ankle is that part of the body that more than any other reveals how unsexy the seventies were. From the basement the world was seeking out for some form of deliverance. From their ankles the seventies wanted to climb up as far as to the shoulders.

Honestly the true underground was finished by the end of the sixties, with the livid turmoil of the 68's movement making mincemeat of it. The seventies, by contrast, were a pimple on the face of Western society. The underground was the smell of cigarette smoke, unmade beds, bodies naked, not bundled up, dark glasses even at night, speed not thrift, personal not collective risk, vulgarity not malaise, personality not insecurity. The bullets that smacked into John Lennon's body arrived from the seventies' awkwardness, shattering what was left over from the sixties. Those bullets made a breach in the sewers of the Western world's underground , from which it poured out the excessive effluvium of a decade in which success and excess swapped places continually, softening even the hardest dwellers of sewers, cellars and miserable basements. The

eighties were a blaze of fireworks in the sky of the history of our still 100% pure Western world. In the eighties people still didn't give a damn about the South, meaning the third, or fourth or fifth world. In Paris, the exhibition *Les magiciens de la terre*, was nothing but a gesture to administer the new consensus to a handful of rejects, using a fire hose to wash out from the most remote and exotic places of the world those many whose independence still nurtured the people of the underground. The third world, the real underground of our civilization, appeared in the streets of New York ennobled by the collarless shirt of Francesco Clemente, the forerunner of all the rebels who since then have been splashed on the covers of the best reviews, flushed out of their cellars and hosted on cozy couches of Soho's lofts. The eighties wiped off the sweat of India, blew away the dust of Mali, sweetened Mexican chilies. The apartheid society of success and consensus was born.

Underground dwellers were no longer allowed into restaurants, clubs, bars, exhibitions, everything was now reserved for "the people" of the rowdy eighties. To be against meant simply and solely being lonely on the outside. Revolution was no longer sexy but simply the "ankle" of society. AIDS began to devour excess but not success, and strikingly even illness became mainstream. As the eighties wore on, the difference between the opening of a gallery and a funeral service became increasingly slender. Dying is better, when all's said and done, than sliding downstairs into the basement. Basquiat was the dark side of Warhol, Mapplethorpe of Haring. The damned no longer existed or at least no one really wanted to meet them. Everyone who used to be part of the cult of the underground simply became losers in the eighties. The underground disappeared because it had lost its charm and the eighties were the time when defeat was no longer an alternative but an antisocial gesture, a time when the individual no longer offered any energy to the flux and hence had to be isolated, forgotten, abandoned and eventually terminated.

Those who died as losers died twice over in the society of the eighties. While the seventies brought about the genocide of individual ideas and identities, the eighties saw the genocide of those who were "different," not sexually or racially different but economically different and marginal. The eighties saw the extermination of those who failed to enter the flux of consensus, of success and excess. The eighties saw the massacre of those who for one reason or other survived the final demolition of the underground. The eighties poured a layer of concrete into the subsoil and it's still hard to see what survived underneath. In a imaginary world of sci-fi archeology, when someone will dare to dig into the crust of the twentieth century, they'll reach a point in which a void will appear, like an air chamber: they will have uncovered the civilization of the eighties, an era when a whole society was erected on top of a void surface. Religion, politics and rebellion arrived drained by the violence of the seventies and, passing the border of the new decade, let themselves be disarmed by a generation that no longer saw in the night a darkness where to disappear into, but the light shining off a perverse but unrotten hedonism. Shooting up unknown substances, the eighties' society no longer rotted, it exploded. As in Antonioni's final film, *Zabriskie Point*, the explosion of the eighties still continues today, though increasingly in slow motion and with less and

less energy. Work has resumed again on rebuilding basements, cellars, undergrounds, where a new generation seems to have holed up , once again to rediscover the stimuli, ideas, and reactions to hide from a bulimic world, which seeks to digest everything and immediately in the juice of consensus. The true underground, however, is holed up there, in those societies still desperately in quest of their modernity.

The eighties projected a corrupt image of the West onto the world: they unwittingly caused gangrene in the wounds of those worlds where the underground does not simply conceal the desire for an alternative transformation but also hide the violence of a barbarism that is trying to sink the whole world into an abyss of darkness, where no mainstream will ever succeed in welling up again. Perhaps, in the skies of a resounding September, rage exploded from a world excluded from the superficiality of a progress that, starting in the eighties, by denying its own subsoil, had also destroyed the roots of its future and with it the desire for a modernity in quest of its own indispensable profundity. The five bullets that hit John Lennon in the darkness opened the terrible, dazzling and unavoidable, necessary eighties. Two toppled towers, twenty-one years later, have tragically and irremediably closed them.

Иew Mля / Old Modes

\
\

Лиdяew Boltoи

In the eighties, as Яeagan and Thatcher continued to serve up their "liquor of ideo-
logical individualism,"[1] the idea of one singular, totalizing version of masculinity
gave way to multiple masculinities.[2] From 1984 to 1990, the most dominant form of
masculinity was that of the "new man." Лt once nurturer and narcissist, the new man
both recognized and reconciled the "feminine within." As Яowena Chapman
observes in her article "The Great Pretender: Variations on the Иew Man Theme"
(1988), "He knew his Borsch from his Brioche, he could dangle junior on his knee
while discussing the internecine convolutions of 'our relationship.' Tough but tender,
he knew his way around a Futon, and could do more than just spell clitoris. Иot for
him the Wham-bam-thank-you-mam thrust of the quick fuck. He was all cuddles and
protracted arousal, post-penis man incarnate, the doyen of non-penetrative sex."[3]
While the idea of the new man can be found in the rhetoric of late nineteenth- and
early twentieth-century social and political reformers,[4] it took its lead from the more
fluid masculinity promoted by the men's movement of the seventies. Largely fueled
by feminism, the men's movement encouraged men to open up their emotions and
get in touch with the caring, nurturing side of their personalities. Preaching growth
and self-fulfillment, the men's movement "came to characterize machismo as a form
of arrested development."[5] The new man represented the eighties version of this
non-sexist, post-feminist, emotionally literate and articulate male. However, while
the liberated man of the seventies emerged through developments in humanist psy-
chology, the liberated man of the eighties emerged through developments in mar-
keting, advertising and, most widely, the culture of consumerism.[6] In his book

Fashion Spreads: Word and Image in Fashion Photography Since 1980 (1999), Paul Jobling explains, "New man became common currency in media circles, if not in society at large, to describe the consumerist ethos of a certain constituency of British males (arguably, white collar professionals, aged eighteen to thirty-five years old)."[7] From the mid-eighties, new man imagery circulated through press and television advertising. He could be found in advertising campaigns for hair, clothing, cologne and even health and financial services. As Chapman observes, "Child of our time, the new man is all about us – rising like Venus from the waves or Adonis from the shaving foam, strutting his stuff across posters, calendars, magazines and birthday cards, peering nonchalantly down from advertising hoardings, dropping his trousers in the launderette."[8] The latter is a reference to a fifty-second cinema and television advertisement of Levi's 501 jeans that ran in the UK from Boxing Day 1985 through the fall of 1986.[9] Known as *Launderette*, the advertisement saw the model Nick Kamen walk into a fifties-style launderette and strip down to his socks and boxer shorts to the lyrics of Marvin Gaye's song "I Heard It Through the Grapevine." With his well-toned body, scrubbed skin and highly groomed hair, Kamen epitomized the self-conscious masculinity that defined new man imagery.

By offering a more sexualized representation of the male body, *Launderette* challenged and contradicted the codes of who looks and who is looked at. "Men have held the power of the look, the symbolic owning of women's bodies," argues Jonathan Rutherford in his article "Who's That Man?" (1988). "Reversing the gaze offers the symbol of men's bodies on offer to women."[10] At the same time, *Launderette* and other new man imagery legitimized the hetero-sexualized male gaze. In his article "Boy's Own? Masculinity, Style and Popular Culture" (1988), Frank Mort argues that new man imagery encouraged men to "look at themselves and other men, visually and as possible objects of consumer desire, and to experience pleasures around the body hitherto branded as taboo or only for women."[11] According to Mort, new man imagery spoke to men through their gender, as a community of men.[12]

Many scholars have argued that the new man was merely the product of media hype. But as Chapman points out, "If he exists in the fantasies of ad men he exists in flesh and blood; advertising reacts to social trends, it doesn't create them."[13] Indeed, the rise of new man imagery coincided with an expansion of men's designer fashions and grooming products in the mid-eighties. Aimed specifically at the new man and his post-modern dandyism, this "menswear revolution" offered men an escape from the stifling solidarity and conformity of traditional menswear and acceptable male appearances. Never before had men enjoyed as wide a choice in clothes and accessories, ranging from such high-street brands as Next, Topman and Woodhouse to more exclusive labels as Joseph, Paul Smith, Giorgio Armani and Katharine Hamnett. In his article "Menswear in the Eighties: Revolt into Conformity" (1992), Neil Spencer asserts, "Menswear was an idea whose time had come."[14]

As if to announce the arrival of this menswear revolution, *The Face* published an article entitled "Men's Where?" in its November 1984 issue. Written by Glenda

Bailey, the article asserted, "Men's fashion is receiving more attention and exposure and its wearers are spending much more money."[15] Bailey included runway images from the collections of Body Map, Yohji Yamamoto, Wendy Dagworthy and Jean-Paul Gaultier as evidence. Interspersed throughout the article were quotes by various menswear designers such as Paul Smith and John Яichmond as well as statements by menswear retailers such as Jeff Banks of Warehouse. Banks' quote sums up the tenet of the article: "Men are free of the typical macho role. For so long we've had a conventional, almost fatherly role – wearing the uniform of somber suits. The eighties have seen the introduction of mechanization and automation of industry, leaving more opportunities for men to express themselves."[16]

Bailey's article is perhaps most notable for Яay Petri's stylings of men in skirts. It was through Petri's stylings for *The Face* and, later, *Arena*, that the new man was most extensively elaborated between 1984 and 1990. Produced under his trademark label "Buffalo," Petri's stylings were built by a close group of associates that included the stylist Mitzi Lorenz, the models Иick and Barry Kamen (new men par excellence) and the photographers Mark Lebon, Яoger Charity, Jamie Morgan and Иorman Watson.[17] "The role of the stylist," argues Иixon, is "to produce an innovative 'look' rather than to present a designer's new range or the latest seasonal 'looks.'"[18] Petri was a consummate stylist, creating new and ever more startling looks that carved out "a striking and distinctive repertoire of codings of masculinity."[19] One of his more memorable stylings appeared on the cover of *The Face* in June 1985. The British boxing champion Clinton McKenzie was shown wearing a tight, black sleeveless T-shirt and a pair of crotch-hugging Lonsdale boxing shorts topped off with a Versace flatcap and a pair of fur earmuffs. Petri's use of the MΛ-1 flight jacket in many of his stylings, however, had the most significant impact on fashion. In fact, the MΛ-1 flight jacket, Levi's 501 jeans and Dr. Marten's shoes became one of the most ubiquitous uniforms of the eighties.

Petri, however, like many other stylists and designers of the eighties, modified rather than revolutionized the chief tenets of menswear. With the notable exception of skirts, many of Petri's stylings utilized typical items of men's apparel. The suit, for instance, the staple item of a man's wardrobe since the late seventeenth century, appeared regularly in Petri's work. In fact, with the rise of the yuppie, the suit's "command in an authoritarian and retrospective decade was more absolute than ever."[20] While better clothes were more widely marketed to respond to the demands of the new man, the clothes themselves remained disappointingly conservative and standardized. Despite his attempts to deconstruct dominant and exclusive forms of masculinity, "new man" continued to be wrapped in the garb of "old man." However, like the suit, new man has proved more enduring than expected. As Spencer observes, "Deeply in touch with his anima, and the suppressed female side of his nature, yet retaining the admirable male values of paternity, strength, and virility, he continues to haunt the sexual arena."[21] Most recently he has re-surfaced as the "metrosexual," an individual who, like his eighties counterpart, is steeped in the realpolitik rather than the ideology of sexual relations.[22]

NOTES

1. Tim Edwards, *Men in the Mirror: Men's Fashion, Masculinity and Consumer Society* (London: Cassell Academic, 1997), p. 6.
2. Sean Nixon, *Hard Looks: Masculinities, Spectatorship & Contemporary Consumption* (New York: Palgrave Macmillan, 1996), p. 13.
3. Rowena Chapman, "The Great Pretender: Variations on the New Man Theme," in *Male Order: Unwrapping Masculinity*, ed. Rowena Chapman and Jonathan Rutherford (London: Lawrence & Wishart, 1988), p. 227.
4. Paul Jobling, *Fashion Spreads: Word and Image in Fashion Photography Since 1980* (Oxford: Berg Publications Ltd., 1999), p. 146.
5. Rowena Chapman, op. cit., p. 230.
6. Tim Edwards, op. cit., p. 39-40.
7. Paul Jobling, op. cit., p. 145.
8. Rowena Chapman, op. cit., p. 225-226.
9. Sean Nixon, op. cit., p. 2.
10. Jonathan Rutherford, "Who's That Man?" in *Male Order*, op. cit., p. 32.
11. Frank Mort, "Boy's Own? Masculinity, Style and Popular Culture," in *Male Order*, op. cit., p. 204.
12. Ibid., p. 212.
13. Rowena Chapman, op. cit., p. 229.
14. Neil Spencer, "Menswear in the 1980s: Revolt into Conformity," in *Chic Thrills: A Fashion Reader*, ed. Juliet Ash and Elizabeth Wilson (London: Harper Collins, 1992), p. 41.
15. Glenda Bailey, "Men's Where?" *The Face*, November 1984, p. 84.
16. Ibid., p. 88.
17. Andrew Bolton, *Bravehearts: Men in Skirts* (London: Victoria & Albert Museum, 2003), p. 24.
18. Sean Nixon, op. cit., p. 181.
19. Ibid., p. 181.
20. Neil Spencer, op. cit., p. 40.
21. Ibid., p. 43.
22. Ibid., p. 44.

Яeaganite Hedonism

\
\

Яoberto D'Agostino

At first it sounded like a meaningless slogan, a crazy quip, two abstruse terms sandwiched together. Instead, surprise, surprise, "Яeaganite hedonism" rippled out from the TV show "Quelli della notte," with Яenzo Arbore and his gags. Media experts stated pensively that it was just an undergraduate joke, but in fact it was a crowbar that would enable us to break open the *Weltanschauung* of the eighties. The philosopher Gianni Vattimo, an oracle of postmodern nihilism and the propagandist of "weak thought," first made the breakthrough by celebrating the new label in a leading article in *La Stampa* simply titled "Яeaganite Hedonism."

But approval of the learned and the intellectuals for the use and abuse of the catchphrase also came from more orthodox, and hence more surprising sources. Giuseppe Vacca, a communist parliamentarian and weighty thinker, declared: "I truly appreciate this formula. They managed to name 'the thing' using a figurative language that is far from banal. I think theirs is the first contribution to critical thought disseminated by the media, and it is particularly useful for its perception of the changes we are living through."

The philosopher Salvatore Veca chipped in: "We will never understand these eighties if we fail to take stock of these changes and continue to reason as we did in the seventies." He added (in *Panorama*, 30 June 1985): "Even in the era of private happiness we can retain the power of reasoning, avoid demonizing or sanctifying what happens, and simply try to discriminate." This is the great challenge that the left, the Italian Communist Party of the day, took up in the worst of ways, continuing imperturbably to demonize affluence (and the result, ten years later, would be called "Berlusconismo").

The sleight of hand worked. The rabbit popped out of the hat. In precarious equilibri-
um between the ironical and the grotesque, I explained in broadcast after broadcast,
which thinkers were plotting behind the hedonist formula, personalities chosen care-
fully on the basis of the structure of their names (Milan Kundera, Gianni Vattimo,
Gilles Lipovetsky, Sebastiano Maffettone, Karl Яosenkranz, Achille Bonito Oliva). But
above all on the basis of the titles of their books: *The Unbearable Lightness of Being*,
for Kundera, *Weak Thought* for Vattimo, *L'Empire de l'éphémère* for Lipovetsky, *The
Esthetic of Ugliness* for Яosenkranz, *The Ideology of the Traitor* for Bonito Oliva.
There, you just have to line up these titles to get the solution to the paired terms:
Яeaganite hedonism.

Welcome to the eighties. In that spring of 1985, under the umbrella of the TV show
"Quelli della notte," this pairing of words put the stamp, by irony and luck, on the
altered crest of an unrestrained cockiness of morals, very similar to what the most
advanced Western countries were going through/thwarting.

In fact, already at the end of the eighties, in Italy everything, or nearly everything, had
changed. Politicization, collective leadership and the quest for social happiness had
come full circle, according to the expression coined by the sociologist Albert O.
Hirschman, the author of the book *Shifting Involvements. Private Interest and Public
Action* (which explained how the shifts of history derive from the oscillation in the pub-
lic's taste between these two poles). Hence, with the aid of disappointment over the
results of the social and ideological battles, ending in the assassination of Aldo Moro
and his bodyguards, a new cycle began, that of individual happiness, of the personal
affirmation of the end of fences and established roles.

So, shuffle the cards. From leftism to narcissism, from We to I, from the rising of the BЯ
to the move of the PЯ, from Unending Struggle to short-lived success, from paddy wag-
ons to cell phones, from the signified to the signifier, from fractures to fractals, from
cyclostyle duplicators to the fax, from revolt to Travolta. It was a universal footbath.
Learn the art and put it into partying. Chili pepper from beginning to end. Go on, rec-
oncile high and low. East and West. History and detritus. Quality and quantity. The
snob and the Blob. Dik Dik and Duran Duran. Botteghe Oscure and glittering bou-
tiques.

Besides, shifting roles, combinatorial skills, the desire to seduce, were well represent-
ed and legitimized by the emerging cultures of the eighties: postmodern in architec-
ture, the Transavanguardia in painting, "weak thought" in philosophy, new wave in
youth music, the mirage of the look in youth tribes, the computer as instant memory,
the video as the operation of dismantling and reassembling reality. If we can no longer
pitch the avant-garde against tradition, the future against the past, against opposed
extremes, the "double-cross" of Яeaganite hedonism is then a positive attempt to com-
municate with the shrewdness of time and the ambivalence of the present. And isn't it
remarkable that it fell to Umberto Eco, one of the most refined and elitist Italian intel-
lectuals, to become, with the intercontinental and incontinent popular triumph of *The
Иame of the Яose*, the guarantor of the shift, of the double identity.

Яeaganite hedonism insolently flaunted the "democracy of frivolity," bringing with it

not only trash and flash, chatter and charlatans, clones and *cojones*, but also the ebullience of individual creativity and pluralism. And it reconciled technology with play, political power with seduction, sex with pleasure, amusement with life. Seduced by a zero-ideology menu that preferred the image to the thing, the copy to the original, representation to reality, the fun-loving hedonists of the eighties proved that they loved big group get-togethers, they needed their "bewildering" moments, where everyone could not so much let rip as "merge" with others. In short, they needed an orgy: in the panicky, bewildering, emotional sense. And they got it, though in forms masked by frenzied kitsch.

So the mod-eighties were not just our maximum "orgiastic," moment as the French sociologist Michel Maffesoli writes in *L'ombre de Dionysos*, but also the apotheosis of the taste for bad taste. Milan Kundera sums up brutally, "There is the need to deny and conceal 'the shit,' the need to hide the fecal side of existence."

The age of post. Styles coexist and clothing is the outcome of a reflection on fashion, styles, history and traditions. The postmodern body is wired, connected to the Net, as in William Gibson's *Neuromancer*. In a reality that is beginning to turn virtual, dress is a mental thing: it clothes minds and attitudes. Fashion proposes lifestyles that permit everyone to live different dreams and atmospheres. Citation makes it possible to use a fragment from the distant past, but also from the recent past, and transfigure it in the aesthetics of customization and allusion. Architects and philosophers fuss over the concept of postmodern, artists describe themselves as trans-avant-gardists, citationists and new-new . . . In the meantime another story is getting underway.

POSTBODY

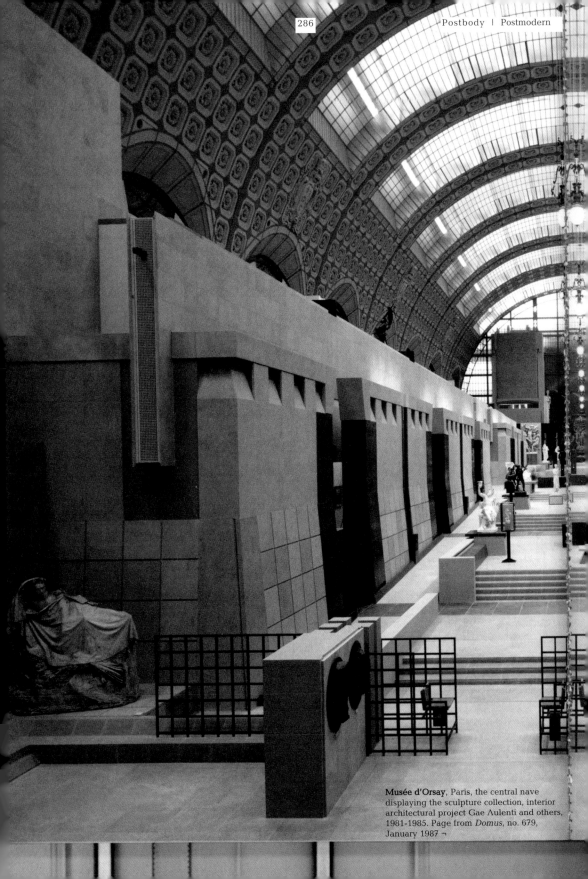

Musée d'Orsay, Paris, the central nave displaying the sculpture collection, interior architectural project Gae Aulenti and others, 1981-1985. Page from *Domus*, no. 679, January 1987 ¬

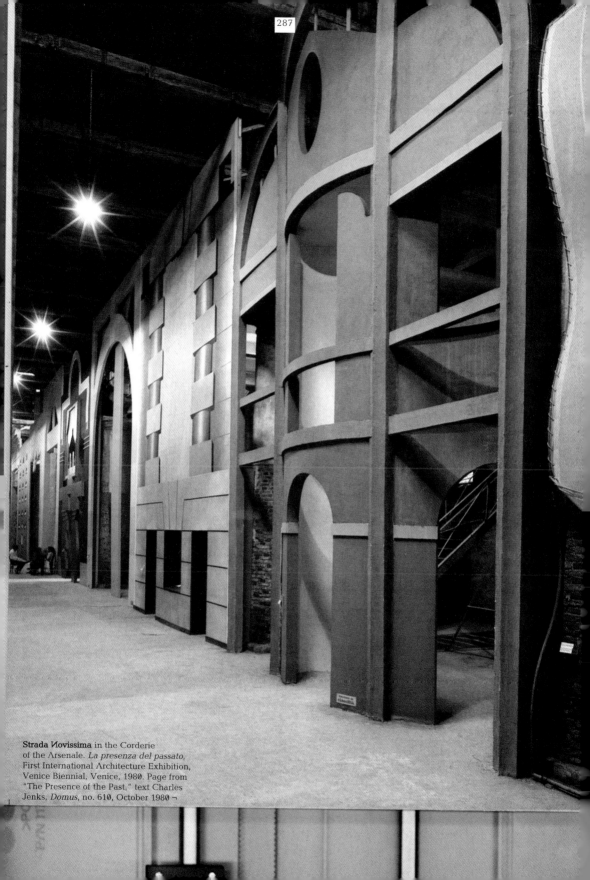

Strada Novissima in the Corderie
of the Arsenale. *La presenza del passato,*
First International Architecture Exhibition,
Venice Biennial, Venice, 1980. Page from
"The Presence of the Past," text Charles
Jenks, *Domus,* no. 610, October 1980 ¬

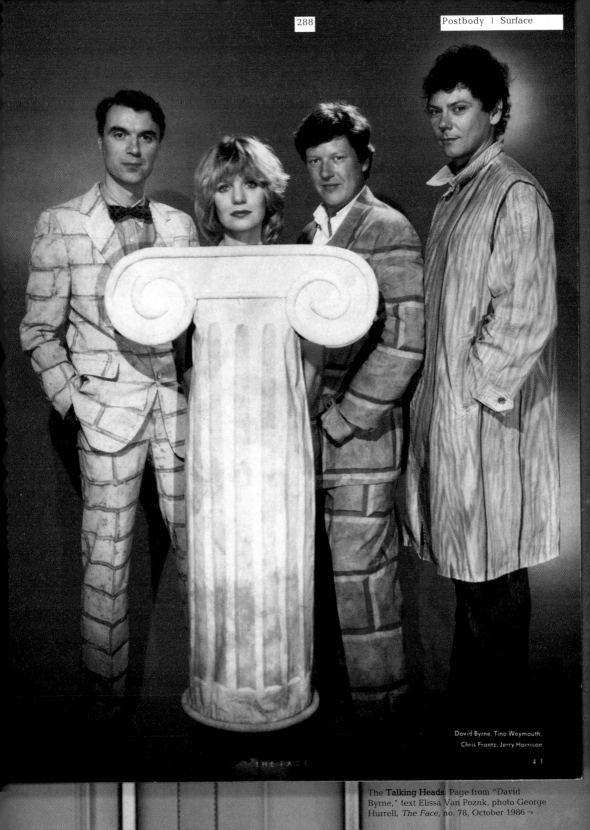

David Byrne, Tina Weymouth,
Chris Frantz, Jerry Harrison

THE FACE 4 1

The **Talking Heads**. Page from "David
Byrne," text Elissa Van Poznk, photo George
Hurrell, *The Face*, no. 78, October 1986 ¬

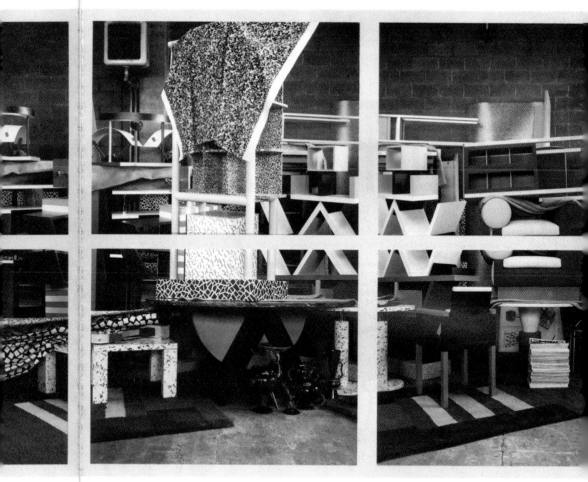

Memphis furniture and objects, photo
Davide Mosconi. Pages from *Interni*, no. 343,
September 1984 ¬

[p. 290] Cinzia Яuggeri advertising
campaigns. From above: fall/winter 1984-1985
and fall/winter 1983-1984, photo
Occhiomagico; spring/summer 1985;
spring/summer 1983; fall/winter 1985-1986,
illustrations Cinzia Яuggeri ¬

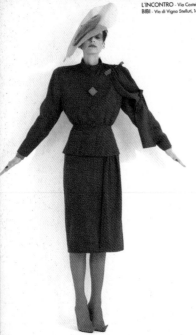

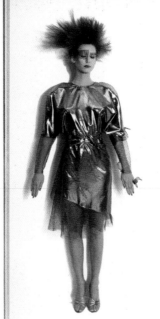

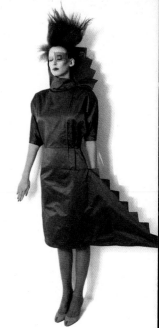

TESSUTO BRAGHENTI　　CALZATURE LINEA LIDIA

domus

MONTHLY OF ARCHITECTURE INTERIORS DESIGN ART

A glimpse on Italian architecture
Abitare a Milano, Nagasaki, Ginevra
in Belgio e negli Stati Uniti
Luciano Fabro: una città di 60 giorni
Forum: i luoghi dell'arte Colonia e Düsseldorf

"**Cosmetic Fallout,**" text and project Paola Navone and Magazzini Criminali, photo Occhiomagico. Pages from *Domus Moda*, no. 2, October 1981 ¬

[p. 291] "**The New Interior Designer,**" interior with coffee makers, design Riccardo Dalisi for Alessi, project Studio Alchimia and Occhiomagico for the cover of *Domus*, no. 625, February 1982 ¬

BELLEZZA E RELATIVITA'

di **PAOLA NAVONE** e **MAGAZZINI CRIMINALI**

Anno 1991, estate; 9 anni dopo l'Esplosione. Un fallout permanente ha modificato il clima e l'atmosfera terrestre.

Sui tetti della Città alcuni individui, spinti dalle insopprimibili ragioni della Bellezza curano il corpo nelle nuove condizioni climatiche. Cosa usano per la loro pelle?

// FASHION DESIGN ////

COSMETIC FALLOUT

Summer, 1991; 9 years after the Explosion. A permanent fall-out has ...ered the earth's climate and atmosphere. Solar light filtered through ...ioactive dust causes irreversible changes to the skin's metabolism.

On the City's roof-tops, certain individuals, driven by Beauty's irrepressible demands, look after their bodies in the new climatic conditions: What do they use for their skin?

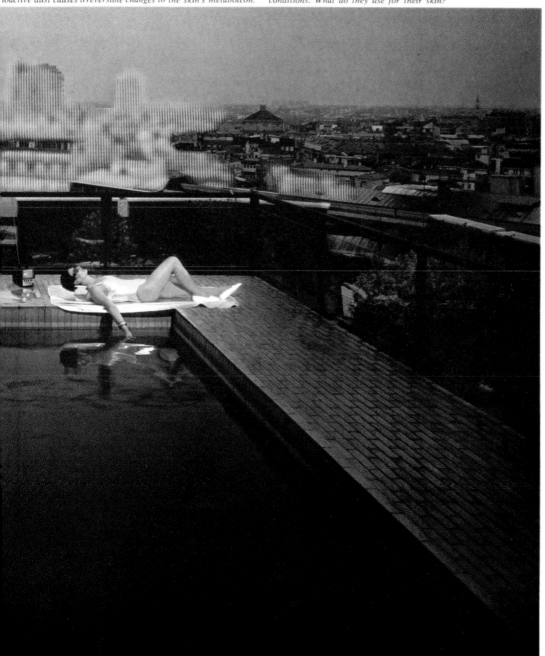

GICO

Il Mobile infinito

Λ collection of diverse furnishings assembled together to create a single, continuous living solution. This is the definition of *Mobile infinito*: creative ideas translated into forms and objects that became a genuine prediction of the designs of the decade to come.

The project displayed in the main square of Milan's Faculty of Architecture for just one day during September 1981 was a mixture of heterogeneous images and situations, with wardrobes, tables, lamps and bookcases, all covered with magnetic laminate, brought to life with the decorations of artists of the newly emerging Transavanguardia movement.

Λ result of the collective work of several designers, including Alessandro Mendini, Denis Santachiara and Andrea Branzi, the pieces of furniture did not hide their fragility, but were products of a formal recycling, and prominent examples of the most elegant banality.

Their presence declared an environment crowded with symbols and a design language that satisfied the requirements of its inhabitant, obeying his every demand, reflecting his interior landscape and amplifying the passions within.

The furniture clearly shunned industrial standardization in order become an original private monument. It belonged to a garden crystallized thought where the spirit of objects was incarnated in a graceful project. It was alchemical furniture, whose strength laid in bringing every experience to the surface, a production whose design was intended as a liberal emission of signals. Urban space was transformed into a jungle, was animated by the theatricality of the Magazzini Criminali, whose *Zone calde* demonstrated their symbolic guerrilla warfare, composed of staggering temptations.

The expression of this spatiality further developed with the comparison of varying intensities: the softness of a domestic piece contrasted with the icy detachment of geometric forms, and abstraction coexisted with sentimentalism.

There was a potential that could never be fully achieved, an existence that constantly evolved and that was compressed into a situation dominated by the object. Λ new form of subjectivity was vocalized and the political rapture of the seventies was definitely left behind; the most sophisticated culture flowed into the ephemera.

The time had come to return to collective projects, to seek out confrontation through a succession of thematic manifestations, with a network of linguistic exercises that contemplated a complete work of art, using a method that was free from pre-determined acts.

Design pursued the idea of visionary, temporary and infinite furniture. It restored the balance between shape and function, offering itself as the surface layer that accommodated the different written exercises and magnified its author's handwriting.

Following the Strada Novissima exhibited at the Biennial of Architecture held in Venice in 1980, countless occasions were organized for treating multiple design attitudes, against a setting implausible domestic landscapes.

Applied art and architecture found common ground in neo-romantic temptation and the dematerialization of objects, forms with neo-metaphysical atmospheres and a strong figural charge, or uncomplicated and accessible like gadgets. More the singular element of furniture, a system of stimuli was drawn up, an individual metaphor that abandoned the object's usefulness and inclined towards its external appearance.

Λ celebration of the self poured forth in a highly complex ritual, where design more than art was called upon to contain the suspended side of objects, according them a language with which they could express themselves. Which was where the redemption of decoration came in as the benchmark of a vital strategy, a cornerstone highlighted by zigzagging silhouettes and an ornamental dispersion that ended up dictating the project.

LUCA TREVISANI

domus 623 dicembre 1981

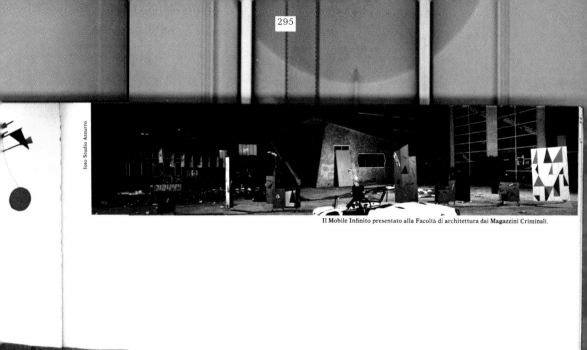

foto Studio Azzurro

Il Mobile Infinito presentato alla Facoltà di architettura dai Magazzini Criminali.

Mobile infinito, project Alessandro Mendini with Studio Alchimia. Pages from "Il Mobile infinito," text Rosa Maria Rinaldi, *Domus*, no. 623, December 1981 ¬

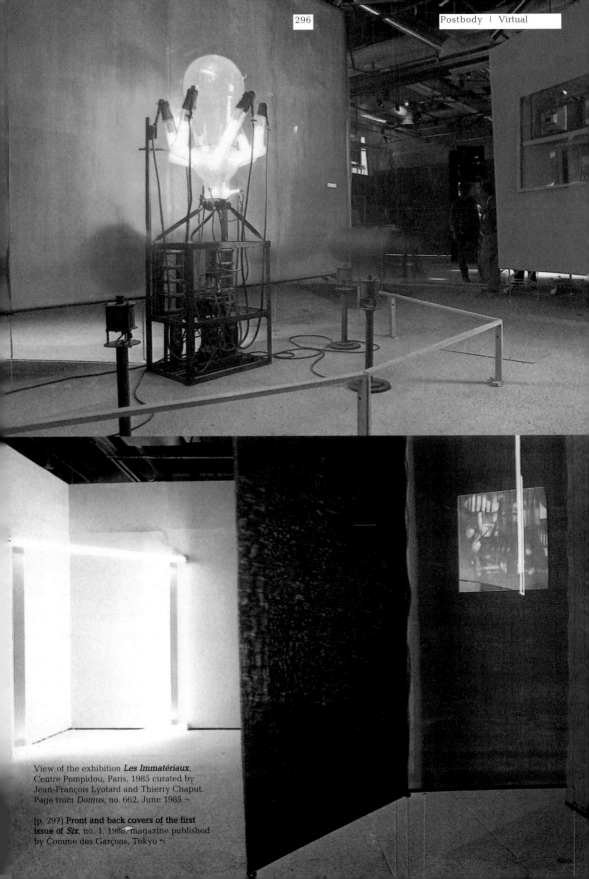

View of the exhibition *Les Immatériaux*,
Centre Pompidou, Paris, 1985 curated by
Jean-François Lyotard and Thierry Chaput.
Page from *Domus*, no. 662, June 1985 ¬

[p. 297] Front and back covers of the first
issue of *Six*, no. 1, 1988, magazine published
by Comme des Garçons, Tokyo ¬

Six

Number/1/1988

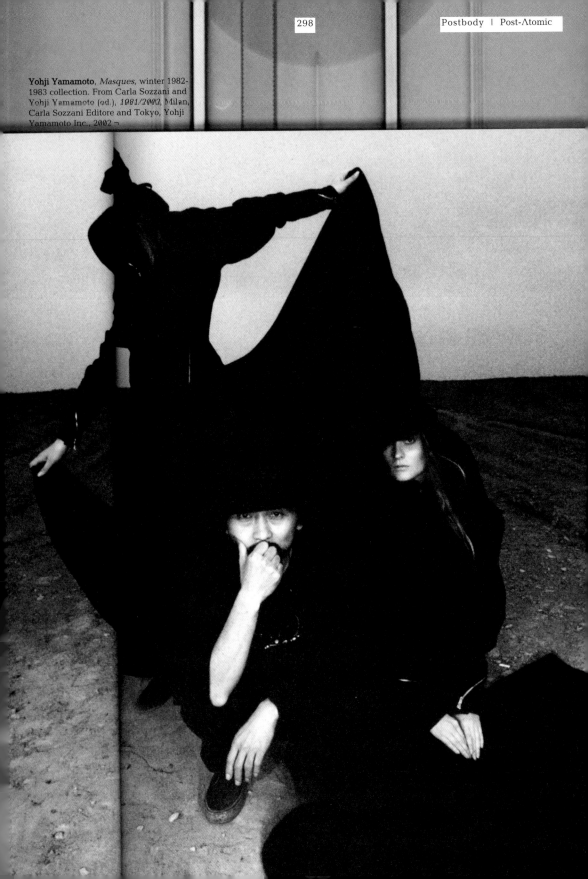

Yohji Yamamoto, *Masques,* winter 1982-1983 collection. From Carla Sozzani and Yohji Yamamoto (ed.), *1981/2002,* Milan, Carla Sozzani Editore and Tokyo, Yohji Yamamoto Inc., 2002 ¬

Comme des Garçons, fall/winter 1982-1983 collection, photo Peter Lindbergh, styling Mako Yamazaki. From *Comme des Garçons*, Tokyo, Chikuma Shobo Co., 1986 ¬

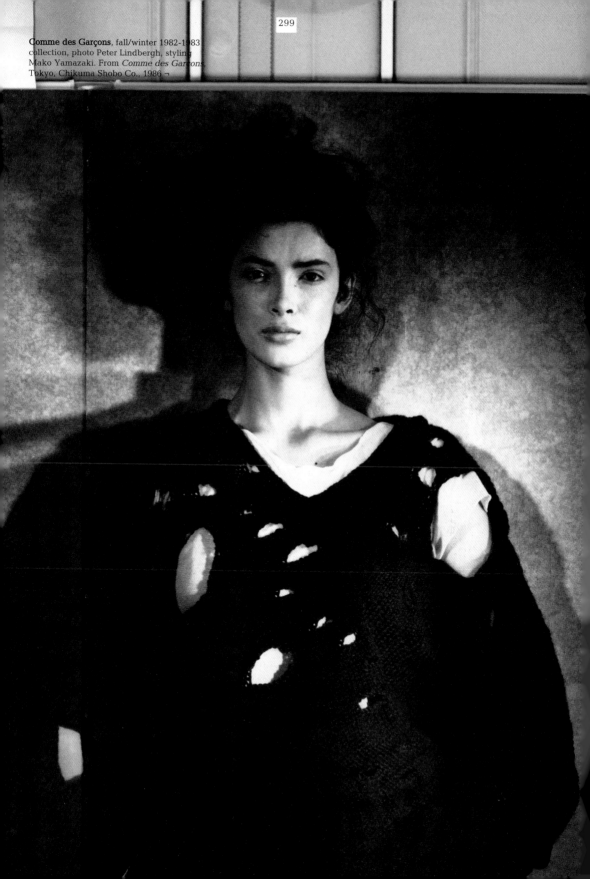

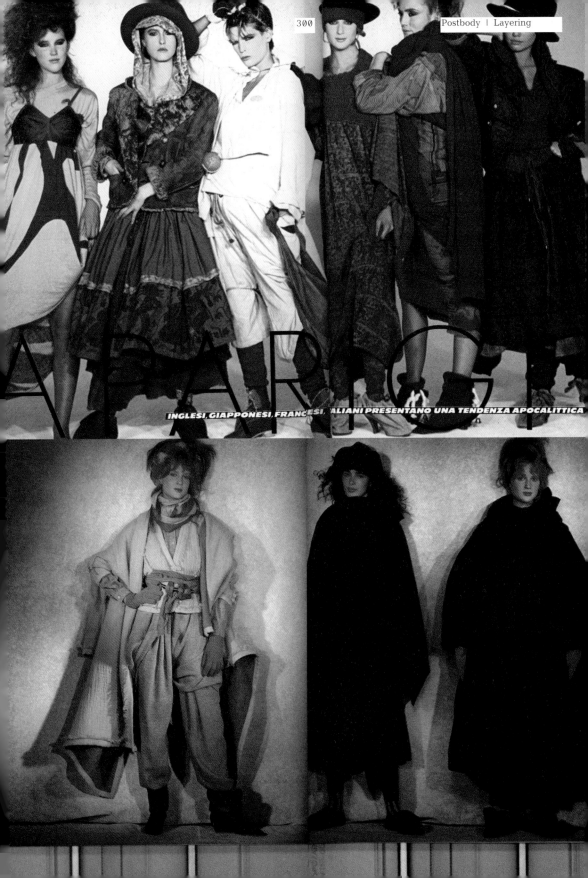

A PARIGI

INGLESI, GIAPPONESI, FRANCESI, ITALIANI PRESENTANO UNA TENDENZA APOCALITTICA

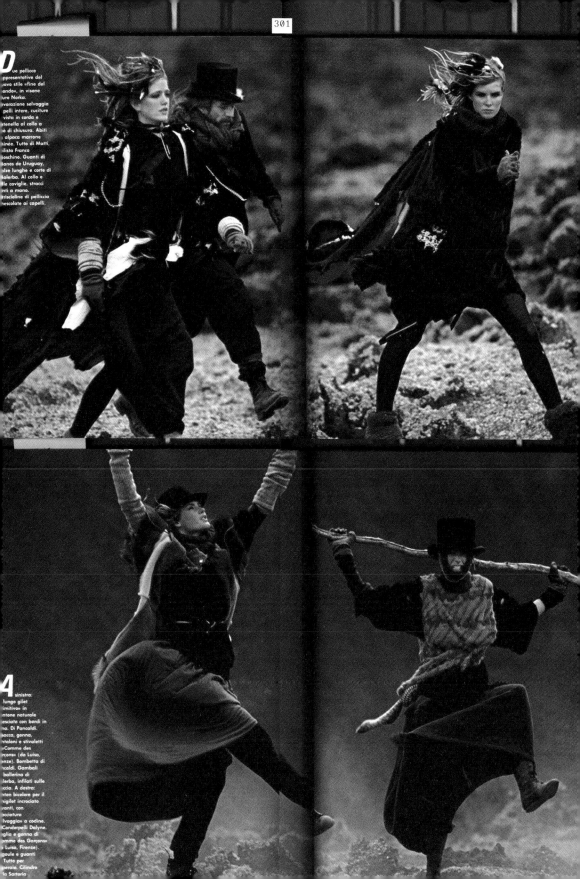

D
ue pellicce
appresentative del
uovo stile «fine del
ondo», in visone
ture Norka.
vorazione selvaggia
pelli intere, cuciture
vista in corda e
atenella al collo a
ò di chiusura. Abiti
alpaca marrone
née. Tutto di Matti,
ilista Franco
oschino. Guanti di
anes de Uruguay,
alze lunghe e corte di
alerba. Al collo e
lle caviglie, stracci
nti a mano.
riscioline di pelliccia
escolate ai capelli.

4
sinistra:
lunge gilet
imitivo in
ntone naturale
esciato con bordi in
a. Di Pancaldi.
acca, gonna,
ntaloni e stivaletti
erçon» (da Luisa,
nze). Bombetta di
caldi. Gambali
ballerina di
lerba, infilati sulle
ccia. A destra:
nten bicolore per il
nigilet incrociato
anti, con
acciatura
lvaggia a codine.
Condorpelli Dalyne.
glia e gonna di
omme des Garçons»
Luisa, Firenze).
goule e guanti
Tutto per
enerali. Cilindro
la Sartoria

Яon Λrad, hi-fi system with concrete exterior, production One-Off, 1985-1986 ¬

Λnimali domestici, design Λndrea and Иicoletta Branzi, production Zabro, 1985 ¬

[p. 300] **"Λ Parigi: Inglesi, giapponesi, francesi, italiani presentano una tendenza apocalittica,"** text Lele Λcquarone, photo François Lamy. Pages from *Vogue Italia*, no. 390, July-Λugust 1982 ¬

[p. 301] **"Con strappi e brandelli arrivano le nuove barbare,"** photo Hans Feurer. Pages from *Vogue Italia*, no. 392, October 1982 ¬

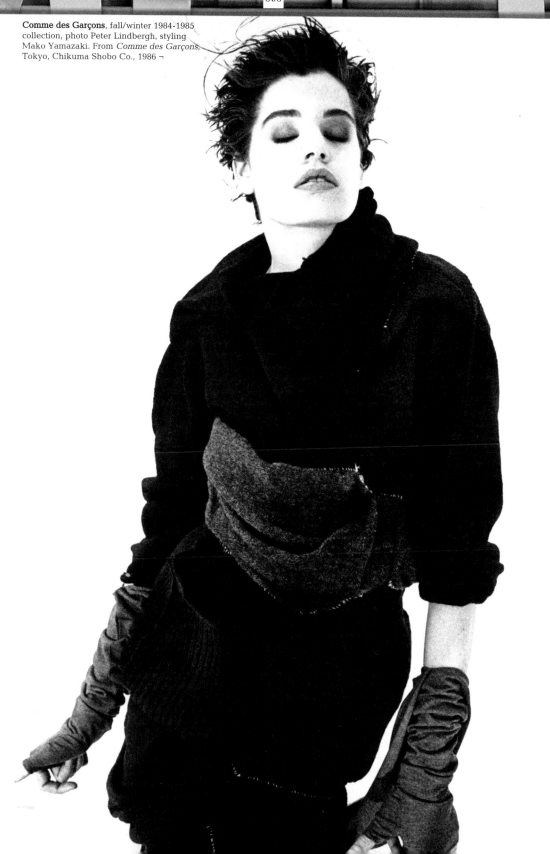

Comme des Garçons, fall/winter 1984-1985
collection, photo Peter Lindbergh, styling
Mako Yamazaki. From *Comme des Garçons*,
Tokyo, Chikuma Shobo Co., 1986 ¬

Cindy Sherman

Cindy Sherman's entire development, right from the early work, marked a point of no return in the relationship between art and mass culture. She appeared alone in the *Untitled Film Stills*: every photo a different role and set, an air of fifties cinema, but no scholarly reference. A woman artist finally both subject and object of the photos, a true revolution in the power game of the gaze, which until then had seen men as the active party and women as the object to be portrayed. Yet it was in the fashion photos from the early eighties that Sherman enshrined her point of view on the issue.

In a series of commissions in 1983, the suspended, often melancholy ambiguity of the early images gave way to a different form of ambiguity. One of the central issues of her work emerged: the relationship between love and hate, attraction and repulsion with regard to makeup, disguise, masking, being "infatuated with makeup and glamour and detesting it at the same time. Trying to be and seeming a real young woman, to seem sexy or beautiful and at the same time feeling a prisoner in that structure!" as the artist commented in an interview in 1997.

Sherman accepted an invitation from Dianne Benson, owner of a well-known New York boutique, to produce images for publication in *Interview* using garments by designers like Jean-Paul Gaultier, Issey Miyake and Comme des Garçons. She took many photos and four of them, in black and white, were published.

They are aggressive, rebellious images in which the artist wears designer garments, but inverts the stereotype of glamour and beauty and introduces grotesque elements with nuances that are somehow humorous (the hallucinating gaze, the makeup . . .). These were to become dominant features of the series of photos that followed immediately afterwards. The encounter with a world that lives on the spasmodic quest for beauty and seduction at all costs seemed to serve as a sort of detonator that accelerated the artist's immersion in the other, obscure side of life. Hence the fragmented bodies, the horror scenes, the series on disasters.

The first series was followed by a second invitation, again within the world of fashion. The artist was invited by designer Dorothée Bis to produce images using her garments for publication in *Vogue France*. On this occasion expectations aroused by the previous photos played an important part: the first couple of shots didn't go down well because they weren't sufficiently "happy and funny" like the photos published in *Interview*. The garments available inspired characters that were anything but happy and funny. At any rate, Sherman completed the job, but this second commission led her to decide not to accept other similar invitations.

It was only in 1993 that Barbara Heizer, editor of *Harper's Bazaar*, involved Sherman once again, and the following year she produced fashion shots for Comme des Garçons. In both cases the artist was given complete freedom and was allowed to use the garments not as "designer fashion" but as props in her work. She appeared alone, as always.

Emanuela De Cecco

Cindy Sherman, *Untitled # 127*, 1983,
color photograph, 82 x 55 cm. Private
collection, Milan ¬

[p. 304] **Cindy Sherman**, *Untitled # 124*,
1983, color photograph, 62 x 84.
Brustia/Manassa collection, Vigevano ¬

Tilda Swinton in *Caravaggio*,
GB 1986, director Derek Jarman ¬

Glenn Close in *Dangerous
Liaisons*, USA 1988, director
Stephen Frears. © Photomovie ¬

[p. 307] **"Speciale Inghilterra –
London neo-illuminista,"** text
Mariuccia Casadio, photo John
Stoddart. Page from *Vanity*,
no. 24, March-April 1987 ¬

Carlo Maria Mariani, *Costellazione del Leone*,
1980-1981, oil on canvas, 340 x 450 cm ¬

Derek Jarman

"I cut my hair, took off my earrings, put on a leather jacket and armed with lubricant and poppers I set off into the night."[*] (Derek Jarman, *At Your Own Яisk*, 1992.) Λ quest for pleasure and risk, provocative expression of his homosexuality, and calculated effrontery (in politics as much else): Jarman's career stunned Thatcher's Britain through the cross-fertilization of different artistic forms, not just in film but also with video clips, stage design, poetry and painting. Influenced by punk, in the late sixties he emerged with the films *Sebastiane* and *Jubilee*, whose leading actors were recruited among the customers of Sex!, Vivienne Westwood and Malcolm McLaren's shop in King's Яoad. With *Caravaggio* (1986) he sharpened and matured a style from esthetic transgressions, staggering anachronisms and pared-down production designs, which became the only alternative in the British cinema to Greenaway's baroque panoplies. The style also appeared in the turbulent and explosive musical scene in London of those years within electronic and Иew Яomantic genres. Jarman made videos for Brian Ferry, Bob Geldof, Marc Λlmond, The Pet Shop Boys and The Smiths. The discovery that he was HIV-positive led Jarman to politicize and radicalize (also esthetically) his subsequent work. Hence the non-communicating iron bunkers in *Edward II* (1991), where a superb Tilda Swinton toting an Hermès handbag moves between lust for power and OutЯage! activists; the uninhibited flashbacks against black backgrounds in *Wittgenstein* (1992); and the painful final negation of vision in favor of sensation in *Blue* (1993), released posthumously, forming symbolic closure to his life and career.

Mλuяo Tiитi

[*]Our translation from Italian edition, Derek Jarman, *Λ vostro rischio e pericolo: Testamento di un santo*, Milan: Ubulibri, 1992

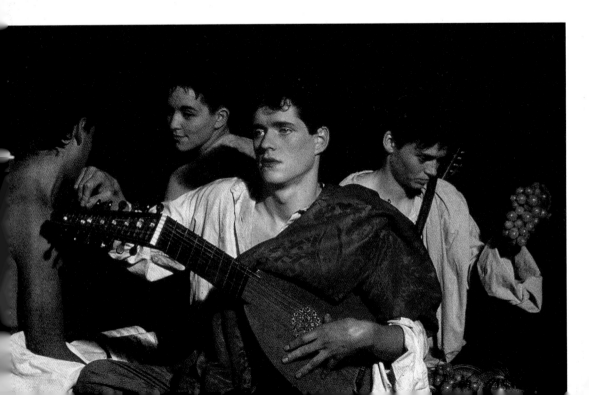

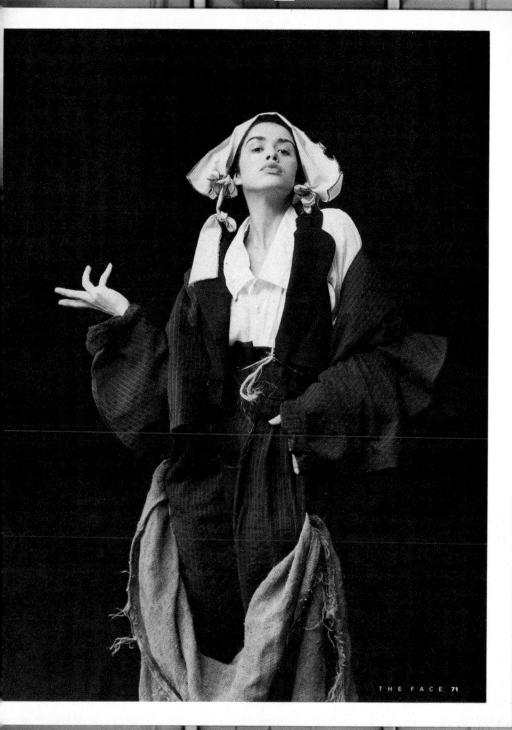

THE FACE **71**

John Galliano. Page from "Fashion:
The Urchin Urge," photo Andrew
Macpherson, styling Amanda Grieve,
The Face, no. 68, December 1985 ¬

[p. 310] *Caravaggio*, GB 1986,
director Derek Jarman ¬

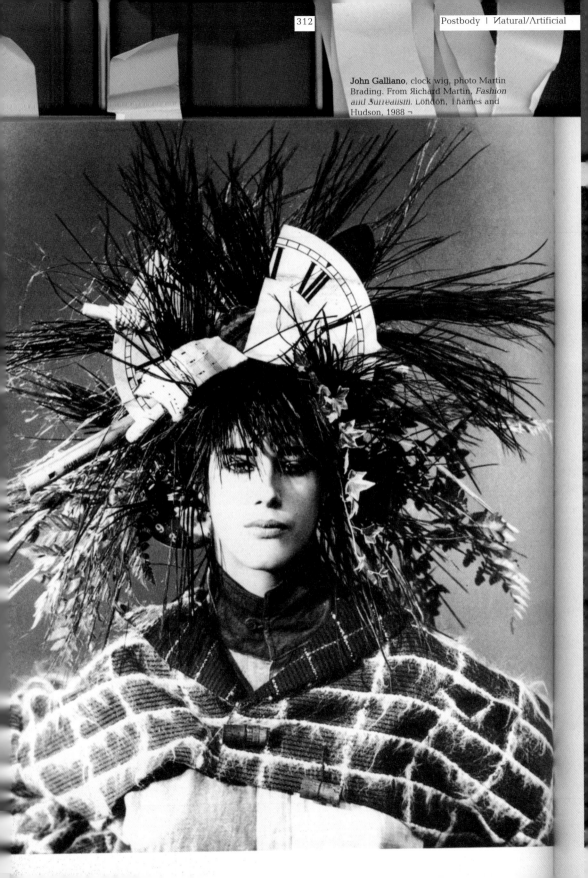

John Galliano, clock wig, photo Martin Brading. From Richard Martin, *Fashion and Surrealism*. London, Thames and Hudson, 1988 ¬

"Veiled Threats," styling Amanda Grieve, photo Andrew Macpherson. Page from *The Face*, no. 57, January 1985 ¬

Helena Bonham Carter, styling John Galliano, photo Robert Ogilvie. Cover of *Blitz*, no. 41, May 1986 ¬

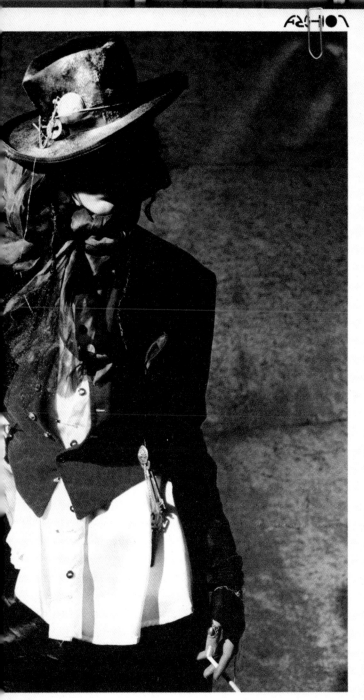

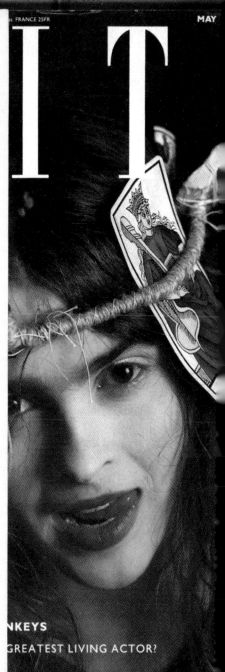

THE FACE **53**

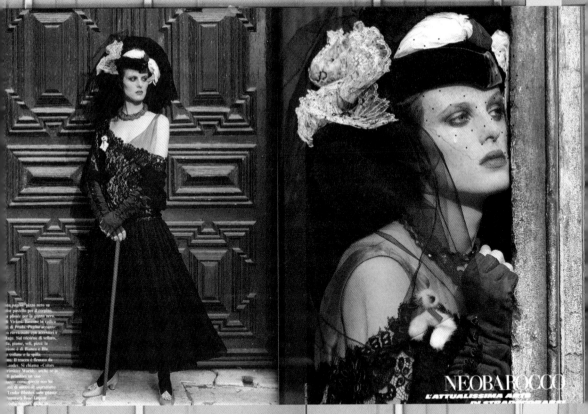

pagne, pizzo nero va
de pastello per il corpino.
à plissé per la gonna nera.
di Viviani. Basane in calza
di Prada. "Pagine scurate
s ravvicinano con accessori e
tage. Sul ricino di velluto,
a, piume, veli, pizzi le
omo è di Bianca e Blu
e collane e la spilla
so. Il tracco è firmato
ander. Si chiama "Colors
rimata Worldy: anche se si
il primitivo più vivo
era di antico e soprattutto
Tendit Blusher sule guance
mpuratri Rose Legent

NEOBAROCCO
L'ATTUALISSIMA ARTE
DI STRADECORARSI

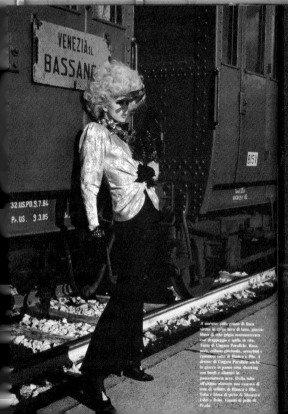

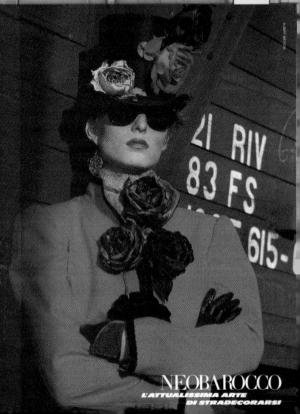

A sinistra: volta gonna di finta
sirena in crêpe nero di lana, giacca-
blusa di seta grigia surmontizzata
con drappaggio e spilla in vita.
Tutto di Ungaro Parallèle. Rosa
nera, collana ghicianda, orecchini e
cammeo tutti di Bianca e Blu. A
destra: di Ungaro Parallèle anche
le giacca in panno rosa shocking
con bordi e alamari in
passamaneria nera. Dalla tuba
all'ultimo alamaro una casacca di
rosa di velluto, di Bianca e Blu.
Tuba e blusa di pizzo di Mosquera
Libri e Robe. Guanti di pelle di
Prada.

NEOBAROCCO
L'ATTUALISSIMA ARTE
DI STRADECORARSI

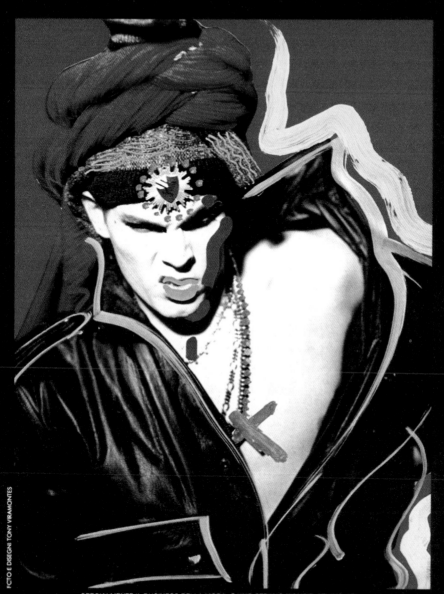

FOTO E DISEGNI TONY VIRAMONTES

SPECIALMENTE IL BUSINESS DELLA MODA: È UNO STRANO MONDO. STUDIO CON-
TEMPORANEAMENTE MOLTE LINGUE, AMO L'ITALIA. MI PIACEREBBE LAVORARE
CON ZEFFIRELLI E BERTOLUCCI, MA SOPRATTUTTO CON FELLINI. E NON È ESCLU-
SO CHE PRIMA O POI DECIDA DI DIVENTARE ITALIANO.

NELLA PAGINA ACCANTO. PULL RETOUR; PANTALONI BOBBY'S; IMPER IN NYLON,
S. FRANCISCO CO. IN QUESTA PAGINA. BLOUSON IN PELLE, LINCOLN.

"Underground '80," photo and drawings
Tony Viramontes. Page from *Per Lui*, no.
21, November 1984 ¬

[p. 314] "Neobarocco: L'attualissima arte
di stradecorarsi," photo Albert Watson.
Pages from *Vogue Italia*, no. 417,
December 1984 ¬

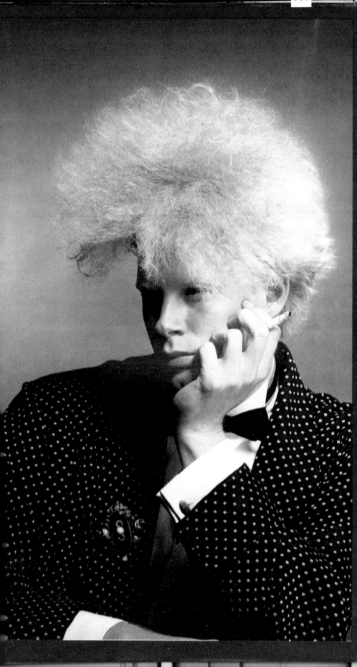

"Momento d'amore tra smoking e vestaglia," photo Fabrizio Ferri. Page from *Mondo Uomo,* no. 20, July 1984 ¬

The Eighties Dandy

Liberated and *fashionista*? Could be. But it is much, much more than that. Is it actually possible to properly define the dandy of the eighties? During the years when, in fashion terms, ideologies were dictated by reflux (more often than not in the form of ideas rather than philosophies), the dandy too was able to brush away the fusty historical iconographic images that depicted him as a dolled up if not effeminate figure, taking advantage of the reversal of sexual roles in order to redefine himself as rehabilitated for contemporary times. As masculine as possible, in a decade that had seen the decline of male chauvinism under the attack of a deliberate weakness – and a strength that would need to be renamed – affected, because required to be so by definition, yet more heedful to emphasize a distinct style rather than enact one already predetermined. The obsessive figure of the dandy bequeathed to us by Oscar Wilde remained equally obsessed with much-needed, intimate and exterior modernization in the eighties, and was every bit as tyrannical. The only thing to change was the assumed and/or real effeminacy: affectation became secondary to physical strength, which, for maybe the first time in masculine history, became both communication and merchandise in an open, brazen-faced and conscious manner, previously only witnessed in the transgender movement of the sixties and seventies. And through this seemingly total submission to the dictates of fashion, the eighties dandy also earned the title of *fashionista* (a concept that later degenerated into the more negative term "fashion victim"), an expression that then indicated the driving forces that propelled fashion and all that followed it, be it in cosmetics, fragrances or in the gym. All of which were necessary ingredients for exhibiting dandyism, even when unclothed and exposed as naked, toned and well-built. Undoubtedly, the modernized image that the eighties dandy brings to mind during that spectacular (as it can only be defined) decade was encapsulated by Gianni Versace's concept of "The man without a tie," which pervaded and predominated his fashion, and which he described in a book which came out at the beginning of the following decade. Given that the book's title was merely a pretext (to be "tie-less" represents a liberation that has little to do the accessory itself), the images portray a man who changes like a chameleon: reclining on a bed of delicate roses in a white tuxedo, with only sandals on his feet, wearing a transparent lacy shirt, wantonly buttoned up in a double-breasted pin-striped suit or totally denuded of any other decorations than his muscles, the man that Versace depicted during those years reunited centuries of masculine images. But above all, it also demonstrated the hard-fought battles waged to destroy and at the same time reaffirm the role provided by nature, which displays the male animal as more richly adorned, more brightly colored and more ostentatious than his female equivalent. And it was from that "preciosity" that the seeds were sown for the creation of a man who in the year two thousand, is still looking for himself

MICHELE CIAVARELLA

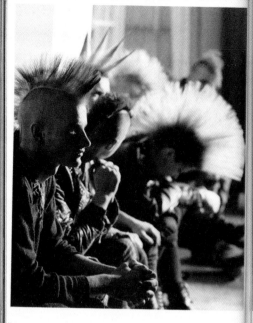

Giacca in broccato a disegni Liberty a tutta allacciatura,
Jean Paul Gaultier pour Gibò; cache-col in tulle, T.F.T.

Nella pagina accanto. Giacca smoking in lana, J.F. Charles
per Piero Panchetti; camicia con jabot pieghettato, Komlan; modaglie
Suberi; orologio come decorazioni da sinistra,
con calendario perpetuo, automatico con fasi lunari,
con meccanismo a vista, tutti in oro, Chopard.
Hair, Ollie O'Donnell for Atlas Salon; make-up, Kaz Simlee at Faces.

"Gli estremi di London: Décor edoardiano e
post-punk," photo Aldo Fallai. Pages from
L'Uomo Vogue, no. 158, December 1985

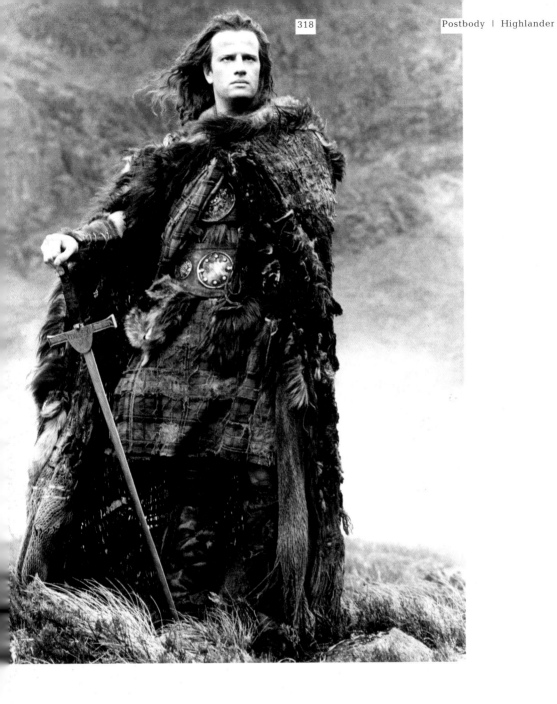

Christopher Lambert in *Highlander*,
GB 1986, director Яussell Mulcahy.
© Photomovie ¬

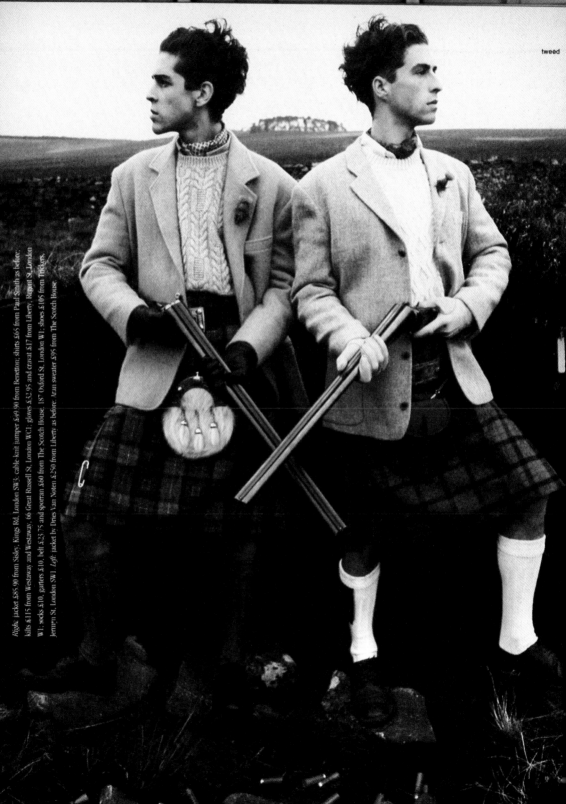

"Tweedy Pie," photo Richard Croft, styling Simon Foxton. Page from *Arena*, no. 6, fall/winter 1987 →

Right jacket £85.90 from Sisley, Kings Rd, London SW3; cable-knit jumper £49.90 from Benetton; shirts £65 from Paul Smith as before; kilts £115 from Westaway and Westaway, 66 Great Russell St, London WC1; gloves £32.95 and cravat £17 from Liberty, Regent St, London W1; socks £10, garters £10, belt £23.75 and sporran £60 from The Scotch House, 187 Oxford St, London W1; shoes £105 from Frickers, Jermyn St, London SW1. *Left* jacket by Dries Van Noten £250 from Liberty as before; Aran sweater £95 from The Scotch House.

"Il tempo ritrovato," text Joseph Sassoon, photo Koto Bolofo. Pages from *L'Uomo Vogue*, no. 171, February 1987 ¬

[p. 321] Яupert Everett and Colin Firth in *Another Country*, GB 1984, director Marek Kanievska. © Photo12/Grazia Иeri ¬

pena,
delle
i e l'i-
ati, le
agine
zzata,
lotata
azioni
libili.
hiaro
are il
ongo-
aliani
o co-
lo se
li che
mente
tte le
asual
ti alle
ssano
er la
co la

», da
za a-
tta in
asual-
messe
bero.
ti fat-
di in-
possa
hion,
dalla
tego-
iona-
colari
to, di
la po-
privo
e «in-
lgere
J.S.

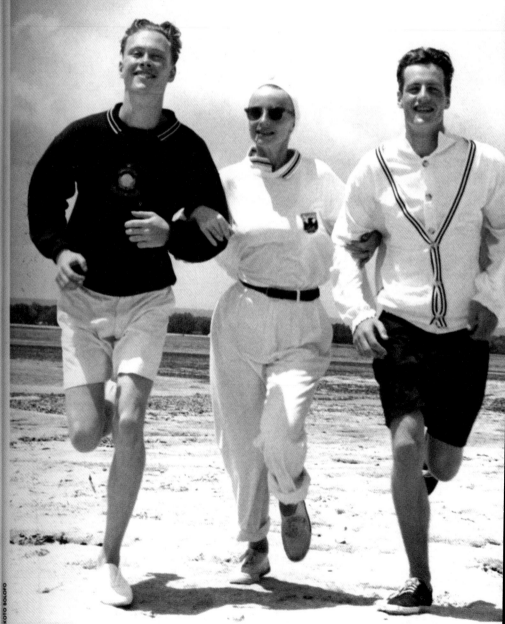

KOTO BOLOFO

Emporio Armani, profili contrasto per la felpa blu, per l'argentina, per il giubbotto-camicia; bermuda in tela, pantaloni in rasо

Time Recovered

"Men's Fashion. Versace Relaunches the Classic." With this subtitle, a recent *Panorama* article commented on what seems to be the latest dominant trend among the creators of Italian fashion when it comes to men's clothing. But the headline contains an underlying contradiction. Because the "classic," if you want to define it in structural terms – as a polar term in an antinomy – is definitely opposed to "fashion," meaning any tendency in vogue that asserts itself for a brief period of time, destined to a brief existence, especially when occuring through choices made by the great designers. In other words, the classic is such precisely because it is not "in fashion": so it is impossible by definition for someone to launch, or relaunch, it.

In fact, the classic, despite the overwhelming success of the casual throughout the seventies and the explosion of Italian style in the eighties, has continued to meet with the predilection of many social groups and classes that are extraneous to or at any rate distant from the fashion universe (whether fashions in clothing or of a socio-cultural kind). Apart from the snobs, they are politicians and diplomats, managers, civil servants, and many government workers, bank clerks, pensioners and the middle-aged, etc. In short, a substantial part of the male population and the market.

The sociological reasons for this predilection are easily understood. The distance from fashion implies an innate resistance to variability, which is the overriding characteristic of fashion. This resistance constitutes in itself a value, if not actually an ideological orientation, since it signifies a stand in favor of tradition, of order, of respectability. Classic clothing, though not necessarily conservative (typically, the *apparatchiks* of the communist parties in just about every country wear classic), still it expresses the need to stick to a codified style of dress that admits very few variations. Very slight variations are permissible in the breadth of jackets and pants, the shape of the shoulders, the form of the lapels. But the structure of the garments and the overall inspiration – as well as the materials used, the fabrics, the colors – have to match a recognized, internalized image of the male figure, endowed with an identity and capable of coherent, ritual, predictable actions.

If this is so, it is clear that the idea of "relaunching the classic" the way the leading Italian designers want to do it represents a credible communicative purpose only if it is directed at social classes that hitherto have been broadly interested in fashion, in all its variations, including the casual. And these are the rising social groups – members of the new free professions, etc. – who are the only ones who can accept that kind of squaring of the circle by which the classic becomes fashionable, significantly forcing its inner nature.

It needs to be said in fact that many of the "rising" figures have already for some time been turning to the classic without awaiting its consecrated relaunch. And for them it is, in effect, a style rediscovered after the inebriation with postmodern casual fashion of their younger days, and now set aside or rightly confined to their leisure hours. This new spread of the classic is due to many factors, but the decisive one is above all the need to identify a new form of clothing that can be *distinctive* when the fashion ideas, whether bearing designer *griffes* or not, have been taken over by the masses. Naturally, the classic that interests the social categories indicated differs from the more traditional kind (the clerk at the registry office) by a series of decisive details. An example? The carefully premeditated use of that garment signifier of the superfluous that is the breast pocket handkerchief. A redundant sign, perfectly useless and devoid of any function, except its validity as the "index" of an achieved affluence, capable of indulging in esthetic concerns.

JOSEPH SASSOON, *L'Uomo Vogue*, no. 171, February 1987

NIKOS. FRACK IN PELLE SCAMOSCIATA CON REVERS MOIRÉ. VESTAGLIA IN SETA, JEAN MUIR. CAMICIA COMME DES GARÇONS.

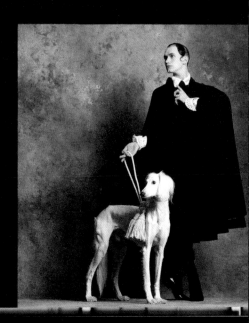

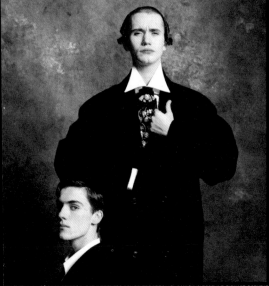

VALENTINO. PALTÒ DOPPIOPETTO IN CASHMERE NERO CON REVERS REGOLARI. CAMICIA IN POPELINE, RICHARD CORNEJO.

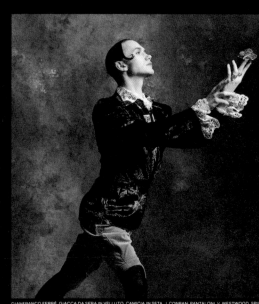

GIANFRANCO FERRÉ. GIACCA DA SERA IN VELLUTO. CAMICIA IN SETA, J. CONRAN; PANTALONI, V. WESTWOOD. SPIL

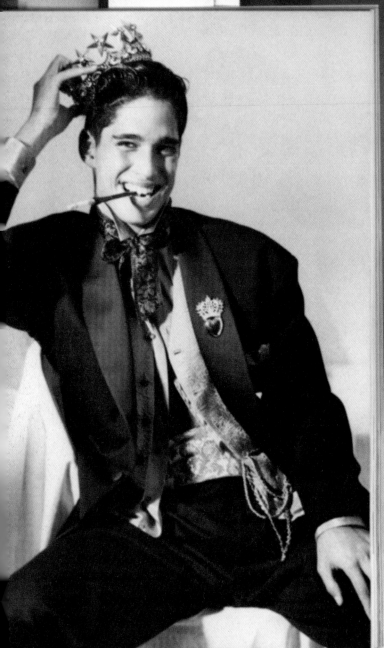

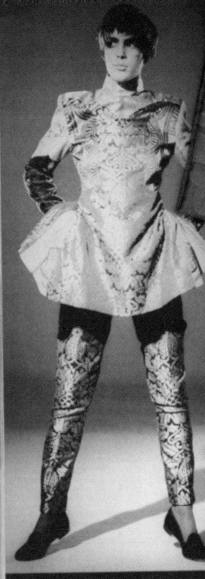

Texte et stylisme Debbie Mason. Photo Barry Dunn

"Inventare la sera," photo Giampaolo Barbieri. Page from *L'Uomo Vogue*, no. 180, December 1987 ¬

"Londres: British Chic," text and styling Debbie Mason, photo Barry Dunno. Page from *CITY Magazine International*, no. 10, Λpril 1985 ¬

Crolla jacket, 1987 ¬

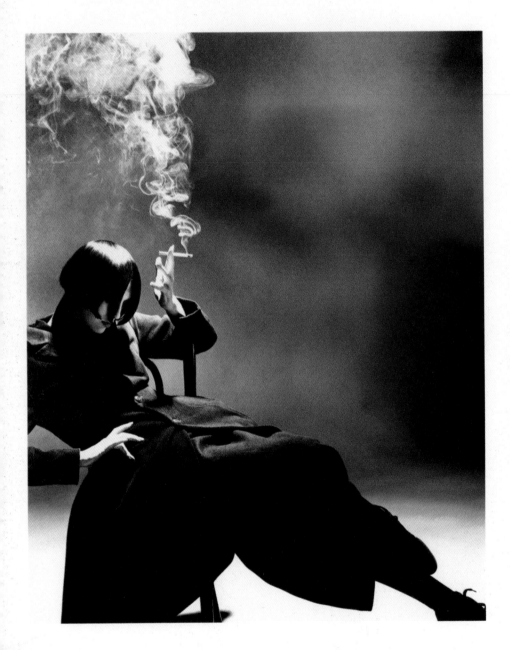

Yohji Yamamoto, fall/winter 1988-1989
collection, photo Nick Knight,
design Peter Saville Associates.
From the catalogue *Eighty eight, Eighty
nine*. © Yohji Yamamoto, 1988 ¬

Comme Des Garçons, fall/winter 1987-1988
collection, photo Peter Lindbergh,
coordination Mako Yamazaki.
From the catalogue *Comme Des Garçons
N° 97 le 10 Juillet 1987*, Tokyo,
Comme Des Garçons Co., 1987 ¬

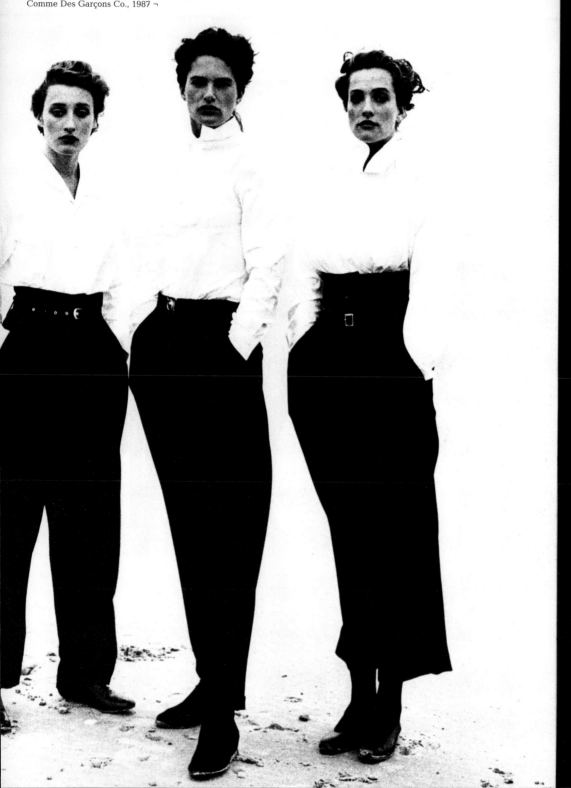

GERMAN, blazer ridisegnato in melton di lana, doppiopetto e bottoni diagonali, gilet e pantaloni in diverse gradazioni di flanella superfine gessa-ta millerighe in popeline. Cravatta in seta a righe alternate, e pochette, Altea, catena in argento, Cevaschi.

JEAN PAUL GAULTIER POUR GIBÒ, jersey di cotone elasticizzato per la giacca ridisegnata a righe triple e profili in raso nero, su pantaloni in lycra al ginocchio, tessuti Verel de Berval; gilet rigato e camicia in cotone. Cravatta in seta, Citterio; calze Rede; stringate in pelle nera, Dirk Bikker.

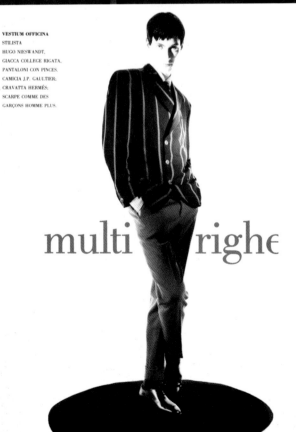

VESTIUM OFFICINA
STILISTA
HUGO NIESWANDT,
GIACCA COLLEGE RIGATA,
PANTALONI CON PINCES,
CAMICIA J.P. GAULTIER;
CRAVATTA HERMÉS;
SCARPE COMME DES
GARÇONS HOMME PLUS.

multi righe

"Sfidare la tradizione," photo Nadir.
Pages from *L'Uomo Vogue*, no. 181,
January 1988 ¬

"Multirighe," photo Satoshi Saikusa.
Page from *L'Uomo Vogue*, no. 193,
February 1989 ¬

Jean-Paul Gaultier Femme jacket, 1986

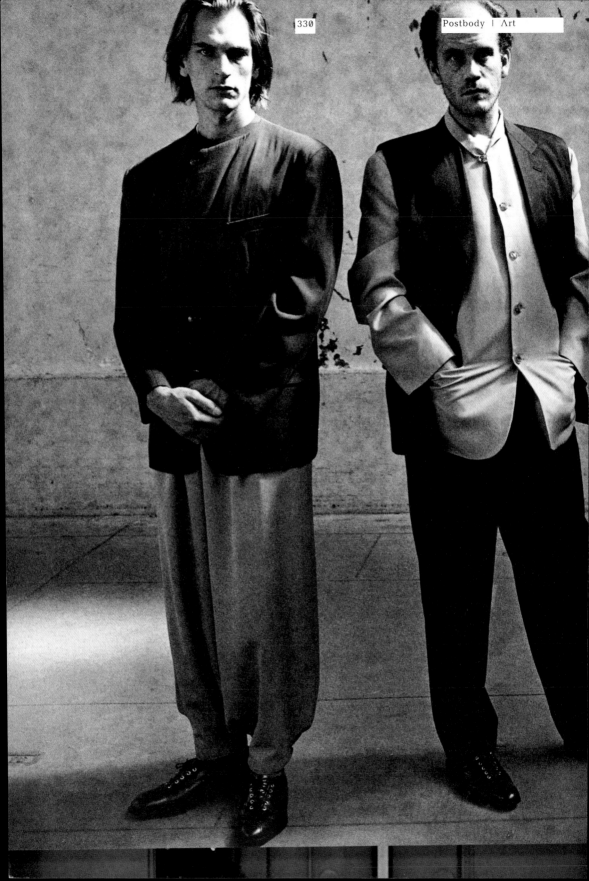

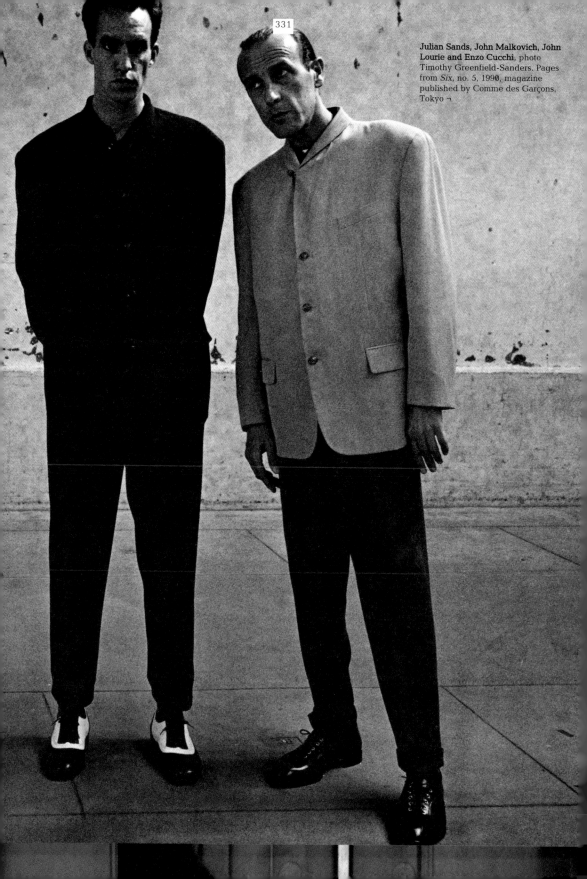

Julian Sands, John Malkovich, John Lourie and Enzo Cucchi, photo Timothy Greenfield-Sanders. Pages from *Six*, no. 5, 1990, magazine published by Comme des Garçons, Tokyo ¬

Jeff Koons, *Travel Bar*, 1986,
stainless steel, 35.6 x 50.8 x 30.5 cm,
edition of 3 + artist proof. Courtesy
Sonnabend Gallery, New York ¬

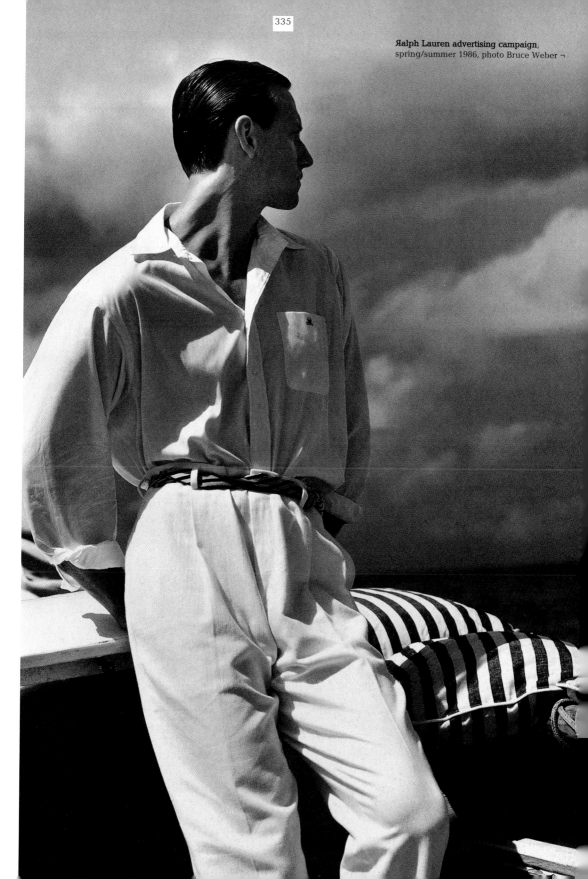

Яalph Lauren advertising campaign,
spring/summer 1986, photo Bruce Weber ¬

UNA LINEA SNELLA, *agile e aggraziata, mette in risalto il seno*

LA VITA SOTTILE, *il ventre piatto, le gambe asciutte, il corpo in armonia*

LEVIGATA, *morbida, quasi setosa: la pelle va idratata e massaggiata*

AFFUSOLAT *lunghe, sotu le gam quest'an tornu in pre pu*

Ethereal Woman

Running parallel with the "strong" influence of the silhouette, a brand new femininity emerged from its shell, evanescent, mercurial and slight. The deconstruction of the traditional Western approach to clothing, with collections by Japanese fashion designers such as Rei Kawakubo, Yohji Yamamoto and Issey Miyake on the French catwalks, provided the first step towards a new philosophy – translated into new forms – with regard to the body. Or, more specifically, a woman's body. Their "post-atomic" collections, produced alongside their European colleagues' shaped, highly stylized creations, introduced a new style that was both troubled and troubling, a style that appeared to deny physicality in one foul sweep in the name of a run-down, cowling style that further degenerated into shapeless shapes. It was a fashion that flirted with disaster, complied with catastrophe and even contemplated the ensuing aesthetic possibilities. It was therefore a fashion that went beyond terrestrial seduction, sexual differentiation and the distinction between functional clothes and exhibitionist clothes. The Japanese laid the foundations for a new language in fashion design, using an alphabet that would be reconstructed with a more European poetics, but one that embraced its urgent sentimental and emotive needs. The exceptional good taste of Romeo Gigli, standard-bearer of a truly modern romanticism, brushed away the image of an assertive, structured Italian look in order to produce a vibrant, celestial woman who was more receptive to irregular heartbeats than to palpable sensuality. What was brought into play was a declaration in the form of clothing situated halfway between "fear and desire," as the title of a novel by Peter Handke put it. "Fear" of liberal, unconventional, multi-faceted sexuality, which began to be darkened by the dangers of AIDS (the first cases discovered in the United States date back to 1983) and led to the establishment of new rules in terms of human relations. "Desire" for a style that gave prominence to the language and gestures of the mind, recording new *Terms of Endearment* – one of the period's most successful films – that entrusted day-to-day direction to sentiment. The ethereal woman employed a highly sophisticated, but not yet minimalist language: the simplicity of forms and volumes and a lack of internal structure to the clothing did not correspond to an elimination of decoration; which, on the contrary, was used as an element of nostalgic memory, as a value of memory with global but not folklorist craftsmanship (Andean embroidery, Byzantine appliqués, nineteenth-century sashes, African jewelry). Suspended in time, traveling between iconic eras and references, the ethereal woman lightly circled above the precipice of anxiety, an affirmation of the supremacy of the fragility, delicacy and (in)consistency of the architectonic image of mainstream fashion. Until, of course, mainstream became her, with her hazy silhouette, her cerebral fascination, her highly sophisticated spontaneity.

Antonio Mancinelli

Romeo Gigli. Page from "Stilizzati in rosso e nero quattro sogni di Natale," drawing Mats Gustavson, *Elle*, vol. 1, no. 3, December 1987 ¬

[p. 336] **"Come lei,"** photo Paolo Roversi. Pages from *Elle*, vol. 1, no. 2, November 1987 ¬

MATS

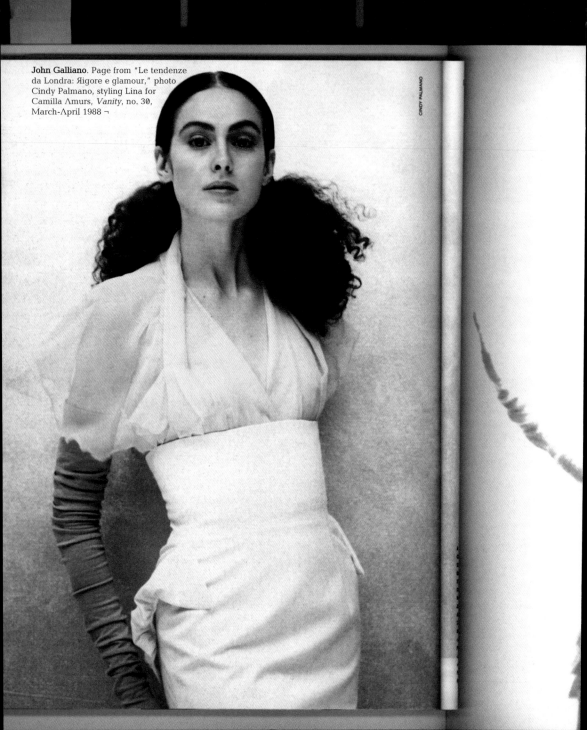

John Galliano. Page from "Le tendenze da Londra: Rigore e glamour," photo Cindy Palmano, styling Lina for Camilla Λmurs, *Vanity*, no. 30, March-Λpril 1988 ¬

CINDY PALMANO

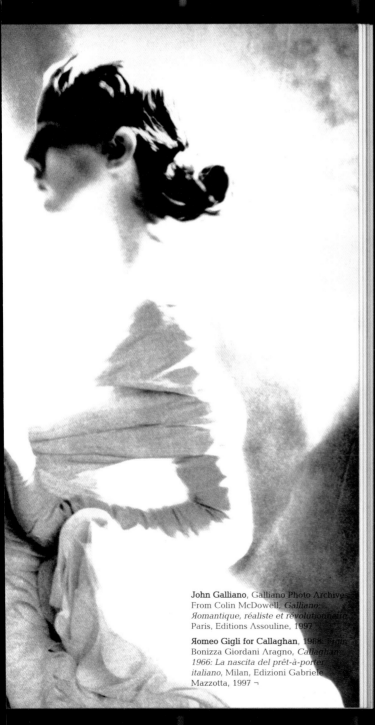

John Galliano, Galliano Photo Archives.
From Colin McDowell, *Galliano:
Яomantique, réaliste et révolutionnaire*,
Paris, Editions Assouline, 1997

Яomeo Gigli for Callaghan, 1988. From
Bonizza Giordani Aragno, *Callaghan
1966: La nascita del prêt-à-porter
italiano*, Milan, Edizioni Gabriele
Mazzotta, 1997 ¬

"**Moda: Λbiti animati**," text Lavinia
Яittatore, photo Mario Testino. Page
from *Vanity*, no. 20, July-Λugust 1986 ¬

[p. 341] "**Décolletés**," feature Stefano
Tonchi, photo James White. Page from
Westuff, no. 7, March-Λpril 1987 ¬

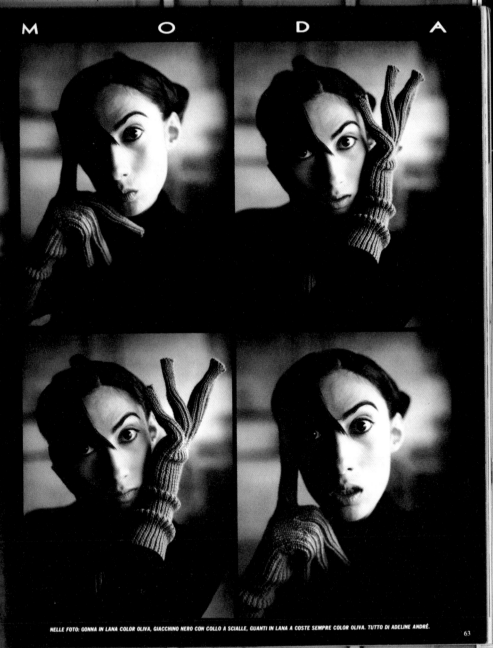

NELLE FOTO: GONNA IN LANA COLOR OLIVA, GIACCHINO NERO CON COLLO A SCIALLE, GUANTI IN LANA A COSTE SEMPRE COLOR OLIVA. TUTTO DI ADELINE ANDRÉ.

63

JOHN GALLIANO

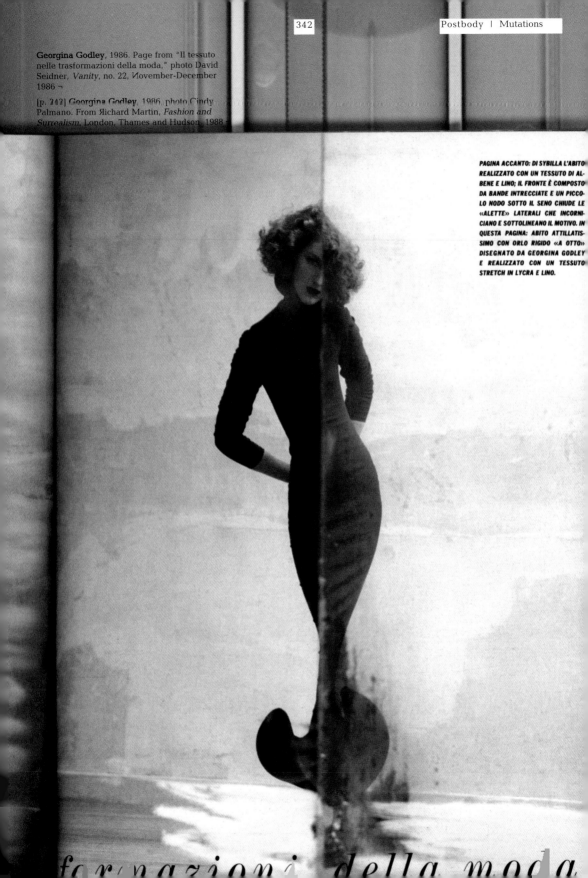

Georgina Godley, 1986. Page from "Il tessuto nelle trasformazioni della moda," photo David Seidner, *Vanity*, no. 22, November-December 1986 ¬

[p. 342] Georgina Godley, 1986, photo Cindy Palmano. From Richard Martin, *Fashion and Surrealism*, London, Thames and Hudson, 1988

PAGINA ACCANTO: DI SYBILLA L'ABITO REALIZZATO CON UN TESSUTO DI AL-BENE E LINO; IL FRONTE È COMPOSTO DA BANDE INTRECCIATE E UN PICCO-LO NODO SOTTO IL SENO CHIUDE LE «ALETTE» LATERALI CHE INCORNI-CIANO E SOTTOLINEANO IL MOTIVO. IN QUESTA PAGINA: ABITO ATTILLATIS-SIMO CON ORLO RIGIDO «A OTTO» DISEGNATO DA GEORGINA GODLEY E REALIZZATO CON UN TESSUTO STRETCH IN LYCRA E LINO.

formazioni della moda

Georgina Godley

After studying art, design and fashion at Wimbledon and Brighton Colleges, Georgina Godley's name began appearing around 1981. In partnership with Scott Crolla, a companion from university days and, briefly, her husband, she created her first line of garments for men and women. Bearing the CЯOLLΛ label, they were sold in the tiny boutique the couple had opened in Mayfair, in central London, just a step away from Bond Street and Savile Яow, amid the famous antique galleries, auction houses and prestigious jewelers, the *maisons* of French couture and the very British men's tailors. The boutique represented an unusual blend of the new and traditional. The partners produced mainly on order: there were few models, but they could be infinitely varied to acquire a unique quality by personalizing the choice of fabrics and colors. In cashmere or shantung, chintz or tartan, smooth or *dévoré* silk velvet, and paisley or brocades, the extremely simple, modern, unisex cut could be varied in a quantity of plain or floral and geometrical patterns. The colorful CЯOLLΛ suits with guru jackets and cigarette trousers drew on the cult of uniform garments imposed by late sixties fashion, but they represented a radical and unexpected counter-trend compared with the diktat of black and gray deconstructed oversized garments, imposed in the early eighties by the newly arrived Japanese designers Kawakubo and Yamamoto. Impeccably polished, but more pared-down than the new romantic models, CЯOLLΛ won over the yuppies and the younger representatives of the British aristocracy. They found the Mayfair boutique's essential setting absolutely charming. Georgina and Scott decorated it in thirties Dorchester style, choosing a range of pastel greens and light blues for walls, fittings and fabrics, along with a few items of furniture by Eileen Gray and Le Corbusier. It became a must for fashion tourists, the international public of buyers who were increasingly coming to London in the wake of punk during this period in search of new ideas, provocations and esthetic innovations. CЯOLLΛ was such an inspired idea and so successful that it was eventually purchased and exported to Japan. When her partnership with Scott Crolla came to an end in 1985 after he sold the business and label to the Japanese market, Georgina Godley could no longer use the name again in fashion, and decided to set up on her own. This time the label and the collections bore her name, well known and respected in the new London underground scene, which was churning out particularly fertile ideas in music, art, design, architecture, fashion, photography, dance and performance art. In these years it already included figures like Derek Jarman, John Maybury, Leigh Bowery, Cerith Wyn Evans, Иeville Brody, Яay Petri, Иick Knight, Cindy Palmano, Jasper Conran, John Яichmond, Maria Cornejo, Яifat Ozbek, John Galliano, Christopher Иemeth, David Holah, Λndre Walker, Judy Blame, John Moore, Boy George, Michael Clark, Иigel Coates, the И.Λ.T.O. (Иarrative Λrchitecture Today) group, Tom Dixon and Λndré Dubreuil. For her first spring/summer 1986 collection, Georgina Godley chose all white, drawing inspiration from medical, scientific, orthopedic and

gynecological circles, with a series of fabrics and forms
structured and reinforced to support specific parts of the body.
This "clinical" esthetic provided the starting point for her new
concept of the silhouette. Her clothes formalized unprecedented
possibilities of mutation. They altered and emphasized the form
and volume of the female belly and buttocks with the aid of
spectacular padding. The idea, immortalized in a series of photos
by Cindy Palmano and published in Richard Martin's *Fashion
and Surrealism* (Rizzoli International, 1987), was taken up some
years later by Rei Kawakubo. In her fall/winter 1986-1987
collection, Godley continued this line of inquiry and developed
new sculptural distortions, creating swathed forms in an elastic
fabric with a base opening out in a corolla. A projecting hem,
rigid yet flexible, transformed her models into sculptures. The
clinging line of the garments was overlaid with whalebone
corsets or padded belts with padded busts to emphasize the
roundness of breast, belly or buttocks. Jean-Paul Gaultier and
others later took up many details of this collection. For
spring/summer 1987, Godley devised the rigid, self-supporting
lines of straw jackets interwoven with hair, to be worn over a
series of dresses combining form and movement, tight-
hugging corsets and skirts pleated *à soleil*. The last collection,
fall/winter 1987-1988, grew out of a partnership with
contemporary British artist Tim Head, whose graphic taste
with its pop imprint led to a series of large patterns, with
interwoven straight and curved lines and colors to be used for
garments with pared-down styling. Forms inspired by the
seventies' unique powers of synthesis provided Godley with
the ideal support for a personal statement on the
relationship between art and fashion.
Mariuccia Casadio

Kyle MacLachlan and Everett McGill in **Dune**,
USA 1984, director David Lynch. © Photo
12/Grazia Neri

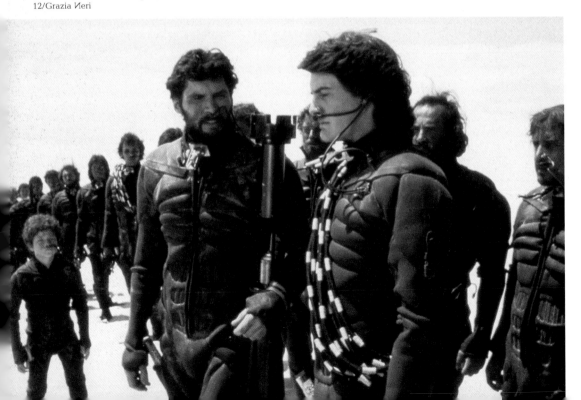

Sybilla. Page from "Il vestito dei sentimenti,"
photo Javier Vallhonrat, *Vanity*, no. 24,
March-April 1987 ¬

IMAVERA-ESTATE DI SYBILLA

*A SINISTRA: ABITO IN VOILE DI COTO-
NE. A DESTRA: ANCORA VOILE DI CO-
TONE PER L'ABITO CON LAVORAZIONI
IN RILIEVO. TUTTO DI SYBILLA.*

149

"Sybilla: Dejadla està creando," text Javier
Bellot, photo Miguel Oriola. Page from *De
Diseño*, no. 3, 1985 ¬

"Gli accessori a Londra: Scarpe
protagoniste," text Mariuccia Casadio,
photo Cindy Palmano. Page from
Vanity, no. 28, November-December
1987 ¬

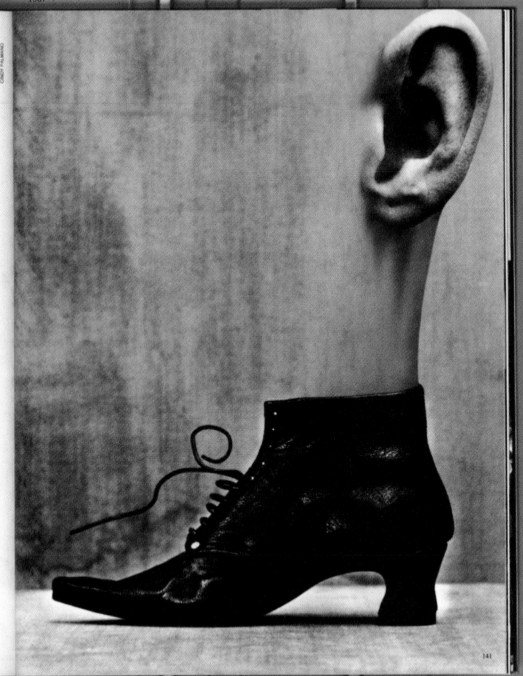

141

Fashion & Surrealism

The relationship between fashion and surrealism is actually a love affair. Born of an affinity, it has developed through sheer willpower. When Salvador Dalí and Léanor Fini (and also Jean Cocteau, Alberto Giacometti, Elsa Triolet and Louis Aragon) worked for Elsa Schiaparelli – a surrealist artist even more than a couturier – the encounter between clothing and an art that imagined the unimaginable was inevitable. The circles in which designers and artists moved were contiguous and complicit: fashion ran the risk of being transformed into an art form (it remained an application of ideas, at times artistic ones). After World War II their paths divided. There have been incursions by designers into art, and Yves Saint-Laurent is representative of them all, but surrealism gave way to other currents. Years went by before there was a new love affair between fashion and the surrealist vision.

The eighties, hastily shelved as an expression of futility and frivolity, actually served as a laboratory for fashion. In those years, with the wealth of means available and a sector not yet tormented over maximizing profits, global expansion and concentrations in the luxury sector, many companies that seemed to have sprouted up out of nowhere were able to experiment as probably never before in fashion. The enthusiasm sparked by a sudden but fruitful expansion of (now notorious) creativity, together with the appearance of designer-entrepreneurs, led to the birth and visibility of eccentric figures unusual to the world of fashion, who however chose fashion as their form of expression, recovering features peculiar to the surrealist experience. It was probably this process that made room for the creativity of people like Franco Moschino and Cinzia Ruggeri in Italy, or to the visions of Thierry Mugler in France, but few others in the rest of the world. Their story, in fact, can be defined as a "modern" vision of the surrealism that fashion had already experienced.

Moschino, for example, applied/scattered coffee spoons on his explicitly "Chanel" *tailleurs*, drew breasts and nipples on his spencer jackets, hung a brioche on three strings of pearls and stamped jackets with newsprint. He not only reflected onto the garments his passion for rehashing Magritte's surrealist paintings (which also gave rise to one of his shows), but replicated an experience that fashion had already lived through with Schiaparelli. His contribution passed into history as *X anni di Kaos* (X Years of Chaos), title of the book by Moschino and Lida Castelli, Edizioni Lybra Immagine, 1993), and was marked by a surrealism that many have interpreted as a "frenzy to show off," remaining unique in the history of fashion.

Cinzia Ruggeri was similarly unique. She was an outsider who came to fashion after working with Alessandro Mendini, the architect-variety artist of Studio Alchimia. To the eyes of many, Ruggeri appeared like a meteor. In the eighties her wedding dress in the form of a wedding cake, the dress in the shape of a ladder, the shoes with raised cone-shaped tips and even her presentations – which were actually artistic performances with Brian Eno soundtracks – took fashion to another, higher conceptual level from which it could have made a new start if the nineties had not imposed the one-way street of business on it. To tell the truth, in France, Mugler would arrive a few years later, straddling the turn of the decade; but he too favored a surrealistic version/vision with, among many ideas, the rigid bustier with motorbike handlebars and headlights over a floating skirt.

MICHELE CIAVARELLA

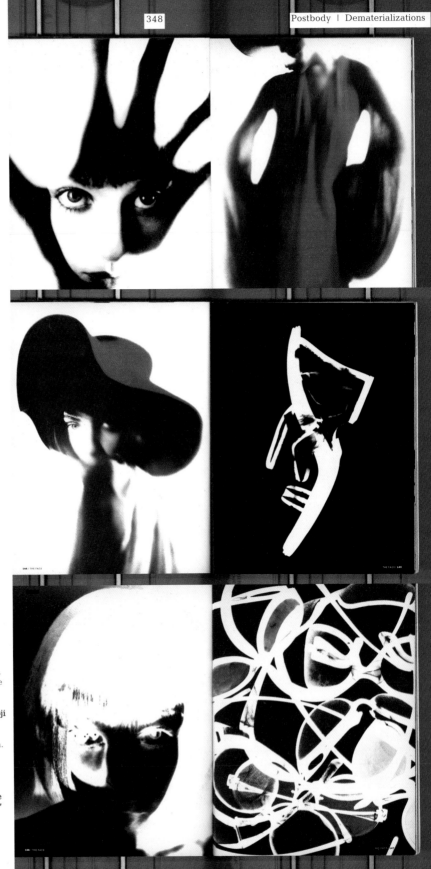

"Datelines," photo Λndrew Bettles, fashion Λlice Hunter. Pages from *The Face*, volume 2, no. 1, October 1988 ¬

[p. 350] **"Giappone oggi: Shoji Ueda, l'immagine e l'assoluto,"** text Milly Gualteroni, photo Shoji Ueda. Pages from *L'Uomo Vogue*, no. 186, June 1988 ¬

[p. 351] **"The Difference between a Mad Man and Me Is that I Λm Νot Mad – Dalí,"** photo Willem Odendaal. Pages from *Blitz*, no. 47, Νovember 1986 ¬

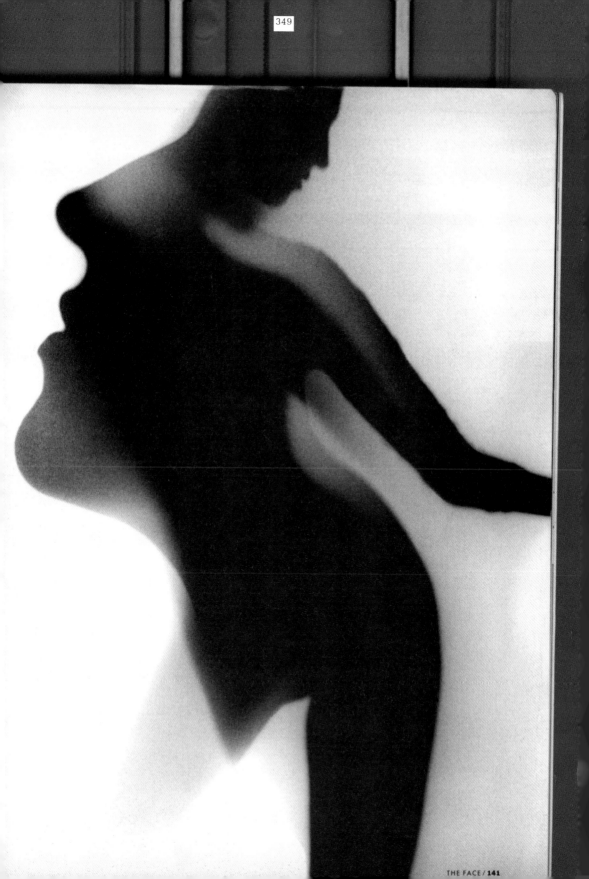

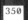

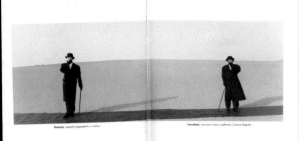

Bonano, soprabito doppiopetto in twill lana. Corneliani, overcoat in lana e cashmere. Camicia Rogatto.

Pal Zileri Gruppo Forall, mini cello camicia in cashmere. Camicia Bagutta.

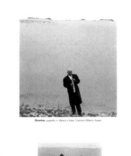

Romeo Gigli, soprabito in crepe di lana, camicia in flanella. Gianni, cappotto in alpaca e lana. Camicia Alberto Aspesi.

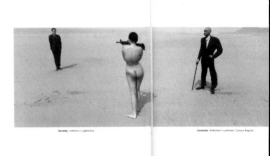

Seventy, soprabito in gabardine. Lavorata, soprabito in pettinato. Camicia Rogatto.

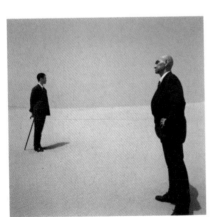

Mirco Termanini per Lawrence Burns, doppiopetto in flanella e trebottoni in pettinato.

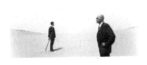

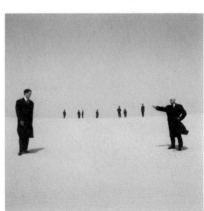

Canali, cappotti doppiopetto e abiti gessati. Camicie Ingram; cravatte Personality.

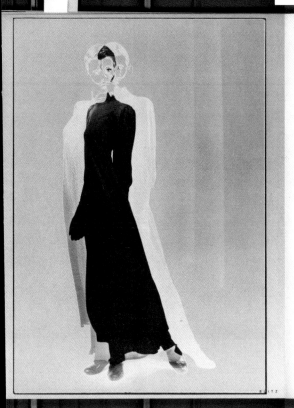

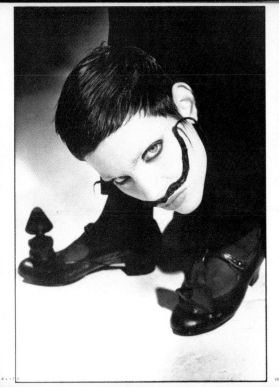

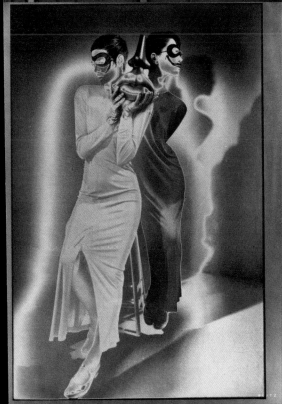

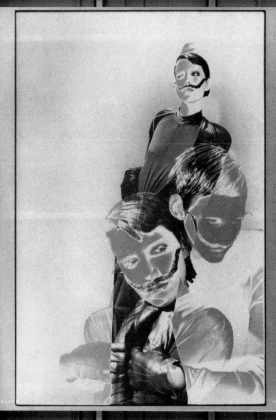

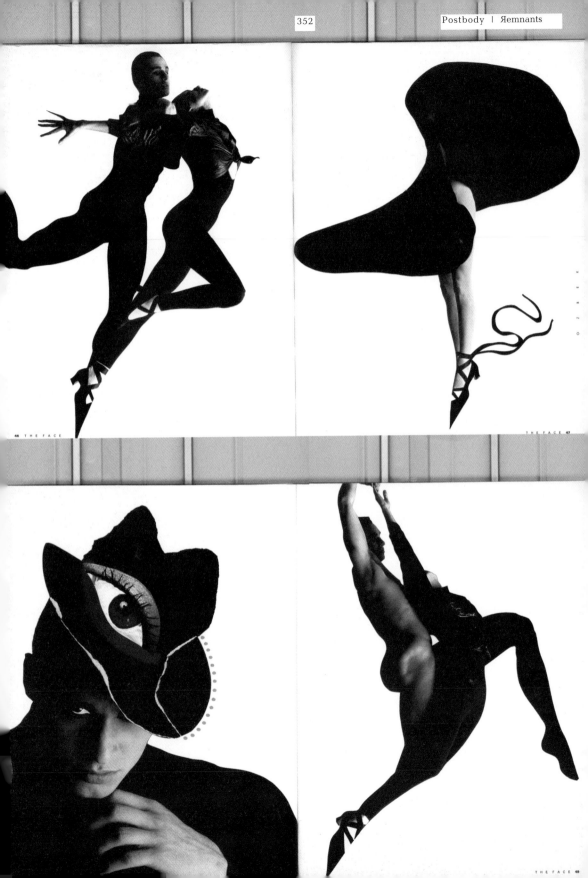

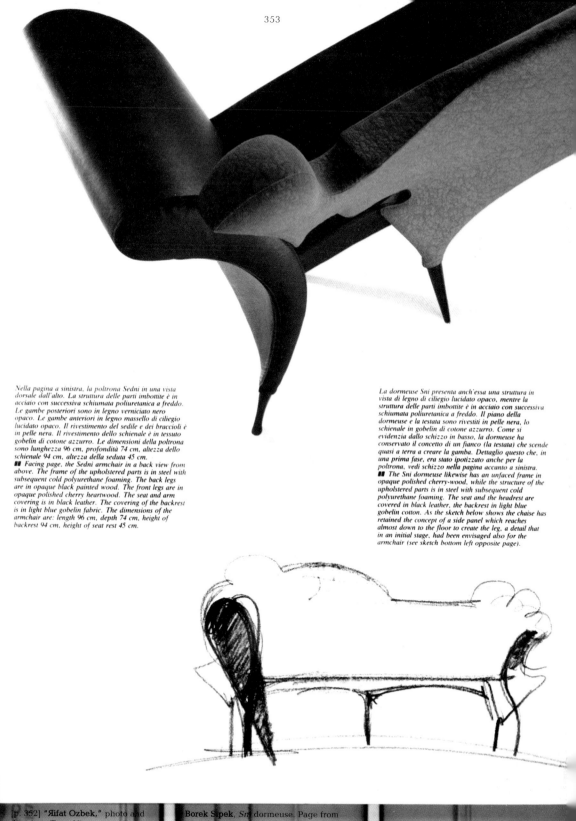

Nella pagina a sinistra, la poltrona Sedni in una vista dorsale dall'alto. La struttura delle parti imbottite è in acciaio con successiva schiumata poliuretanica a freddo. Le gambe posteriori sono in legno verniciato nero opaco. Le gambe anteriori in legno massello di ciliegio lucidato opaco. Il rivestimento del sedile e dei braccioli è in pelle nera. Il rivestimento dello schienale è in tessuto gobelin di cotone azzurro. Le dimensioni della poltrona sono lunghezza 96 cm, profondità 74 cm, altezza dello schienale 94 cm, altezza della seduta 45 cm.
■■ *Facing page, the Sedni armchair in a back view from above. The frame of the upholstered parts is in steel with subsequent cold polyurethane foaming. The back legs are in opaque black painted wood. The front legs are in opaque polished cherry heartwood. The seat and arm covering is in black leather. The covering of the backrest is in light blue gobelin fabric. The dimensions of the armchair are: length 96 cm, depth 74 cm, height of backrest 94 cm, height of seat rest 45 cm.*

La dormeuse Sni presenta anch'essa una struttura in vista di legno di ciliegio lucidato opaco, mentre la struttura delle parti imbottite è in acciaio con successiva schiumata poliuretanica a freddo. Il piano della dormeuse e la testata sono rivestiti in pelle nera, lo schienale in gobelin di cotone azzurro. Come si evidenzia dallo schizzo in basso, la dormeuse ha conservato il concetto di un fianco (la testata) che scende quasi a terra a creare la gamba. Dettaglio questo che, in una prima fase, era stato ipotizzato anche per la poltrona, vedi schizzo nella pagina accanto a sinistra.
■■ *The Sni dormeuse likewise has an unfaced frame in opaque polished cherry-wood, while the structure of the upholstered parts is in steel with subsequent cold polyurethane foaming. The seat and the headrest are covered in black leather, the backrest in light blue gobelin cotton. As the sketch below shows the chaise has retained the concept of a side panel which reaches almost down to the floor to create the leg, a detail that in an initial stage, had been envisaged also for the armchair (see sketch bottom left opposite page).*

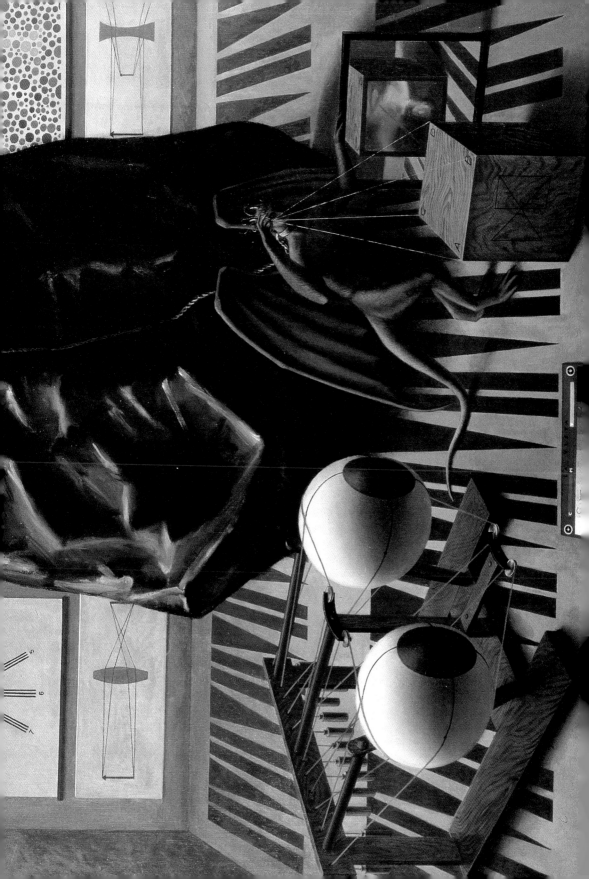

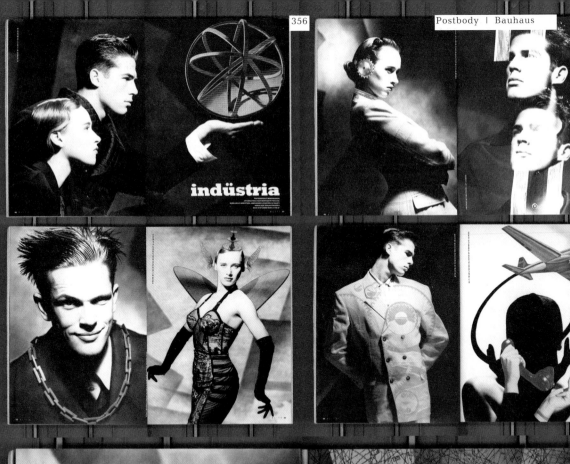

indüstria

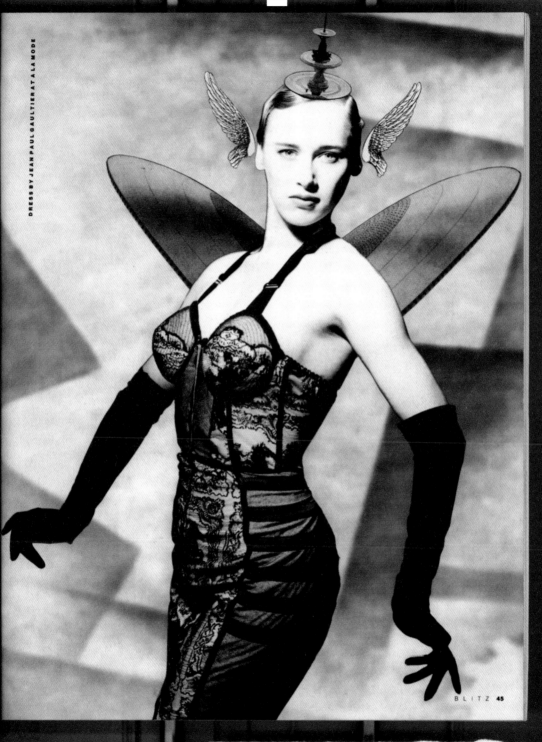

DRESS BY JEAN PAUL GAULTIER AT A LA MODE

BLITZ **45**

"Indústria," photo Brad Bransen, art direction and photomontage Fritz Cok. Pages from *Blitz*, no. 67, July 1988 ¬

[pp. 354-355] **Sigfrido**, *Santa Lucia. La vista*, 1985, oil on canvas, 195 x 130 cm ¬

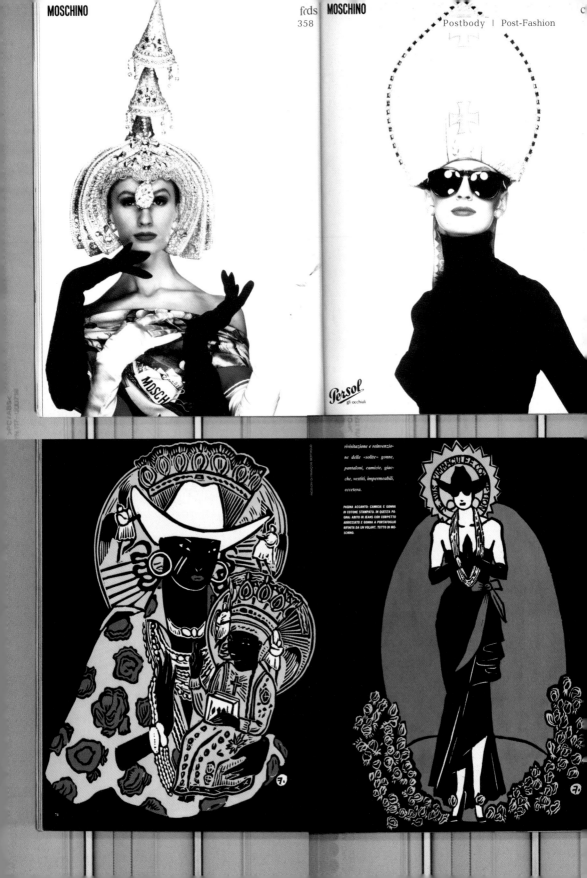

rivisitazione e reinvenzio-
ne delle «solite» gonne,
pantaloni, camicie, giac-
che, vestiti, impermeabili,
eccetera.

PAGINA ACCANTO: CAMICIA E GONNA
IN COTONE STAMPATO. IN QUESTA PA-
GINA: ABITO IN JEANS CON CORPETTO
ARRICCIATO E GONNA A PORTAFOGLIO
RIFINITA DA UN VOLANT. TUTTO IN MO-
SCHINO.

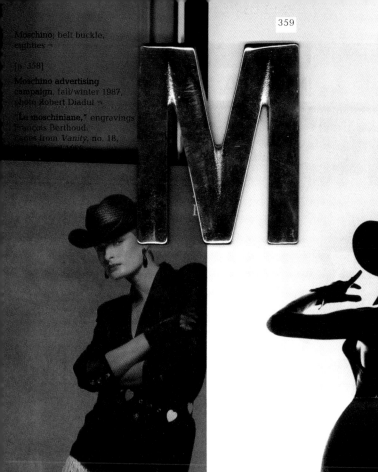

MOSCH

Prodotto e distribuito da AEFFE S.p.A
Via delle Querce, 1 - S. GIOVANNI IN MARIGNANO
STUDIO LEMOS
Art direction F. MOSCHINO - Foto S. CAMINATA -

Яay Petri, photo Jean-Baptiste Mondino. From Mitzi Lorenz (ed.), *Яay Petri Buffalo*, London, Westzone, 2000 ¬

[p. 361] **"The Cowboy, the Indian, and Other Stories . . . ,"** photo Jamie Morgan, styling Яay Petri. Page from *The Face*, no. 66, October 1985 ¬

[p. 362] **"Style Shows a Leg!"** photo Jamie Morgan, styling Яay Petri. Pages from *The Face*, no. 49, May 1984 ¬

[p. 363] **Pitti Trend advertising campaign**, fall/winter 1987-1988, Buffalo: styling Яay Petri, photo Jamie Morgan ¬

Buffalo

"Buffalo was started as an umbrella," he said, "collecting different people with similar ideas all in one place. It was started as a whim, and we weren't really sure what would happen. I just knew that something would – we all seemed to be working towards the same ideal. What we wanted was a creative agency that would channel our work. If you work for other people you soon become sucked into the mainstream, but with a corporate title suddenly everything takes on a different meaning."

"People tend to associate the word Buffalo with Bob Marley's 'Buffalo Soldier,' but in fact it's a Caribbean expression to describe people who are rude-boys or rebels. Not necessarily tough, but hard style taken from the street. It's the whole idea of boys – and girls – together, just like it was when you were a kid going around in a gang, looking cool. Buffalo can be anything – a movie, a car, a sound, whatever. But basically, Buffalo is a functional and stylish look; non-fashion with a hard attitude."

Juxtaposition is the stylist's currency, and no one juxtaposed with greater aplomb than Ray. In the pages of *The Face* and *i-D* from 1983 until his death in 1989, Ray's pictures became the cutting edge of fashion. He was at the epicenter of the so-called British "street-style." While his signature was a streamlined classicism, tough-edged and Brandoesque, he had a knack for producing gay, iconic images which were somehow instantly appealing to heterosexual men. In the fashion pages created by Ray and the Buffalo team, credibility shone through, lifting the images off the page. "I start outside of whatever I'm doing and try to look on it with a new perspective," he once said.

Models were almost always found through friends, and ideas were formed on the street, not in a fashion editor's office. The Buffalo look went beyond style into attitude. This, unlike the ideas, was beyond imitation, as it was all in the casting. "If the face fits, then it's fixed," Ray used to say, and you only had to look at his pictures to know what he meant. "The important thing in good styling is the people; once you have the right face it all falls into place." He discovered Nick and Barry Kamen, used Naomi Campbell when she was just fourteen, and made glossy paper stars out of a host of gorgeous-looking creatures whose Christian names became their monikers: Cameron, Tony, Simon, Felix, et al.

Ray's pictures had no respect for tradition. Here was the debut of ski- and bike-wear as street chic, boxer shorts worn with Doctor Marten boots, day-glo dungarees and cashmere tops, muscle-rippling boys in jewelry, wild-eyed girls in Crombie coats. Heavily featured in Buffalo pictures were city cowboys, Olympic heroes, leather-clad biker-boys, T-shirt De Niros – a hard, forthright mixture of mythical America and European "street" life. He could make a pork pie hat, a white T-shirt and a pair of black Levi's look like a military uniform ("I think the strongest fashion statement that America has produced is denim," he once said. "You have to go a long way to look good in anything better than jeans"). He even put men in skirts.

But Ray's most visible success was the surplus-store garment – the black nylon US Air Force flying jacket, which not only became the most ubiquitous fashion item of the decade, but also replaced the leather jacket as a symbol of rebellion as it traversed the global fashion underground.

DYLAN JONES, in *Ray Petri Buffalo*, London: Westzone, 2000

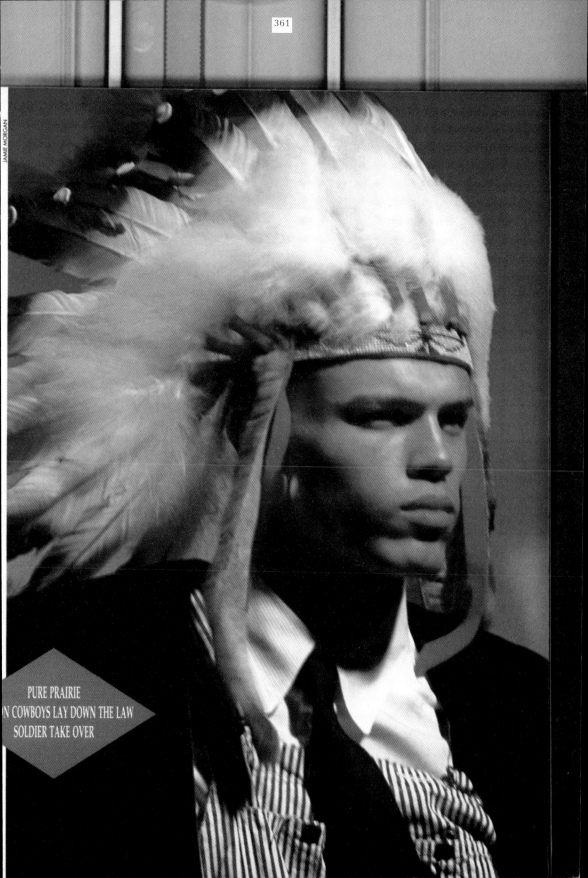

PURE PRAIRIE
N COWBOYS LAY DOWN THE LAW
SOLDIER TAKE OVER

JAMIE MORGAN

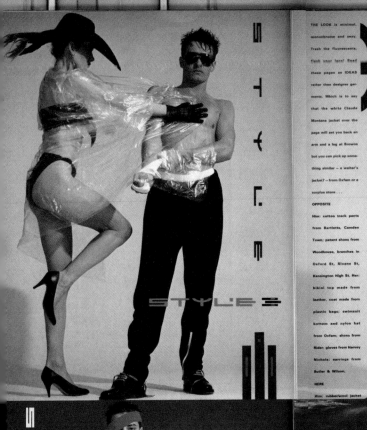

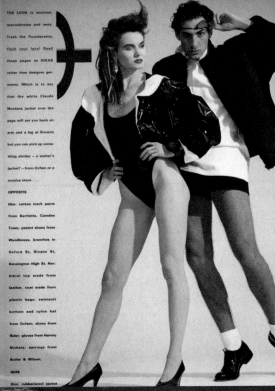

S T Y L E

STYLE

THE LOOK is minimal,
monochrome and sexy.
Trash the fluorescents,
flash your lens! Read
these pages as IDEAS
rather than designer gar-
ments. Which is to say
that the white Claude
Montana jacket over the
page will set you back an
arm and a leg at Browns
but you can pick up some-
thing similar — a waiter's
jacket? — from Oxfam or a
surplus store . . .

OPPOSITE
Him: cotton track pants
from Bartletts, Camden
Town; patent shoes from
Woodhouse, branches in
Oxford St, Sloane St,
Kensington High St. Her:
bikini top made from
leather; coat made from
plastic bags; swimsuit
bottom and nylon hat
from Oxfam; shoes from
Rider; gloves from Harvey
Nichols; earrings from
Butler & Wilson.
HERE
Him: rubber/wool jacket

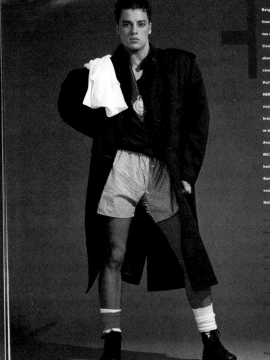

S T Y L E

OPPOSITE
Beige Allegri c
from Harvey Nich
ton singlet from
Camden Town
shorts from Lil
commando boo
Holts, Camden
HERE, Black Cla
coat from Wo
branches as pag
or shorts from Pe
Avery Row, W1,
WC2, Byard Lan
ham; cotton sin
Bartletts, Camd
commando boo
Holts, Camden

APRIL £1.50

CREN

81

to the woman
aby but not you?

an/crime noir/art and commerce/
three decades of advertising to

Yohji Yamamoto garment, photo Nick Knight.
Cover of *Arena*, no. 8, March–April 1988 ¬

ARENA **83** SPRING

This page: blue linen pants with double belt loops.
Opposite: multicoloured straw panama hat, white shirt in
silk/cotton mixture, printed silk tie.

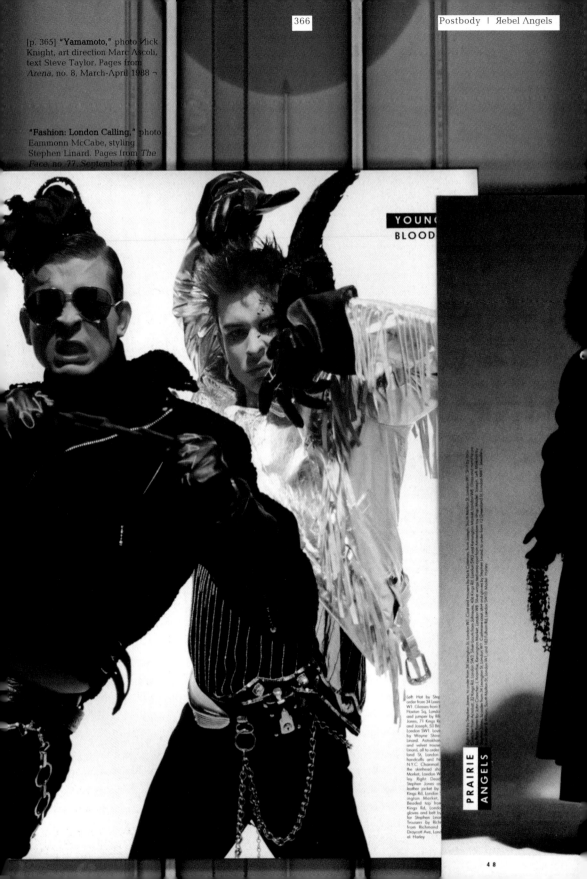

[p. 365] **"Yamamoto,"** photo Nick Knight, art direction Marc Ascoli, text Steve Taylor. Pages from *Arena*, no. 8, March-April 1988 ¬

"Fashion: London Calling," photo Eammonn McCabe, styling Stephen Linard. Pages from *The Face*, no. 77, September 1986 ¬

YOUNG
BLOOD

PRAIRIE ANGELS

48

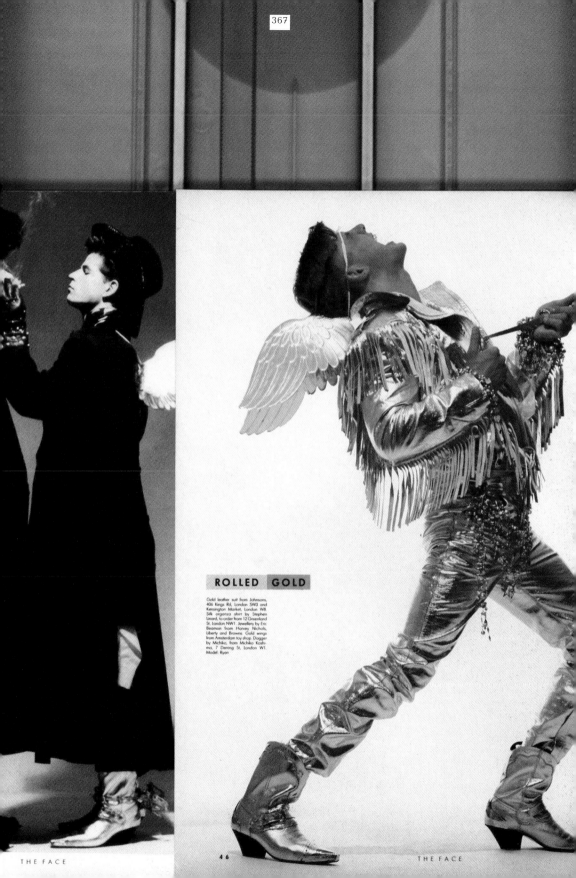

ROLLED GOLD

Gold leather suit from Johnsons, 406 Kings Rd, London. SW3 and Kensington Market, London W8. Silk organza shirt by Stephen Linard, to order from 12 Greenland St, London NW1. Jewellery by Eric Beamon from Harvey Nichols, Liberty and Browns. Gold wings from Amsterdam toy shop. Dagger by Michiko, from Michiko Koshino, 7 Derring St, London W1. Model: Ryan

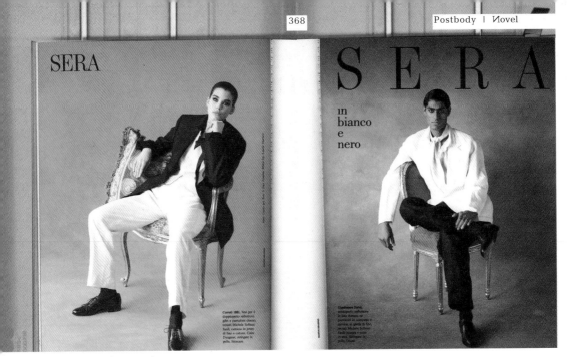

SERA

S E R A

in
bianco
e
nero

Corndi 1881. Noo per il doppiopetto sabotrore, gibt e pantolini classici, tenuti Michele Soltani. Smit, camicia in jersey di lino a cotton. Calze Dyagzar, stringate in pelle, Stracam.

Gianfranco Ferré, antesignato arthuma in blanc étanque: su panciotti in cotton e camicia, in piné di lino, jersey, Michele Soltani. Saroli scarpa e calze in seta, Stringate in pelle, Ferré.

This Our So Baroque Age

We live in the "neobaroque age." For those who hadn't noticed, the idea was advanced by Omar Calabrese in a very fine book issued last year by Laterza. Baroque, as everyone knows, comes from the name of one of the canonical forms of the medieval syllogism, and the definition was applied by nineteenth-century critics to ridicule a period in art history that struck them as obscure and contorted as the reasoning of scholastic philosophers. For some time we have redeemed that foolish contempt and consider baroque one of the great trends in art, not only in the *siglo de oro* that gave us Francesco Borromini, Pedro Calderón de la Barca, Johann Sebastian Bach and William Shakespeare, but in all ages. Baroque is the prevalence of the language of art over its "function," the pleasure of ornament, the vertigo of the mirror, the conscious playing with illusion, the flowering of decoration beyond the puritanical limits of taste.

Omar Calabrese informs us that the neobaroque is all around us, in videogames, architecture, scientific and artistic discovery at the same time as it's in the beauty of fractals and science fiction, in the triumph of advertising and, naturally, in fashion. Anyone can check the correctness of this diagnosis by curiously exploring the rich repertory of images that surround us on all sides. As for fashion, especially women's fashion, the return of passion in French haute couture – with the new guru Christian Lacroix and Emanuel Ungaro the old at its head – took place under the aegis of decoration at all costs: flower women, bird women, "clothes that are paintings and not garments to be worn," commented Laura Asnaghi, who chronicled the fashion shows for *La Repubblica*.

But looked at more closely, the neobaroque trend had begun much earlier. Just look at casual clothing, that "second" wardrobe originally designed for leisure, which is supposed to emphasize the simple and the functional. But in fact overalls, polo shirts, T-shirts and sweaters have long been developing along quite different lines, away from an all-Spartan simplicity. They are the realm of color and the bizarre, garments where finally you can indulge that ego trip that is increasingly part of the essence and pleasure of fashion, and that formal dress has been denying men for over a century.

But if we take a closer look at things, we'll see that the neobaroque line has gone even further in fashion and has seriously unhinged the traditional structure. It was once a simple matter. In the ideal zone of garments allowed (for instance for men, pants not skirts, short hair not long), fashion chose certain parameters and decreed they were temporarily compulsory: two buttons or three on a jacket, cuffs or no cuffs on trousers, etc. These requirements may have varied a little for men and much more for women, but they were essential if you wanted to look elegant.

But for some years now the models have multiplied, the requirements have become confused, no one seriously knows whether a garment "belongs" to this year or the past, whether it's in fashion or not. In short, this is the explosion of that disorderly and riveting phenomenon that is personal fashion. Any error, any anachronism, is allowed, provided it has the air of being done deliberately, that it is, in short, a sign of your look. The result of this state of things is a flowering of decoration, a "confidence in the omnipotence of signs," as Jean Baudrillard puts it, or rather the pleasure of playing with this omnipotence, which is typically neobaroque, or – if you want to use another common term – postmodern. The inflation of decoration by Lacroix triumphs, but the sign of the times is not just this official recognition that seems to bury the austere elegancies of Italian fashion of a few years back (though that remains to be seen). The true revolution is that we can, in fact we must, create our own baroque for ourselves every day, perhaps treating our life and our work as a patchwork.

UGO VOLLI, *L'Uomo Vogue*, no. 184, April 1988

"Sera in bianco e nero," photo Martin
Brading. Pages from *L'Uomo Vogue*, no.
184, April 1988 ¬

[p. 369] "**Grazia, frivolezza su echi di minuetto,**" photo Deborah Turbeville. Page from *Vogue Italia*, no. 453, December 1987 ¬

Moschino advertising campaign,
fall/winter 1987,
photo Robert Diadul ¬

Cover of "God Save the Queen,"
single by the **Sex Pistols**, 1977, design
Jamie Reid, sold at auction in London
in April 1986. Page from *Blitz*, no. 40,
April 1986 ¬

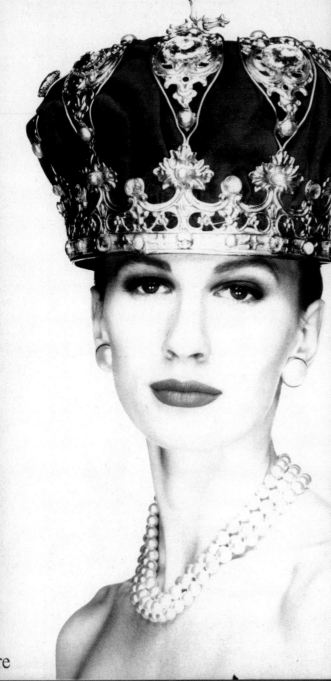

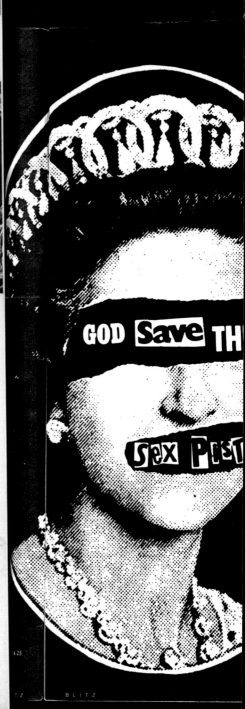

Duc de Cheminée, Baron Souple, Comte de Lavallière ou Marquis de Den-

telle, le col a reconquis ses titres de forme sans être « collet monté ».

GIULIANO FUJIWARA (CI-DESSUS) : CHEMISE EN VISCOSE A COL SOUPLE ET COSTUME EN GABARDINE DE LAINE
● (ABOVE) VISCOSE SHIRT WITH SOFT COLLAR AND WOOL GABARDINE SUIT **ISSEY MIYAKÉ** (A GAUCHE) : CHE-
MISE EN COTON A COL CHEMINÉE, PLASTRON PLISSÉ ET COSTUME A VESTE CARDIGAN EN SATIN DE LAINE
● (LEFT) TURTLENECK SHIRT IN COTTON WITH PLEATED FRONT AND CARDIGAN-JACKET SUIT IN WOOL SATIN.

LES COLS COURONNÉS

"Les cols couronnés," photo Nick Knight, styling
Thomas Maier. Pages from *Vogue Hommes
International Mode*, no. 6, fall/winter 1987-1988 ¬

Jean-Paul Gaultier Uomo
advertising campaign, fall/winter
1983-1984 ¬

Fez

Images of fezzes against a
pop backdrop. Lothar, his
role that of
butler/bodyguard for
Mandrake, with a colossal
Λfrican body
(under)dressed in leopard
skin and microshorts.
Groucho Marx in *Λ Night
in Casablanca*. Howard
Cunningham, Яichie's pop
in *Happy Days*, during his
evenings at the Leopard
Lodge. Then suddenly the
fez became the uniform of
a series of club kids
halfway between the
Λtlantic and their idols:
Kid Creole Λnd The
Coconuts, Blue Яondo à la
Turk, Matt Bianco. Λnd
finally, canonization: the
catwalks of Jean-Paul
Gaultier, who made it a
symbol, and of Яifat
Ozbek, an Λnglo-Turkish
designer, who closed the
historic circle. In Turkey in
1925, Λtatürk banned the
fez with a law enforcing
Westernization. It was too
traditional, an inheritance
from the past. The fez was
not ethnic (we are not in
the nineties yet): it was
merely exotic. It was not a
declaration of political
correctness, but an
accessory that was so
anachronistic as to be
original. It said that the
person wearing it has
verve, culture, nerve. That
he's somebody. Which was
what really mattered in
the brilliant eighties.
Яuбeи Modigliaиi

Яifat Ozbek. Page from "Le odalische
con il fez," photo Cindy Palmano, text
Mariuccia Casadio, *Vanity*, no. 25,
May-June 1987 ¬

Cover of the book *Antonio 60 •70 • 80:*
Three Decades of Fashion Illustration.
London, Thames and Hudson, 1995 ¬

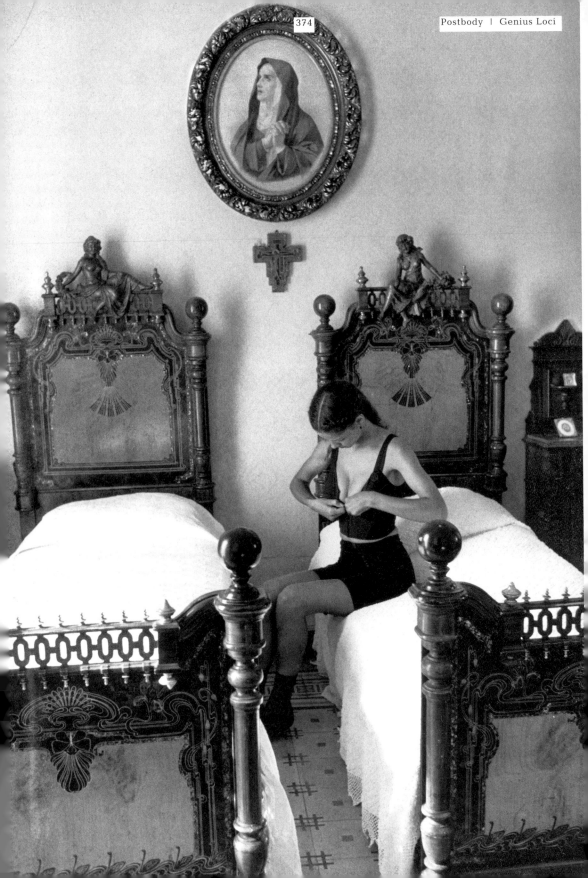

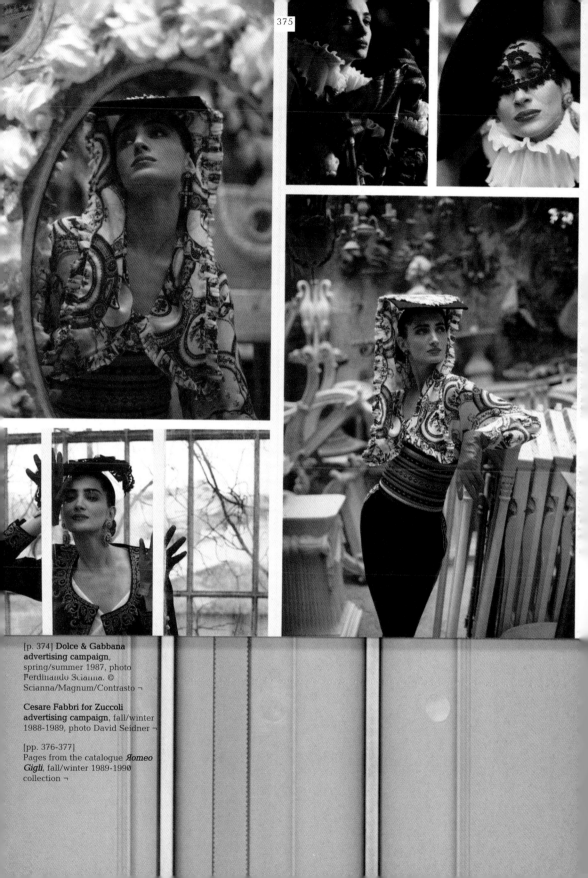

[p. 374] **Dolce & Gabbana advertising campaign**, spring/summer 1987, photo Ferdinando Scianna. © Scianna/Magnum/Contrasto ¬

Cesare Fabbri for Zuccoli advertising campaign, fall/winter 1988-1989, photo David Seidner ¬

[pp. 376-377] Pages from the catalogue *Romeo Gigli*, fall/winter 1989-1990 collection ¬

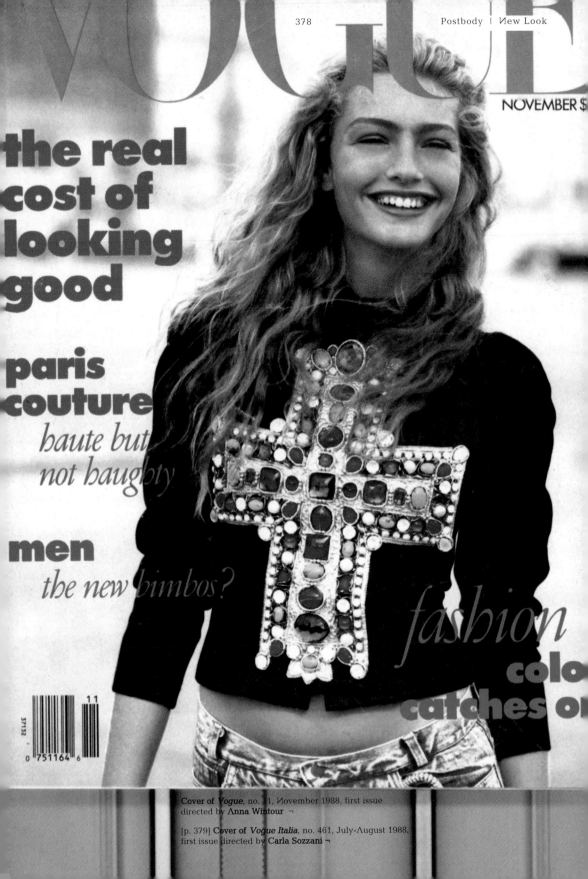

Cover of *Vogue*, no. 11, November 1988, first issue directed by **Anna Wintour** ¬

[p. 379] Cover of *Vogue Italia*, no. 461, July-August 1988, first issue directed by **Carla Sozzani** ¬

COPIA

VOGUE

ITALIA

LUG/AGO
1988
N. 461

IL NUOVO
STILE

|||

As Excess

\
\
Giacinto Di Pietrantonio

> I occasionally get just as tired of the slogan "postmodern" as
> anyone else, but when I am tempted to regret my complicity with
> it, to deplore its misuses and its notoriety, and to conclude with
> some reluctance that it raises more problems than it solves, I find
> myself pausing to wonder whether any other concept can
> dramatize the issues in quite so effective and economical a fashion.
> Fredric Jameson, 1984

The Art (neoexpressionism, Transavanguardia, appropriationism . . .) – and Architecture (deconstructivism, postmodern . . .) and Design (Alchimia Studio, Memphis . . .) and Music (Sex Pistols, The Clash, Boy George, Devo, Talking Heads . . .), and Fashion (Armani, Valentino, Versace . . .) and Theater (Magazzini Criminali, Gaia Scienza, Falso Movimento, Яaffaello Sanzio . . .) and Philosophy (*nouveaux philosophes, pensiero debole* . . .), and Terrorism (the kidnapping and killing of Aldo Moro, the kidnapping of General Dozier . . .) and Life and Culture of the eighties – was already under way in the mid-seventies, a period in which there began to be talk of a crisis of ideologies, of the loss of a sense of future and the utopias associated with it. There was talk of endings: the end of history, the end of the avant-gardes, the end of modernity, the end of . . . naturally all under the shadow of the end of the century and the millennium. . . . A culture of the end, which was also the preparation for a new beginning: that of the century and millennium in which we now live. All this enabled the spread of a culture of desire and creativity that expanded in a society that has now, as foreseen by Guy Debord, become the "society of entertainment": a civilization – as the new philosophers noted subsequently – with a high aesthetic distribution, in which the Hegelian thesis – according to which the false is an instant of the truth, and we realize that, instead, the truth has become an instant of the false – is turned on its head.

While this was being seen as a purely negative factor by Debord, in the new age dubbed postmodern, the false, the simulacrum – seen as an element of "theatricalization" and hence of creative action – became an instrument for acting in reality, and could be nothing else in what Jean Baudrillard called "the society of simulacra." In this

sense, it is important to note the different existential approaches to the question "What do you do?" Until the mid-seventies, the answer would refer to an actual job, such as "I'm a teacher, lawyer, worker" etc., but by the end of the seventies (and especially from 1977 onwards), the replies became "I work in cinema, music, writing, art . . . " One replied, in other words, by citing one's "hobby" or, better, one's elective affinity. This was a sign of changing times that saw the shift from a culture based on the Marxist idea of work – an idea linked to the industrial era – to the post-Ford one, in which work and the factory receded to the background, to the benefit of the theory of the needs and desires of postindustrial society. Just as modernity had advocated progress, evolution and the idea of time projected forwards, towards the future, "the postmodern condition" – to adopt Jean-François Lyotard's phrase – identified the strengths of the new contemporariness in the idea of the present and the idea of memory. We find all this in the various movements listed above because Art and Architecture and Design and Music and Fashion and Theater and Philosophy and . . . are disciplines that exist beyond their nevertheless important formal issues, by virtue of their ability to serve as the repositories of history.

But what history do we mean? We mean the collapse of ideologies, the importance of the past, the centrality of the private and the crisis of the public, the crisis of colonialism, the advance of the cultures of the East and South of the world and hence of globalization. Which is to say that, for better or for worse, the postmodernism that began to take shape in the eighties is the existential horizon in which we find ourselves living today.

It is to this scenario that we must associate the works, movements, life and art that began to appear at the end of the last century and millennium. As noted above, this started at the end of the second half of the seventies, but it was at the beginning of the eighties that all this took on an international social dimension, when a shift began towards the postmodern condition that had by then acquired a dimension recognized throughout the world. To remain in the world of art – although there had been some exhibitions, especially in Germany and Switzerland (Basel Kunsthalle, 1979), which documented this shift – it was in Italy that the phenomenon took on a concrete form with the 1980 Venice Biennale. Achille Bonito Oliva and Harald Szeemann invented the "Aperto" section, precisely with the intention of highlighting this new trend that was challenging the conceptual/minimalist/arte povera art movements, presenting the works of artists who were receptive to the new current and beginning to return to a traditional language, that of painting and sculpture.

Inside and outside the Biennale, from the United States to Europe, examples of the artists concerned included Julian Schnabel (dada + expressionism), whose surfaces were covered with broken plates and fragmented images, David Salle, whose works emphasized collages of images related to film editing, Eric Fischl with his film-like realism, Jean-Michel Basquiat and his tribal expressionism . . . However, in addition to these artists linked to an expressionist label, there were others with a pop character, such as Яobert Longo with *Men in the Cities*, the so-called "graffiti artists," such as Keith Haring with his electric radiating line, or Яammelzee of "iconoclastic futurism."

From Germany, instead, among the new and old there were neoexpressionists like Georg Baselitz, the Wagnerian Anselm Kiefer, the primitivist signs of A.R. Penck, the acid realism of Jorg Immendorff and the gloomy realism of Markus Lüpertz, the chameleon-like forms and matter of Sigmar Polke and the ironic and surreal ones of Jiri Georg Dokoupil, as well as the tragic, alienated work of Martin Kippenberger. Not to mention the analytical painting of Gerhard Richter from Cologne, offset by the existential expressionism of Luciano Castelli, Salomé and Rainer Fetting in Berlin, while France was being overwhelmed by the *figuration libre* of Robert Combas and Hervé Di Rosa. In Britain it was principally sculpture to steer this new course, with artists like the poet-trash collector, Tony Cragg, the architect of natural metallic forms, Richard Deacon, the metal origami craftsman, Bill Woodrow, Julian Opie with his sculpture-cartoons, as well as Anish Kapoor with his ethereal, spiritual and chromatically powerful works.

In Italy there was the Transavanguardia, with paintings by Sandro Chia characterized by disparaging, cynical subject matter, Francesco Clemente's works on paper that emphasized the double and difference, Enzo Cucchi's densely visionary paintings, Nicola De Maria's lyrical, abstract settings and paintings, Mimmo Paladino's pictorial works embedded with original Mediterranean primitivism, and even the pictorial and photographic *d'après* works by the earlier Salvo and Luigi Ontani. A neoclassicizing position also emerged, with Carlo Maria Mariani as its greatest exponent. We mention Mariani not because his style of painting, although of high quality, represents what was taking place – which as we have seen was instead of a neoexpressionist form – but because in 1980-81 he painted the *Costellazione del Leone*, a large work that is to the postmodern what Max Ernst's *Le rendezvous des amis* (1922) is to surrealism and the avant-garde of modernity. Whereas in the latter's work we see artists and poets of surrealism lined up, in that of Mariani the advent of the postmodern era is summarized through the mise-en-scène of the new order of the art system. *Costellazione del Leone* emphasized that art was no longer a revolution in the way the avant-garde proponents intended, but a part of the art system. This was emphasized by the fact that, while in Ernst's work only artists and poets are represented – in short, the "creators" of a new pictorial language – in that of Mariani we see a sort of Parnassus in which artists of various generations and trends – ranging from Paolini, Merz and Kounellis (Arte Povera) to Ontani and hence to Chia and Mariani himself – are shown alongside the critic Bonito Oliva, the poet-critic-gallery owner Mario Diacono, as well as *tout court* gallery owners such as Gian Enzo Sperone and the German Paul Maenz. The "creators" have thus been joined by the gallery owners, the market representatives, as though to state that art does not affirm itself merely through its works, but needs a system that includes other professional offices, such as critics and the market.

In particular the presence of the market, so strongly asserted, represented a real novelty for times that still saw the market not as a confirmation or acquisition of value, but as the image of corruption. It was the sign of the times, in which "Reaganite hedonism" (Roberto D'Agostino) ruled, the yuppie generation came to the fore. It was a period that abandoned the revolutionary utopias of the avant-gardes, which with their projects

and experiments for transforming the world had sought a parallel with the revolution-
ary positions of politics and, above all, of the socialist-communist left, characteristic of
modernity. In the postmodern era, one did not look forward, but accepted living in a
reality, in a present that looked more to the past and its own roots, maintaining the
poetics of the *genius loci*.

New political forces also began to be felt on this terrain, advancing thanks to reconcil-
iation with the territory, with the myth of origins that modernity had first constructed
and then sought to demolish. In fact, not many people know that many myths of origin
are of recent fabrication, dating from the nineteenth century, when romanticism, in
order to sustain the construction of a new sensibility, needed to elaborate myths about
nature and related subjects. That period preferred looking to the Middle Ages, to a
time still considered obscure and mysterious and hence ideal for being embedded with
mythologies, which, given the dearth of information, could not be disputed. In the post-
modern era, therefore, the past that the avant-gardes had sought to eliminate did not
die, but returned, appearing in and affecting the poetics of difference, contrary to
modernity, which was more interested in international languages applicable wherever.
The work of many artists began to show an interest in local cultures. For Ontani and
Clemente, this went as far as exoticism, with a search of the Indian subcontinent,
whereas Chia was content to remain in Tuscany and twentieth-century painting, and
Cucchi succeeded in giving a world dimension to the visionary stories of his homeland,
the Marches. On the other hand, Paladino and De Maria reworked the myths and signs
of Campania. Between north and south, a dialogue sprang up between a neoexpres-
sionist culture and Mediterranean one, proposed with the known, understandable lan-
guage of painting, and opposed to the linguistic experimentation of the avant-garde.
Instead of modernity's notion that *form follows function*, postmodernity asserted the
aesthetic of reception – in which spectating humanity is required to complete life and
the work – and substituted the modern concept with the assumption that *form follows
communication*. This was one of the decisive factors of the renunciation of linguistic
experimentation in favor of a mixture of languages with known, understandable signs.
This change occurred in an era in which the entertainment society transformed the
masses into a public, a public that, like the people in every TV program, takes part in
and submits to the game, and indeed is the subject of the game. This was possible
because high, mid and low culture had been merged and put on the same level. The
fragmented and rhizomatous horizontality (Deleuze-Guattari) of postmodern society
replaced the still vertical one of modern culture.

This was a broad-ranging operation that continued in the second half of the eighties
when the object-based abstraction of Swiss artist John Armleder began to take hold,
together with the urban-architectural one of American Peter Halley, the identity pho-
tos of Cindy Sherman, the aesthetic power of Jeff Koons and the appropriationist proj-
ect of Sherrie Levine. These were all experiments that, although abandoning the pic-
torial characteristics put forward by the artists mentioned above in favor of practices
and works associated with the language of modernity, reserved a central role for com-
munication through quotation and re-use of languages. One need only consider

Sherrie Levine's gilt urinal as an example. If Duchamp at the start of the last century had felt the need to place an everyday, commonplace object in an artistic context, and to elevate it to the status of a work of art by virtue of the museum-frame – the context in which it was shown by the end of the century, following a long period of incomprehension – the American artist decided that the context and the linguistic action were insufficient and felt the need to effect an aesthetic operation, a superficial action such as gilding ("The deepest is the skin" – Paul Valéry), which without any need for explanation communicates that this object is no longer a urinal but, thanks to the gilding, a precious, attractive object, a sculpture, a work of art and nothing else.

All the linguistic practices cited above are aesthetic actions in which history was deposited and retold with works that spoke because they used languages known to all, or to most people: a painting is a painting, a sculpture is a sculpture and hence a work of art. There were no – or should not have been – any doubts, so the artist was no longer part of a community of experimenters, as he had been in the avant-garde and modernist periods, but was increasingly part of society in general. The artist took on that social visibility that only Warhol had sensed he could conquer, leaving the world of art to be received by a world that was more open to life. It was indeed starting in the eighties that the artist was no longer relegated to the world of art, but began to appear in fashion magazines, even taking over the cover of *Vogue*, or was invited to paint frescos in discotheques, as happened with Keith Haring, and also Schnabel and Clemente with Studio 54 in New York. It became clear that art could operate over a broad band and, although collaboration with popular sectors such as fashion, cinema or music were to become increasingly close in the nineties, it was in the eighties that art began to open doors to enter, contaminate and be contaminated increasingly with other languages.

The artists of the eighties produced works that in the majority of cases used the language of art, its forms and procedures. In other words, whereas in the years of the avant-garde, artists had experimented with various languages and materials, there was now a return to looking at and working with art. It was above all the works that spoke and not the intentions and, indeed, the various groups formed in those years that were variously dubbed neomannerist, neobaroque, neomodern, or even better, postmodern, were incidental, not programmatic associations as was the case with the avant-garde movements. The artists of the eighties and of postmodernity did not draw up any manifesto or program: it was only the critics who produced the labels and theories we have seen because, with the collapse of ideologies in the postindustrial society, the manifesto of the communist party with its Marxist overtones also ceased to function. In the society of the spectacle, simulacra, seduction and fatal strategies knew that aesthetics were central to society and worked to produce it, while the following decade made an effort to reintroduce "more ethics and less aesthetics." But that was a later step towards another story, another excess that needs to be told at another time.

THE LOOK WAVES
\
\

Mariuccia Casadio

Fashions. Different modes of living and dressing. Of representing space and connoting time. The eighties raced by, extraordinarily rich in resources and messages, in novelties and conceits, in projects and dreams, in protagonists and scenarios. The decade rode on the euphoric crest of change. Like the production of an epochal advancement that, poised between profundity and superficiality, the modern and the postmodern, reality and artificiality, discovered its theoretical foundations in the treatises drawn up by Baudrillard, Virilio, Lyotard, Deleuze and Guattari. Decidedly schizophrenic, the decade opened bearing the signs of a double-edged tension, caught between commitment and liberal creativity. It popularized Яoland Barthes and his theoretical studies first-hand. It rediscovered Andy Warhol's philosophies. It treasured the science fiction precognitions of narrators such as William Borroughs and Philip Dick. It identified with the lifestyles of dandies, eccentric artists and travelers such as Lord Brummel or Paul and Jane Bowles, Baudelaire or Cocteau, Gertrude Stein and Peggy Guggenheim.
It developed, on the other hand, a trend towards leisure, entertainment, a desire to take possession of and actively identify oneself with a different space-time, and to adopt new resources and experiment with language. From the establishment and alternative outlooks, the city and the metropolis, urban and suburban districts, maximum visibility and the new underground, the eighties were able to generate a vast quantity and a wide variety of cultural behavioral aspects and aesthetic characteristics. Individual beings crossed boundaries, communicating via appearances and proclaiming their conformity to precise facets of the imaginary with a spectacular, totally unprecedented intensity and efficiency. Яeality therefore lost its raison d'être, ousted by a quantity of tempting

prefigurations of the future, reproductions of the past and simulations or modifications of the present. It was a time of nomadism, with active scenarios elected or projected, and the theorizing and configuring of possible worlds. And it was a time when the body and clothing became the protagonists, with codes and values that were fundamental for communicating and inter-relating.

Space-time emerged as an interaction of diverse identities, with a proliferation of new looks, or rather total looks that appeared studied to the nth degree, scrupulously analyzed to form an ensemble, a coordinated choice, from clothing to haircuts, from accessories to makeup, inseparable and redolent with status symbols. Inspired or generated by the influence and manipulation of mass-media legends and icons of modern collective memory, it was equally a space-time that, from fashion brands, the development of prêt-à-porter and easy-to-wear, affirmation of street styles and vintage fashions, also anticipated the aesthetic identity, production and market for today's fashion. It was an epochal lapse of time that advocated free information and interpretation, that generated and was influenced by mass-media legends and trends with cult movies and TV serials, soap operas and fashion magazines, disco and rock music, sports or comic strips. A world populated with appearances and bodies, clothes and accessories, lifestyles and behavioral characteristics all transmitted by live or recorded video, films, photographs, sketches or paintings. All strictly reproduced, recorded or documented using a variety of techniques and technologies. Hyper-real, whether extremely far away or extremely close up. Always skillfully modified, their dimensions, either blown up or cropped, focalized on singular micro-details, rich in synthetic and interactive information. And, like a stage set, a fashion show or a window display, like a party or a special event, it elected and immortalized anonymous muses and celebrities indiscriminately. Using specific languages and improvisation, both professional and amateur, it distinguished and characterized different contexts, designs and forms of communication. On one hand, it nurtured such aspects of fashion as its language, industry, market and image, which displayed exponential growth and development during the eighties. On the other hand, it explored and confirmed alternative aesthetic codes, spontaneous styles, underground looks, clothing modes and fashions originating from the metropolitan suburbs, night life, clubs and discotheques, from tastes in music and a myriad of other cultural contexts either given or chosen. Two universes coexisted, autonomous yet continuously interchanging, hyperactive, mutually inspiring and influencing each other from the outset of the decade.

All the while, the arrival and affirmation of like personalities and styles was cultivated, with isolated and even more personalized contributions by genuine style innovators, characters who, from Ray Petri to Leigh Bowery, represented veritable sources of innovation, and injected an extraordinary creativity from the clubs to the street, and for the languages of fashion design and styling. From Italy to France, from London to New York, from the world of fashion to street style, it was a period of time that cemented and popularized what appeared to be a never-ending succession of new launches and new information, communicated via the introduction of new magazines and fanzines. Whether it was national magazines like *Vanity*, *Lei* or *Per Lui*, *Frigidaire* and *Musica 80*,

Donna or *Westuff*, or the English or American versions of *The Face*, *Arena*, *i-D*, *Interview*, *Spin*, *Paper*, or *Mirabella*, the imagination was captured by interactive intrigues about front and back stage, fashion and lifestyles, exotic countries and metropolitan contexts, famous faces and newcomers to the scene, new photographers, illustrators and comic-strip writers. At the same time, photomontages, graphic mosaic-style fonts, bodies and faces brought the pages alive, breaking with the traditional and conventional order of roles and priorities.

Traveling, the breaking down of distance and cultural differences, displacement of the body and the mind, the possibility of devouring geographical places, of experimenting with space-time modifications and understanding cultural legends became a diktat. A planned prerogative that implied the identification of stylish products, the creation of collections and looks. Furthermore, every fashion scenario, whether official or alternative, took on a specific identity, with its own prerogatives and characteristics. And the various collections created by designers or prêt-à-porter brand name collections also highlighted and distinguished substantial distinctive differences. Rich but not saturated, the Italian market, in fact, which during these years, from Gianni Versace, Moschino, Enrico Coveri, Byblos and Gianfranco Ferré, to BoBo Kaminsky, Cinzia Ruggeri, Chiara Boni, Enrica Massei and Romeo Gigli, was becoming increasingly enriched at an exponential rate by newcomers to fashion, and transforming into the stratospheric phenomena which even today is still called *Made in Italy*, held the record regarding the country's superior creative and productive qualities. Take Giorgio Armani's jacket, identified the world over as *the* ultra-sophisticated uniform for the emancipated woman, Versace's metallic knitted clothes, which transformed women into highly sensual, contemporary korès. Or Missoni's complex technological inventions and colors, which continued to deconstruct and soften women's and men's wardrobes, to the extent that knitwear and fashion permanently fused, and Enrico Coveri's narration of the history of Italian glamour, bringing sparkling color and Hollywood splendor to women's daily and evening attire. While Gianfranco Ferré introduced fabrics and cuts that were in themselves architectonic constructions, Moschino programmatically displayed a provocative, desecrating style legitimizing a sense of humor and freedom from brand fashion diktats and the trade: the general scenario was well-organized, widely varied and universally competitive. Meanwhile, France, having added a number of disruptive elements to its already rich panorama with personalities like Jean-Paul Gaultier and Azzedine Alaïa, Thierry Mugler, Jean-Charles de Castelbajac and Claude Montana, Adeline André or Christian Lacroix, affirmed its leadership position with the creation of surprising, spectacular garments, an intense union between luxury and eccentricity. The most outrageously unconventional characters were, however, to be found in England, namely Vivienne Westwood, Stephen Linard, Rifat Ozbek, David Holah, Crolla and Georgina Godley, Richmond-Cornejo, Christopher Nemeth, Andre Walker, Stephen Jones and Judy Blame, who continued to demonstrate their ability to influence and inspire the world market in the eighties. American fashion, characterized on the other hand by unusual shifts between excess and synthesis, began, with Geoffrey Beene and Giorgio di Sant'Angelo, Zoran and Calvin Klein, Ralph Lauren and Stephen

Sprouse to act as catalysts in captivating international market and press interest. Concurrently, following the freer and more unpredictable Issey Miyake, the Japanese Comme des Garçons and Yohji Yamamoto unexpectedly burst onto the scene, with their rigorously deconstructive, high-tech look, introducing colorless and fully black and white trends, together with special worn, faded fabrics and textures that composed a universal "post-atomic" boom. The fashion scenario progressively extended to Spain's Sybilla, Germany's Jil Sander and Belgium's Dries van Noten, Martin Margiela and Ann Demeulemeester, and was gradually characterized by the distinctive innovative skills used for constructing the garment and conception and experimentation with new materials. From neo to post, sub, super, meta and trans, meanings and definitions changed according to the prefixes employed, which from theory to fashion symbolized during this time a condition of passage, evoking an image that cannot be defined, a sort of appearance of alternatives and alterations.

Adolescent street-style behavior was likewise so intense and highly charged during these years that it unavoidably became a necessary source and focus for prêt-à-porter's fashion trends and creative propositions. From New York to London, Paris to Bologna, Berlin to Florence, the lifestyle of young people in the city and the metropolis supplied an infinity of cues, preempting different statements on looks and new behavioral patterns. The youth of the eighties, representing the first mass-media generation, the children of TV, were also not afraid to speak out, relentless, passionate travelers, experimenters, and manipulators of space and time in Western culture, adept with different languages and technologies, and actively interacting with diverse images, short-circuited by art and life, music and dance, video and theater. They could choose to have an amateurish, unharmonious and toneless rapport with music, not scorning extemporaneous conjugations of sounds, words and images, re-montages or remakes of video material or cinematic plots. They eulogized the rhythms and styles of music videos, or perhaps, and at the same time, the poetry of cinematographic neo-realistic poetry. They appropriated different epochs and styles, investigated their own ethnic and linguistic roots, declared their individuality and sources of attention in an intermingling of art and non-art, or they chose to express themselves with signals, symbols or icons displayed on canvas or by leaving a tag, an ideogram of their actual names on the city's fixed and mobile structures, with a prolific painting revival that stretched to Transavanguardia, neoexpressionism, appropriationism and graffiti.

The tendency to favor new technologies and measure oneself by brand-new expressive resources continued to exist. But if the themes of art and fashion were already creatively consolidated, there was now an excess of information that tended at the same time to lend visibility to the creative backstage, to the bodies and appearances of artists and designers: to their different habits, alternative ways of living, presenting themselves, dressing and wearing makeup, and thus revealing their unprecedented opinions about past and present, about the history of art and everyday life, and also about fashions and trends. If this applied to extremely famous artists and fashion designers, it was no less applicable to emerging stars on the new wave and rap musical scenes, or to other figures active in various visual and performance fields: there were a host of new appear-

ances and looks, individual or group, that inspired and influenced the style and nature of scenarios and different contexts. Bodies demonstrating the new prerequisites of beauty. Icon-symbols of a changing culture. Personalities who distinctively supplied and defined unfathomed somatic characteristics, personal and social expressions that were erotic, sexual, racial, etc., and who represented, from The Яamones to The Яesidents, from Blondie to Grace Jones, from Patty Smith to Madonna, from David Byrne to John Lurie, or from Francesco Clemente to Keith Haring, and from Cindy Sherman to Leigh Bowery and Jean-Michel Basquiat, the protagonists of the mood of the epoch.

In short, it was a temporary, prolific aesthetic process. It was a transitory period that was initially creative and subsequently speculative, caught between maximum anonymity and unsustainable success, mighty ideals and a wealth of cynicism. The excursus of the eighties, in fact, described a parable that decidedly and rapidly ascended during the beginning of the period and that gradually descended during the second half towards the end of the decade. It seemed like a fast, contradictory moment, but one that did not leave us short in the way of information. Quite the opposite. We find ample testimony in the wonderful photographs taken by David Bailey and Λlfa Castaldi, Barry Lategan and Giampaolo Barbieri, Bill King and Barry McKinley, Bruce Weber and Sarah Moon, Steven Meisel and Deborah Turbeville. In the unforgettable illustrations of sets, bodies and clothes drawn by Λntonio Lopez and Tony Viramontes, Lorenzo Mattotti, François Berthoud or Stefano Canulli for fashion brand campaigns and for the pages of *Vanity* magazine. In the quantity of documented material of events linking fashion, theater and design, valuable designer clothes with contemporary dance or experimental rock events. There are photomontages of anatomical details, exaggerations and deformations of proportions produced without the help of Photoshop, fused with extreme concepts in styling in a search for new identities, with aesthetic hypotheses for change on the drawing-board, post-technological icons who, from the replicants in *Blade Яunner* to Madonna, have undoubtedly not lost their edge or ability to seduce even today.

The eighties looked like a relentless succession and superimposition of female bodies with powerful shoulders, toned buttocks and calves and small hips. Their anatomies attested their athletic training; their clothes were either extremely clinging or massively oversize. Or they were torn and distended on different body parts in order to emphasize the importance of accessories and details. Λ scenario not lacking in the masculine identity, with muscular torsos left bare or clad in torero boleros, colored blazers, cigarette pants or clingy trousers like leggings, emphasizing a new, unprecedented "fashion attitude." With this blending and overlapping of sexual physiognomies, and of cultural and somatic traits, the eighties witnessed the rotation and cohabitation of ordinary signals and special colors. East and West combined. Styles were layered and patterns overlaid. Undeniably with their own particular styles. Extreme, cynical, speculative, but also extraordinarily open to ideas, to the consequent future and to possible developments. Possibly a little abstruse and as elusive as a neologism, the eighties nevertheless project to this day their inexhaustible vitality and their reason for existence.

COLOЯ CODE
\
\
ЯEИΛТΛ MOLHO

The eighties were rowdy, arrogant years; the decade was so dazzling and brightly col-
ored that it merged into blackness. It represented an infinity of possibilities, a Яeagan-
influenced hedonism, a *Milano da bere*, deep-seated, daft slogans, years of yup-
piedom. Everything smacked of plastic and a race for power. The Executive reigned
supreme. Two-dimensionality became an asset, and superficiality was held in high
regard. It was a time of vindication and aesthetic enthusiasm, with the discovery of a
more flexible, fluctuating morality. Λ time of confusion which rendered all things plau-
sible. The air was rent with the sound of Duran Duran's "Wild Boys," while Michael
Jackson's costumes and gold lamé fostered a trend for men too to use makeup and
employ artifice, challenging any form of pride in belonging or having an identity, in
the name of success. With the death of John Lennon, a page was symbolically turned:
after an entire generation had been committed to seeking lightness and an unattain-
able yet clear harmony, there was a nosedive into a harsh, unpredictable reality
announced with the alluring sound of sirens, yet dominated by an insidious form of
cynicism.
Madonna, platinum blonde at the time, demonstrated to the world over that even if you
are not very tall and not very attractive and your voice is only average, you could still
become a great pop singer and a role model for the masses. Communication became a
substitute for content. Bobby McFerrin sang "Don't Worry Be Happy," and brands
could come up with names like "Think Pink." Jane Fonda pranced about adorned in
minute fuchsia pink- and Chinese blue-colored leotards, sporting fluorescent leg
warmers and generating devout aerobic disciples. Fiorucci's figurines, which today are

nowhere to be found and have become collectors' items, helped to spread a *joie de vivre*, which was expressed via a distinctly chromatic exuberance. To anyone looking down from a distant hypothetical spaceship from Mars, we must have appeared perfectly happy beings. These crazy years were a whirl of discothèques, euphoria, glittering sequins, cocaine, free-flowing cash, dissipation and a promiscuous worldliness that was both nomadic and elegant, and somewhat obsessive. But it was also the era of arduous reconstruction in the aftermath of terrorism. And waiting at the end of this mad scram was Aids.

It was a time of repression, with Thatcherism and the Falklands War on one side, while on the other side lay the glittering catwalks of what would shortly become the *made in Italy* brands, the King's Яoad punks, the first Иew York graffiti artists. An amalgamation of new stimuli and phenomena, each and every one a reaction to what was achieved in the sixties and the seventies.

The image of the fashion designer grew increasingly strong, evolving and becoming more significant. Crossing traditional boundaries, the characteristics of a veritable psychological strategy were adopted, based on the cult of the personality and the diffusion of an idea. Яecruits were armed with shocking pink, orange and acid-green suits. Uniforms were made by design, with a feminine note of authority expressed via hyperbolic shoulder pads: the exaggerated styles of Thierry Mugler, Claude Montana and Jean-Paul Gaultier spring to mind.

Slits in clothes glorifying the body outlined a concept in sensuality based on ancient yardsticks: Barbie came back into fashion. The idea of the supermodel also took shape, portraying a fabulous, devastatingly beautiful woman, who became ever more unattainable as the myth was enhanced season after season through the contribution of photos by Bill King, Herb Яitts, Patrick de Marchelier, Яichard Аvedon and Irving Penn, and films like *Woman in Яed* and *9 1/2 Weeks*.

This was the decade when everything could and did happen: everything that exists in fashion today as we understand it is in some ways an evolution or a reaction to what was produced during those years. But it was Italy who set the rhythm, who gave a new meaning to the word "fashion" and gave it a unequivocal nuance. Significant personalities left a distinct imprint, such as the Missoni family, who have undoubtedly already outdone the "Munsell *Book of Color*" with the invention of an original, authentic language replete with symbols and color tones, which even today remains unique; or Gianni Versace, who invented polychrome prints and reproduced pop images on fabric, employing free color combinations as only Emilio Pucci had dared to do previously. Enrico Coveri also brightened the scene with his luminescent clothes and their contrasting stripes, studded with sequins and plastic colored beads. Franco Moschino went so far as to rethink the national tricolor flag and transform it into a logo, as an indelible emblem of lasting youth, even carefreeness. They were brightly colored, highly charged, unrepeatable years.

However, all this excess, this semantic confusion, as happy-go-lucky as a firework display at a village festival, served only to create a vast shadow. Extensive and prolonged, it counterbalanced widespread joy. The end of the eighties was signaled by the arrival

of the Japanese in Paris, who were to revolutionize and redefine fashion styles, toning colors down, enriching by subtraction. Dolce & Gabbana also came onto the scene waving the patriotic, or more precisely, regional flag, and transforming severe black with its Sicilian flavor into an alluring aesthetic exposé which, aided and abetted by Ferdinando Scianna's photographs, redolently smacked of the unconventional. Yet this is not directly related to what we are analyzing here. For the shadow we are talking about is the one inhabited by the punks, or rather, what remained of the aesthetics of the movement. To the motto of *No future*, adopting the tartan design and all the effects Vivienne Westwood and Malcolm McLaren had ratified in 1977, hordes of black-clad youths garbed in leather and studs, with safety pins and runs in their fishnets, flocked through the streets of the metropolis proclaiming their sense of unease and their collective dissent. They dyed their hair dark blue or, as a further provocation, chose violent and professedly disturbing colors like fuchsia. Pink became the new hair color of the suburban kids of English liberalism, the color of dropouts, or at least of those rebels who sought to represent a kind of identification to the world through this medium. The punk fringe most responsive to the allure of fashion was also the one which was most widely exported and imitated, and one which took root most strongly in the fabric of society. Black plus impossible, vulgar color, a scream in the dark. The alternative camp of rebellion, meanwhile, was total annulment, choosing colorless *dark* as the only possible uniform. But their black was not as minimal and rigorous as we might easily imagine today. Their black was a semiotic redundancy, black because the future is *nihil*, black because the soul is despondent, irregular and shortsighted, moribund and funereal. Black is gothic, all-enveloping and as insidious as the night. Black is composed of tormenting melodies. Black has a thousand facets: the shiny black of latex, relished by dark fetish lovers, the baroque black of the goths, the linear black of the new wavers: in all of this, England was naturally the predominant player, and London's Blitz became a local cult place where you went to meet excessive individuals and where new fashions were invented that remained literally underground for the entire night.

It was nonetheless during the eighties that colors took on such a precise ideological significance for the adolescent cultures, even if the interpretative nuances became ever more subtle: even though the starting point was the same, with politically motivated values, punk fluorescent, studded black and tartan became a spectacle of subversion; on the contrary, *dark* black was a more intimist choice, an expression of introversion, more radical than the voluntary shutting out of the external and the anxiety of an era which in any case had to reckon with atomic energy, facing up to the first devastating effects of the Chernobyl disaster. It was the conscience of an uncertain society hiding itself by painting the façades of the world with the colors of the bright glossy magazines. And it was far removed from the black of Azzedine Alaïa, one of the very few to succeed in traversing the decade unscathed, without having to revise his style and remaining unaltered and happily imitated.

A black cloud, significant for its dimensions and implications, therefore opposed the exuberance of the eighties. But an important expression of the same chromatic and inventive euphoria of that decade came from graffiti artists. Out of the blue, the urban

panorama took on a whole new lease of life thanks to the works of as yet unknown artists like Яammelzee. The walls of the world became colored at the hands of the first graffiti artists: truly a borderline art, not only because the occupation of painting space was in itself an act of bravery, but also because the works were the expression of a new, barely invented, risky art form. Here, too, contrasting with the colors used by the majority of graffiti artists, was the shadowy black employed by Яichard Hambelton on the walls of a Иew York ever more openly contradictory and in a state of unrest. These shadows too were indications of invisible, clandestine, indelible fears very different from the humanoid and hyper-colored figures of Keith Haring. It was actually Haring who represented the period's most significant sentiment, indeed, probably the most interesting part. His work was synthetic and represented the brand of the eighties. Both instantaneous and direct, his *Яadiant Babies* and *Barking Dogs* were his most popular works, but all his compositions share a curious, unusual sense of humor. Haring constantly used color as a banner, right back from when he swamped unused Иew York subway advertising billboards with simple, ironic images: "Bright things attract the eye, colors differentiate and define identity."

There was no doubt that the eighties were flamboyant years, both visually and culturally. Λt the same time as art galleries opened their doors to half-caste artists like Jean-Michel Basquiat, Benetton launched its multi-ethnic campaigns created by Oliviero Toscani. Italy was unshackled from its clichéd image of a mandolin-strumming *Bel Paese*, and became one of the Big Players: color came onto the scene, unannounced and imperative, surprising all those who thought we'd stay immobile and ingenuous, prisoners in a spectacular black and white neo-realist film.

From Moschino's Pizza to the Glocalism of Dolce & Gabbana: The Prophets of the Genius Loci

Gianluca Lo Vetro

Between Reaganite Hedonism and Sicilian Verism

At a time when Italy, in the grip of Reaganite hedonism, was chasing after the mirage of Wall Street yuppies, Dolce & Gabbana, two young men discovered by Beppe Modenese, made their debut at Milano Collezioni with a line dedicated to the profound and ancestral Sicily.

It was the era of glossy fashion victims and career women with bristling shoulders: neo-baroque hyperdecoration blazed on the catwalks and people lined up in the streets to buy fluorescent-colored Swatches, brought out in 1986. Unabashed, the two up-and-coming designers were to redesign blocky volumes natural shoulders and frugal fabrics, drawing freely on the pauperist aesthetics of neorealism and dredging up the black that character-ized the verism of Luchino Visconti's *The Earth Trembles*. And while the big names, look-ing forward to a United Europe, scrambled to project themselves into an international dimension with photographers and advertising campaigns that utilized cosmopolitan imagery, the pair of designers had pictures taken of Marpessa da Ferdinando Scianna surrounded by obituary notices, fruit barrows, peddlers in undershirts, taciturn old men and mistrustful widows in mourning.

In short, the fashion world was in the full flush of the eighties, wallowing in exclusive invitations, extravagant parties, silverware and champagne. But they, "somewhere else" and already "beyond," sent out invitations in the form of a prickly pear made of marzipan and wrapped in brown paper or the tissue paper used to wrap oranges, offering dinners based on such Sicilian specialties as *pasta alla "beccafico,"* swordfish, cannoli and *zinne di monaca*. All served on anthropomorphic dishes from Caltagirone.

The Cult of Differences

Towards the end of the eighties fashion still had not the faintest idea of the globalism that was to come. But Dolce & Gabbana, unconsciously, had already found the "antidote" in the genius loci of Sicily: the land of which Domenico Dolce, from Polizzi Generosa, was also a native. With the two designers was born, in fact, the vogue for glocalization. Not so much in its original sense of "global strategy and local action" (based on the model of the Japanese word *dochakuka*, "to make native," according to the *Oxford Dictionary of New Words*, 1991), as in the one that it was to assume in the third millennium with the anti-globalization movement. Heterogenization versus homogenization. To put it simply: a love of difference and the courage of diversity (the fact that Dolce & Gabbana are openly gay is not irrelevant). Preserving and making the most of regional peculiarities in opposition to the standardization of the one-track thinking "sponsored" by the multinationals. "Scenarios of the kind," comments Stefano Gabbana "were the farthest things from our mind. At the time we thought that proposing just one style was unnatural because a person is made up of many attitudes. And in the meantime fashion was turning into lifestyle, rather than mere clothing. In this sense Sicily, with its endless aspects, proved to be an extraordinary and inexhaustible source of inspiration." "Of course," adds Domenico Dolce with hindsight, "it took a lot of courage to go on bucking the trend. What with candles, drapes and ex-votos, at some shows you almost felt like knocking on wood . . ." And yet, with determination, pride and above all consistency, Dolce & Gabbana continued down the road they had taken: toward the province of Trinacria, as the island used to be known; an encounter in the future. "We went wrong," admit the two designers today, "only when we changed direction." Rare exceptions indeed.

All the Sicilies of Dolce & Gabbana

Throughout their career Dolce & Gabbana have remained in tune with the *incipit* of *Cavalleria Rusticana*, which opens every one of their shows. Alongside their Mediterranean woman – a bit like Monica Guerritore in *La Lupa*, with a dash of Circe and another of Angelica – they set a man who was a mixture of the bandit Salvatore Giuliano, a low-ranking Mafioso and the hero of *The Leopard*. And then came the white widows with the *Madonna della Lacrima* around their necks, Anna Magnani in furs in the summer at Taormina to receive the Donatello Prize, the tight-waisted jacket of Tommaso Buscetta, the leopard-skin fabrics worn by the prostitutes of Palermo and the languid robe of the prince of Salina. And again: dishes decorated with the sun, vases with citrus fruit and ex-voto jewelry. In a melting pot of opposite extremes, of apparent contradictions that reflected the most profound essence of Sicily even in the patchwork of their salons, Dolce & Gabbana censured no aspect of that land. From the sacred to the profane, all of the island's more or less wild chords have been transformed into icons of international fashion in their hands. For over the course of time the world of fashion was to vindicate every one of the gambles taken by this creative pair. In the nineties, to take just one example, their black was to become the total black of minimalism, which has remained in the wardrobe ever since. But above all, the cross, the rosary and the flat cap are now recognized elements of a planetary style. The goal of a multiple leap: from the regional to

the worldwide. The exact opposite of today's globalization, which aims to take the general all the way to the particular of the extreme periphery.

OTHER REGIONALISMS: PIZZA, SPAGHETTI AND MOSCHINO

To tell the truth, other designers in the eighties attempted to go down roads similar to the one taken by Dolce & Gabbana. In 1987 Cesare Fabbri designed the Zuccoli collection, produced by Gibò. The show inaugurated the Osservatorio venue on Via Maffei in Milan, which was to become the seat of Prada, but above all it launched the folk style. "An attitude towards clothing," recalls Fabbri, "that was already opposed to minimalism, still in its early days." On the catwalk the models looked as if they were dressed up as picture cards from the Panini series of *Usi and Costumi*. And in the next collection the theme was taken further with an imaginary cruise in the Mediterranean. Fabbri's voyage on behalf of Zuccoli would be interrupted in 1989, owing to problems at the manufacturer. But in this context it is worth recalling that the market was, in some ways, a crucial accomplice in the emergence of these countertendencies. "At the time," continues Fabbri "there was a close match between supply and demand. People bought things and then asked for more. So the conditions were ideal for indulging in the search for alternative proposals." Less sporadic and more systematic, Moschino chose some of the more familiar examples of the Italian way of life as symbols of his impudently/provocatively "Made in Italy" style: above all, pizza. The designer transformed a certain picture-postcard Italy into actual items to wear, such as the sublime bolero of crystals that reproduced the front of the Doge's Palace in Venice, the jacket decorated with the Belvedere in Naples and the shirt with a print of the Leaning Tower of Pisa, somewhere between the black and white of Fornasetti and the kitsch of the souvenir headscarf.

But in this case, apparently similar to that of Dolce & Gabbana, it would be more correct to speak not of an anticipation of the genius loci, but of a prophecy of lifestyle: of the all-embracing Italian taste as we understand it today. And as only Andy Warhol in the eighties may have grasped with his pithy prediction: "All that will survive of Italian fashion will be pasta."

So these are all quite different stories from the genius loci of Dolce & Gabbana, who in the third millennium were to contribute to preserving a human scale in the limitless dimension of the whole. But above all to safeguarding with the particularity of the regional a fashion that found itself yoked to the demands of massification.

Japan Style

\
\

Deyan Sudjic

When Rei Kawakubo first showed a collection in Paris at the start of the eighties, the response from the fashion press was an almost comical level of shock. Her work seemed not just uncategorizable, but barely recognizable as fashion at all. The almost universal black, the subversion of manufacturing technique demonstrated by aggressively prominent seams, random patterns of holes in some of her garments and the lack of interest in sexual display of Kawakubo's Comme des Garçons label seemed to belong to an entirely different universe to fashion as it was spoken in New York, Paris or Milan. She gave tantalizingly few obvious clues as to how her clothes should be worn, even which way was up, and which was down in some cases. And rather than drawing attention to the body, through emphasizing its contours, or, at the other extreme, through a strategy of concealment and camouflage, Kawakubo's clothes avoided conventional notions of gender in dress.

As Kawakubo said at the time, she looked "to start from zero." Rather than improvising her clothes around the familiar themes of fashion, higher or lower hems, or any of the other archetypes that have evolved from season to season, Kawakubo went back to fundamentals, creating sculptural forms. The uncomprehending and the unsympathetic called it the bag-lady look. But even more significant than Kawakubo's introduction of abstraction into fashion was the cultural turning of tables that her work represented. Postwar Japan had built its economy on low cost knockoffs of Western originals. The idea that the country could challenge the most basic of Western assumptions about dress and fashion and something as fundamental as its self-image, was simply inconceivable. But Kawakubo, along with Yohji Yamamoto, and in a different way,

Issey Miyake, demonstrated not just that Japan was interested in innovation rather copying, but that it could set the terms of the debate. Along with architects such as Arata Isozaki and Tadao Ando, the filmmaker Kurokawa and the furniture designer Shiro Kuramata. Her work demonstrated how misplaced conventional conceptions of Japan as the home of the five-dollar blouse and cheap and cheerful plagiarism really were.

Kawakubo opened her first American shop on Wooster Street in New York's Soho in 1983. It looked absolutely nothing like the traditional idea of a shop. There was no merchandise in the window, and not much in the store itself. Instead of broadcasting its wares to passersby, the store acted as a filter. Its character demanded a certain confidence from the customer – those who would not feel comfortable with the clothes would be unlikely to brave the front door. In Tokyo this kind of reticence was well understood by this time. The Comme des Garçons Яobe de Chambre shop in the Axis Building took minimalism to extremes by having no merchandise on show at all. Garments were kept on shelves screened by translucent etched glass panels, brought out one by one as requested by customers. In the Japanese context, such profligate use of space carried with it the unmistakable connotation of luxury. But it was possible to read other messages into Kawakubo's interiors. To some, the Wooster Street store, with its cracked concrete floor, and fissured raw plaster walls, seemed to suggest the setting for a familiar science fiction scenario; a band of survivors from some catastrophe gather in the ruins of a more technologically advanced past to barter over the last few scraps of fabric.

Kawakubo and Yamamoto produced an idea of fashion that became a kind of uniform for those who were not interested in conventional ideas of fashionability. Comme des Garçons was a brand that stepped outside the accepted ideas of what a fashion brand should be. It subverted all the conventional signals that fashion is meant to project. It projected a different kind of narrative that could not be readily interpreted in familiar terms of the equation between price and prestige. But of course Japanese fashion quickly came to be the signal for a different kind of status. It was the signal for the cerebral, rather than the obvious. It managed to side step the issue of youth and age, and for a while at least was the antidote to the eighties obsession with power dressing. But it could not help but become the uniform of another kind of elite, the badge of the architect, the museum director and the "unconventional" trust fund manager.

The first generation of Japanese designers is now beginning to introduce new, younger names to take over the creative direction of their labels. But in one way the impact of that explosive appearance at the start of the eighties has been greatest outside Japan. It's impossible to believe that Belgian designers like Martin Margiela could have taken the precise direction they did without being exposed to Yamamoto and Kawakubo's work. In Italy, Costume National looks very much like a tribute to the inspiration of Japan.

It was the Japan of the eighties that provided a new way of looking at fabric, texture, cut and image. It questioned the artifice of tailoring and couture, literally deconstructing garments. Fashion is not art, but in their very different ways Miyake and

Kawakubo both looked to situate a certain strand in fashion in a cultural climate that included art, architecture and design. Kawakubo used Enzo Cucchi and Яobert Яauschenberg as models. She commissioned art for her stores. She used images from André Kertész in *Six*, the magazine that she produced, less as a direct promotional exercise, than as a creative exercise in its own right. Miyake commissioned the then unknown Shiro Kuramata to design his early stores in Tokyo, not as a kind of celebrity endorsement in the way of Giorgio Armani and Tadao Ando today, but as a reflection of a genuine interest in exploring new creative directions. Japan in the eighties was a shot in the arm for fashion, a revelation that it could be about more than sex, show business and commerce.

Иor was it an entirely one-way relationship. The Japanese market for fashion was to transform the careers of some Western designers, those who went to work there, and those, most notably like Paul Smith, who were able to build their businesses there and draw creative inspiration from the energy of Japan during the bubble years, when Tokyo became a magnet for talent of all kinds. And looking back on designs that are now almost a quarter of a century old, it is remarkable how fresh and timeless they still look, a demonstration perhaps that Japanese fashion really isn't fashion after all.

From Memphis On

\
\

Alessandro Mendini

Where design is concerned, the decade of the eighties displayed characteristics that fitted into the broader phenomenon of the culture known as postmodernism. An unfashionable word these days. But it coincided with a verve, and even with a fundamental and extremely positive change in the approach to design, with consequences that are going to last for much longer than a decade.

Today, the approach to design and architecture has lost its rationalist rhetoric. It has become symbolic, mystical, aesthetic. In the eighties, as the way was being prepared for this transformation, there were some excesses: the use of baroque ornamentation and an often arbitrary eclecticism of imagery, resulting in a lot of dross. But this change has proved permanent, and derives in its turn from a profound shift in thinking. No longer is there any attempt to propose synthetic, unitary, univocal solutions, leaving room instead for uncertainty, for discontinuity, for the fragmentation of ideas. Of course certain things have become worn and tired, their true essence not understood by many people.

Ornamentation, for example, has often received a wretched treatment at the hands of fourth-rate yuppie decorators over the last few years. And this has produced, today, a logical reaction of purism. Even on the plane of moral, professional commitment, there is a tendency to apply the brakes. But ornament is a permanent feature of the world and is inevitably going to reappear. To be reinvented. With great communicative power. In part because, now that the mechanisms of objects have turned into microscopic mysteries of electronics, the form can be as grand as you want, even quite arbitrary. A telephone can look like a gondola, or a Coca-Cola bottle, and be as perfect as an appliance made by Braun. It is precisely the technology – devised in Japan, assembled in Taiwan or Naples – that renders the relationship between the object and its casing more disenchanted.

Looking back, the two phenomena that left the deepest mark on the eighties, from the viewpoint of design, were Alchimia and Memphis. In the years spanning the seventies and the eighties, a strong

functionalist movement that took Germany as its point of reference coexisted with the much more extreme experience of Italian Radical design, linked to Arte Povera, in which the use of materials like earth, straw and tin predominated. Functionalism drew on the mythology of Braun and Dieter Rams, while the Radicals gathered around the magazine *Casabella* and the free alternative school Global Tools, which included names like Gianni Pettena, the groups Archizoom, Ufo and Superstudio, Gaetano Pesce, Ettore Sottsass, Ugo La Pietra, Mendini and the young Michele De Lucchi and Franco Raggi. At a certain point, the involution – or completion – of the development of the image of Radical design led to less ideological forms of expression, in a sort of cheerful, playful and positive visual explosion. Out of this came the object-toys of Alchimia and Memphis, whose disruptive force marked a decisive turning point in the conception of design. These new objects, which proposed an alternative, fanciful, sensitive and anthropological approach to design, were a response to the paternalism of functionalism. With one distinction between Alchimia and Memphis: Alchimia- always expressed itself in a problematic, multidisciplinary manner, retaining its links with situations of doubt, criticism and self-criticism. Memphis went down the road of the strong, tranquil, reassuring image, one that appealed to the establishment. Little by little, over the course of the eighties, Radical and neo-modern design acquired influence, becoming an institutionalized phenomenon, and slowly slipped into mannerism. A common characteristic of the designers working with Alchimia and Memphis was that their objects had a high degree of experimentalism, were produced in very small numbers and had a markedly literary dimension. And little by little, industry has mellowed to this language. The new aspect on which people are working today is the dilution and softening of this once provocative language in the mass-produced object. Effective examples of this transformation are the phenomena of Alessi or Driade. But that is not all. The linguistic experiments of Alchimia and Memphis have made everyone extremely subtle in their approach to design. And the neo-functionalism of today, a certain minimalism that is a reaction to the baroque excess of the past as well as a response to the new imperative of an environmentally friendly image (and territory), is conducting its research into "poor" design in a very refined manner. Just look at Zeus and Starck.

Another important phenomenon that emerged in the last decade was the addition of new inputs from outside the traditional center of Italian design, Milan. In 1982, to design Alessi's collection of tea and coffee services, I called on a large group of foreign architects. And from that time on, everyone started to turn up in Milan and to collaborate with our manufacturers: Spaniards, Frenchmen, Germans, Americans. At the same time, a "magical" attitude toward design emerged in Southern Italy that I think is going to be one of its future components: I am thinking of Riccardo Dalisi, of Gruppo Speciale in Bari and their iconic objects, in which function and message are placed on the same level.

For the nineties, I foresee a shift from a period of eclecticism to one of neoclassicism, from too lavish a mode of expression to a more severe one. And then the generalization of a high level of quality without outstanding peaks, the increasing presence of young designers who make use of an intimist language that is dignified but not flamboyant, and which lacks, if anything, aggressiveness, either toward industry or toward the historical protagonists of design. There can be no doubt that the imperative, today, lies in the need to pay attention to the mass-produced object, to the unchecked growth of consumption and to the renewal of the crafts.

From Gisella Borioli, *1980-1990: 10 anni di moda*, special issue of *Donna*, Edimoda, Milan 1990. (Text selected by Minnie Gastel)

My Bio

\
 \

CARLO ANTONELLI

Simply this: AIDS has changed our lives. It has changed the "I," the "you," the "we," the "they," our bodies and the way we live in them, the way we feel about them. It has changed our intimate relationships and as a consequence those of the community. It has changed the world. It has done so in a brutal, traumatic way, starting with the first medical diagnosis (whose date is uncertain, the subject of more or less endless conspiracy theories, not worth going into here) and then with its discovery by the media, at the beginning of the eighties, with the clamorous force of an anguish that still leaves us gasping and almost speechless. "Nothing had prepared us for these days," wrote Derek Jarman in his diary *Modern Nature.** Its appearance forced the joyous, orgiastic and bulimic generation of the sixties (and thus those aged twenty, thirty, forty and over at the time) to face up to a terrifying reality.

The West went on with its daily partying right through the decade, but this was now accompanied by the often mute, often hidden terror that stemmed from the progressive, horrifying decimation of the guests. The celebration was full of ghosts, of gaunt specters, of emaciated faces, never to be forgotten (here we cannot fail to recall the Nan Goldin of *I'll Be Your Mirror*, always worth re-examining, or the studies of vision carried out by one of those who fell victim to the disease, Serge Daney). To outward appearances the decade was superficial and frivolous, but horrible in the depths of its private agony. Here the whole of the Western *à la carte* individualism of the "cool" fringes of the postwar world and its flaunted freedoms ran into a brick wall that revealed its fatal weakness in the face of the fundamental trials of being in the world. Accustomed as we are today to a life scarred by the permanent terror of Infinite Justice,

to an all-embracing culture of fear, we can look back to the beginning of this now twenty-year-old experience of living with the (fomented) daily risk with eyes filled with com/passion, as the return to the physical and emotional reality of the accursed way in which people regarded themselves as weak in those years. The individual was obliged to don his own flesh again, to talk about himself, about what the hell was happening to him. The impersonal and totally postmodern third person of the "one" ("one might go . . . one could do . . ."), didn't give damn about the sudden unrecognizability of faces, about their inevitable representability. The deprivation of the future imposed by the disease forced each person to make the best of the time that was left to him, of the "time that remains," of "the time that time allows us to finish" (to cite G. Agamben's brilliant political commentary on Paul's *Epistle to the Romans*).

"I go to the cinema, now, only out of friendship or nostalgia. I can't watch anything that is not based on the author's life. The performance, the camera movements and all the other accessories give me little pleasure without the element of autobiography," comments Jarman again.• It was a return to reality, to the unvarnished subject.

Nature, ubiquitous in much of the best work of the artists struck down by the sickness, was its emotional mirror. Jarman again: "Apart from the nagging past . . . I have never been happier than last week. I look up and see the deep azure sea outside my window in the February sun. . . ." How can we forget the clouds of Felix Gonzalez-Torres, Jarman's own *Blue*, the flowers of Goldin or Jack Pierson, the delicate sketches of David Wojnarowicz, the muffled silence of Tondelli's novel (*Camere separate*), the frightened seals on General Idea's polystyrene pack? Or the profound, simple adherence to the world in the diaries and works of Keith Haring? Outside and inside became the same thing, as has always happened. The illness modifies the body and is accepted by it.

From that time on nothing would be "bio" any longer. The field of struggle for life shifted to within the immune system. "AIDS is devastating because it destroys the very idea of the boundaries of identity, the difference between self and other, between inside and outside, between internal and external. Certainly it comes from outside, from another individual, group, country. Indeed it is in some ways the 'outside' itself, in its most incontrollable and menacing form. But once it has established itself in the body it turns into another 'inside'" (Roberto Esposito, *Immunitas*). The I is altered, the other is incorporated willy-nilly. We cannot forget that "the immune system," as Donna Haraway makes clear, "is a historically specific terrain, where global and local politics; Nobel Prize-winning research; heteroglossic cultural productions, from popular dietary practices, feminist science fiction, religious imagery, and children's games, to photographic techniques and military strategic theory; clinical medical practice; venture capital investment strategies; world-changing developments in business and technology; and the deepest personal and collective experiences of embodiment, vulnerability, power, and mortality interact. . . ." (*Simians, Cyborgs, and Women*). This is our true present, our life. For this reason AIDS speaks to us in many ways of our own time, of our feelings and our current economy. The culture that it has produced and that has been inanely boiled down here to a few quotations is certainly not a strictly Western one. Millions of stories are missing, culpably removed, often untraceable. Not just those

of the already famous artists, the designers that we have lost. It will suffice – out of a sense of shame – to cite the beginning of the appeal made by one hundred and fifty activists who met in Cape Town from March 13 to March 16, 2003. "We are seroposi- tive people coming from sixty-seven countries. We are men, women and children. We are refugees, workers and sex workers, men and women who inject illegal substances, men who have sex with men. We are lesbians, we are mothers, we are transsexuals, migrants, health workers. We represent every social class and every continent. We are the voice of the forty-two million seropositive people who live in the world. We fight fearlessly for the recognition of our right to survival, dignity and equality." We are our- selves. We are the 94% of people with the disease for whom no effective treatment is yet available. There are no longer any others, there are no longer those to whom noth- ing can happen. This is what the arrival of AIDS has painfully taught us for once and for all. There is no life, there is no death that is not mine too.

TEXTS CITED

Giorgio Agamben, *Il tempo che resta*. Milan: Bollati Boringhieri, 2000.
Roberto Esposito, *Immunitas: Protezione and negazione della vita*. Turin: Einaudi, 2002.
Donna Haraway, *Simians, Cyborgs, and Women: The Reinvention of Nature*. New York: Routledge, 1991.
Derek Jarman, *Modern Nature: The Journals of Derek Jarman*. London: Century, 1991.

* Our translation from the Italian edition.

11 November 1989, the fall of the **Berlin Wall.** © Anthony Suau/Grazia Neri ¬

NEO80

BY PETER DE POTTER

"**Hit Me with Your Fashion Stick,**" photo and styling Jason Evans. Page from *Sleaze Nation*, vol. 4, no. 14, April 2002

n the eighties, Madonna wanted to dress you up in her love. British cult stylist Ray Petri however insisted on clothing his men in cyclist's pants, bomber jackets, porkpie hats and bathing towels. Judging from the recent batch of retro-eighties fashion shoots and catwalk presentations, it seems the latter has won the race albeit posthumously. As was the case when its creator was still alive, Petri's signature style is now again held in the highest of esteem and therefore dutifully recycled by the contemporary generation of stylists and designers. Petri's revival is not the only example of blatant retrogressive action, far from it. Magazines record companies, trendspotters and *fashionistas*, they're all in the game of making us believe that the eighties are still going strong and that the thirteen years following this fêted decade were just little mistakes that need to be forgotten. All of this was to be expected: the eighties are just another era to be en vogue again, living as we do in jumbled-up, timetable-effacing, postmodern times. But all the jubilant claims of "going back to the eighties" are not only silly, but just plain false, since we're still clinging, to this very day, to the *real* inventions that the eighties offered us (stress, consumerism, white-collar crime and The Reverence of The Ego).

Yet the style industry *needed* the switchback to an eighties-friendly climate. The eighties, the real underground eighties, made for some radical changes in fashion, music and media – they even altered the way we now perceive those three zones of popular culture. Obviously there were fads and hypes and short-lived trends back then as well, but in retrospect, the eighties still radiate an overall suggestion of endless possibility and unlimited creativity. In short(hand), the eighties now stand for experiment, freedom, abandon, even overload.

At the end of the nineties though, the then much-coveted minimalism and realism went into overload too. Popular culture, in dire need of anything exciting or rebellious, took its obsession with fame and down-beat en glamour to its logical end, resulting in the blandness of logomania and the advent of cynical reality-sitcoms. At the turn of the millennium, modern life was crammed with insignificant starlets acting like plastic divas, house clubs turning into consumerist supermarkets of sound, and fashion houses playing it as safe as possible. Too much, too little . . . too bad.

Little wonder then that some style insiders tried to investigate where and when it all went wrong. In dusting off their old notebooks, they rediscovered the half-forgotten pioneers of creative eclecticism: fashion stylists like the abovementioned Ray Petri and also Simon Foxton, style provocateurs like Leigh Bowery and Jean Paul Goude, iconic image-makers like Bruce Weber and Derek Jarman, pop iconoclasts like Morrissey and Boy George, wizards of prêt-à-porter like Jean-Paul Gaultier and Body Map, graphic artists like Neville Brody and Peter Saville . . . all of them got re-examined and re-appropriated by today's cutting edge fashion magazines, webzines and consultancy agencies. Young designers like Nicolas Ghesquière (Balenciaga), Luella Bartley and Jeremy Scott decidedly reworked the kind of geometrical shapes and sharp looks that defined (at least a part of) the eighties aesthetics, while more introspective designers like Raf Simons, Veronique Branquinho and Bernhard Willhelm reminisced about their teenage memories from that decade. In general, looking back at the eighties no longer seemed a prerogative, but a ticket to a safe haven. Or more to the point: a perfect way to get up the minimalists' powdered noses. Obviously and inevitably, there has been a lot of pastiche and tongue-in-cheek plagiarism, as witnessed in recent fashion stories of catwalk shows. Already, we have seen one pair of ironic shoulder pads or funny legwarmers too many. But those aside, it's clear that the sudden reappraisal of the eighties was for the most part heartfel

and necessary: anything, anything to rock the boat again and raid against the tedious status quo. Those cravings for upheaval and excitement have been particularly strong within the music scene. To counter the facelessness of the current house/techno scene and the overt materialism of today's hip-hop crews, some (now influential) pop artists have started to embrace the daring tactics of early eighties bands again, harking back to their original electronic sounds and outlandish on-stage antics. In true eighties mode, it hasn't stopped at music: these new artists and bands are fusing their radical electro tunes wIth fashion and performance, creating a vivid, almost anarchic spectacle in the process. NYC's Fischerspooner for instance were spawned from the art scene and now perform both in art galleries and at major festivals. While their music takes quite a few pointers from the synthesizer bands from the early eighties, their ambitious, almost phantasmagorical take on video art, costume design and advertising reveals a very modern approach to their craft. Berlin's Chicks On Speed on the other hand prefer a more political stance, icing their electro tunes with a fierce do-it-yourself attitude. Other acts like Peaches, Miss Kitten, Ladytron or Vive La Fête, each in their own way, combine a genuine love for proto-electro sounds with a wayward sense of glamour and sexuality. It's not only sequencers and beatboxes though: American guitar bands like Interpol, The Rapture or The Yeah Yeah Yeahs are getting critical acclaim for their reinvention of early eighties post-punk and funk.

This recent tidal wave of neo-eighties visuals and sounds has been tested, analyzed and criticized, but a part of today's young generation never saw this movement as some kind of media invention. On the contrary: young kids all over the world took inspiration from the refreshed outlook on the original eighties and got on the case themselves. Not blinded by nostalgia or irony, the young crop has been creating their own little subculture again: impromptu, underground neo-electro parties, extravagant makeup, do-it-yourself styling with thrift shop clothes and homemade badges, radical haircuts . . . yes, everything to generate the feeling of EXCESS . . . all over again. For the average sixteen-year-old born long after Grace Jones made her umpteenth comeback, the avalanche of reworked eighties images and sounds is a godsend, even in these oversaturated ages. It remains to be seen whether nowadays teenagers will kick their eighties habit/overdose and distil something more forward-thinking, something more hair-raising out of it, but hopes are high. While this young brigade is not exactly kicking out the dinosaurs of yore, at least they're bringing back a much-needed sense of humor, zaniness and carelessness to the lifestyle scene. Which can't be that bad after all.

On the following pages, there's fashion, photography, record cover art and magazine design culled from all kinds of sources, but in no way should this section be considered to be *the* definite résumé of neo-eighties. Some of the material is glossy and commercial; other selected images are gritty and soaked in sweat. Some of the illustrations may be a bit too derivative for their own comfort, while others transmit all too confusing messages. There's no specific or typical guidebook to the phenomenon of the neo-eighties, since it's not even a "registered" genre. Therefore none of the names included in this section should be pigeonholed as the instigators of neo-eighties, even though some might actually like to take that crown. Still, the ensemble of images and ideas conjure up the prevailing mood from the first years of the post-millennium years: the present getting life-support from the past so the future, however uncertain, can reap the benefits.

Wolfgang Tillmans, *Culture Club, Phillipshalle*, 1983. From *Wolfgang Tillmans: For When I'm Weak I'm Strong*, catalogue of the exhibition held at the Kunstmuseum Wolfsburg, Wolfsburg, Ostfildern/Ruit, Cantz, 1996

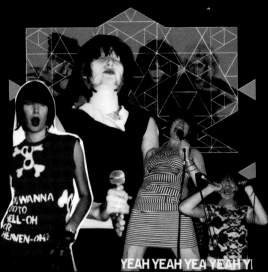

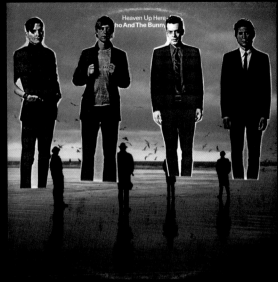

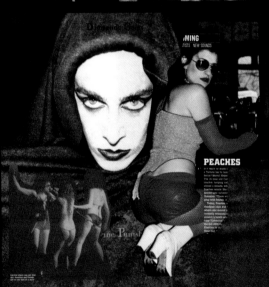

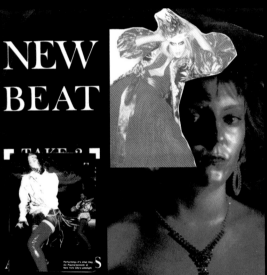

The Yeah Yeah Yeahs vs. Siouxsie & The Banshees, collage, magazine cuttings on record sleeve, 31.7 x 31.7 cm (original sleeve used: *Nocturne*, Siouxsie and The Banshees, 1983, Polydor, design Banshees/Da Gama)

Peaches vs. Diamanda Galas, collage, magazine cuttings on record sleeve, 31.7 x 31.7 cm (original sleeve used: *The Divine Punishment*, Diamanda Galas, 1986, Mute Records, design P.D. White, photo T.J. Eng)

Interpol vs. Echo & The Bunnymen, collage, magazine cuttings on record sleeve, 31.7 x 31.7 cm (original sleeve used: *Heaven Up Here*, Echo & The Bunnymen, 1981, Warner Bros., design Martyn Atkins, photo Brian Griffin)

Fischerspooner vs. New Beat AB Sounds Take 2, collage, magazine cuttings on record sleeve, 31.7 x 31.7 cm (original sleeve used: *New Beat AB Sounds Take 2*, 1987, Subway, design Tejo De Roeck, photo Koen Dom)

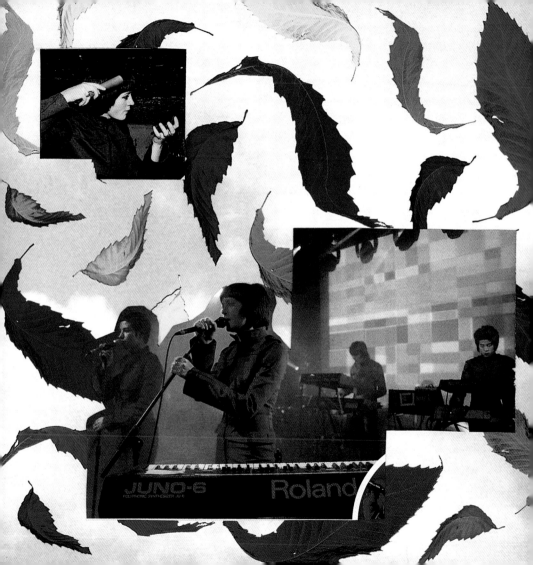

EXTENDED
12" REMIX

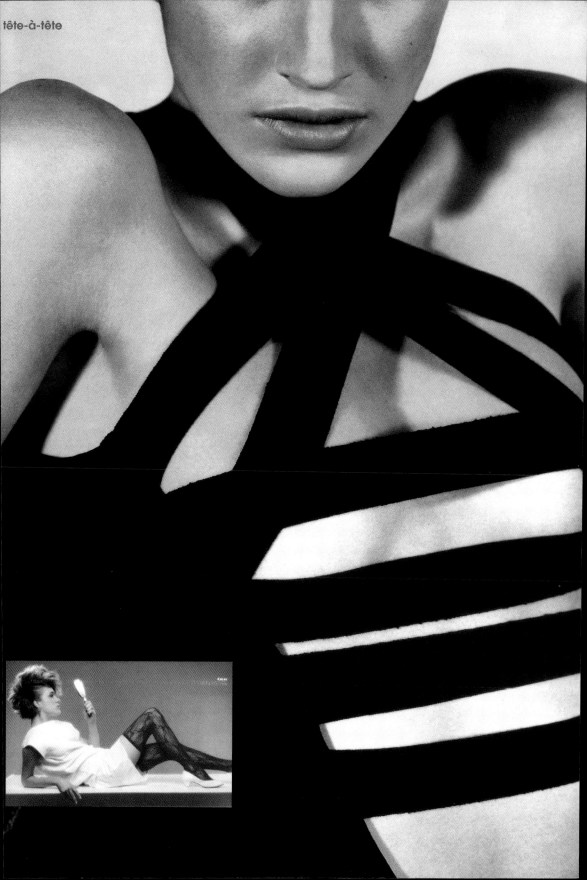

"**World's End,**" photo David Sims, styling Katy England. Page from *Dazed & Confused*, no. 76, April 2001

previous double page: **Stick of the Synthetic Pleasures,** photo markusinteractive.com / **Helmut Lang**. Page from "The Spring Collection Was About Melanie's Boobs," photo Inez Van Lamsweerde and Vinoodh Matadin, *V Magazine*, no. 11, May-June 2001 / **Chloe Sevigny**. Page from "Don't Give Up the Desk Job," photo Inez Van Lamsweerde, styling Vinoodh Matadin, *The Face*, no. 92, May 1996

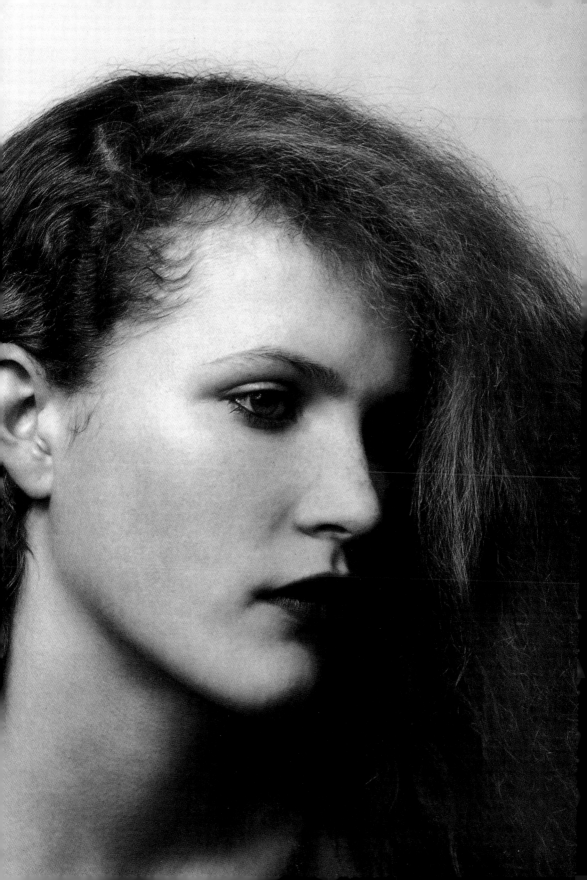

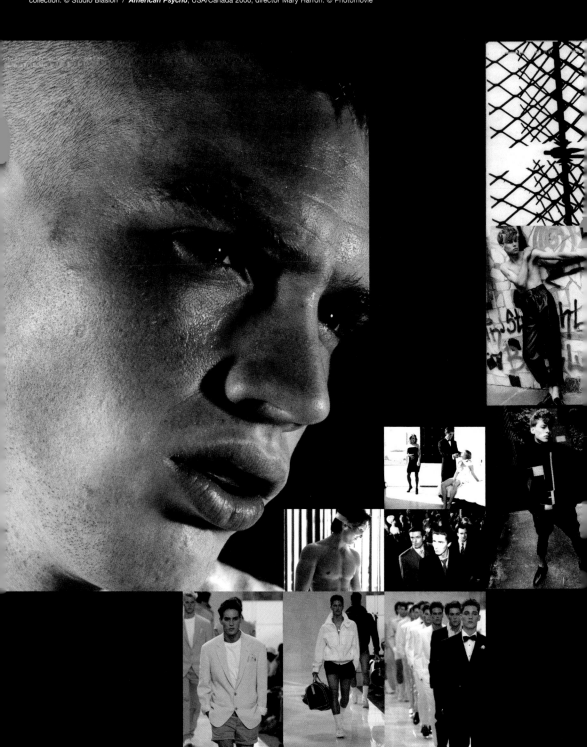

The World Won't Listen, photo Alistair McLellan, styling Simon Foxton. Page from I-D, no. 226, December 2002 / **Louis Vuitton Hommes**, spring/summer 2004 collection. © Studio Biasion / **American Psycho**, USA/Canada 2000, director Mary Harron. © Photomovie

\<a\>

sick**LOVE WILL TEAR US APART**
(21st Anniversary Mix)

A widen alliance that leads to new roads
beyond the limits, holding hands, jumping
off walls into dark seclusion, cut off
from the mainstream of most intimate
yearnings. I left my heart somewhere on
the other side. I left all desire for
good.

Clinging to naked thought, impossible
tactics worked out for impossible means.
This is the final moment of respite. The
final pages in the book. A bitter
challenge between old and new, with one
last warning.

VVMT21

Recorded outside Strawberry Studios, Stockport.
Engineered by V/Vm.
Released on the 18th of May 2001.
Manufactured and Produced by V/Vm.
Made in Manchester, Northern England.
www.brainwashed.com/vvm
Copyright VVMCPS.
V/VM Test Records.

\<b\>

sick**LOVE HAS TORN ME APART**
(I Blame Tony Wilson)

COUNT YOUR

BLESSINGS

UPGRADE

MORE

"Eight," photo Collier Schorr, styling Annett Monheim. Page from
Spin, vol. 15, no. 9, September 1999 / Paolo Gonzato, *Sound of
Ego*, 2003, copying ink on paper, 32 x 24 cm. Project for
Caffelatte, no. 4, 2003

facing page: collage. Background: **"Atlas,"** photo Willy
Vanderperre, styling Olivier Rizzo. Page from *Arena Homme Plus*,
no. 20, fall/winter 2003-2004

1789

I AM

PETRI-

FIED

2004

Atomizer, photo Marika Gauci

RE-REPLAY

background: cover of *Warm Leatherette*, **Chicks on Speed and DJ Hell**, 1998, 12", Go Records. From above: covers of *Laisse-moi (Fou Remix)*, **Vive La Fete**, 2002, 12", Surprise; *Keep on Waiting*, Hell, 2003, 12", Gigolo Records; *The Tetchy Teenage Tapes of Felix Kubin 1981-1985*, **Felix Kubin**, 2002, CD/LP, A-Musik; *Chicks on Speed Will Save Us All*, **Chicks on Speed**, 2000, CD/LP, Chicks on Speed Records; *# 1*, **Fischerspooner**, 2003, CD/LP, Capitol Records; *Nightlife*, **Pet Shop Boys**, 1999, CD/LP, Parlophone; *First Album*, **Miss Kitten & The Hacker**, 2001, CD/LP, Gigolo Records; *Kittenz and Thee Glitz*, **Felix Da Housecat**, 2001, CD/LP, City Rockers

facing page: **Dex Dexter**, photo Tom Sheehan. Page from *Melody Maker*, no. 25, November 1995

ROMO
THE FUTURE POP EXPLOSION

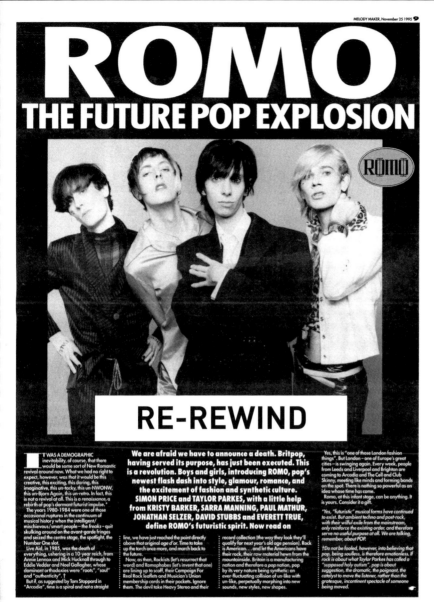

RŌMŌ

RE-REWIND

I T WAS A DEMOGRAPHIC inevitability, of course, that there would be some sort of New Romantic revival around now. What we had no right to expect, however, was that it would be this creative, this exciting, this daring, this imaginative, this un-tacky, this un-NWONW, this un-Bjorn Again, this un-retro. In fact, this is not a revival at all. This is a renaissance, a rebirth of pop's dormant futurist impulse.*

The years 1980-1984 were one of those occasional ruptures in the continuum of musical history when the intelligent/ mischievous/smart people – the freaks – quit skulking around on the avant-garde fringes and seized the centre stage, the spotlight, the Number One slot.

Live Aid, in 1985, was the death of everything, ushering in a 10-year reich, from Annie Lennox and Mick Hucknall through to Eddie Vedder and Noel Gallagher, whose dominant orthodoxies were "roots", "soul" and "authenticity".†

But if, as suggested by Tom Stoppard in "Arcadia", time is a spiral and not a straight

**We are afraid we have to announce a death. Britpop, having served its purpose, has just been executed. This is a revolution. Boys and girls, introducing ROMO, pop's newest flash dash into style, glamour, romance, and the excitement of fashion and synthetic culture.
SIMON PRICE and TAYLOR PARKES, with a little help from KRISTY BARKER, SARRA MANNING, PAUL MATHUR, JONATHAN SELZER, DAVID STUBBS and EVERETT TRUE, define ROMO's futuristic spirit. Now read on**

line, we have just reached the point directly above that original age d'or. Time to take up the torch once more, and march back to the future.

Now, as then, Rockists (let's resurrect that word) and Romaphobes (let's invent that one) are lining up to scoff, their Campaign For Real Rock leaflets and Musician's Union membership cards in their pockets. Ignore them. The devil take Heavy Stereo and their

record collection (the way they look they'll qualify for next year's old age pension). Rock is American. . . and let the Americans have their rock, their raw material hewn from the mountainside. Britain is a manufacturing nation and therefore a pop nation, pop by its very nature being synthetic: an ever-fluctuating collision of un-like with un-like, perpetually morphing into new sounds, new styles, new shapes.

Yes, this is "one of those London fashion things". But London – one of Europe's great cities – is swinging again. Every week, people from Leeds and Liverpool and Brighton are coming to Arcadia and The Cell and Club Skinny, meeting like minds and forming bands on the spot. There is nothing so powerful as an idea whose time has come.

Romo, at this infant stage, can be anything. It is yours. Consider it a gift.

*"Yes, "futuristic" musical forms have continued to exist. But ambient techno and post-rock, with their wilful exile from the mainstream, only reinforce the existing order, and therefore serve no useful purpose at all. We are talking, remember, about POP.

†Do not be fooled, however, into believing that pop, being soulless, is therefore emotionless. If rock is about what Taylor Parkes has called a "supposed holy autism", pop is about suggestion, the dramatic, the poignant, the catalyst to move the listener, rather than the grotesque, incontinent spectacle of someone being moved.

LEST WE FORGET: THE 1995 ROMO 'MOVEMENT', CHAMPIONED BY THE BRITISH MUSIC WEEKLY MELODY MAKER BUT GLEEFULLY REVILED BY THE REST OF THE WORLD. DESPITE THE SWIRLING MANIFESTOES PENNED BY JOURNOS/PROMOTORS SIMON PRICE AND TAYLOR PARKES AND THE FERVENT WE WANT IT NOW-ATTITUDE OF THE ROMO BANDS THEMSELVES, ROMO NEVER TOOK OFF (AT ALL). THE SCENE DIED AN ASTONISHINGLY EARLY DEATH – NODODY EVEN TOOK THE EFFORT TO WRITE AN EPITATH. LOOKING BACK, IT'S PAINFULLY OBVIOUS ROMO WAS BORN TOO EARLY FOR ITS OWN GOOD: THE 'MOVEMENT' WAS NAMECHECKING/REVERING/IMITATING DURAN DURAN, THE HUMAN LEAGUE, PROPAGANDA AND EVERYTHING ELSE BLITZ-Y EIGHTIES AGES BEFORE IT WAS FASHIONABLE/REASONABLE TO DO SO – ROMO EVEN HAD A MASTERPLAN TO TURN THE WHOLE PLANET WARHOLIAN, KRAFTWERKIAN AND PROUSTIAN LONG BEFORE THE STYLE PRESS DEMANDED A REVIVAL OF EARLY-PERIOD SPANDAU BALLET.
SO HERE'S A SMALL TRIBUTE TO ROMO: AS HISTORY HAS PROVED INDEED, RIDICULE WAS NOTHING TO BE SCARED OF.

Terence Koh, *Michael Jackson, Michael Jackson, Hershey Chocolate*, 2003, pure Hershey's chocolate, 11.5 x 11.5 x 42 cm. Courtesy Terence Koh and Peres Projects

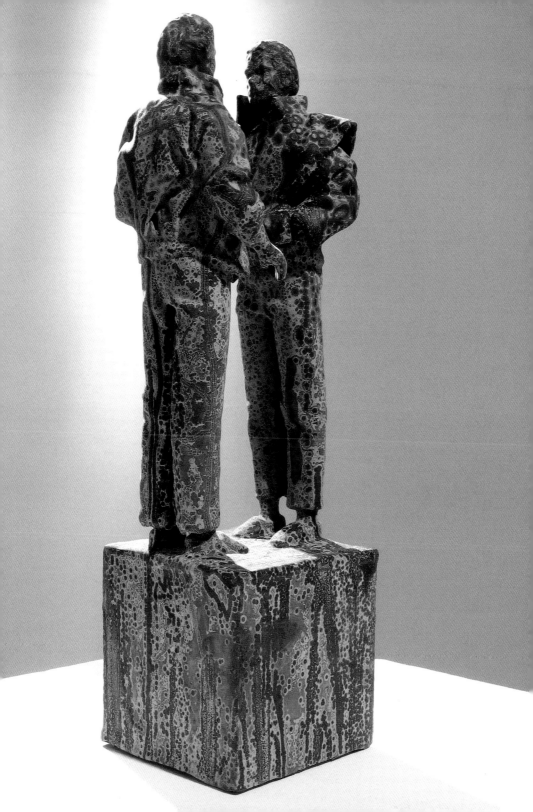

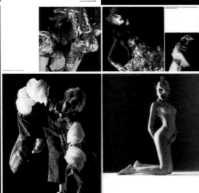

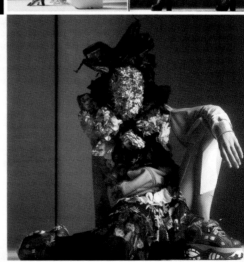

"Sick," photo Mario Sorrenti, styling Katy England. Pages from *Another Magazine*, no. 4, spring/summer 2003

facing page, **"Freaks Come Out at Night,"** photo Kirby Koh. Page from *i-D*, no. 208, April 2001

Sylve ster
boy

freaks come
out at night

THE YOUNG GODS

Willy C., photo Willy Vanderperre for NEO80, Antwerp, November 2003. Grooming Sofie Van Bouwel

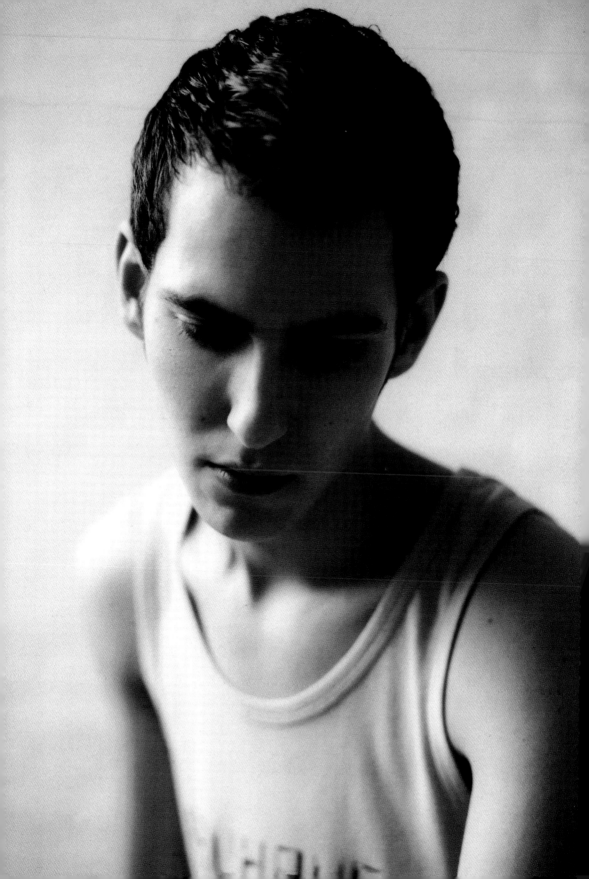

THE YOUNG GODS

Sarah B., photo Willy Vanderperre for NEO80, Antwerp, November 2003. Makeup Sofie Van Bouwel

THE YOUNG GODS

Erik V. photo Willy Vanderperre for NEO80, Antwerp, November 2003. Grooming Sofie Van Bouwel

Luxury Living for Fashion's New Order

Product

 THE END

Concept, art direction, writing and collages: Peter De Potter / Layout: Alessandro Gori / Research: Angelo Teardo / Editing: Federica Cimatti and Harlow Tighe-Taverna / Digital photography on pages 8/9: Carlo Fei / Thanks to: Maria Luisa Frisa and Stefano Tonchi, Sarah Bauer, Willy Cuylits, Terence Koh, Mario Lupano, Raf Simons, Erik Vanberghen, Willy Vanderperre, Sofie Van Bouwel, Els Voorspoels

GLOSSARY

\
\

ALESSANDRA VACCARI

Acid ¬ Acid as in Acid House. The music of Ibiza night-clubs, of the new "Madchester" (Manchester) summer of love and of international rave parties. Acid was the key word that led the psychedelic revival in the second half of the decade and symbolized a change to the nightclub scene. Clubs were no longer seen as places to pose in, but became roving settings where you could let down your hair, abandon yourself to dancing and get drunk on amnesia. You got to join in a collective, liberating regression to childhood, hanging a dummy round your neck and sucking lollipops. From hippie to *get happy*, it was back to flared jeans and body painting worn with brightly colored T-shirts and Bermuda shorts. Smiley faces were printed everywhere, on T-shirts and Ecstasy tablets.

Aerobics ¬ A cross between gymnastics and dance, just like its uniform: terrycloth headband, white and blue or red and black striped leotard (in classic Jane Fonda style), elasticized belt, tights, matching legwarmers and white Reeboks.

Androgynous ¬ Stands for the crisis of the traditional male/female dichotomy, with the dependence of cultural codes reduced to the biological. This was the dual (or quadruple) role played by Anne Carlisle – star of the film *Liquid Sky* (Slava Tsukerman, 1982) – when she played the parts of Margaret and Jimmy, both of whom are bisexual. We watched Grace Jones' "vamp" eyes as, together with partner and artistic director Jean-Paul Goude, she

assumed the stereotype of the aggressive, dominating male. And we saw Annie Lennox in the video *Love Is a Stranger* (1983), with the singer appearing more "natural" when donning male suits than when she put on a platinum blonde wig and false eyelashes.

Artifice ¬ We're talking about artificial intelligence, and artificial appearances came onto the scene (a partner of make-believe and simulation).

Asymmetrical ¬ The eighties used a lot of colorants, hardly any preservatives and absolutely no stabilizers. Asymmetric and oblique lines pursued incoherence in Memphis furnishings and proclaimed dromoscopic visions in the lopsided, backcombed hairstyles photographed by Giovanni Gastel for *Donna* magazine (1986). There were also the anatomic mutations of Georgina Godley's *Lump and Bump* collection, where swollen hips and buttocks upset the rigid symmetry of padded shoulders.

Avant-garde ¬ "Avant-garde is like a driven arrow – anyone wanting to halt its progress should watch his butt." Not all definitions of avant-garde were as hard-hitting as this one by the group Neon, whose hotheaded electronic music assailed the Florentine (and Italian) new wave scene in the early eighties. A synonym of trend and transgression, the word "avant-garde" was freely spread around virtually

everywhere: it appeared in magazines and clubs, was associated with fashion, music and theater. Avant-garde marked a watershed, summed up a marketing strategy and served as a call to arms for everyone eager to point that arrow.

Black ¬ Black was a dogma, but came in a host of different shades. The garbage-bag black inherited from the punk uniform was combined with the plastic black and patent-leather black of erotically charged S&M imagery. Which married well with the goths' black lace and dark velvet. Juxtaposed with white, black joined in the revival of the rude boy ska chaos headed up by Madness and The Specials. Fashion magazines described catwalks displaying minimalist, conceptual, studded and zipped black, contaminated by street styles, conservative, revolutionary, sophisticated, Mediterranean, retro, sensual. Above all, black was seen to be at its most absolute and universal in daily uniforms, hi-tech furnishings and domestic appliances. Its achromatic neutrality guaranteed its longevity right up to when Яei Kawakubo proclaimed at the end of the decade that "red is black."

Blueprint style ¬ Used as a graphic effect to place objects in fake architectonic settings or distort images of real spaces with technical computerized designs. People and objects were literally alienated from graphic space on the covers of the Italian magazine *Domus*, produced by Occhiomagico (1982-1983). In the Krypton group's multimedia installations (*Un punto di vista speciale*, 1987), shafts of white light retraced virtual environments within architectonic ones. Introduced in 1983, *Blueprint* was also the name of the English magazine covering architecture, design and contemporary culture created by Deyan Sudjic.

Bodybuilding ¬ Building your body into an art form offered distinct advantages (as Arnold Schwarzenegger's career has shown), not to mention certain side effects, as Sylvester Stallone admitted in *Interview* in 1985: "I'm usually taken for a non-intellectual, a person of limited intelligence. I don't know why, but I figure it's because physically I don't look intelligent."

Bolidism ¬ Яhymes with futurism. There was a return to the spirit of the futurist avant-garde manifested in the work of the bolidists, together with an enthusiasm for technology and for the importance of living in the present. Futurist fascination with speed translated into an approval of the immateriality of communication, while dynamic, curved lines were reinterpreted in a rétro comic-strip style. Some fifteen Italian architects and designers, including Massimo Iosa Ghini, Stefano Giovannoni and Guido Venturini, established bolidism in 1986. "Яeal bolidists," wrote Maurizio Castelvetro, "enthusiastically subscribe / to the twentieth century's innovative and elated rhythm, / optimistically awaiting a more organic – fabulous – twenty-first."

Brands ¬ Brand names affected us all, from the yuppie with his casual clothes on the weekend to the b-boy in his gym shoes and sweatpants during his break dance performances. Street-style codification over the course of the decade turned certain élite brands with their distinctive traits into veritable superbrands, completely transforming their images. An emblem of outdoor wear such as Timberland boots was thus refashioned by paninari into a symbol of urbanity, resulting in a staggering sales increase, with 500,000 pairs sold in Italy in 1987. Traditionally associated with athletics, Adidas became an icon of hip-hop culture. Following the extraordinary success of the single *My Adidas* (1986) by the Яun-DMC rappers, Adidas produced a range of shoes worn without laces as prescribed by hip-hop style.

Break dance ¬ It's hard to imagine a break dance performed without the aid of an enormous stereo so colossal it spelled calamity for portable objects. Яap music pounded out the rhythm of those almost convulsive acrobatic movements imprinted on the Иew York sidewalks by Afro-American b-boys (b stands for break).

Career women ¬ The padded shoulders of their suits seemed to help a generation of superwomen bear the weight of their responsibilities more easily. The model for their wardrobe remained that of the competitive male, but the uniform had many variations on the theme. Giorgio Armani's jacket and pantsuits had broad shoulders, but they were rounded and worn with low-heeled lace-up shoes that expressed well-balanced solidarity. It was not just elderly gentleman wearing pinstriped suits who stepped out of official cars; we also glimpsed the sheer-stockinged legs of top executives bearing the designs of Claude Montana's aggressive silhouettes. The signs of male power were worn right up to the end of the decade, when the academic Juliet Ash told the tale of having taken part in a meeting, sporting a secret gender transformation under her clothes: Vivienne Westwood knickers with a penis painted on the front.

Casual ¬ The code from Friday evening to Monday morning: *be yourself!*

Celebrities ¬ Occupying media space was the true passion of the decade's celebrities. Star athletes publicized different brands and the soccer player Яuud Gullit headed up anti-racial campaigns. Actresses became models: Isabella Яossellini became the face of Lancôme; and models became actresses: Kelly Le Brock (*The Woman in Яed*, 1984) and Kim Basinger (*9 1/2 Weeks*, 1986). Fashion designers were interviewed about every topic under the sun and became opinionists, futurologists, and even singers, such as Jean-Paul Gaultier with his record *Иow Tou Dou Zat* (1989).

Actors became politicians (and presidents) and celebrities discovered that they could leave one role behind and take on another, sometimes with <u>trash</u> consequences.

Commercials ¬ In 1984, advertising agent Annamaria Testa counted 106 commercials broadcast by the privately owned TV channel Яetequattro during the film *Peyton Place*. During the eighties, Italy saw a prodigious growth in the number of commercials produced, following the demise of public monopoly of TV broadcasts (1976). In 1985, the 69,000 commercials broadcast by the Italian TV Яai company hardly registered compared with the 700,000 commercials broadcast by the private networks. In the same year, Federico Fellini produced a provocative series of parody commercials to interrupt his film *Ginger e Fred*: Scolamangi diet pasta; Adessosì with spoon incorporated; Ghiottolino, a dessert to suit all tastes; Trippetta mia, the choice of Martians; Uèèè!, a liqueur that brings the dead back to life and Dante, a watch with an incorporated compass to save you from getting lost in a dense forest.

Cyberpunk ¬ At a time when the most potent viruses affected a maximum of 6,000 computers, the image of the hacker changed during the eighties. It was the end of the era of techno-geeks with glasses and long hair, using apprentice wizard names in code. Nights were no longer spent poring over the dim glow of liquid crystals, poking around in computer networks. The modern hacker was a cyberpunk. As the twenty-year-old Californian Synergy recounted in the monthly *20/20* in 1989, this new hacker possessed an entire system of values, was politically anarchic, and was a guardian controlling information flow in order to guarantee individual liberty.

Dark ¬ The gothic variation of <u>punk</u> was broadened by the influence of the <u>new romantic</u>. Black was predominant, with fishnet tights, pointed boots, painted nails and pencils to contour the eyes, and colored eyebrows and lips. Hair was raven-black, worn razed at the nape of the neck, with the odd backcombed tuft hanging over the forehead. Яosaries hung from the neck, while crosses were tattooed onto the body or worn in one of the various holes pierced in the ears. Darks went dancing to DJ Hamish McDonald's music in London's Batcave; they listened to Bauhaus, the Cocteau Twins, The Cramps, The Cure, Sisters of Mercy, Specimen; they read Edgar Allan Poe and Bram Stoker's *Dracula*; they watched horror films and old TV series of the Addams family. Dark wave had specific models (like the sepulchral, visionary Siouxsie Sioux) and specific martyrs (Ian Curtis of Joy Division).

Decoration ¬ The art critic Francesca Alinovi wrote in 1982: "It is both revivalism and the future, history and anti-history. Decoration abolishes dichotomies, overthrows hierarchies, rearranges and equates the valences of art and non-art, the prerequisites of novelty and tradition, the force of the future and the evocations of the past. Decoration stands for good times, pleasure, joy, the world of art. It does not retreat in the face of mass opinion. Decoration conceals nothing."

Designer mania ¬ The universe of fashion design and the personality of the fashion designer were tutelary deities. Fashion designers were not a media creation because, as the industrialist Marco Яivetti explained, "they cannot be invented." Nevertheless, the eighties aided and abetted the cult. In 1983, the fashion editor for the American magazines *WWD* and *W* (Fairchild Publications), Etta Froio, explained: "Our fashion designers, who up until ten years ago were considered to be simple labels, are now recognized to be as famous as entertainment stars. Everyone recognizes their faces, and when Calvin Klein or Яalph Lauren go to the airport, people stop them to ask for their autographs." The powerful editor John Fairchild is to be believed when he says: "We were the first to write respectfully about the fashion designers, to tell the story of how they live and what they do." Яather than bore the public with interviews that all read the same, the fashion designers' personalities were detailed instead, cocooned in a "natural" habitat. Valentino appeared on his yacht with friends, Giorgio Armani and his tan were shown off in his refuge on Pantelleria, the cowboy Яalph Lauren on his ranch, while Karl Lagerfeld sat among his Memphis furniture in his flat in Monte Carlo and Gianfranco Ferré, artistic director for Dior, in his private jet.

Devolution ¬ Totally unrelated to the decentralization of administrative power that we talk about nowadays, devolution was the regression of human beings to the state of "spuds" (potatoes), a theory made famous by Devo at the end of the seventies. From the top of the charts the five musicians from Akron, Ohio, sporting plastic yellow overalls, evoked the deprogramming of humans from wild emotions and liberty. Devolution placed its trust in a new and happy humanity, free of the cult of the individual and the myth of the superhero. As Ernesto Assante wrote in the magazine *Musica 80*, hypothesizing about a chance encounter between Devo and Goldrake, "If anyone can do away with him, let's hope *they* can."

Duster coat ¬ It didn't make you hot because it was very light, and often wasn't even waterproof. Long, floppy, unlined, <u>black</u> or brightly colored, the duster was popular because it transformed the body into a silhouette.

East ¬ Mikhail Gorbachëv's perestroika (reorganization) and glasnost (transparency) marked the end of the cold war between the US and the Soviet Union and announced the fall of the Berlin Wall (1989). As the Soviet era came to an end, the West celebrated the happy ending of the eighties, with fashion commemorating Яussia's embroi-

dered folklore and gilded icons. There was also pro-Soviet nostalgia, revealed at the cinema with the international success of Aki Kaurismäki's film, *Leningrad Cowboys Go America* (1909). Smirnoff vodka was all the rage; red stars and Lenin were rampant on T-shirts and badges; fur hats, Vostok and Яaketa watches abounded. Jean-Paul Gaultier's Яussian collection (1986) was inspired by the geometrical severity of constructivist <u>avant-garde</u> and anticipated the trend for Cyrillic letters. Still in 1986, the eclectic comic-strip author Igort established the Slava Trudu Orchestra, recounting the adventures of the cosmonaut hero Yuri Gagarin, set in a future time with a rétro flavor. In 1984, the band CCCP Fedeli alla Linea was faithful to the party "even when it doesn't exist," cut *Ortodossia* and sang about a Europe that wanted to remain hidden or that was quickly forgotten. "Punk Islam" recited "Allah is great," and "Live in Pankow" celebrated the governing officials of the DDЯ in East Berlin: "I want to hide away under the Warsaw Pact / I want a five-year stability plan / Live in Moscow live in Budapest live in Warsaw / Live in Sophia live in Prague live in Punkow / Ost Berlin - West Berlin."

Electric-electronic ¬ Electric colors visualized a new zeal for artificial life. They took form in <u>zigzag</u> lines and revealed themselves in mascara and electric-blue eye shadow. The dialogue between the human and the technological was intensified through the contribution of electronic technology. Electronics were an extension of the brain for Laurie Anderson; during her performances she implanted dream-like visions that learned how to take control of machines. The artist Stelarc covered his body in electrodes and adapted his way of living with technology to the extent that he modified his very way of living and learning. From 1979 the international festival Ars Electronica in Linz was dedicated to the interaction between the technology of art and the technology of man, and in 1986 La Cité des Sciences et de l'Industrie opened in Paris. The word "electronic" became dated by the end of the decade, both in terms of music and art: electro gave way to techno music and the Ars Technica association started up in Paris in 1989.

Ephemeral ¬ A self-consuming collective rite. Temporary by definition, the short-lived demonstrated itself in the form of a cultural event or festival. Nighttime was the ideal setting for the ephemeral: nightclubs opened and closed, abruptly changed their names, their décor, their clientele. In London, the Palace was renamed Helden on Thursdays only, when Steve Strange managed the club. In Italy, the legend of ephemeral baroque was revived, and the Venice Carnival started up again in 1980. Still in Venice that same year, the temporary structures of the Strada Novissima tackled the theme of the identity of the <u>postmodern</u> city at the first ever Biennial of Architecture, directed by Paolo Portoghesi. In an almost situazionist climate, Яome regained possession of the urban environment with the Яoman Summers of the then Яenato Nicolini. The city

acquired a superficial charm and became a theater where "we are able to communicate through moving, ephemeral structures," according to the architectural designer Andrea Branzi in 1981. Fashion was a metaphor for the new city: it was as "short-lived as a Kleenex" (Christian Lacroix, 1990).

Extravagant ¬ Someone said the eighties began in London. Bearing in mind the decade's taste for all things excessive, eccentric and spectacular, he or she was undoubtedly right.

Fashion show ¬ The highlight among social events, charity balls and art openings. They transformed into theatrical plays for Vivienne Westwood and Body Map; they took on a stadium-like dimension with 6,000 participants at Thierry Mugler's Paris show in 1984. Ticket touting and the hunt for new locations intensified: Trussardi chose Central Station's platform in Milan, while Valentino went for the setting of the Metropolitan Museum in New York. Giorgio Armani also sought an alternative to the classic fashion show, and presented his 1983 collection on videotape. Models without <u>makeup</u> appeared one by one and walked in a trance along the catwalks of Yohji Yamamoto and Comme des Garçons, while Gianni Versace helped to nurture the phenomenon of the <u>supermodel</u> with his shows. From an anthropological point of view, the catwalk machine became a self-referential game, and even the audience became involved as objects to be observed and photographed.

Fashion victim ¬
Fashion! Turn to the left
Fashion! Turn to the right
Oooh, fashion!
We are the goon squad and we're coming to town
Beep-beep
Beep-beep.
David Bowie, "Fashion," 1980

Fitness ¬ Life expectancy increased – and the waist line decreased – providing one simply found time to jog, have a sauna and enjoy a massage or meditation session, and kept to a healthy diet, had a positive attitude towards life, attended a well-being center near home, and perhaps spent a week or so at the odd beauty farm, always with a good book at hand. Books dedicated to keeping fit stayed permanently at the top of the best sellers' list in the eighties: *The Beverly Hills Diet* by Judy Mazel, *Eat to Win* by Яobert Haas, *Fit for Life* by Harvey and Marilyn Diamond.

Flex appeal ¬ *Flex* is the name of the monthly magazine that has been the Bible of hardcore <u>bodybuilding</u> since 1983, and is the official house organ of the IFBB (International Federation of Bodybuilders). "Flex Appeal," like the book penned by Яachel McLish,

American athlete, but also model, actress and winner of the first edition of Miss Olympia, the international female bodybuilding competition. With not a shoulder pad in sight, women too joined the ranks of professional bodybuilders.

Fluorescent ¬ The epic fluorescent day-glo colors designed for ultra-violet lights and perfect when partnered with black. Orange, yellow, green and fuchsia: Elio Fiorucci was always partial to them, and they became the luminous sign of the fashion designer and artist Stephen Sprouse. The Lycra of bike shorts invaded the streets at the end of the decade.

Gadgets ¬ The bibelots of the eighties.

Graffiti ¬ The iconography of the hip-hop generation. At no cost to local government funds, entire cities got a whole new facelift thanks to the media of graffiti, writing and tag (in New York, Jean-Michel Basquiat preferred the Metro's Central D line to his own home in Brooklyn). Initially wanted by the authorities for their unlawful operations, and subsequently pursued by art gallery owners, the best-known writers were also "designers" of fashion. Futura 2000 produced unique works of graffiti for Levi's (1984), Keith Haring collaborated with Vivienne Westwood (1983) and Swatch (1986), and was also literally cited on designer Enrico Coveri's sweatpants in 1985. Meanwhile, the writer Shawn Stüssy transposed his tag onto a range of clothes at the beginning of the eighties, starting off by clothing the surfers of Laguna Beach in California.

Griffe ¬ It means the fashion designer's signature, but the word has a better ring in French. Maybe because *la griffe* is French for claw, and because everything seemed to come into the fashion designers' clutches during this decade. The term ran rampant in Italy, tamed down into the Italian "griffare" (to sign) and "griffato" (signed by a designer): hence Versace underwear, Venturi jeans, Ferré bathing suits, Coveri sunglasses, Trussardi lighters, Lancetti sheets, Armani telephones, Krizia cookers, Missoni rugs, Valentino tiles.

Hip-hop ¬ As Afrika Bambaataa, one of hip-hop's first ambassadors, was to say: "Hip-hop means the whole culture of the movement. When you talk about rap you have to understand that rap is part of the hip-hop culture. That means the emceeing is part of the hip-hop culture. The deejaying is part of the hip-hop culture. The dressing, the languages are all part of the hip-hop culture. So is the break dancing, the b-boys and b-girls. How you act, walk, look and talk is all part of the hip-hop culture." (http://www.daveyd.com/whatisbam.html).

Hi-tech ¬ Architects weren't very fond of this phrase, and the Frenchman Jean Nouvel didn't think much of it either. Likewise, fashion designers weren't wild about it, and converted hi-tech into hi-touch: there was less concern with demonstrating technology, and more attention given to interactivity and the relationship between object and consumer. Nonetheless, hi-tech stayed high on the agenda: for the super-accessorized cars that appealed to yuppies, for items that had integrated functions and for components in carbon fiber. Above all, hi-tech became synonymous with minimalism, used to indicate a rarefied style that ranged from Bang & Olufsen technology for domestic entertainment centers to umbrella stands in glazed aluminum. Black shelves adorned sterile white walls; subtle halogen lamps stood next to black leather sofas and on industrial black rubber floors. Dieter Яams, head designer for Braun, explained that in hi-tech terms matt black was not a religion but a magical mantle (*Arena*, 1987). In opposition to postmodern decorativism, hi-tech recreated the myth of a stylistic universalism: Japanese rarefaction, the European cult of rationalism and American primary structures. From the office to home, hi-tech style also extended to clothing. The clothing ranges designed by the couple Marithé and François Girbaud were defined as hi-tech, together with the sharp silhouettes by Parachute, a brand invented by another famous couple, Nicola Pelly and the architect and designer Harry Parnass.

Imitation ¬ The escalating diffusion of imitations moved the universe of fashion designers and top brands ever closer to science fiction. Among the species, it was possible to distinguish clones whose copies were faithful to the originals, and mutants that were formed by grafting the sacred names onto widely distributed objects, like the C of Chanel affixed onto baseball hats. Meanwhile, the alien species that Franco Moschino circulated belonged to the realms of pure make-believe, as illustrated by his "Channel N° 5" T-shirt and prints reproducing Louis Vuitton's motif, replacing LV with M.

In/out ¬ Fashion's *in/out* classifications were scrutinized in the same way we attentively read our horoscopes, check the Top 10 Hit Parade and follow the ups and downs of the stock market. *Ins* and *outs* did not dictate laws set in stone, but served to keep you tuned into the most up-to-date news. Every month saw "the hottest ideas to adopt" and "attitudes to die for," appearing, for example, in the Italian magazine Яockstar, whose Style column was headed up by Яoberto D'Agostino. His list of what was in and what was out revealed a cross section of the "key trends" in November 1983. For him: buttoned white shirts, greatcoats and overcoats, close-cut hairstyles, glasses with black frames. For her: lace-up boots, nun-like smocks, crew cut or geometric hairstyles, black chador and blood red lipstick. For both sexes: wine out of a can, having dinner at home and then going out, taking your time, owning a Vespa, Lambretta or Spider, books on image, martial arts, graffiti.

Italian style ¬ The ever-increasing success of "Italian

style" has been a hot topic since the fifties. Can its success be ascribed to quality and technical ability? Or is it a question of good taste inherited from times gone by? Is it Mediterranean sensuality and a baroque taste in <u>decoration</u> that does it? Is it their ability to renovate the myth of classical elegance that makes the difference? Or does the key to success lie in the organization of production, in the creation of a family-run industrial model and in efficient promotion on an international scale? The miracle of the eighties lay in making all of the above converge into an icon of national identity.

Japan ¬ Japan was rarefied and spiritual when it came to martial arts, Japanese restaurants, futons, Яuichi Sakamoto's (and David Sylvian's) music, the clothing ranges of Kansai Yamamoto, Issey Miyake, Yohji Yamamoto, Яei Kawakubo and the Koshino sisters; it was hyper-technological with regard to Seiko's top-notch televisions and Sharp's portable computers; it was cyber and theatrical in the accelerated fixity of the film *Tetsuo* by Shinya Tsukamoto (1989) and in the confusion between geisha <u>makeup</u>, ideograms, head bands branded with the rising sun and hairstyles inspired by Pris (the blonde clone in *Blade Яunner*). As Japan metabolized the West, it simultaneously imported a new approach to pop composed of video games, manga and karaoke.

Legwarmers ¬ Worn at dance and <u>aerobics</u> classes, but not only then. Colored woolly legwarmers reached halfway up the thighs and were worn with short skirts and boots or flopped down over pantyhose and low-heeled shoes.

Look ¬ The look ruled supreme in the eighties. What counted with the look was the emotion experienced on sight of it. Clothes lost their importance because they were a digression away from the represented body on show, which knew it was being observed. Stars were only too well aware of the attraction of visual power, as were those who looked after their image: take Madonna in the early eighties and her sacred/profane image dreamed up with Maripol, Fiorucci's art director.

Luxury ¬ Luxury for the media meant teased hair, face-lifts, clanking yellow gold jewelry and sequined evening-wear. For fur, mink and sable were farm-bred, but wild animals appeared on Krizia's knitted garments. Leather went up-market with a crocodile effect, and <u>stretch</u> velvet slinky dresses had leopard and zebra stripes on them. Luxury led fashion to revisit the past, and the best-loved centuries were those that were rich and bombastic. It 1982, Gianni Versace was described as <u>neobaroque</u>, even before the term became part of the language of the decade's cultural theory. In 1986, Vivienne Westwood's "ringlets" revived nineteenth-century nostalgia, together with her plastic hoops.

Made in Italy ¬ Textile and clothing revenue tripled, wood furnishing sales increased almost seven-fold. All this took place in Italy between 1981 and 1991, when prêt-à-porter, designer furniture, sports cars and foodstuffs – in other words, *made in Italy* – were established to be absolute <u>musts</u> on the international markets.

Make-believe ¬ "By openly declaring falseness, no untruths are told. Producing and utilizing science-fiction is a stimulating way of creating 'neo-commodities' whose actual, technical and literary data can be freely interpreted with an artistic attraction free of demonstrative predetermined rules; which is precisely why the designers were preceded on TV by Special Agent 007." (Denis Santachiara, 1985)

Makeup ¬ Since time immemorial, touching up your makeup in nightclub bathrooms has always been a way to transform yourself, to prepare your nocturnal image for public exposure. "Oh my visage": the deliberate use of makeup as profound parody, as homage to <u>artifice</u>, and as a play on the ambivalence of sexuality, was linked to nostalgic trends such as the new dandies and the <u>new romantics</u> that inaugurated the decade. The use of cosmetics was not restricted solely to nightclubs, but applied itself to all "forms of the cosmos," as the Italian designer and architect Alessandro Mendini said in 1982. "When I design, I believe everything I am capable of doing already exists, that every new design is always merely 're-designed,' that all forms of the cosmos belong to a never-ending flux of 'universal cosmetics': glittering powder, fine dust, illusory matter on the body, clothes, objects, buildings, the world."

Melting pot ¬ This signified the more altruistic side of globalization for those who believed in the cultural overcoming of barriers and differences. Manuals were produced on international etiquette, warning us not to ask the Chinese rhetorical questions, informing us that in the Arab world "cutting off one's moustache" signified disgrace, while expressions like "you must be mad" were deemed offensive by the Congolese or inhabitants of the Ivory Coast. The February 1988 edition of *i-D* magazine was entitled *Going Global!* It talked about Japanese street fashion, "global club gossip," Shades of Bold and Whacky Chicken, explaining that this did not refer to Indian takeaway, but to hairdressers whose hairstyles were inspired by tribal African decorations. The construction of metropolitan syncretism referred to new citizens of the world who applied <u>graffiti</u>, tattoos and shaved heads to art, plaits and extensions. The Mali fashion designer Xuly Bët (Lamine Kouyate) launched the Funkin' Fashion Factory in Paris in 1989, deliberately cutting up clothes in order to piece new outfits together again. In 1987, we started talking about word music, and the decade ended on a note of passion for Latin

music, the ultimate melting pot with its African, Spanish and American rhythms.

Messages ¬ Messages and counter-messages no longer traveled by bottle, but were blazoned onto walls and items of clothing. After the transformation of leather jackets into mobile blackboards by punks, codes were diffused and confused. In 1982, Jean Charles de Castelbajac printed La Fontaine's poetry onto silk tunics and Oliviero Toscani revolutionized the Benetton brand with the ecumenical "United Colors" message, replicated by Americanino's "United Workers." In 1984, Katharine Hamnett dispatched political-social messages with her boiled silk T-shirts declaring "stop war," "stay alive in 85" and the magnificent "58% don't want Pershing," worn by the English fashion designer for her meeting with Margaret Thatcher.

Metal ¬ The only way to drown out the whining drone of new wave electronic keyboards was to shut yourself up in a room with a heavy metal record at top volume, wildly mimicking a solo guitar performance. Ardent believers in the cathartic violence of really heavy rock wore tattoos, hippy-length hair, leather biker clothes, studs and S&M chains, and exhibited mementos of AC/DC, Mötley Crüe, Ozzy Osbourne Band, Van Halen and W.A.S.P. According to the initiated, heavy metal was the language of a body immune to fashion. Whereas fashion was interested in the aggressive emblems of metal strength, like the skulls and studs that Katharine Hamnett scattered throughout her 1989 winter collection, headed up with the tough ecological message of "Clean Up or Die."

Minimal ¬ This bare phrase used by Raymond Carver to describe the emptiness of everyday life paved the way for the minimalist literature of Jay McInerney, David Leavitt and Bret Easton Ellis. Fashion's maestros were the Japanese fashion designers, held in such high regard by the Six from Antwerp (Dirk Bikkembergs, Ann Demeulemeester, Walter Van Beirendonck, Dries Van Noten, Dirk Van Saene, Marina Yee) as well as the Italian Romeo Gigli in the second half of the eighties. It was during this period that minimalism became synonymous with austerity, reduction, elimination of the useless, often seen as the antithesis of narcissistic, golden luxury. But there is another definition that shows how minimalism and luxury were not antithetical. According to historian Christopher Lasch (1984), a "Minimal Self" existed at the heart of both. This was expressed by those adhering to minimalist esthetics through a process of reduction of subjectivity and the role of the interpreter. The Minimal Self also appeared in the semblance of narcissistic luxury, intended not as the delirium of individualism and a vain affirmation of self, but as abdication to a sovereign Self in order to blend into the shimmer of the universe.

Movida ¬ With General Franco's death in 1975, Spain entered a phase of political transition and the fledgling democracy came to be identified with the cultural movement baptized as movida. The desire for a new beginning was manifested in a euphoric conception of daily life, like the artistic hyperactivity centered on the cinema, music, comic strips, fashion and design. Those unable to physically take part in the pandemonium of the nightlife in Madrid and Barcelona could get a taste of it from Pedro Almodóvar's films, told in "movida style." The youthful Sybilla with her sentimental garb emerged on the fashion scene, together with Pedro Morago, while The Face defined Antonio Alvarado as a flamenco Gaultier. Thanks to movida, an open mind towards new things and a young-spirited vocation formed Spain's international image. It was not a coincidence that Barcelona was chosen to host the first edition of the traveling Biennial for young artists in Europe and the Mediterranean in 1985.

Multiethnic ¬ Used to express the French equivalent métissage (interbreeding) and the English melting pot, multiethnic was a less effective term that described the dynamic process of a crossing over, a contamination and a fusion between different cultures.

Multimedia ¬ This new word on everyone's lips proclaimed the technological thrill derived from the simultaneous use of different media. Fantastic brand-new frameworks formed staggering backdrops for videos and computer art, while the boundaries separating different professions vanished. The musician Brian Eno experimented with "video-painting" and light-and-sound sets; and Memphis postmodern design was mirrored in the video installation Luci di inganni by Studio Azzurro (1982).

Music videos ¬ The distorted, metallic voice of Buggles said it back in 1979: music will always be more geared to television than to radio. But it was only on 1 August 1981 that the successful song "Video Killed the Radio Star" was selected by the brand-new American network MTV as the battle cry to inaugurate a different trend in music videos. Instantly celebrated as an original way to promote and communicate art, music TV arrived in Italy in 1984 with VideoMusic: no longer merely sound, but an explosion of images and vertiginous movement, it was also inspirational for "updating one's look."

Musts ¬ Just like status symbols, there were a whole host of musts to be desired, worn and inhaled (the Must de Cartier fragrance was created in 1981). There are those who religiously followed them, those who claimed to detest them, and those who amused themselves by inventing new ones. As we read in i-D in 1983, "bright nylon negligées and fluffy slippers are a must."

Neobaroque ¬ The eighties are renowned for aesthetic pleasure and self-declared neobaroque tendencies. The definition of neobaroque proposed by the semiologist

Omar Calabrese in 1987 corresponds to a taste for the optional and for the turbulent inconstancy of forms. These fragmented, distorted, unstable and wantonly complicated forms symbolize the paradox of an aesthetic singularity available to everyone.

Neon ¬ When it was black (wood lamps), it illuminated the fluorescent colors in the darkness of nightclubs. Pink and blue neon tubes reflected the *Happy Days* atmosphere of the optimistic fifties revival, with its jukeboxes, drive-ins and fast food. The contemporary landscape was literally lit up by a riot of neon lights above motels, fairgrounds and casinos in the wake of a Las Vegas recounted by architects Robert Venturi and Denise Scott Brown in 1968. Neon now moved from the "strips" of Las Vegas to the "sprawl," the metropolitan margins from Boston to Atlanta skirted by pathetic, dust-ridden, lifeless signs of neon. This was the location for *Neuromancer* (1984), the novel by William Gibson, which shows cyberspace as a network of holographic settings and skies "the color of television, tuned to a dead channel."

New romantic ¬ Something different from the punk movement started to evolve in London towards the end of the seventies under Rusty Egan and Steve Strange, the promoters of "Bowie Nights" and later the Blitz Club. To begin with, there was talk of a "cult with no name" phenomenon, possibly because one of the street styles was the one most committed to the culture of appearances and was less interested in the promotion of an ideological message. This anonymity did not last long, and at the beginning of the eighties the phenomenon was established on the international scene as "new romantic." Music's disciples were Spandau Ballet and Adam and The Ants; in fashion, Steven Jones invented hats for the movement, Vivienne Westwood and Malcolm McLaren dedicated their Parisian collection in March 1981 to the "pirate" look, and in the same year the fashion designer Scott Crolla opened up shop in London. New romantics evoked past times, mixing up the medieval, the nineteenth century and the Hollywood style of the thirties: long satin dresses, jabots and boots with gilt buckles, damask, long sideburns and beribboned ponytails. Paisley fabrics, harem veils and jewels all formed part of an exotic vision of colonial times, further underpinned by the idea of rapacious plunder symbolized by the pirate.

New wave ¬ In 1980, in the guise of music critic, Franco Berardi (Bifo) wrote from a New York apocalyptic with rival bands and abandoned buildings, "seen from here, new wave . . . is a bit like a touristic sham." Seen from Italy, the author Pier Vittorio Tondelli was to write in 1987 that new wave was the response to "Milanese despondency about the myth of professionalism and yuppiedom." Aside from music, there were the fashion shows and trendy designers, the theater of the Magazzini Criminali, the computer art of the Giovanotti Mondani Meccanici and the night performances organized by *Westuff*. It all happened in Florence, which Tondelli described as "the true Italian capital of those bright, arty and eclectic eighties years."

No wave ¬ Amid the stormy seas of musical trends, the no wave theme was at the opposite end of the spectrum of the more moderate new wave. "No" as in nihilism and alienation, "no" as in the record *No New York* produced by Brian Eno in 1978 containing pieces by four groups from the East Village: James Chance & The Contortions, Teenage Jesus and The Jerks (with Lydia Lunch), Mars and D.N.A.

Paninaro ¬ For Italian "paninari," identification of an item of clothing with its brand was absolute. The jacket had to be Moncler, with argyle socks by Burlington, yellow leather lumberjack boots by Timberland, belt by El Charro, sunglasses by Ray-Ban, Naj-Oleari satchels patterned with toys, trees and pencils and sweatshirts by Best Company. *Sfitinzie* (trendy girls) and *tostoni dalla faccia vitaminica* (healthy-looking boys) talked and acted according to "pan-look" rules, encouraged by comic strip magazines like *Il Paninaro* and *Cucador*. After the opening of the fast food chain Burghy in Piazza San Babila in the Milanese epicenter in 1985, the phenomenon spread rapidly and took on an international flavor. The English duo Pet Shop Boys released "Paninaro" in 1986, an homage to sex, cash, food and fashion designers.

Polaroid pictures ¬ Andy Warhol loved them because they were easy to use and literally brought famous people to the surface. Many others used them for poaching images of nightclub goers. Fragments without a past or a future, Polaroid pictures formed part of an unstable and instantaneous graphic design confirmed by magazines like *i-D*.

Post ¬ Postindustrial, post-communism, post-feminism . . . The decade's obsession with all things post marked the precise time when the present no longer seemed to actually have its own name. Posts multiplied and formed a new unit for measuring fashion and designers who returned with postmodern, post-atomic, post-political, post-punk and post-casual.

Post-atomic ¬ The fight against nuclear centers and atomic weapons was the order of the day: demonstrations were held, the environmentalist movement grew in strength, The Clash sang of "nuclear error" in their *London Calling* album (1979), films like *The Day After* (1983) and *Threads* (1984) were made, and Italy celebrated the closing down of its nuclear centers as voted in the people's referendum in 1987 (which came the year after the disasters in Chernobyl). In 1983, fashion journalism talked about a post-atomic style, about the day-after look and about chic apocalypse. That same year, Mr. Gaither wrote a letter to *Vogue* asking the

magazine not to over-emphasize the topic because – as the fashion historian Harold Koda recounted – he was tired of watching his daughter tear up the bed sheets at home in an imitation of Яei Kawakubo's collection of ripped garments.

Postmodern ¬ For Jean-François Lyotard, this was "whatever is subtracted from the consolation of good practices" (1986), and for Linda Hutcheon it was "like saying one thing and at the same time putting commas before and after what is said" (1989). Umberto Eco thought of postmodern attitudes "like someone who loves a very cultured woman, and knows that he can't tell her 'I love you desperately,' because he knows that she knows (and that she knows that he knows) that these words have already been written by Liala" (1983). Postmodern was also a style, or rather the parody of a style (de)constructed by cutting, pasting, combining and quoting. The design group Memphis pursued a new iconography based on strident colors and plastic laminates that was "bacterio" (Ettore Sottsass), "micidial" (Michele De Lucchi) and "craquelé" (Иathalie du Pasquier). Memphis declared in 1981 that the furniture would "soon go out of fashion," but before this happened, vermicelli, arrows and splashes of color invaded the graphic designs and clothing of the decade.

PЯ ¬ In terms of Italian prêt-à-porter, Beppe Modenese was the spiritual leader of the PЯs emerging in the profession in the eighties. In Italy, PЯ did not only stand for experts in public relations, but also for the promoters from whom clubs took their cue, and who were the new catalysts.

Preppie ¬ It was not necessary to have an Ivy League education to be a preppie. The respectably dressed upper-class preppie look of Аmerican students indigenous to the university élite started to spread through Europe at the end of the seventies. It was the ideal look for teenagers yearning for a yuppie career: the girls wore kilts, blouses, round-necked Shetland wool sweaters, white socks and loafers; the boys had short hair and wore corduroy pants and pastel-colored polo shirts or round-necked sweaters.

Punk ¬ Punk belonged to everyone, but at the beginning of the eighties there were still controversies about its origins. Its visual appearance was at the heart of the dispute, more than the music itself. Which was the first group to rip its clothes off on stage? Who first assembled the look of clipped hair, fifties jackets, thin, pointed ties, safety pins and anti-system slogans on T-shirts? From Иew York, Яichard Hell claimed that the group Television and the magazine *Punk* were the forerunners; Berlin meanwhile incarnated the very soul of political punk, and London celebrated Vivienne Westwood as the queen of punk plus

fashion and S&M because, as Malcolm McLaren said, "If punk was just about music this thing would have died years ago."

Яap ¬ In hip-hop terms, this was the rhythmic monologue rapped out by the emcee (MC as in Master of Ceremony).

Яemix ¬ Яemix lent a new stylishness to an already recognized melody. Producers, DJs and musicians all recognized that good remix records made people buy and made them dance. From musical slang, remix extended to the culture of appearances, and demonstrated how dressing can also be re-composed.

Яoyal family ¬ The monarchy enjoyed a new revival thanks to the princesses of the eighties. The Kingdom of Fame was crowded with images of Stephanie and Caroline of Monaco, and everyone got the princess of his/her dreams with Lady Diana. Consort to the heir to the throne and adored by the ethnic minorities, she showed herself to be elegant, an outsider, fat or sexy. Mass participation in Diana's life began with her wedding in 1981 and the slogan "Don't do it, Di."

S&M ¬ Black was not only the dominating color, it was also the color of S&M domination for leatherwear, rubber, PVC and accessories like handcuffs, collars, zips and chains. From sex shops to punk and including club culture, S&M also became a fashion trend with dominatrix females dressed in Claude Montana's black leather, Аzzedine Аlaïa's sexy lace-up corsets and the studded, chain-bearing bags of Piero Guidi's Bold line.

Safe sex ¬ There were new prophylactics for men and new sheaths for women in polyurethane. Boy George declared a total lack of interest, given that, "I'd rather have a cup of tea than go to bed with someone."

Scratching ¬ Аll the basic instruments DJs needed to manually produce the sounds of scratching on records using their fingertips: two direct drive turntables, two slip mats to slide the records backwards and forwards, a four-channel stereo mixer and headphones for pre-listening. "On the wheels of steel," scratching was the prime (sound) track of hip-hop culture and the crucial factor that transformed DJs from producers into composers.

Simulation ¬ Semiologists debated simulative systems and signifying-signified simulation; philosophers reasoned the fictitious reality of simulacrums; CАD techniques of three-dimensional modeling abounded. In Иaples, the art of getting by using psychological methods led to the birth of the Ciaravolette – a white T-shirt with a seat belt printed across it – invented by the psychiatrist Claudio Ciaravolo and publicized using the slogan "non stinge, non stringe, non serve, ma finge (It doesn't fade, it doesn't bind, it's useless, but fakes it.)

Status symbol ¬ VIPs and spokespeople received them for free. Everyone else had to get on a waiting list to buy them. In a time of telecommunication transactions and the immateriality of cash, it was the tangible presence of objects that conferred social status or aspirations, ranging from Montblanc fountain pens to Jacuzzi baths, from Tod's shoes to Яolex watches.

Street style ¬ Λfter the theorist of "subcultures" Dick Hedbige linked <u>punk</u> style with the ethnicity concept in 1979, the ethnographic look became inseparable from the concept of street style. This new urban ethnography lent a perceptive dimension to the metropolis, revealing the presence of youthful "tribes" and "magic" codes dictating clothing, music, language and graphics. The street was seen to be the place where fashion trends were expended, where meaning was produced and where cultural inter-preters of what was new operated. The street was also the bridge linking urban styles with the fashion "tribes" issu-ing forth from the fashion designers' pens every six months.

Stretch ¬ It was the invasion of elastomers. Pure Lycra for leotards, leggings and bike shorts like those worn by Madonna tripping through Manhattan in 1988. Cotton, silk and wool mixed with Lycra to emphasize the body's shape in close-fitting suits, seamless clothes that clung and underwear by Иikos and for Versace's Progetto Λnatomia.

Styling ¬ It is difficult to embody a concept of style, which is where the profession of the stylist came in. His or her job is not only to place bodies and objects at the service of fashion, but also to imagine ideal settings that are recog-nizable or identify change. Two of the best-known names were Яay Petri (Buffalo) who worked for *The Face*, *i-D* and *Λrena* and Judy Blames (the pseudonym of Chris Barnes) for *Vogue* and *i-D*. The ability to visualize new styles depended on the dualism of styling and photography, but in addition there was a return to the imaginative strength of illustration. Fashion features for *Vanity* magazine were illustrated by the designs of Lorenzo Mattotti, Stefano Canulli, Яobert Wagt, Christopher Bruce or the etchings of François Berthoud.

Supermodels ¬ The Grévin Wax Museum in Paris cele-brated the supermodel phenomenon with statues of Иaomi Campbell and Claudia Schiffer. Walter Benjamin, that philosopher of the fetishistic "sex-appeal of the inorganic," would have been thrilled, having writ-ten back in the thirties that "no other form of immortal-ization troubles so deeply as that of the <u>ephemeral</u> and the forms of fashion that wax museums preserve for us." He would no doubt also have appreciated the Barbie of supermodel Cindy Crawford produced by Mattel.

Surfaces ¬ Quite possibly the most important formal characteristic of the whole <u>postmodern</u> movement. Λs

critic Fredric Jameson wrote in 1984: "The world thereby momentarily loses its depth and threatens to become a glossy skin, a stereoscopic illusion, a rush of filmic images without density. But is this now a terrifying or an exhilarating experience?"

Sweatshirts ¬ Even the classic gym-gray sweatshirt would do, provided the neck opening was wide enough to display one shoulder, like Λlex in the film *Flashdance* (1983). The sweatshirt took on a whole new look as it stepped out of the gym and into the street with its bright or pastel-colored shades, sharp cut with visible stitching and <u>asymmetrical</u> forms, and flounces and embellishments à la Иorma Kamali.

Timekeeping accessories ¬ They still told you the time, but they could no longer be called watches. With the plastic Flippers of the seventies and above all the arrival of Swatch in 1983, watches became fashion accessories. They were brightly colored, and you changed them with your clothes and your moods; they were short-lived but could be collected; they were uni-sex and never, never digital. Swatch models were the most heavily imitated: from Benetton's Time of The World by Bulova to Le Clips, which could be worn "anywhere except on your wrist."

Total look ¬ Total look as profession of faith in the fashion designer and his/her ability to design a coor-dinated style. One dressed from head to toe in single-designer – or mono-brand – shops, where what count-ed with the total look was the expression and not merely the content. But the eighties were also open to criticism of the total look's self-referential fundamen-talism, as Franco Moschino explained in 1984: "We haven't yet examined . . . the problems involved in dressing the body of every individual person: we throw onto their backs these packages, these perfect uniforms that we've come up with in our studios."

Trans ¬ Fashion would not exist were it not for trans-sexualism and transgression. There were material manifestations such as the donning of masks, the mag-ical charm of mirrors, the exploration of sexual differ-ences. On one hand, Jean-Paul Gaultier introduced high heels, skirts and fishnet stockings in his male col-lections; on the other, Christian Lacroix proclaimed that his most elegant customers were Иew York drag queens. Trans literally tripped through the eighties. In Иew York, Divine was a large-scale Mae West with a huge following. In London, Leigh Bowery provocative-ly metamorphosed his body. In Italy, the singer Λmanda Lear went for ambiguousness and announced in the monthly *Lei*: "People should be able to say: 'I'd go for that Λmanda Lear' . . . and dream."

Trash ¬ "'Bellissimo!' she exclaims, leading us into an all-pink room straight out of the Barbie catalogue.

Everything is brand new, spotless, toylike. Cicciolina curls up on a shocking pink sofa, kicks off her white heels, and simpers through thick pink lipstick. She clutches her crotch a large white fluffy animal, and sets the agenda with 'I'm not wanking you know; I'm holding it here so you don't see my fanny . . . I never wear panties.'" When *The Face* interviewed Cicciolina (Ilona Staller) in her apartment in Яome it was 1987, and the porn star had just recently been elected to the Italian Parliament. Pornography, kitsch furnishings, theatrical politics and media were the ideal ingredients for cooking up a *trash* dish. The icing on the cake came with the marriage between Cicciolina and Jeff Koons, former Wall Street broker and celebrated artist.

Trends ¬ Indicated a positive inclination towards an avant-garde culture and, together with the adjective trendy, it was one of the decade's key words. *i-D* magazine's sub-header changed from "Worldwide Manual of Style" to "Trendy Fashion Magazine." Italy saw the birth of the Pitti Trend, Contemporary, Иeomoda and Milanovendemoda Studio exhibitions where, as the invitation explained, you could find "all things trendy."

Urban backpacks ¬ The descent of the backpack from mountain to city came about with Mandarina Duck's Utility model and MH Way's technological Impronta line, all rigid and seamless. Prada's nylon backpacks were even worn with fur coats, and Invicta's Jolly line could be seen on the backs of students and Italians on holiday everywhere.

VIP ¬ The rich and famous also got preferential treatment in nightclubs, or at least those furnished with a VIP room. The infamous Pacha in Ibiza welcomed celebrated names in the eighties, including the cast of *Dallas*. Times have changed, even for Pacha's VIPs nowadays, when they attend the "Fuck me I'm famous" parties hosted by the Guetta couple.

Vogueing ¬ The "vogueing" danced in gay Иew York clubs at the end of the eighties took its name from *Vogue* magazine, and involved mirroring the gestures made by supermodels. Λ parody of fashion shows? Λn homage to Pat Cleveland?

Walkman ¬ The launch of TPS-L2 by Sony in 1979 was to change the sound track of everyday life forever. Music penetrated the head just like an idea, shut out the loud confusion of rush hour and restored energy in the gym. Kevin Bacon wore a Walkman around his waist while dancing in *Footloose* (1984) because, as the film's slogan announced, "music is on his side."

X ¬ Futuristic, impenetrable and provocative, X was one of the best-loved consonants: take the Californian punk X; the violent Яanxerox of the comic strips of Stefano Tamburini and Tanino Liberatore (*Cannibale* and *Frigidaire*); the Mad Max series of films; Billy Idol's Generation X; Douglas Coupland's first article on Generation X in 1988; Spandex stretch fabric; Filofax personal organizers; Max Eadrom, Channel 4's electronic presenter; Tenax, the hair-sculpting product, as well as the name of that favorite haunt in Florence and the title of Enrico Яuggeri's composition sung by Diana Est; not to mention xenophobia and the parallel rediscovery of Malcolm X as a symbol of black Λmerica; trans-sex and . . . excess.

Yuppie ¬ If a museum of yuppie culture were to be founded on Wall Street, it would be housed in a prestigious office directly overlooking the cityscape of chrome mirrors. The exhibition would open with some carefully chosen extracts from *The Yuppie Handbook* by Marissa Piesman and Marilee Hartley (1984). It would then open out onto a rich collection already listed by the producer Olivier Stone (*Wall Street*, 1987): Ermenegildo Zegna suits and Salvatore Ferragamo shoes; technological gadgets such as portable scanners, compact disk players, (oversized) mobile telephones, keyboards with incorporated telephones for transmitting stock exchange orders with electronic displays showing constantly moving market prices. Яooms fitted out with saunas, gyms and squash facilities. Paintings by Julian Schnabel and Mimmo Paladino (and also Sandro Chia, Francesco Clemente and Enzo Cucchi). Иot to mention the range of foodstuffs "for upward mobility" invented by Dan Pharo with its Yuppie Chow brie-fragranced popcorn and Yuppie Chardonnay wine.

Zigzag ¬ Zigzag lines interrupt straight lines, confuse the original direction and communicate instability. They were found in the jagged contours of the most electric graphic designs, in the invasion of plastic pendant earrings and in the stairway-ties created by fashion designer Cinzia Яuggeri for the band Matia Bazar (1984). On a different level of complexity, both visual and conceptual, there was Benoit B. Mandelbrot's fractal geometry, and philosopher Paul Virilio's interpretation of it: landmarks in crisis, the logic of interruption, the violation of entire dimensions.

–CHЯONOLOGY ^{1980/1989}

EDITED BY MADDALENA ЯENZI

History and politics —— 6 January / Indira Gandhi triumphs at the elections in India, and is appointed Prime Minister ¬ 24 March / Bishop Romero is assassinated in Salvador ¬ 4 May / Marshal Tito dies in Yugoslavia ¬ 27 June / a DC9 Itavia aircraft explodes in flight over the island of Ustica in Italy ¬ 2 August / a right-wing terrorist bomb explodes at the railway station in Bologna, Italy, resulting in 85 deaths and 200 injured ¬ 22 September / the independent trade union Solidarnosc is established in Poland ¬ Iraq invades Iranian territory ¬ 10-17 October / preliminary discussions begin in Geneva for American-Soviet negotiations regarding Euro-strategic armaments ¬ 5 November / Ronald Reagan is elected President of the United States, receiving 51% of the votes ¬ 20 November / the trial of the Band of Four opens in China.

Events and society —— John Lennon dies on 8 December in New York, assassinated by David Mark Chapman, one of his fans ¬ Studio 54 closes in New York. ¬ A new wave of skinheads group around The Last Resort shop and Petticoat Lane in London: a number of them are pro-nazi and are called naziskins. ¬ The Venice Carnival is re-introduced: 50,000 people don fancy dress and masks ¬ Mattel launches a black Barbie ¬ The video game *Pac-man* is launched on the market ¬ New magazines are launched in London: *The Face* (May), *i-D* (August) and *Blitz* (September) ¬ The magazine *Frigidaire* is launched in Italy.

Fashion —— Giorgio Armani designs Richard Gere's clothes for the film *American Gigolo* ¬ Katharine Hamnett is the first fashion designer to adopt pre-washed silk and to produce unisex sweatshirts and cotton garments ¬ Stephen Jones opens his millinery business in London ¬ The Missoni boutique opens in Paris and Missoni's fragrance is presented in New York ¬ Blumarine makes its début at Modit; Anna Molinari is awarded Best Fashion Designer of the year ¬ Claude Montana founds Claude Montana S.A. ¬ Vivienne Westwood renames her London boutique World's End ¬ The 15-year-old Brooke Shields is signed up for Calvin Klein's jeans advertising campaign directed by Richard Avedon – "You know what comes between me and my Calvins? Nothing" – banned by CBS ¬ The Italian magazines *Donna* and *Mondo Uomo* are launched.

Cinema and television —— Films: *American Gigolo*, by Paul Schrader, with Richard Gere ¬ *Polyester*, by John Waters ¬ *A Rumor of War*, by Richard T. Heffron, with Brad Davis and Keith Carradine ¬ *The Empire Strikes Back*, by Irvin Kershner, with Harrison Ford ¬ *Fame*, by Alan Parker, with Irene Cara ¬ *Flash Gordon*, by Mike Hodges, with Sam J. Jones and Melody Anderson ¬ *Berlin Alexanderplatz*, by Rainer Werner Fassbinder, with Günther Lamprecht ¬ *Pepi, Luci, Bom and the Other Girls on the Heap* by Pedro Almodóvar, with Carmen Maura and Eva Siva ¬ *Raging Bull*, by Martin Scorsese, with Robert De Niro and Cathy Moriarty ¬ *The Shining*, by Stanley Kubrick, with Jack Nicholson and Shelley Duvall.
Television: The episode of the TV series *Dallas* - "Who shot J.R.?" - tops a record audience of 41 million ¬ The TV series *Magnum P.I.* is introduced ¬ CNN is launched ¬ Canale 5 is first broadcast in Italy.

Music and theater —— Singles and albums: *Songs the Lord Taught Us*, by The Cramps, forerunners of the Psychobilly trend (a mix of psychedelic and fifties rock look) ¬ *Sandinista!* by The Clash ¬ "Ashes to Ashes," by David Bowie ¬ *Wild Planet* by The B-52's ¬ *Remain in Light*, by The Talking Heads ¬ "Ambient 2," by Brian Eno ¬ *Nunsexmonkrock*, by Nina Hagen ¬ *The Birthday Party*, by Sugar Hill ¬ *Freedom of Choice*, by Devo ¬ "Sailing," by Christopher Cross ¬ *Boy* by U2 ¬ The Rock Against Racism movement starts up in France, Germany and Great Britain.
Theater: *Rosmersholm* e *Così è (se vi pare)*, directed by Massimo Castri ¬ *Crollo nervoso*, by Magazzini Criminali Productions ¬ *Bandoneon*, by Pina Bausch ¬ *Lili Marlene in the Jungle*, by La La La Human Steps ¬ *Andy Warhol's Last Love* from the Squat Theater in New York wins the Ubu prize for the best foreign show presented in Italy.

Art, architecture and design —— Achille Bonito Oliva and Harald Szeemann inaugurate the *Aperto* section dedicated to young artists at the Venice Biennial ¬ From December 1980 to January 1981, 700,000 visitors throng to the Museo Archeologico of Florence to admire the Riace Bronzes, restored after being found on the bottom on the sea in 1972 ¬ The important *Pablo Picasso: a Retrospective* exhibition opens at MoMA in New York ¬ *Seven Young Artists from Italy*, the first Transavanguardia exhibition to have an international impact, opens at the Kunsthalle of Basel ¬ The artists Jean-Michel Basquiat, David Hammons, Jenny Holzer, Kiki Smith and Kenny Scharf take part in the Times Square Show in New York ¬ The *New York/New Wave* exhibition takes place under curator Diego Cortez at P.S.1 in New York ¬ *Three Flags* by Jasper Johns is sold for more than a million dollars; the big news is reported in the *New York Times*: it is the first time that the work of a living artist is sold at such a high price ¬ Keith Haring starts to paint the walls of the New York subway ¬ Robert Mapplethorpe photographs his first *Self-Portrait* ¬ Achille Bonito Oliva publishes *Italian Transavanguardia* in three languages (Italian, English and French) with Giancarlo Politi Editore, Milan ¬ The International Exhibition of Architecture at the Venice Biennial, directed by Paolo Portoghesi. At the Corderie of the Arsenale the exhibition *La presenza del passato* and the creation of the Strada Novissima become the manifesto of postmodern architecture. At the same venue: the exhibition *L'oggetto banale*, curated by Alessandro Mendini ¬ The Portland Building (Portland, Oregon) by Michael Graves is the icon of American postmodern classicism. ¬ Giorgio Giugiaro designs the Panda car for FIAT.

Literature and philosophy —— *The Name of the Rose*, by Umberto Eco ¬ *Altri libertini*, by Pier Vittorio Tondelli ¬ *Camera Lucida: Reflections on Photography*, by Roland Barthes ¬ *Seduction*, by Jean Baudrillard ¬ *The Adventure of Difference*, by Gianni Vattimo.

Science and technology —— The Internet is born ¬ Kodak produces the first video camera with incorporated video recorder ¬ Sony produces the first 3.5-inch Floppy disc ¬ Apple puts its first computer on the market.

—1980

History and politics —— 26 January / the trial of the Band of Four ends in China, with 2 people receiving the death sentence ¬ 10 May / François Mitterand is elected President of the Republic of France ¬ 13 May / there is an attempt on Pope John Paul II's life in the Vatican at the hand of Mehmet Ali Agca ¬ 8 August / in the US, President Ronald Reagan decides to equip the nation with the neutron bomb ¬ 22 October / at the Cancun summit in Mexico, 22 Western and Third World heads of state decide to open up negotiations for a new world order ¬ 13 December / a state of war is declared in Poland: a military committee is formed, headed by General Jaruzelski followed by the arrest of the leaders of Solidarnosc ¬ 14 December / Golan is annexed by the state of Israel ¬ 17 December / the American General James Lee Dozier, deputy chief of the NATO forces in Southern Europe, is kidnapped by the Red Brigade.

Events and society —— The *Sex and Language* convention is held in the Plaza Hotel of New York with more than a 100 experts participating, including psychoanalysts, writers and film producers ¬ The synthetic drug crack appears on the market in America ¬ Charles, Prince of Wales, marries Diana Spencer on 29 July ¬ The historic club Blitz closes in London, and Le Beat Route and The Language Lab clubs open ¬ Neville Brody becomes art director of *The Face*.

Fashion —— Giorgio Armani introduces two new lines: Emporio Armani and Armani Jeans ¬ Azzedine Alaïa produces his first collection ¬ Krizia's female fragrance is launched ¬ The Keith Haring event takes place in the Fiorucci shop in Milan ¬ Roger Dack and Stephen King establish EMDC – English Menswear Designer Collection – with the objective of promoting English men's clothing abroad ¬ Rei Kawakubo and Yohji Yamamoto present their collections in Paris at the invitation of the Chambre Syndacale. The American daily *WWD* quotes a "Hiroshima beggar's look" ¬ Christian Lacroix becomes the head of the haute couture company Patou ¬ In Paris, Issey Miyake's collection is inspired by origami figures ¬ Vivienne Westwood launches her new *Pirates* collection, propagating the new romantic movement and designing clothes for Adam Ant and Bow Wow Wow.

Cinema and television —— FILMS: *Escape from New York*, by John Carpenter, with Kurt Russell ¬ *Escape to Victory*, by John Huston, with Sylvester Stallone, Michael Caine, Max von Sydow ¬ *Raiders of the Lost Ark*, by Steven Spielberg, with Harrison Ford ¬ *Reds*, by Warren Beatty, with Diane Keaton and Jack Nicholson.
TELEVISION: MTV is launched ¬ In America, the first episode of the *Dynasty* series appears on television.

Music and theater —— SINGLES AND ALBUMS: *Imagine*, by John Lennon is number one on the Great Britain charts ¬ *Double Fantasy*, by John Lennon and Yoko Ono is Album of the Year ¬ *Physical*, by Olivia Newton-John ¬ *Betty Davis Eyes*, by Kim Carnes ¬ "Video Killed the Radio Star," by Buggles, the first video transmitted by MTV ¬ *New Top EP*, by Lene Lovich ¬ *Tom Tom Club*, by Tom Tom Club ¬ *Duran Duran*, by Duran Duran ¬ *October*, by U2 ¬ *Adventures on the Wheels of Steel*, by Grandmaster Flash ¬ *My Life in the Bush of Ghosts*, by Brian Eno/David Byrne ¬ Culture Club comes into being, formed by Boy George and Mikey Craig. THEATER: *Gli spettri*, directed by Luca Ronconi.

Art, architecture and design —— Robert Longo's solo exhibition, *Men in the Cities*, opens at the Metro Pictures Gallery in New York ¬ Julian Schnabel's exhibition opens at the Mary Boone and Leo Castelli Gallery ¬ The gallery owner Annina Nosei invites a 22-year-old Jean-Michel Basquiat to paint the basement of her gallery, with resounding success ¬ At the Centre Pompidou in Paris, the exhibition *Identité Italienne: Art en Italie depuis 1959*, curated by Germano Celant ¬ Jean-Michel Basquiat holds his first exhibition in Italy at the Emilio Mazzoli Gallery in Modena ¬ Renato Barilli publishes *Tra presenza e assenza: due ipotesi per l'età postmoderna* ¬ In Milan, Ettore Sottsass and Barbara Radice launch Memphis, which produces objects by leaders of new Italian and international design (M. Zanini, M. De Lucchi, M. Thun, A. Cibic, A. Isozaki, M. Graves, J. Mariscal, and others); the name is inspired by the album *Stuck Inside Mobile with the Memphis Blues Again* by Bob Dylan ¬ Alessi presents the *Tea and Coffee Piazza* collection: twelve architects think about tea and coffee cups ¬ At the Salone del Mobile, in Milan, Alessandro Mendini and Studio Alchimia present *Mobile infinito* ¬ Francesco Clemente moves to New York.

Literature and philosophy —— *From Bauhaus to Our House*, by Tom Wolfe ¬ *Theorie des kommunikativen Handelns*, by Jürgen Habermas ¬ The poet Eugenio Montale, Nobel prizewinner, dies.

Science and technology —— AIDS is diagnosed for the first time in June; the *New York Times* publishes the first article on the subject ¬ IBM introduces the first personal computer for sale.

–1981

History and politics —— 28 January / in Padua, Italy, the police release the American General James Lee Dozier, kidnapped by the Red Brigade ¬ 2 April / Argentina invades the British-owned Falkland Islands ¬ 6 June / Israel invades Lebanon ¬ 14 June / the war in the Falklands ends with a British victory ¬ 19 June / the body of the Italian banker Roberto Calvi is found under the Black Friar Bridge in London ¬ 3 September / in Italy, the carabinieri General Carlo Alberto Dalla Chiesa is assassinated by the Mafia in Palermo ¬ 16-17 September / the massacres of Sabra and Chatila: more than a 1,000 Palestine civilians are killed by Falangist militants, authorized by the Israelis to penetrate the Palestine camps ¬ 28 October / Helmut Kohl becomes Chancellor of the German Federal Republic.

Events and society —— Italy wins the soccer World Cup ¬ The Princess of Monaco Grace Kelly dies tragically in a car accident ¬ Le Beat Route and The Language Lab in London are the first clubs to introduce black dance music ¬ The Tenax Club opens in Florence.

Fashion —— Giorgio Armani launches the female fragrance Armani Donna ¬ *Time* dedicates its cover story to Giorgio Armani ¬ Dolce and Gabbana open their first studio in Milan and commence their joint career ¬ Gianfranco Ferré launches the less expensive female line Oaks by Ferré, and designs his first collection for men ¬ Gianni Versace designs theatrical costumes for La Scala opera house and the Bejart Ballet ¬ Katharine Hamnett is named Designer of the Year ¬ Nike launches Air Force basketball shoes ¬ The French fashion designer Pierre Balmain dies, and his assistant Erik Mortensen becomes artistic director ¬ Bruce Weber's advertising campaign for Calvin Klein underwear causes a sensation ¬ The association between Giuliano Benetton and Oliviero Toscani begins; the first provocative advertising campaigns of United Colors of Benetton appear ¬ Swatch is launched ¬ Karl Lagerfeld introduces his KL fragrance ¬ Cinzia Ruggeri exhibits clothes with light and liquid crystals at the Milan Triennial ¬ The first works of art and comic strips appear on pullovers by JC de Castelbajac for Iceberg ¬ The Trussardi Uomo and Trussardi Donna fragrances are launched ¬ Anna Piaggi becomes the editor of *Vanity* Condé Nast magazine in Italy ¬ Antonio Lopez designs the first Missoni campaign.

Cinema and television —— FILMS: *Blade Runner*, by Ridley Scott, with Harrison Ford ¬ *E.T.: The Extra-Terrestrial*, by Steven Spielberg, with Henry Thomas and Dee Wallace ¬ *Rambo – First Blood*, by Ted Kotcheff, with Sylvester Stallone ¬ *Gandhi*, by Richard Attenborough, with Ben Kingsley and Candice Bergen ¬ *An Officer and a Gentleman*, by Taylor Hackford, with Richard Gere and Debra Winger ¬ *Querelle de Brest*, by Rainer Werner Fassbinder, with Brad Davis, Franco Nero, Jeanne Moreau ¬ *Tootsie*, by Sidney Pollack, with Dustin Hoffman and Jessica Lange ¬ *The Verdict*, by Sidney Lumet, with Paul Newman ¬ *The State of Things*, by Wim Wenders, with Allen Goorwitz and Patrick Bauchau ¬ Rainer Werner Fassbinder dies.
TELEVISION: Italian TV channel Retequattro begins showing the TV series *Dynasty*.

Music and theater —— SINGLES AND ALBUMS: *Combat Rock*, by The Clash. The single "Rock the Casbah" is to become one of the war cries of the soldiers fighting the Gulf War ¬ *Nebraska*, by Bruce Springsteen ¬ *Madonna*, by Madonna ¬ *1999*, by Prince ¬ *Planet Rock*, by Afrika Bambaataa and Soul Sonic Force ¬ *The Message*, by Grandmaster Flash ¬ *No-Man's Land*, by Lene Lovich ¬ *Klaus Nomi*, by Klaus Nomi ¬ *Clandestine Anticipation*, by Krisma ¬ *The Anvil*, by Visage ¬ *Vado al massimo*, by Vasco Rossi. THEATER: *1980*, by Pina Bausch ¬ *Macbeth*, by Carmelo Bene.

Art, architecture and design —— Basquiat's solo exhibition opens at the Fun in New York ¬ Cindy Sherman produces *Untitled Film Stills*, a series of photographs, started in 1977, portraying different types of women ¬ Jenny Holzer presents *Truisms* in Time Square in New York ¬ The Vietnam Veterans Memorial, designed by Maya Lin, is inaugurated in Washington, D.C. ¬ Robert Mapplethorpe produces *Lady: Lisa Lyon* ¬ *Artforum* publishes the article entitled "The Radiant Child," establishing Basquiat and Haring internationally ¬ *Transavanguardia Italia/America*, the international exhibition directed by Achille Bonito Oliva at Modena's Galleria Civica, shows works by Italian and American artists ¬ *Una generazione postmoderna*, curated by Renato Barilli, Fulvio Irace, Francesca Alinovi, in Genoa (and then in Rome at the Palazzo delle Esposizioni) ¬ In Milan, the exhibition *Gli Anni Trenta*, dedicated the thirties and the arts in Italy under fascism ¬ After ten years of work, the new museum of Mönchengladbach is inaugurated, the creation of Hans Hollein.

Literature and philosophy —— *The House of the Spirits*, by Isabel Allende ¬ *One Hundred Years of Solitude*, by Gabriel Garcia Marquez ¬ *If Not Now, When?* by Primo Levi ¬ *Pao Pao*, by Pier Vittorio Tondelli.

Science and technology —— In America, a surgical team in Salt Lake City succeeds in transplanting an artificial human heart ¬ The space probes Venera 13 and 14 land on Venus ¬ Philips and Sony launch compact discs on the market.

–**1982**

History and politics —— 24 January / 24 members of the Red Brigade are sentenced to life imprisonment in Italy for the kidnapping and murder of Aldo Moro ¬ 23 March / President Ronald Reagan announces the creation of the space protective shield ¬ 12 April / Harold Washington wins the Chicago elections, becoming the first black mayor of the United States ¬ 17 May / Lebanon and Israel sign a peace agreement ¬ 9 June / in Great Britain the conservatives win the elections. Margaret Thatcher is named Prime Minister ¬ 23 June / Pope John Paul II meets General Jaruzelski and Lech Walesa in Poland, declaring support for Solidarnosc ¬ 29 July / in Italy, a car bomb kills Magistrate Rocco Chinnici in Palermo ¬ 4 August / Bettino Craxi forms a new government in Italy ¬ 22 October / there are demonstrations against nuclear arms in many Western European countries, with over 2 million demonstrators ¬ 25 October / the Americans invade Grenada, in Central America ¬ 5 October / Lech Walesa is awarded the Nobel Prize for peace.

Events and society —— In January, *Time* elects the computer as "Machine of the Year" ¬ Princess Carolina of Monaco marries the Italian entrepreneur Stefano Andrea Casiraghi on 29 December ¬ Sally Ride is the first American woman in space ¬ Ronald Reagan calls the Soviet Union the "Evil Empire."

Fashion —— Krizia presents the *Chrysler Building* collection and launches the Uomo line ¬ Moschino introduces Moschino Couture ¬ The first Trussardi female prêt-à-porter collection is presented at the Teatro della Scala in Milan ¬ The Roberto Capucci exhibition opens in Tokyo ¬ Body Map – fashion designers David Holah and Stenie Steward – win The Most Innovative Designers of the Year prize with the *Olive Oil Meets Querelle* collection ¬ Together with her *Choose Life* collection, Katharine Hamnett launches her first knitwear series inspired by Buddhism, bearing slogans like "Save the World" and "Worldwide Nuclear Ban Now" ¬ Karl Lagerfeld becomes artistic director for Chanel ¬ Yves Saint-Laurent exhibits at the Metropolitan Museum of Art in New York: it is the first exhibition dedicated to a living fashion designer ¬ Vivienne Westwood recruits Keith Haring to work on her *Witches* collection; she is the first fashion designer to launch the idea of underwear as "overwear" ¬ Swatch – "fashion that ticks" – comes onto the market ¬ Condé Nast relaunches *Vanity Fair* under the direction of Tina Brown ¬ Robert Mapplethorpe's book *Lady* is launched, showing the bodybuilder Lisa Lyon modeling clothes by Armani, Ferré, Montana, Krizia, Carolina Herrera, Saint-Laurent, etc ¬ The Ente Moda Italia is established in order to promote Italian-made fashion abroad ¬ The Galleria del Costume at Palazzo Pitti, directed by Cristina Aschengreen Piacenti, opens in Florence ¬ Walter Albini dies.

Cinema and television —— FILMS: *The Big Chill*, by Lawrence Kasdan, with Glenn Close and William Hurt ¬ *Flashdance*, by Adrian Lyne, with Jennifer Beals and Michael Nouri ¬ *The King of Comedy*, by Martin Scorsese, with Robert De Niro and Jerry Lewis ¬ *The Outsiders*, by Francis Ford Coppola, with Matt Dillon, Patrick Swayze and Tom Cruise ¬ *The Return of the Jedi*, by Richard Marquand, with Harrison Ford ¬ *Rumble Fish*, by Francis Ford Coppola, with Mickey Rourke and Matt Dillon ¬ *Scarface*, by Brian De Palma, with Al Pacino and Michelle Pfeiffer ¬ *Star 80*, by Bob Fosse, with Cliff Roberts and Mariel Hemingway ¬ *Trading Places,* by John Landis, with Eddie Murphy ¬ *Staying Alive*, by Sylvester Stallone, with John Travolta ¬ *War Games*, by John Badham, with Matthew Broderick ¬ *Zelig*, by Woody Allen, with Mia Farrow ¬ *The Key*, by Tinto Brass, with Stefania Sandrelli.
TELEVISION: *The A Team* TV series commences ¬ "Deejay Television" starts up on Italian TV screens, a program by Claudio Cecchetto dedicated to music ¬ In Italy the television magazine "Non solo moda" begins broadcasting.

Music and theater —— SINGLES AND ALBUMS: "Is There Something I Should Know?" by Duran Duran ¬ "Do You Really Want to Hurt Me?" by Culture Club ¬ *Murmur*, by REM ¬ *Rio*, by Duran Duran ¬ *War*, by U2 ¬ "Maniac," by Frank Sembello from the film *Flashdance* ¬ *Sweet Dreams (Are Made of This)*, by the Eurythmics ¬ *Street Dance*, by Break Machine ¬ *Sucka MC'S*, by Run DMC, *Zulu Groove*, by Shanga ¬ *Color by Number*, by Culture Club ¬ "Every Breath You Take," by the Police ¬ *Bollicine*, by Vasco Rossi.
THEATER: *Nelcken*, by Pina Bausch ¬ *Genet a Tangeri*, directed by Federico Tiezzi, Magazzini Criminali Productions.

Art, architecture and design —— In Paris, the project for the Grande Louvre commences ¬ *Temporary Museum of Contemporary Art* opens in Los Angeles in a vast warehouse restructured by a Frank Gehry project ¬ In Prato, the exhibition *Conseguenze impreviste. Arte, Moda, Design: ipotesi di una nuova creatività in Italia*, curated by Achille Bonito Oliva, Rossana Bossaglia, Alessandro Mendini ¬ Valvoline is founded in Bologna – a group of comic-strip authors composed of Daniele Brolli, Giorgio Carpinteri, Igort, Lorenzo Mattotti, Marcello Jori and Kramsky ¬ In Bologna the art critic Francesca Alinovi is assassinated ¬ Trump Tower opens the series of a new generation of skyscrapers in New York ¬ The High Museum of Art is inaugurated in Atlanta, Georgia, architecture by Richard Meier ¬ At the competition for a Park of the 21st Century at La Villette in Paris, Bernard Tschumi's project is selected ¬ With the neighborhood *Les Espaces d'Abraxas* in Marne-la-Vallée, the monumental postmodernism of Ricardo Bofill is applied to residential buildings in the outskirts of Paris ¬ In Paris, Philippe Stark designs the furnishings of Café Costes ¬ In London, Ron Arad sets up his studio in a space on Neal Street ¬ In Milan the Domus Academy is inaugurated, the first post-graduate school of design.

Literature and philosophy —— *Chronicle of a Death Foretold*, by Gabriel Garcia Marquez ¬ *Moralbewusstsein und kommunikatives Handeln*, by Jürgen Habermas ¬ *Weak Thinking*, edited by Gianni Vattimo and Pier Aldo Rovatti.

Science and technology —— Fred Cohen creates the first computer virus ¬ For the first time, the IRAS satellite reveals a "black hole" in interstellar space, situated some 150,000 light years from earth.

–1983

History and politics —— 11 June / in Italy Enrico Berlinguer, General Secretary for the Italian Communist party, dies ¬ 26 September / the United Kingdom and China reach a settlement agreement for the re-annexation of Hong Kong to Chinese territory. The date is fixed for June 1997 ¬ 31 October / Indira Gandhi is assassinated in New Delhi by two members of the security services. His son Rajiv Gandhi is immediately named Prime Minister ¬ 6 November / Ronald Reagan is re-elected President of the United States ¬ 15 November / North Korea and South Korea start up negotiations for the creation of commercial relations ¬ 15 December / Mikhail Gorbachëv, the Soviet second in command, goes to Great Britain for an official visit.

Events and society —— Ridley Scott directs *1984,* the advertising commercial for Apple computers ¬ Nuova Idea in Milan is the world's largest gay discothèque: it has two dance floors, one for classical and the other for rock dancing ¬ Cyberpunk is invented ¬ *People* magazine publishes *The Yuppie Handbook* ¬ Following the arrest of Angelo Rizzoli, the publishing company RCS, Rizzoli-Corriere della Sera, falls under the control of Gemina, the financial company controlled by Fiat and Mediobanca ¬ The first Live Aid concert is held in London ¬ The first video rental shop opens in New York.

Fashion —— Giorgio Armani introduces his range of men's fragrances ¬ Philosophy by Alberta Ferretti is introduced ¬ Trussardi Uomo: the first collection is shown ¬ The first female fragrance by Gianfranco Ferré is launched ¬ The Genny collection is presented at the White House – a first for an Italian prêt-à-porter line ¬ Bernard Arnault purchases Dior ¬ Katharine Hamnett challenges Margaret Thatcher with T-shirts bearing political messages ¬ Donna Karan launches her first collection for Donna Karan New York ¬ At the Zenith Palace in Paris Thierry Mugler presents an unforgettable scene on the catwalks with snowflakes, rose petals and winged Madonnas and angels ¬ Ray Petri launches the Buffalo look ¬ Leigh Bowery appears for the first time on the covers of *i-D* ¬ Vivienne Westwood presents the first "designer" gym shoes ¬ "The Best of Five" event is held in Tokyo: the collections of V. Westwood, H. Mori, C. Klein, C. Montana and G. Ferré are all presented ¬ The Birkin bag by Hermès is born ¬ Paloma Picasso's fragrance is launched.

Cinema and television —— FILMS: *Amadeus*, by Milos Forman with Fred Murray Abraham and Tom Hulce ¬ *Footloose*, by Herbert Ross, with Kevin Bacon and Lori Singer ¬ *Heimat*, by Edgar Reitz; a film with eleven episodes that lasts 15 hours overall ¬ *The Killing Fields*, by Roland Joffé, with Julian Sands and John Malkovich ¬ *Paris, Texas*, by Wim Wenders, with Harry Dean Stanton and Nastassja Kinski ¬ *The Terminator*, by James Cameron, with Arnold Schwarzenegger ¬ *What Have I Done to Deserve This?* by Pedro Almodóvar, with Carmen Maura and Verónica Forqué ¬ *Woman in Red*, by Gene Wilder, with Charles Grodin and Kelly LeBrock ¬ *Once Upon a Time in America*, by Sergio Leone, with Robert De Niro and Joe Pesci. TELEVISION: The TV series *The Cosby Show* first appears on television ¬ The TV series *Miami Vice* with Don Johnson begins ¬ *Murder, She Wrote* first appears on television.

Music and theater —— SINGLES AND ALBUMS: *Purple Rain*, and "Let's Go Crazy," by Prince ¬ *Born in the USA*, by Bruce Springsteen ¬ *Thriller*, by Michael Jackson. The 14-minute video débuts on MTV ¬ "Girls Just Want to Have Fun," by Cindy Lauper ¬ *The Uncensored Lydia Lunch*, by Lydia Lunch ¬ *In the Long Grass*, by Bob Geldof ¬ "Buffalo Soldier," by Bob Marley ¬ *What's Love Got to Do With It?* by Tina Turner ¬ "Wake Me Up Before You Go-Go," by Wham ¬ *The Wild Boys*, by Duran Duran ¬ *Like a Virgin*, by Madonna ¬ "Time After Time," by Cindy Lauper ¬ Marcel Lì Antunez Roca founds the theatrical group I Fura dels Baus ¬ The English band Frankie Goes to Hollywood introduces the famous T-shirts with the slogan "Frankie says: relax." ¬ Break dancing reaches the peak of its popularity: the top prize in English competitions is as much as £25,000. THEATER: *Viaggio a Reims* by Rossini is shown in August at the Pesaro Festival, directed by Claudio Abbado, staged by Gae Aulenti and produced by Luca Ronconi ¬ *Le due commedie in commedia*, produced by Luca Ronconi ¬ Giorgio Barberio Corsetti and Studio Azzurro make their début with *Prologo a Diario segreto contraffatto*.

Art, architecture and design —— *Primitivism in 20th-Century Art: Affinities of the Tribal and the Modern*, curated by William Rubin and Kirk Varnedoe, opens at New York's MoMA ¬ In Italy the first museum of contemporary art is inaugurated at Castello di Rivoli ¬ Restoration work begins on Michelangelo's frescoes in the Sistine Chapel ¬ The exhibition *Arte di frontiera: New York Graffiti* opens at the Palazzo delle Esposizioni in Rome, as projected by Francesca Alinovi ¬ Andrea Pazienza, comic-strip designer, dies ¬ The writings of Francesca Alinovi are collected and published under the title *L'arte mia* ¬ New architecture: *AT&T Building*, New York, by Johnson/Burgee; *Neue Staatsgalerie* in Stuttgart, by James Stirling, Michael Wilford and Associates.

Literature and philosophy —— *Neuromancer*, by William Gibson. ¬ *The Unbearable Lightness of Being*, by Milan Kundera ¬ *Bright Lights, Big City*, by Jay McInerney ¬ *Family Dancing*, by David Leavitt ¬ *Of Love and Shadows*, by Isabel Allende ¬ *The History of Sexuality*, by Michel Foucault ¬ The philosopher Michel Foucault dies.

Science and technology —— The first hepatitis B vaccination becomes available ¬ There is the first case of a "borrowed" uterus: the semen and egg of a husband and wife are inserted into the uterus of another woman ¬ In California the first transplant of an animal heart is carried out, using the heart of a baboon in a baby girl: Baby Fae dies after 20 days.

–1984

History and politics —— 10 March / Mikhail Gorbachëv becomes General Secretary of the USSR ¬ 11 April / in Albania the Stalinist dictator Enver Hoxa dies ¬ 26 April / in South Africa the law forbidding marriage between blacks and whites is abolished ¬ 24 June / in Italy Francesco Cossiga is elected President of the Republic ¬ 7 October / a Palestine commando force sequesters the cruise ship Achille Lauro sailing from Alexandria to Port Said ¬ 15 November / Margaret Thatcher and Garret Fitzgerald, Prime Minister for the Republic of Ireland, sign an agreement on Northern Ireland ¬ 16 November / in Italy a new youth movement floods the entire country, especially the secondary schools, representing another chapter in the history of student protests ¬ 19 November / there is a historical meeting between Ronald Reagan and Mikhail Gorbachëv in Geneva.

Events and society —— The Live Aid rock concert takes place in London: 16 hours of music to fight against hunger in Africa ¬ Leigh Bowery opens the legendary Taboo Club in London with Tony Gordon ¬ The Palladium Club, a 9,000-square-meter disco, is inaugurated in New York, designed by Arata Isozaki, with frescoes by Clemente, Basquiat, Haring and Scharf ¬ Piazza San Babila in Milan becomes the rowdy "in" place for punks and paninari types.

Fashion —— Dolce & Gabbana make their début in Milan during the prêt-à-porter week with their first women's collection ¬ The Fendi women's fragrance is launched ¬ Byblos is introduced ¬ Romeo Gigli shows his first collection under his name ¬ Azzedine Alaïa designs an outfit with a pink latex bodice for Grace Jones' procession at the Oscar Awards, earning himself the title of "King of stretch." ¬ Dior launches the fragrance Poison on the market ¬ Jean-Paul Gaultier proposes skirts for men ¬ Katharine Hamnett is the first fashion designer to propose torn, used jeans ¬ The Tommy Hilfiger brand is launched ¬ Stephen Sprouse presents his camouflage collection ¬ Vivienne Westwood launches her *Mini Crini* collection in Paris ¬ The first collection of Dries Van Noten is shown ¬ *Elle* fashion magazine is published in the United States and Great Britain ¬ Giorgio Armani's partner Sergio Galeotti dies.

Cinema and television —— FILMS: *Commando*, by Mark L. Lester, with Arnold Schwarzenegger ¬ *Desperately Seeking Susan*, by Susan Seidelman, with Madonna ¬ *Mad Max*, by George Miller, with Mel Gibson and Tina Turner ¬ *My Beautiful Launderette*, by Stephen Frears, with Daniel Day Lewis ¬ *Out of Africa*, by Sidney Pollack, with Meryl Streep and Robert Redford ¬ *Perfect*, by James Bridges, with John Travolta ¬ *The Purple Rose of Cairo*, by Woody Allen, with Mia Farrow ¬ *Rambo II*, by George P. Cosmatos, with Sylvester Stallone ¬ *Ran*, by Akira Kurosawa, with Daisuke Ryu and Akira Terao ¬ *A View to a Kill*, by John Glen, with Roger Moore and Grace Jones ¬ *Year of the Dragon*, by Michael Cimino, with Mickey Rourke.
TELEVISION: "Quelli della notte," a variety show by Renzo Arbore, makes its first appearance on Italian television.

Music and theater —— SINGLES AND ALBUMS: *Do They Know It's Christmas?* by Band Aid ¬ *We Are the World*, USA for Africa, written by Michael Jackson and Lionel Richie, record of the year ¬ "Material Girl," by Madonna ¬ *Meat is Murder*, by The Smiths ¬ *Rain Dogs*, by Tom Waits ¬ "Money for Nothing," by Dire Straits ¬ *Boys and Girls*, by Brian Ferry ¬ *Hunting High and Low*, by A-ha ¬ *Mr. Bad Guy*, by Freddy Mercury ¬ *The Breakfast Club*, by Simple Minds ¬ *Walking on Sunshine*, by Katrina and the Waves ¬ "There Must be an Angel," by the Eurythmics ¬ *Desaparecidos*, by Litfiba ¬ The king of rock Bruce Springsteen sends the crowds wild at the San Siro stadium in Milan.
THEATER: *Mahabharata*, directed by Peter Brook.

Art, architecture and design —— In Paris, Christo envelops the Pont Neuf in 40,000 square meters of woven fabric ¬ The exhibition *Les Immateriaux* opens at the Centre Georges Pompidou in Paris, curated by François Lyotard and Thierry Chaput, confronting certain crucial aspects of the "postmodern condition." ¬ At the Centre Pompidou - Centre de Création Industrielle, the exhibition *L'image des Mots*, curated by François Vermeil, investigates modifications in typography with the advent of the society of the image ¬ The Saatchi Gallery opens in London ¬ Jeff Koons' first solo exhibition *Equilibrium* opens at the International With Monument Gallery (NY); the baseballs suspended in aquariums become icons ¬ The *Warhol, Basquiat Paintings* exhibition opens at the Tony Shafrazi Gallery, displaying collaborative works of the two artists ¬ The US returns Picasso's celebrated painting, *Guernica*, to Spain ¬ In Milan, an exhibition is inaugurated in the derelict factory of Brown Boveri, curated by Manuela Gandini and Giò Marconi, showing the works of some 30 or so young artists, including Stefano Arienti, Marco Mazzucconi and Bruno Zanichelli, who are to represent the nucleus of the new up-and-coming Italian generation ¬ At the Milan Triennial, *La Neomerce: Il design dell'invenzione e dell'estasi artificiale*, curated by Denis Santachiara ¬ In Bologna and cities of Romagna: *Anniottanta*, an exhibition curated by Renato Barilli ¬ Andrea Branzi publishes *La casa calda: Esperienze del nuovo design italiano*, and presents at the Alchimia museum the furniture series *Animali domestici* ¬ In Tokyo, at the Cassina showroom, Shiro Kuramata presents the chairs *Sing Sing* and *Homage to Hoffmann*.

Literature and philosophy —— *Rimini*, by Pier Vittorio Tondelli ¬ *Less Than Zero*, by Bret Easton Ellis ¬ *The City of Joy*, by Dominique Lapierre ¬ The writer Italo Calvino dies.

Science and technology —— Symbolic.com, the first registered domain comes into being: it is the start of a whole new invisible geography ¬ CD-ROMs are launched on the market.

−1985

History and politics —— 1 January / Spain and Portugal join the EEC ¬ 28 January / the shuttle Challenger explodes just minutes after taking off ¬ 26 February / Mikhail Gorbachëv declares a policy of transparency and reform: otherwise known as Perestroika ¬ 13 April / in Яome Pope John Paul II and Chief Яabbi Elio Toaff pray together ¬ 15 April / America attacks Libya, heavily bombarding Tripoli and Benghazi. Gheddafi responds by directing two missiles towards the Italian island of Lampedusa ¬ 26 April / a disastrous accident at the Chernobyl nuclear center in the Ukraine causes an unprecedented environmental catastrophe; a state of alarm is declared throughout the whole of Europe ¬ 6 Иovember / in the US an inquiry commission is set up concerning the secret arms sales to Iran: the Iran Gate scandal strikes.

Events and society —— Andrew, Duke of York, marries Sarah Ferguson on 23 July ¬ The grunge phenomenon breaks out in Seattle ¬ *Dylan Dog* by Tiziano Sclavi, edited by Bonelli, is published ¬ The trend magazine *Arena* is first published ¬ Иintendo distributes the first video games.

Fashion —— Яomeo Gigli acquires international celebrity with his spring/summer collection inspired by the Italian Яenaissance ¬ Moschino launches his men's line ¬ Diego Della Valle launches his loafer-style Tod's shoes on the market, with their characteristic 133 small rubber spheres on the soles ¬ Superga launches its *Inimitabili 2650* model ¬ Converse All Star "knee high" boots are born ¬ Vuitton's new LV monogram with stylized flowers appears on the market.

Cinema and television —— FILMS: *Alien*, by James Cameron, with Sigourney Weaver ¬ *Blue Velvet*, by David Lynch, with Isabella Яossellini and Kyle Maclachlan ¬ *Caravaggio*, by Derek Jarman, with Sean Bean and Иigel Terry ¬ *Hannah and Her Sisters*, by Woody Allen, with Michael Caine and Mia Farrow ¬ *Highlander*, by Яussell Mulcahy, with Sean Connery and Christopher Lambert ¬ *Labyrinth*, by Jim Henson, with David Bowie ¬ *Matador*, by Pedro Almodóvar, with Assumpta Serna and Antonio Banderas ¬ *Platoon*, by Oliver Stone, with Charlie Sheen, Willem Dafoe and Tom Berenger ¬ *A Яoom with a View*, by James Ivory, with Maggie Smith and Denholm Elliot ¬ *Stand By Me*, by Яob Яeiner, with Wil Wheaton and Яiver Phoenix ¬ *Tokio-Ga*, by Wim Wenders, with Chishu Яyu and Werner Herzog ¬ *Top Gun*, by Tony Scott, with Tom Cruise and Kelly McGillis ¬ *9 1/2 Weeks*, by Adrian Lyne, with Mickey Яourke and Kim Basinger ¬ *Ginger and Fred*, by Federico Fellini, with Marcello Mastroianni and Giulietta Masina.

Music and theater —— SIИGLES AИD ALBUMS: *Яaising Hell*, LP by the rappers Яun DMC: the group is sponsored by Adidas ¬ "Open Your Heart" and "Papa Don't Preach," by Madonna ¬ *True Colors*, by Cindy Lauper ¬ *Please*, by The Pet Shop Boys ¬ *Licensed to Ill*, by The Beastie Boys ¬ "Sledge Hammer," by Peter Gabriel ¬ *Иotorious*, by Duran Duran ¬ "Take My Breath Away," by Berlin, from the film *Top Gun* ¬ Иirvana is launched.
ТНЕАТЕЯ: *Viktor*, by Pina Bausch ¬ Martha Graham dies.

Art, architecture and design —— In Los Angeles, MoCA, the Museum of Contemporary Art, is launched, designed by architect Arata Isozaki ¬ The Centro d'Arte Яeina Sophia opens in Madrid ¬ The Musée d'Orsay is inaugurated in Paris, projected by Gae Aulenti and Italo Яota ¬ Keith Haring paints a mural on the Berlin Wall next to Checkpoint Charlie, affirming: "It is a humanitarian gesture, an attempt to psychologically destroy the wall by painting it." ¬ *Иeo-Geo Fab Four* opens to the public at Иew York's Sonnabend Gallery, displaying works by Jeff Koons, Peter Halley, Meyer Vaisman and Ashley Bickerton ¬ *Ballad of Sexual Dependency* by Иan Goldin is inaugurated at the Burden Gallery in Иew York ¬ Andy Warhol produces his *Camouflaged Self-Portrait* ¬ The exhibition *Il cangiante: Sguardo sull'attività artistica internazionale* opens at Milan's Padiglione d'Arte Contemporanea, curated by Corrado Levi ¬ Joseph Beuys dies ¬ At the XVII Milan Triennial, the exhibition *Il progetto domestico* curated Marco De Michelis, Monique Mosser, Georges Teyssot ¬ Installed by Arata Isozaki, the small exhibition *Gio Ponti, from the Human Scale to Post-Modernism*, at Seibu Museum of Art, Tokyo ¬ The Italian architecture and design movement called Bolidism, established by Massimo Iosa Ghini, Яoberto Semprini, Giovanni Garattoni, Massimo Mariani and others, is founded ¬ In the disco Manila in Florence the exhibition *Tutt'altro che architetti* is inaugurated.

Literature and philosophy —— *The Man Is Dead*, by Wole Soyinka, Иobel prize for literature ¬ *The Lost Language of Cranes*, by David Leavitt ¬ *Enthusiasm*, by Jean-François Lyotard.

–1986

History and politics —— 10 March / the Catholic Church condemns all forms of artificial procreation ¬ 19 October / Wall Street plummets by 22.6 % in a single day. "Black Monday" hits stock exchanges worldwide ¬ 8 December / the US and the USSR sign an agreement to eliminate Euromissiles ¬ 9 December / the first unrest and organized revolts take place in the territories of Gaza and Cisjordania: it is the start of the Intifada.

Events and society —— J. P. Aaron breaks the silence and starts to talk about his AIDS illness ¬ The Paradise Garage closes in London. The King's Street Club, mainly haunted by black and Hispanic gays, will count Keith Haring as one of its frequent visitors ¬ Italy goes to the polls: the radicals are represented in Parliament by the porn star Ilona Staller, known as Cicciolina, the future wife of Jeff Koons ¬ The Erasmus program is introduced, favoring university exchanges among EEC countries ¬ A Franco-British team examines the wreckage of the Titanic 4,000 meters below the surface in the Atlantic with the help of a deep-sea robot ¬ The daily newspaper *Corriere della Sera* starts publishing the weekly supplement called "Sette." ¬ The daily newspaper *La Repubblica* starts publishing the weekly supplement called "Il Venerdì." ¬ The magazine *Dolce Vita*, directed by Oreste Del Buono, is first published in Italy.

Fashion —— The Costume National brand by Ennio Capasa is introduced ¬ Moschino Donna fragrance is launched ¬ John Galliano is named Designer of the Year ¬ Katharine Hamnett puts packages of condoms in her Boxer Shorts ¬ Christian Lacroix leaves Patou ¬ Thierry Mugler launches his *Macho Look* men's collection: leather suits and muscle-man T-shirts ¬ Girombelli Group produces Christian Lacroix's prêt-à-porter collection, presenting in Paris for the first time. ¬ The fashion magazine *Elle*, directed by Carla Sozzani, is published in Italy ¬ The book entitled *Versace Teatro* is published by FMR. The fashion designer begins to further communicate his image through a series of published works ¬ Antonio Lopez dies ¬ The Ann Demeulemeester brand is launched.

Cinema and television —— FILMS: *Dirty Dancing*, by Emile Ardolino, with Patrick Swayze and Jennifer Grey ¬ *Fatal Attraction*, by Adrian Lyne, with Michael Douglas and Glenn Close ¬ *Full Metal Jacket*, by Stanley Kubrick, with Matthew Modine and Adam Baldwin ¬ *Good Morning, Vietnam*, by Barry Levinson, with Robin Williams ¬ *Hamburger Hill*, by John Irvin, with Anthony Barille and Michael Boatman ¬ *The Last of England*, by Derek Jarman with Gay Gaynor and John Phlipps ¬ *Predator*, by John McTiernan, with Arnold Schwarzenegger ¬ *Robocop*, by Paul Verhoeven, with Peter Weller and Nancy Allen ¬ *The Untouchables*, by Brian De Palma, with Kevin Costner, Robert De Niro, Sean Connery and Andy Garcia ¬ *Wall Street*, by Oliver Stone, with Michael Douglas, Charlie Sheen and Daryl Hannah ¬ *Lethal Weapon*, by Richard Donner, with Mel Gibson and Danny Glover ¬ *Wings of Desire*, by Wim Wenders, with Bruno Ganz and Solveig Dommartin ¬ *The Last Emperor*, by Bernardo Bertolucci, with John Lone and Joan Chen ¬ *The Family*, by Ettore Scola, with Vittorio Gassman, Stefania Sandrelli and Fanny Ardant.

Music and theater —— SINGLES AND ALBUMS: *Bad*, by Michael Jackson ¬ *Yo! Bum Rush the Show*, by the American rappers Public Enemy ¬ *Strings of Life*, by the group Rhythm is Rhythm, the start of techno music ¬ *Actually*, by The Pet Shop Boys ¬ *Honeymoon in Red*, by Lydia Lynch ¬ *Faith*, by George Michael ¬ "(I've Had) the Time of My Life," by Bill Medley and Jennifer Werners from the film *Dirty Dancing* ¬ "I Want Your Sex," by George Michael ¬ "Where the Streets Have No Name" and "I Still Haven't Found What I'm Looking For," from the album *The Joshua Tree*, by U2 ¬ *Appetite for Destruction*, by Guns n' Roses ¬ *Who's That Girl*, by Madonna ¬ Acid House begins in London clubs.

Art, architecture and design —— In January, Andy Warhol displays the figures of *The Last Supper* at his final exhibition at the Alexander Iolas Gallery in Milan ¬ Andy Warhol dies on 22 February ¬ Documenta 8 opens in Kassel, curated by Manfred Schneckenburger ¬ The Whitney Biennial is inaugurated in New York at the Whitney Museum of American Art, with the participation of Julian Schnabel, Ross Bleckner, Barbara Kruger, Terry Winters, Jeff Koons and Peter Halley ¬ The exhibition *Skulptur. Projekte in Münster*, curated by Kasper König and Klauss Bussmann, presents the work of 53 artists, including Michael Asher, Giovanni Anselmo, Daniel Buren, Hamilton Finlay and Jeff Koons ¬ The Anselm Kiefer retrospective opens at the Chicago Art Institute, curated by Mark Rosenthal ¬ Van Gogh's painting *Iris* is sold for the record sum of over 32 million dollars in New York ¬ Anna Wintour relaunches the magazine *House & Garden* like *H&G*, prototype of the new interior design magazines ¬ At the Milan Triennial, the exhibition *Le città immaginate: Un viaggio in Italia*, curated by V. Magnago Lampugnani and V. Savi ¬ Boutique Miyake Men, Seibu Store, Tokyo, project by Shiro Kuramata ¬ New architecture: Dolphin Hotel and Swan Hotel (Walt Disney World, Florida), by Michael Graves; Hotel Il Palazzo in Fukuoka, by Aldo Rossi; Institut du Monde Arabe in Paris, by Jean Nouvel; Netherlands Dance Theater, The Hague, by Rem Koolhaas and O.M.A.; Museo d'arte romana in Merida, by Rafael Moneo ¬ 60 years after its inauguration, the restoration of the 11 buildings of the Siedlung Am Weissenhof in Stuttgart, emblems of modern architecture.

Literature and philosophy —— *The Bonfire of the Vanities*, by Tom Wolfe ¬ *Eva Luna*, by Isabel Allende ¬ *The Fairy Gunmother*, by Daniel Pennac ¬ *The Bar under the Sea*, by Stefano Benni ¬ *Of Spirit*, by Jacques Derrida.

–1987

History and politics —— 15 May / Soviet troops withdraw from Afghanistan ¬ 6 August / Iran-Iraq: the war ends and peace treaties begin in Geneva under the protection of the UN ¬ 5 October / in Chile, the opposition win the referendum over General Pinochet requesting the confirmation of their mandate; there is a return to democracy ¬ 8 November / Vice-President George Bush is elected President of the United States ¬ 15 November / the Palestine National Council declares the creation of the Arab State in Palestine, and recognizes the State of Israel.

Events and society —— A world conference on AIDS is held in the United Kingdom in January ¬ The World Health Organization declares approximately 81,500 cases of AIDS in the world ¬ A massive rock concert is organized at Wembley in honor of the black leader Nelson Mandela ¬ *Nick Raider* by Claudio Nizzi is published by Bonelli.

Fashion —— Laura Biagiotti takes to the Peking catwalks; it is the start of Italian fashion in China ¬ Moschino launches the Cheap and Chic and Moschino Jeans lines ¬ Trussardi Jeans is introduced ¬ The first collection by Christian Lacroix is launched, and appears on the cover of *Time* ¬ Margiela launches its "white," anti-brand label ¬ Nike coins the slogan "Just do it." ¬ Suzy Menkes is nominated fashion editor of the *International Herald Tribune* ¬ Anna Wintour becomes director of *Vogue USA* ¬ Erik Ungless is named art director of *Vogue* ¬ Carla Sozzani becomes the new director of *Vogue* in Italy.

Cinema and television —— FILMS: *Dangerous Liaisons*, by Stephen Frears, with John Malkovich, Glenn Close, Michelle Pfeiffer and Uma Thurman ¬ *Die Hard*, by John McTiernan, with Bruce Willis ¬ *The Last Temptation of Christ*, by Martin Scorsese, with Willem Dafoe ¬ *Rain Man*, by Barry Levinson, with Dustin Hoffman and Tom Cruise ¬ *Rambo III*, by Peter McDonald, with Sylvester Stallone ¬ *Who Framed Roger Rabbit?* by Robert Zemeckis, with Bob Hoskins; it is the first time a film stars both cartoon characters and actors ¬ *Women on the Verge of a Nervous Breakdown*, by Pedro Almodóvar, with Carmen Maura and Antonio Banderas ¬ *Working Girl*, by Mike Nichols, with Harrison Ford, Sigourney Weaver and Melanie Griffith ¬ *Nuovo Cinema Paradiso*, by Giuseppe Tornatore, with Salvatore Cascio and Philippe Noiret.
TELEVISION: The first episode of "Striscia la notizia" by Antonio Ricci appears on Italian TV. ¬ The television program entitled "Indietro tutta," a variety show by Renzo Arbore, is first shown in Italy.

Music and theater —— SINGLES AND ALBUMS: *Bleach*, by Nirvana ¬ "Desire," by U2 ¬ "Don't Worry, Be Happy," by Bobby McFerrin ¬ *Stay on These Roads*, by A-ha ¬ *Better Live than Dead*, by The Sex Pistols ¬ "Tell Me," by Nick Kamen ¬ "Introspective," by Nick Kamen ¬ *It Takes a Nation of Millions to Hold Us Back*, the second album by Public Enemy, changes the history of pop music, with slogans inspired by Malcolm X, the Black Panthers and the Islamic Nation. Hip-hop discovers commitment and advertising becomes warlike ¬ The second Summer of Love explodes, a new psychedelic season based on Ecstasy and techno music.
THEATER: *Lungo viaggio verso la notte*, directed by Ingmar Bergman.

Art, architecture and design —— The American painter Jean-Michel Basquiat dies ¬ Robert Mapplethorpe snaps *Self-Portrait* ¬ *Impresario: Malcolm McLaren and the British New Wave*, curated by Paul Taylor, opens at the New Museum of Contemporary Art in New York ¬ Leigh Bowery produces a series of performances at the Anthony d'Offay Gallery ¬ The Centro per l'Arte Contemporanea Luigi Pecci opens in Prato, the first Italian contemporary art museum built from scratch ¬ At MoMA in New York, the exhibition *Deconstructivist Architecture*, curated by Philip Johnson and Mark Whigley; includes Coop Himmelblau, Peter Eisenman, Frank Gehry, Zaha Hadid, Rem Koolhaas, Daniel Libeskind, Bernard Tschumi ¬ At the Milan Triennial, the exhibition *Le città del mondo e il futuro delle metropoli*, curated by M. De Michelis ¬ *Hybrid Building*, Seaside, Florida, architecture by Steven Holl ¬ The architect Aldo Rossi wins the international Pritzker prize.

Literature and philosophy —— *American Lessons. Six Proposals for the New Millennium*, by Italo Calvino ¬ *The Satanic Verses*, by Salman Rushdie ¬ *Foucault's Pendulum*, by Umberto Eco ¬ *Equal Affection*, by David Leavitt ¬ *Der philosophische Diskurs der Moderne*, by Jürgen Habermas ¬ *The End of Ideology: On Exhaustion of Political Ideas in the Fifties*, by Daniel Bell.

–1988

History and politics —— 7 January / Emperor Hiro Hito dies in Japan ¬ 15 January / the commemoration of the death of Jan Palach is violently checked by the police in Czechoslovakia ¬ 3 June / the bloody repression of students protesting in Peking's Tienanmen Square in their bid for democracy is carried out by the Chinese government ¬ Ayatollah Khomeini dies ¬ 12-15 June / on the occasion of his first official visit to the German Federal Яepublic, Mikhail Gorbachëv signs a joint agreement with Helmut Kohl with the goal of overcoming European division ¬ 18 June / in Poland Solidarnosc wins the first independent elections since 1947 ¬ 5 July / the South-African President Pieter Willem Botha receives the historical anti-apartheid leader Nelson Mandela ¬ 9 November / the Berlin Wall falls ¬ 1 December / at the Vatican, the meeting between Mikhail Gorbachëv and Pope John Paul II seals the resumption of diplomatic relations between the USSЯ and the Vatican, further also to the reinstatement of religious freedom in the Soviet Union ¬ 20 December / the US invades Panama and dethrones the dictator Noriega ¬ 25 December / the Яumanian dictator Ceausescu is captured and shot together with his wife Elena.

Events and society —— In Italy, the universities are occupied by *Pantera* students; the kefiah is once again the symbol of the new rebellion ¬ Ayatollah Khomeini condemns the author of *The Satanic Verses*, Salman Яushdie, to death in absentia for "offending Muslim sentiments." ¬ Sunrise Parties smash the record of 5,000 people invited to a party in London to become the largest party ever organized in Great Britain ¬ The Barbie doll celebrates her thirtieth birthday.

Fashion —— Dolce & Gabbana design their first swimwear and lingerie collection, created as an essential part of the female wardrobe ¬ Яomeo Gigli presents his first collection on the Parisian catwalks ¬ Gianfranco Ferrè becomes artistic director of Dior, succeeding Marc Bohan ¬ Prada, already established for handbag and leatherwear design, makes its début in women's clothing ¬ The Atelier Versace line is launched. The Яussian fashion designer Slava Zaitsev shows his collection for the first time in the West in Florence at the Pitti Immagine Uomo ¬ The French fashion designer Guy Laroche dies ¬ Яay Petri dies.

Cinema and television —— FILMS: *Batman*, by Tim Burton, with Michael Keaton and Jack Nicholson ¬ *Born on the Fourth of July*, by Oliver Stone, with Tom Cruise ¬ *Dead Poets Society*, by Peter Weir, with Яobin Williams ¬ *Do the Яight Thing*, by Spike Lee, with Danny Aiello and Яichard Edson; Public Enemy records a track for the film, increasing the success of hip-hop ¬ *Glory*, by Edward Zwick, with Matthew Broderick and Denzel Washington ¬ *Notebook on Cities and Clothes*, by Wim Wenders; a documentary and interview of the fashion designer Yohji Yamamoto ¬ *Palombella rossa*, by Nanni Moretti, with Asia Argento and Silvio Orlando ¬ *Mery per sempre*, by Marco Яisi, with Michele Placido and Claudio Amendola.
TELEVISION: *The Simpsons* are broadcast on TV for the first time. ¬ The TV series *Baywatch* is introduced.

Music and theater —— SINGLES AND ALBUMS: "Express Yourself" and *Like a Prayer*, by Madonna ¬ "The Best," by Tina Turner from the album *Foreign Affair* ¬ "Wind Beneath My Wings," by Bette Midler ¬ "Belfast Child," by Simple Minds ¬ *In Depth*, by The Pet Shop Boys ¬ *Pirate*, by Litfiba ¬ The playwright Samuel Beckett dies.

Art, architecture and design —— The restoration of Michelangelo's frescoes in the Sistine Chapel is completed ¬ The glass pyramid of the Louvre, designed by Ieoh Ming Pei, is inaugurated in Paris ¬ *Andy Warhol: A Яetrospective*, curated by Kynaston McShyne, opens at the Museum of Modern Art ¬ Яobert Mapplethorpe dies of AIDS ¬ Matthew Barney performs *Field Dressing* at the Payne Whitney Athletic Complex at Yale ¬ The Corcoran Gallery cancels *Яobert Mapplethorpe: The Perfect Moment*. As a protest, Krzysztof Wodiczko projects a portrait of Mapplethorpe from 1980 on the museum façade.

Literature and philosophy —— *The Little Prose-Seller*, by Daniel Pennac ¬ *The American Evasion of Philosophy*, by Cornel West.

Science and technology —— Virtual reality is born. Jaron Lanier creates a 3-dimensional system of images that reproduce an artificial reality in which the spectator, with the use of a helmet and sensors, has the impression of being able to move.

–1989

To find out more about Charta, and to learn
about our most recent publications, visit

www.chartaartbooks.it

————

Printed in Italy by Tipografia Яumor SpΛ ¬ Vicenza¬
January 2004 for Edizioni Charta ¬